SUCCESSFUL
NATURE
PHOTOGRAPHY

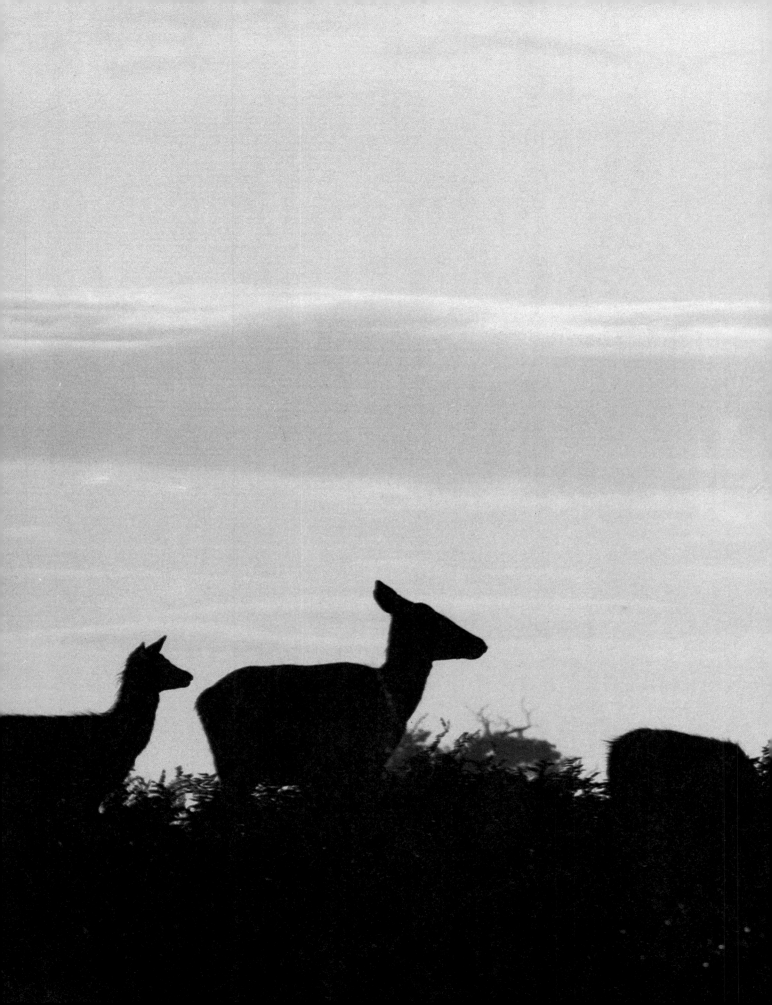

SUCCESSFUL NATURE PHOTOGRAPHY

How to take beautiful pictures of the Living World

Edited by Christopher Angeloglou and Jack Schofield

with an introduction by Heather Angel MSc FIIP FRPS

AMPHOTO
American Photographic Book Publishing
An imprint of Watson-Guptill Publications
New York, New York

Consultant: Neville Maude
Book Editor: Caroline Ollard
Editors: Christopher Angeloglou, Jack Schofield
Art Director: Carol Collins
Copy Editors: Mundy Ellis, Joselyn Morton,
Suzanne Walker

Contributing Editors: Heather Angel, Ian Beames
Ron Chapman, John Hannavy, Colin Jones,
David Kilpatrick, Robin Laurance, Kevin
MacDonnell, David Pratt, Tina Rogers, David
Saunders, Peter Scoones, David Sewell.

Designed and produced for Amphoto by
Eaglemoss Publications Ltd.

First published in 1983 in the United States by
Amphoto, American Photographic Book
Publishing, an imprint on Watson-Guptill
Publications, a division of Billboard Publications,
1515 Broadway, New York, N.Y. 10036.

Most of this material first published in
You and Your Camera magazine
© 1982 by Eaglemoss Publications Ltd

ISBN 0-8174-5925-1
Library of Congress Catalog Number 82—62883

D. L. TO: 30 -1983
Printed by Artes Gráficas Toledo, S.A. Spain

CONTENTS

INTRODUCTION

The natural world offers an infinite variety of photographic subjects ranging from spectacular landscapes and sunsets to detailed close-ups of plants and animals. Everyone's motivations for photographing nature will differ, but your enjoyment will be enhanced by knowing how to get the best out of your equipment. You will find that the hundreds of colour photographs in *Successful Nature Photography* will inspire you to learn more about the techniques for getting consistently better nature photographs.

The development of the highly versatile 35mm single lens reflex system with a wide range of interchangeable lenses has made nature photography possible far beyond the scope of the back garden, for so many people who enjoy being out and about. To achieve successful nature photographs you need to be a keen field naturalist *and* a competent photographer, capable of handling cameras and lenses quite instinctively.

This book explains in simple terms, not only how to look for the best viewpoints for taking landscape pictures and how to compose a picture, but also which equipment to select for photographing plants, insects, birds and other wildlife subjects. There are tips on using special filters, on stalking wild animals in the field and on setting up a hide for photographing birds. More specialized topics include taking close-ups, life in aquaria, night photography and underwater photograpy.

One of the delights of nature photography—which has blossomed out of all proportion in recent years—is that in striving to achieve better photographs, you will inevitably become much more observant about the private lives of your subjects. The ten years I have spent working as a professional wildlife photographer have in no way diminished the pleasure I gain from looking at other nature photographs. I am sure that this book will help to launch you on a lifetime of pleasure and enjoyment from recording nature as you see it—wherever you are.

Heather Angel

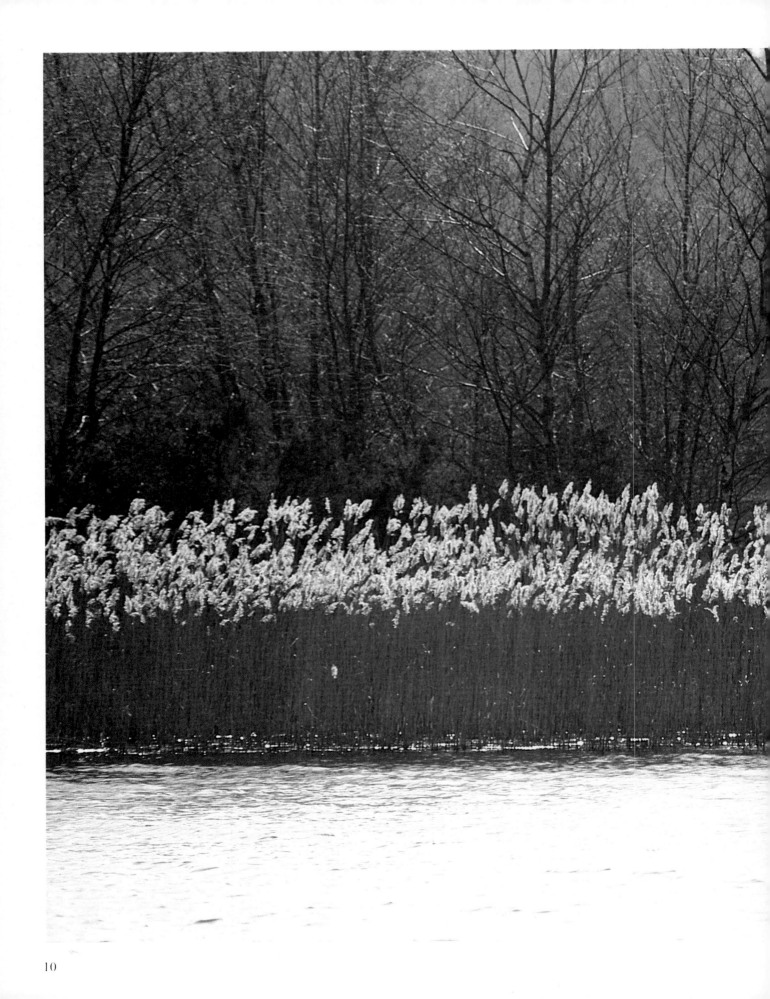

THE NATURE PHOTOGRAPHER AT LARGE

The world of nature is packed with a wealth of subjects, large and small, from which the photographer can choose. Trees, shrubs, plants and flowers are parts of the overall picture and so are animals, birds and insects. This chapter shows you where to go with your camera and tells you what you are likely to spot in the garden, park, woods and forests, by the riverside and on the seashore.

As the seasons pass, the appearance and behaviour of living plants and creatures alter so that photographers have their favourite times of the year for pictures of various types of activity or scenery. The weather can make all the difference to your pictures and affects the natural lighting of shots from landscapes to close-ups.

Your equipment is always important. The best kinds of camera for general nature photography are described and special attention is paid to the types of lenses suited to the different subjects found in nature. The sky is nature's backcloth and the keen photographer can use filters to control its appearance in photographs. The technique of employing such filters is introduced in this chapter as a foundation for more detailed treatment later in the book.

The illustrations provide ideas for photographs as well as technical information to help you select the right lens setting or shutter speed wherever you may be with your camera in the world of nature.

A winter reed-bed taken with a 400mm lens against the light to highlight the fluffy seed heads.

The garden

Every garden is full of subjects for your camera. Wide expanses of flower borders, separate plants and close-ups of individual flowers are only a part of the pictorial possibilities. The wild plants, which we call weeds, can be attractive also.

Pets are happy in the garden and so photograph well. There is always wild-life,—birds in abundance and variety, some welcome to the gardener like the robin, others enemies such as the pigeon, but all subjects for photographs. A bird table can attract the brightly-coloured tits and finches; also it keeps the birds in a small area so you can have the camera ready set up and focused. Damp places harbour fascinating frogs and even newts; these are always worth a picture. Insects are another facet of the pictorial wealth which can be found.

However, before you start snapping left, right and centre, take a few moments to have a good look around. Consider the overall view, the garden's shape and size, the way the house and garden relate. Some houses, hidden by creepers or trees, take second place to their gardens. With others, the solid mass of the house is balanced by the softer forms of nature.

The garden itself is full of contrasts: shape, volume, texture, light and shade, old and new. Consider your composition carefully. A focal point helps, both in close-ups and longer views. Apart from flowers and trees, there may be mossy paving you can use, an old wall, a fence or gate. Sheds and greenhouses make good subjects, and what's inside is often just as interesting.

Try taking photographs in all types of garden, from cosy cottage gardens bursting with old-fashioned herbacious plants and gnarled apple trees to large formal gardens such as you find at stately homes. A high viewpoint can portray their distinctive geometrical layout.

When to photograph

You can choose any time of the day or year to emphasize something special about your garden.

Morning The ideal time for general garden views is just after dawn when everything is fresh and dewy. Morning light is soft. There are no hard shadows and the air is usually still. This is a good time for flower studies.

Afternoon Unless the day is overcast (when light is low and there is little contrast) you will find that the higher sun causes shadows to become short and harsh. Colours record well in this bright light. If the light is diffused, objects can look two-dimensional without

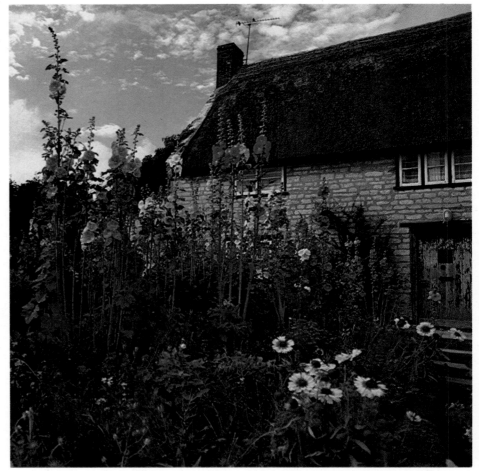

sufficient shadow to give them form. The best results are obtained on 'cloudy/bright' days when there is some sun and blue sky, but enough cloud to soften and diffuse the light.

Evening Shadows are long, colours warmer. Lights come on—and this opens up new possibilities. Photographing at dusk, you may get the shapes of trees and house outlined against the sky, as well as glowing windows and lights.

The seasons also allow you to make the most of your garden.

Spring Flowering trees and shrubs can be photographed as a whole or in close-up—say, against a blue sky. Birds and insects are always around, so keep your camera handy. High-key pictures sometimes express the ethereal quality of spring light perfectly. Choose pastel colours, such as almond blossom, and over-expose by about a stop.

Summer This is the time to record beds and borders. But be careful of dark shadows. Get in close and concentrate on small groups of related colours. Pure light and shadow can be used for dramatic, contrasty pictures.

Autumn During this season shrubs and

▲ **A 'cloudy/bright' day is best for garden shots when colours record full tonal range and lots of detail. Direct sun would make this shot too contrasty, putting the lower level in deep shade. A garden need not be carefully tended—this one, with its riot of overgrowth, echoes the slightly dilapidated-looking house behind. George Wright**

▶ **Spots of sunlight filter through to highlight the soft spring colours. The white cat makes a serene focal point, its colour balancing the spray of blossom above it. Derek Bayes used a 35mm lens and an exposure of 1/125 at f6·3 on 100 ASA film.**

▶ **Left: H. Gritscher used a 105mm macro lens to focus on the heart of this flower. An off-centre composition makes the shot more dramatic. Bright, but diffused, lighting accentuates the dazzling colour.**
Centre: George Wright lets us into the secret of his garden shed! Studio flash with a diffuser attachment creates warm, hazy light to complement the window-lit composition. It also highlights the warm, autumnal colours.

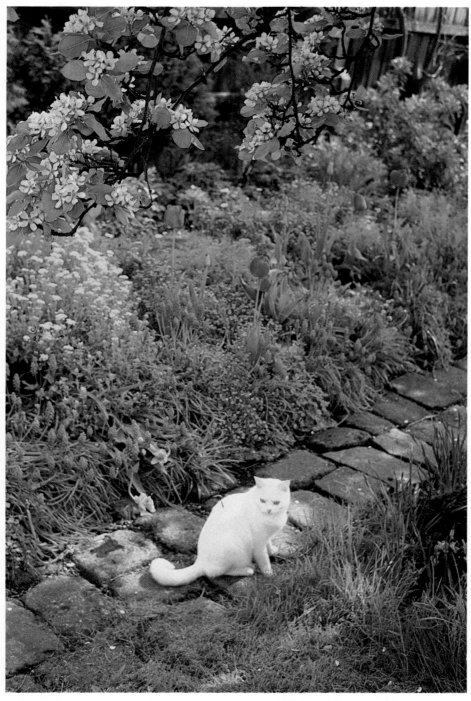

fences are hung with spider-webs. In early morning water droplets shine on every leaf. Autumn leaves are a favourite subject, but pictures of whole trees can be disappointing no matter how colourful. Individual leaf shots are often more successful. Some of the most atmospheric garden pictures are taken when colours are softened by haze or wood-smoke.

Winter Skies are usually grey and cloudy. Light is weak and diffuse. Although there isn't much colour, the delicate forms of twigs or dead leaves outlined in frost are simple and beautiful subjects. Everything glitters when the sun comes out, and gardens are transformed when it snows.

Necessary equipment

For most garden photos, you can use your basic SLR system, but for that *particular* one, you may need a little extra.

A moderate telephoto lens is good for birds and small animals. A standard or macro (50mm or 55mm) lens is fine for general shots. A macro lens focuses from infinity down to a reproduction ratio of 1:2 (half life-size). With extension rings it will give a 1:1 (life-size) ratio. A TTL meter compensates for the necessary exposure increase. To take in all of a small plot, a wide-angle lens (28mm or 35mm) is best. This is also good for dramatic effects like shooting up the trunk of a tree.

Flash 'freezes' flowers or leaves on windy days and isolates them from the background, which comes out dark. You can use fill-in flash to lighten shadows in small areas. Reduce the amount of flash normally required by one or two stops.

Because of the constant movement of most outdoor objects, a medium or fast film (100-400 ASA) is preferable. This allows faster shutter speeds.

▼ **Freshly-picked vegetables glistening with dew suggest an early morning shot. George Wright focused on the front tomatoes, giving limited depth of field and a blurred, contrast background.**

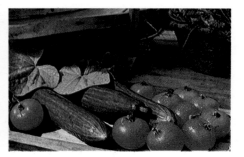

Exposure hints

For saturated colours, under-expose by at least half a stop if using slide film (say, for an indicated exposure of f11, set the aperture between f11 and f16). With backlit subjects, exposure according to the TTL meter reading gives a silhouette effect. For shadow detail, open up by one stop for slides or two stops for colour negative film (set f11 or f8 on an f16 reading). Bracketing the exposures—at half-stop intervals for colour, one-stop intervals for black and white—gives a choice of effects.

Outdoors with plenty of light and a fast film, it's tempting to work at small apertures. This gives maximum depth of field, but it can result in pictures with *too* much background detail. Press the preview button, if your camera has one, to check the effect at the taking aperture. Selective focusing simplifies compositions. Working at larger apertures (f5·6 or f3·5) can give romantic views framed by smudges of soft colour —out-of-focus leaves or flowers in the foreground. A telephoto lens gives the best results for small areas.

Using filters

A polarizing filter controls reflections from the surface of water. It also darkens blue sky and increases colour saturation by reducing glare. Keep the sun beind the camera for maximum effect. Remember, however, with a polarizer you'll need an exposure increase of one to two stops (The TTL meter takes this into account.)

A day-by-day record

To be really creative, photograph your garden every month, or every week, or even every day. This provides an interesting record of the changes in nature, as well as changes in your own life, and the use of your garden. Take your pictures from the same spot.

You will be amazed at the increase in your awareness—even if you only photograph your garden during the summer when you can be reasonably sure of good weather. But be aware, also, of the creative possibilities of the other times of the year. Not only glorious butterflies and intriguing caterpillars but also spiders in their dewy webs and a whole jungle of minature life wait to be discovered and recorded.

If you have no garden of your own, borrow those of friends and relatives. They may be amazed at how much you can find to photograph in them. Also, the many gardens open to the public are always worth a visit.

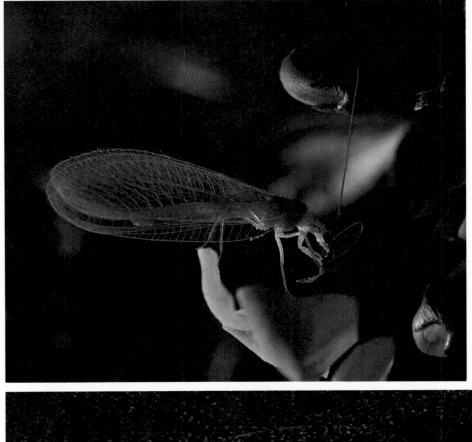

◀ A single electronic flash-gun and reflector captured this delicate lacewing fly hovering over a flower. The background is left in deep shadow, contrasting with the soft foreground colours. Mike Anderson used a 90mm/f2·8 macro lens on his Cosina CSR.

▶ A 'study in green'. George Wright's photo of cucumbers poking out under the edge of the whitewashed garden frame has little colour variety. But a strong composition using sharp contrasts of shape and line carries the picture. Wright used a 100mm lens at f16 to provide sufficient depth of field.

▼ Hidden in the shadow of a wall, this brightly-hued bed retains its pure colours, even when photographed on a dull day. George Wright set his camera on a tripod, exposing for 1 second at f22 on Kodachrome 25 film.

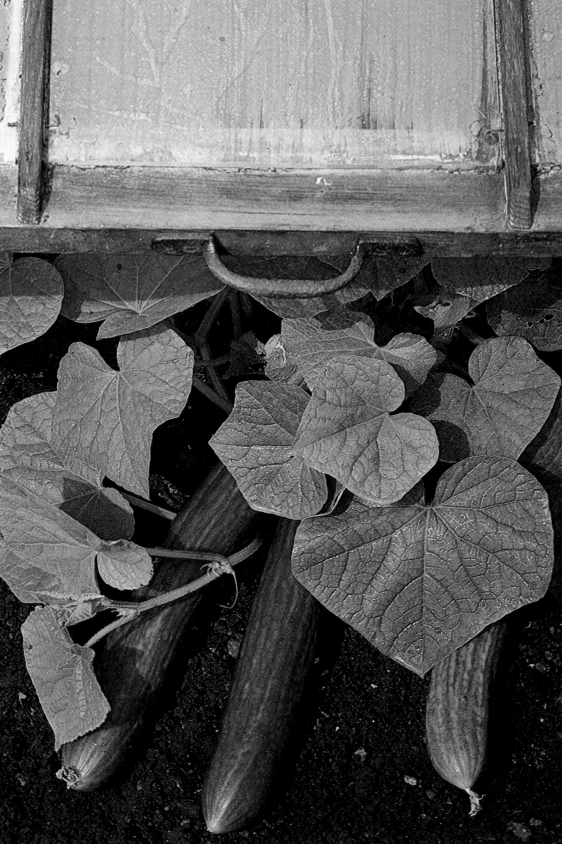

The park

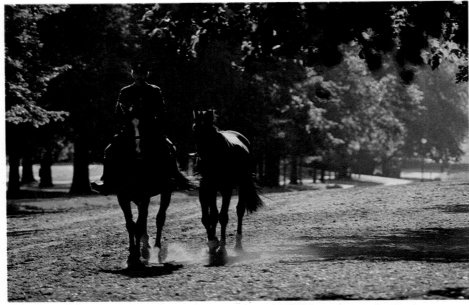

A park is a piece of the countryside within a crowded city. It is a place to walk, to sit, to breathe fresh air, to see trees and flowers, birds, even some animals, and, of course, to take superb photographs of these natural subjects. Every season has its own special charm. The year begins with spring as new life starts to grow. It is a period of transition and with care the photographer can show it as it happens. The light becomes clearer as well as stronger; colours begin to show that vivid sparkle which has been missing during the winter months. The days grow longer, giving more time for picture-taking.

Trees

Trees are signposts for the spring. They show the way. A great deal happens to a tree during this season. Take pictures in the winter to compare an evergreen with its leafless neighbour. Then in the spring, contrast the light, gay green of the deciduous tree with the sombre evergreen. Spring leaves are lighter and more translucent than at any other season. Try taking young leaves backlit against the sky. Closeups of bursting buds make good subjects, the chestnuts so often found in parks are especially good for this. Note that parks often have exotic and unusual trees not found in ordinary woodland. If you make regular visits to the same tree you can take a series of shots to show its spring progress—from tightly closed buds, through the stages of the swelling buds bursting open and rounded off with the bright new leaves fully formed.

With small young leaves just emerging on the branches, you have more chance to photograph the wildlife that lives in trees. Squirrels are extra active, and it is also the busiest time of year for birds. Their nest-building activities have reached fever pitch, and you may even be able to catch sight of some of their young with a long lens. But try not to disturb them: keep still, keep quiet and remember that they regard you as a threat and may quit a nest altogether if they feel you are a danger. One classic springtime picture to look for—especially in city or suburban areas—is a magnificent branch laden with delicate pink blossom taken from below against a blue sky. In the middle of the day, when the sun is high, this approach is also good for showing the fine translucence of new green leaves, as the light filters through them. Or go out on a misty morning and single out one or two catkins or sprigs of pussy-willow. In close-up, the detail of these spring tell-tales shows up all the better against at misty background.

Flowers

The first flowers are another herald of the spring, and park-keepers usually make the most of them in brilliant displays.

Early spring flowers are mostly yellow. Aconites are followed by yellow crocuses, the blue and striped ones follow. The wild primrose is yellow, though parks also have cultivated types. Daffodils are also yellow, though some late flowering types can be white. The tulips follow, not only red but many other hues. Try not only the medium distance pictures, with masses of colour, but also individual close-ups. Look inside the tulip to see the pollen-

◄ ▲ Seasonal differences in Hyde Park. Early one morning. . . John Garrett went into the park to photograph military horses being exercised. He used a 180mm Nikor lens and Ektachrome 64, warmed by an 81A filter. For a boat on the Serpentine, Garrett used bare branches and silhouetted figures to make a frame.

laden stamen in its coloured cup. Other flowers follow, each in its season, and all can provide photographs.

If you spend the whole day in the park, you can record the daily cycle of one particular flower. Catch it very early in the morning when it is closed tight, and perhaps covered with dew. Then take several pictures showing the flower opening and being visited by insects. A centre-focus filter singles out one sharp bloom surrounded by softer neighbours. Use a starburst filter to catch the sun glinting on frost or raindrops. Use a polarizing filter to reduce any unwanted

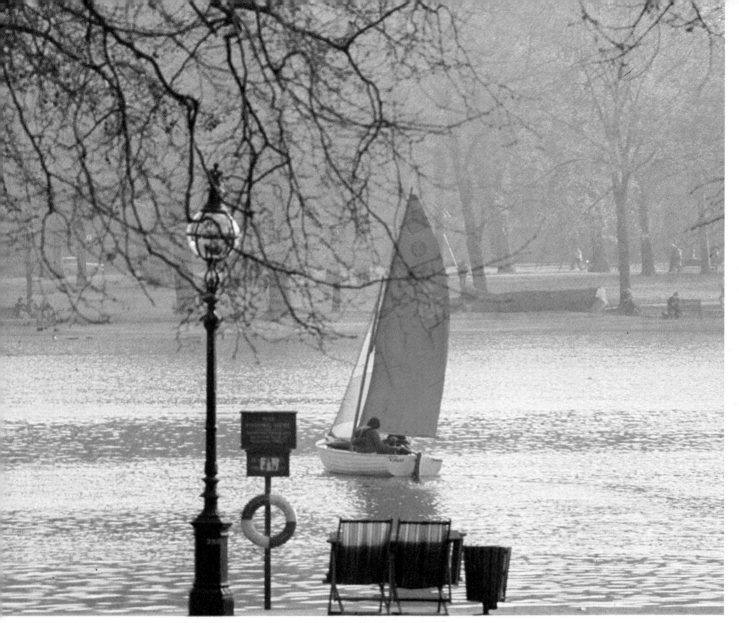

reflections on petals or leaves, and to deepen the colours of the flowers as well as the background sky.

Lighting

It is easy to get so carried away by the beauty of the flowers that you forget about the lighting altogether. Poor lighting ruins your shots. The delicate colours and structures of spring flowers look wonderful when they are photographed against the light. Move the camera until you have light filtering through the petals so that they seem to glow. To concentrate on texture, however, you will need to find a position to shoot from so that the light hits your subject at a sharp angle.

Whether you use back or side-lighting, however, you will have more success if you take your pictures early or late in the day when the sun is fairly low in the sky. Choose a slightly hazy day when the sunlight will not be harsh. If the sun is very bright and the shadows too dark, use a sheet of white paper to reflect light back into the flowers.

Changing scenery

Everything happens quickly in the spring, and it is a season of great variety. There are several photographic projects you can try out.

The weather is completely unpredictable from one moment to the next. There can be wind, rain, sunshine and snow all on the same day. Record these changes by photographing them as they happen. To get the full effect, include a large area of sky in the pictures. Look around for a group of shapely trees on the horizon with a path or a fence which leads the eye away into the distance. Then simply wait for the weather to 'happen' to the landscape and record it

▶ The distinctive bark of the plane is to be seen in many London parks. Close in on a section of bark for an interesting study in tone and texture.

17

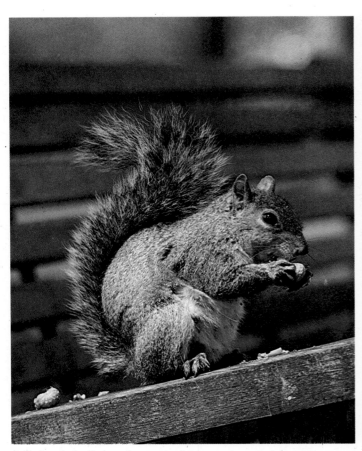

▲ Animals in the park are used to people—and to cameras. Eric Crichton had an 85mm lens on his camera when he saw this docile squirrel enjoying a feed, and he took the shot from a distance of 6ft (2m). Using Kodachrome 64, his exposure as 1/250 at f4, which left the background a blur to contrast with the sharp detail of the animal's coat. He focused carefully on the eye (which was focused just as carefully on him!) and the rest of the body stayed sharp.

on film.

Capture the changes which take place during this season by choosing one particular view of the park which includes a wide range of subjects: a small pond flanked by flower beds, for example, with a group of trees in the background and some shrubbery to one side. Take a picture of this scene every week from the same camera angle. Use the same lens, the same framing and take the pictures at the same time of day. You may find it a help to use a tripod and mark its position for the next time you take a picture. You might also make a sketch of the objects in the photograph so that you can repeat the scene exactly. The photographs will show changes that are difficult to follow with the naked eye, as well as a wonderful record of the changing seasons.

What to take

You may have a lot of walking to do,

so travel as light as you can. For some shots, specialized equipment is essential. But most subjects you would want to take in the park can be tackled with one camera and one lens. Perhaps the ideal choice would be an SLR with a 70-210mm or 80-200mm macro-zoom, but a 70-150mm would be very nearly as good.

Do not be discouraged if your equipment is less versatile than this. Parks are naturally photogenic places. Wonderful pictures can be taken with even the simplest fixed-lens compact cameras. However, if you particularly want to photograph the wildlife in a park, a long lens is essential. The birds and squirrels in a park are often relatively tame, so a 200mm lens (or zoom) should be enough. If they are used to being fed, some bread or nuts will lure them within the range of a 135mm or even a 100mm lens.

If you particularly want to photograph

flowers in close-up, or insect life, then a set of extension tubes or a macro lens will be most useful. (Tubes are preferred to bellows for outdoor use as they are more rigid and durable.) These will give a better quality image and—usually—greater magnification than the sort of macro facility which is fitted to any modern telephoto zooms. However, the loss of quality with macro-zooms is noticeable only at the edges of the picture area. For many park pictures—such as a single flower filling the centre of the frame—the image quality will be quite good enough where it counts most.

For quick close-ups, you can use close-up lenses which fit into the filter-thread of the lens. These do not seem to be used much with SLR cameras, though the image quality given by the better ones is very good.

A wide-angle lens can also come in very useful for general views of the park.

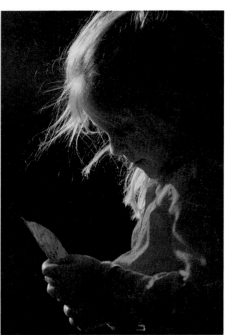

▲ An autumn reminder. John Garrett photographed this girl with a leaf left from last year so that only the backlit areas of the picture were properly exposed. He used a 400mm lens at f3·5, which gave a shutter speed of 1/500 on 64 ASA film, and he added a pale brown 81C filter to warm the colours.

◄ With a wide-angle lens, you can use a bed of bright spring flowers as an eyecatching foreground, without losing detail in the flowers or in the scene beyond. The extra depth of field retains sharp focus throughout at small apertures. I Lewis

Most modern wide-angle lenses of 28mm f2·8 and similar specifications are quite small and light, so it is no trouble to carry one in a spare pocket for the odd shot.

A tripod can be handy for close-ups of flowers—particularly on windy days! You can set the camera to take the picture using its delayed action self-timers, while you hold a coat or news-paper (out of sight of the lens) to shield the flower from gusts of wind.

Finally, however, there are some non-photographic essentials for a day in the park: a flask of tea or coffee and a packet of sandwiches!

► In summer you are very likely to spot a small tortoiseshell butterfly on a shining honeysuckle shrub because the caterpillars of this, and other species, live on stinging nettles which are often to be found in odd clumps in shady parts of parks and gardens.

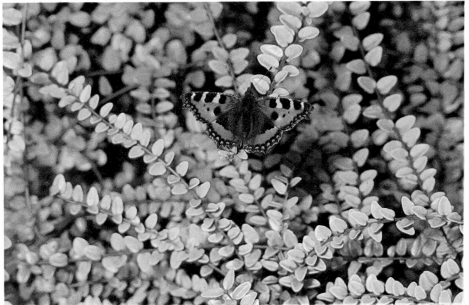

Woods and forests

Walking in the woods is enjoyable in every season of the year. In spring the new leaves unfold as the whole world wakes from its winter sleep. You may find the first flowers, such as the shy wood anemone. Later the bluebells carpet the dells. With early summer comes the busy time for insects, and the birds that feed on them as they raise their nestlings. The pace continues through high summer into early autumn, which is the time for brightly coloured fungi. Wet weather makes these fungi grow. In late autumn, the leaves turn colour, making a succession of subjects for the camera. The brightest hues come when the sun shines after frost, but before winds blow down the leaves into multi-coloured drifts.

Different times of day
The best times to see most woodland creatures are—fortunately—also the best times to take pictures of them. Early morning and late afternoon provide low sidelighting from the sun. This lower angle picks out detail far better than the light around noon, especially in summer when the sun can be almost directly overhead at midday.
A keen photographer will begin his day

in the forest at dawn. The colours in the sky at that time can resemble the splendour of a sunset if there is rain on the way. But a normal summer dawn creeps slowly up from half-light to full low sunlight over a period of around half an hour. Early morning is your best chance to photograph deer. They are often to be found on dewy meadows and in clearings, and the low sidelight throws their coats into sharp relief.
Stalking deer and other forest animals requires time, skill and patience. The high seats (used by keepers for shooting and foresters for fire watching) make good vantage points. Or perch yourself on a branch about ten feet up, few mammals will look up and spot you, and your scent will be carried over them. Wear clothing that blends into the background, and try to avoid making any sudden movements.
Stalking at ground level is an art learned through many mistakes. With practice, you will learn to notice the direction of the wind and when it changes, also to avoid cracking twigs underfoot or rustling your clothes. It is *possible* to walk up to a Roe or Fallow deer in broad daylight—but it is difficult. Long telephoto lenses make the job easier, but

it is still necessary to be within 30 yards (27 metres) with a 300mm lens to produce a good picture.
Squirrels are often very wild and unapproachable in the middle of large areas of woodland. Plan your day so that you are on the edge of a large clearing at mid-morning—somewhere you have seen squirrels before. A few well-placed nuts and pieces of cut apple will increase your chances of a picture.
When you are using a long lens for pictures like this it is best to use a tripod and a cable release to avoid vibration and camera shake. Even if you do not have time to set up the tripod on the ground, it helps to hold it braced against your chest. If you are using a high fixed seat, you can attach the camera to a piece of aluminium angle nailed into the wood. Cameras have 1/4in Whitworth or 3/8in screw tripod holes, and it is simple to fix the camera on to the aluminium angle with a bolt and a wing nut. Shoulder-pods are also useful, but they are no guarantee against camera shake at speeds of 1/125 and slower. Many woodland pictures will be taken in deep shade, so prepare yourself with some high-speed film—Ektachrome 200 or 400, with XP1, HP5 or Tri-X for black and white shots.

Flowers and insects
The middle of the day is a quiet time for birds and animals, but it is the busiest time for insects, which rely on warmth, and flowers which respond to the strong light. Most flowers are at their best fully opened to the midday sun.
Flower photography is an art in itself. Flowers have an annoying habit of moving gently in the wind just as you are about to release the shutter. The only answer is to wait, because every few minutes there will be a lull in the breeze, even on the windiest of days. A small, low tripod is really useful for pictures of flowers. Or you can make a do-it-yourself version by screwing a small tripod head into a block of wood. Some 4in (10cm) or 6in (15cm) nails sticking out of the bottom will anchor it firmly into the ground. You will also find a wide angle lens useful for flower photography, along with a close-up lens or extension tubes and a flower spike. This is a piece of wood two feet (61cm) long and sharpened at one end: push it into the ground nearby and it makes an ideal support for a small flashgun which is strapped to it.

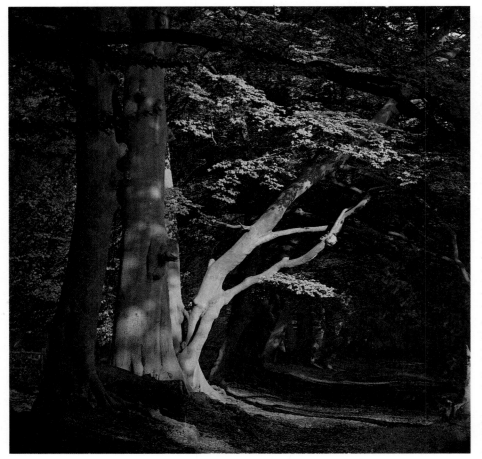

◄ The dappled sunlight filtering through leaves is a study in itself. E A Janes bracketed to make sure of balancing the light and shaded areas.

▶ When Raymond Lea walks his dog, he seldom goes without a camera. On this occasion he had with him his Praktica LTL 3 fitted with a 50mm Tessar lens. The lens has the enormous advantage of being an ordinary standard which focuses down to only 9in (23cm). It was a September day, and the film in the camera was Kodachrome 64, ideal for conveying the richness of the early autumn colours. Lea chose a viewpoint which showed the berries sidelit by the slanting afternoon sunlight to show their depth and roundness. He had no tripod with him so he hand-held the camera for 1/125 at f8. This aperture gave a fairly limited depth of field with the lens focused so close, so that the background is softened into a blur, with the indistinct blue sky adding contrast to the composition of bright berries.

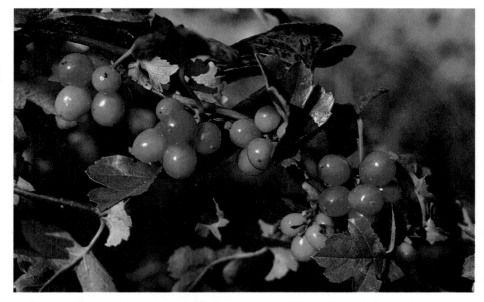

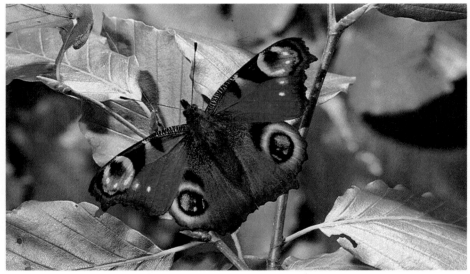

◀ In the middle of the day, woodland wildlife tends to quieten down, waiting for the next feeding time as evening draws in. All except for the insects: they thrive in the warm midday sun, when the flowers they feed from are fully opened to the light. E A Janes found this Peacock butterfly around noon, when the sun was directly overhead. He photographed downwards onto the extended wings, so that the toplight would bring out the striking colouring. To photograph insects well, you need to fill the frame with your subject, which means using a close-up lens or accessories that will give a 1:2 (half life-size) or even 1:1 (life-size) ratio. A tripod is another useful aid, allowing longer exposures, smaller apertures and consequently a greater depth of field where focusing is so critical.

▶ Peter O'Rourke found this bank of flowers in the woodland garden in Bushey Park, and on the next sunny day he returned to experiment with the rich colours and intricate shadows. He went at midday when the flowers were wide open and the shadows from above gave the variation of light and shade to each of the colours. He took along a tripod so that he could take a series of exposures, ranging from 1/30, and use a similar range of apertures. He also took along a flashgun to fill in the shadow areas and increase the range of exposures. Of all the shots taken on this exercise, this one gave the most vivid impression of a typical woodland scene. The picture was not lit by flash, relying on the play of natural light and shade on the textures and colours of the flowers to convey the atmosphere that drew him to the shot.

There are literally hundreds of species of flowers to photograph, even in quite dense woodland so, a little research with a good field-guide beforehand will help you to decide what to look for. Insect photography, too, can be quite specialized. But again you can get excellent results with just a close-up lens and perhaps a small flashgun. You have to learn to stalk an insect, like an animal, slowly and carefully. When it flies to another flower, don't be put off. It will not fly far, so simply follow it. After a while you may be able to predict where an insect will settle next. It is best to use a long focal length—preferably a zoom with macro facility—and work from a comfortable distance. However, you can use a standard lens with extension tubes or a close up lens and work from a few inches away. If so, take extra care with the last part of your approach. Go in smoothly and slowly with your eye to the viewfinder until the insect comes into focus.

As with flowers, there are hundreds of species of insect to photograph, but the best ones to try out your technique on are the larger ones: butterflies like Peacocks and Tortoiseshells, dragonflies around small ponds, and even bees, hoverflies and wasps visiting flowers. One useful tip when photographing insects is to be careful of your own shadow. An insect basking in sunshine has an instant reaction to the chill of your shadow and flies away.

Trees

Although trees are often neglected, they provide opportunities for pictures. Deciduous trees like the beech and oak make friendly forests which support life of all kinds. Conifers are impressive but little can live round them and there are no autumn colours. In winter, frost and snow transform the woods into a white wonderland.

Look for studies in texture as the afternoon draws in and the sun again casts long angled shadows. Or look for a curving forest path to give your scenic shots some depth and perspective. For this you will probably want good depth of field, so set a small lens aperture such as f16. To avoid camera shake or blur you also need a tripod even on a still day with bright sunlight.

Animals

Late afternoon/early evening is a very productive time. A lot of animals that have spent the day lying up will now appear. If you take a good position down wind you can often get excellent pictures of rabbits especially if you find a small warren on a well-lit, sunny bank. Deer, foxes and squirrels all become more active in the afternoon. If you have spotted these in the morning, it is worth returning later in the day to see if you can get better pictures by taking a subtler approach. Forewarned is forearmed, so be ready and waiting in a comfortable position for the early evening activity.

It is even more important to blend in with your surroundings in the evening. A camouflage jacket or net (a strawberry net with bits of green cloth sewn into it will do) can fool an animal into ignoring your human outline. By dusk it is even a good idea to wear a face mask! Animals recognize a white human face very easily, and if they do, you will certainly not see them.

By now the forest will have turned to night and to an entirely different kind of photographic challenge. Save it for another day. (See page 150).

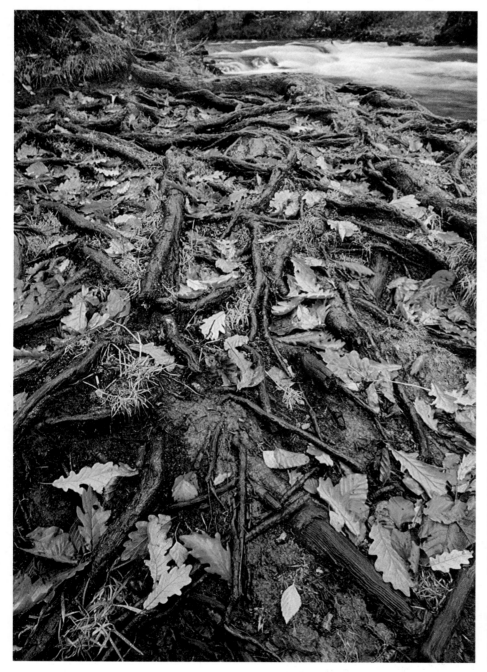

◄ **To include both foreground and background detail, Graeme Harris used a 24mm lens. He set a slow shutter speed to show movement in the stream, with the camera on a tripod.**

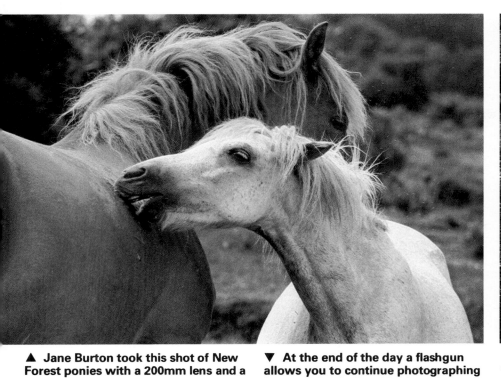

▲ Jane Burton took this shot of New Forest ponies with a 200mm lens and a single frame autowinder. With this you can keep your eye to the viewfinder with no chance of missing a shot.

▼ At the end of the day a flashgun allows you to continue photographing forest nightlife. For this shot of a squirrel at bait, Ian Beames used two guns bracketed beside the camera.

▲ Even human animals look good in a woodland setting! Graeme Harris was attracted to the picture by the low evening backlighting, and framed this shot with an 80-200mm zoom lens.

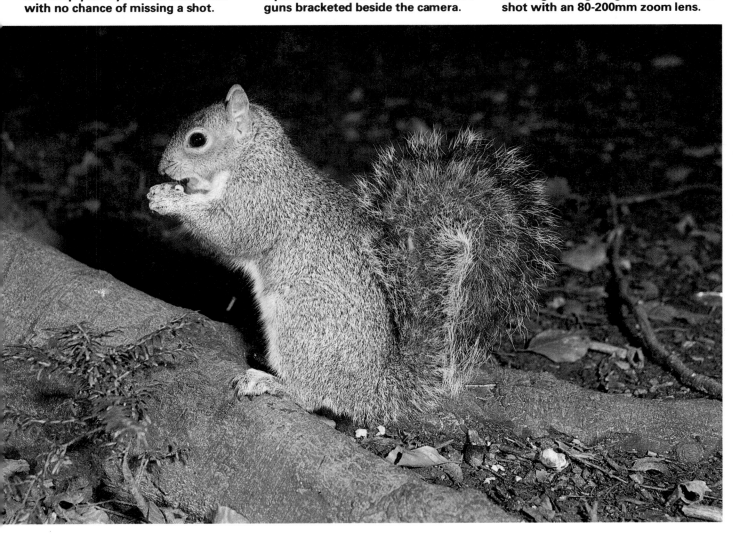

The riverside

Rivers and their banks teem with possibilities for striking photographs. There is the water itself, whether splashing and foaming as it rushes round rocks or as a sluggishly flowing expanse ruffled only by the wind. Reflections in the water can double the interest of a photograph. A pattern of reeds, the glorious colours of autumn leaves or a golden sunset can all be reflected. If the water surface is too smooth, tossing in a pebble can give interesting ripples. Look for natural patterns and designs, especially repetition of shapes. A single swan is effective, but a parent swan followed by a train of cygnets is better. Notice how the feathers fluff up to give a better shape when the wind is behind the swans. Ducks often form bobbing lines, echoed by the line of the further bank. In quiet waters the ducks can leave V-shaped wakes if dashing to snatch a piece of bread tossed to entice them to the best place. The one thing to remember is that the river is wild—it belongs to the landscape and the creatures, plants and people who live along its course. They are all influenced by its presence, so try not to spoil that relationship. Do not drop litter by or in the water; do not disturb plants or animals, or birds and their nests.

Starting at the source

The rushing streams and waterfalls of the river's headstreams are always attractive to look at, but hard to photograph well. Often it is best to use a wide-angle and crouch down for a low viewpoint. Use too fast a shutter speed and the running water 'freezes', looking unnatural. With too slow a speed the result resembles whipped cream! A reasonable compromise is about 1/60 or 1/125 second. The headstream is also rich in attractive plants, especially those growing among damp rocks. Many ferns like the 'splash zone' alongside streams. The best way to photograph them is with the camera on a tripod. Set a small lens aperture for good depth of field, then wait for the wind to drop before you release the shutter. (If the plant moves you may not get a sharp picture.) As the river leaves the hills behind, it widens, and many more subjects become available. You may find fishermen after trout or salmon. A fisherman can make a lovely picture, but you need a fast shutter speed to catch the line snaking out over the water.

Further downstream the river will have cut banks of some size as it curves into its valley floor. These provide a good foreground for landscape views. Also, as the water is still clean, it will harbour a growing wealth of plant and animal life. Here you may even find a kingfisher. You need, in the UK, a schedule 1 licence from the Nature Conservancy Council to photograph kingfishers at the nest, but they can be taken at a regular fishing perch. Kingfishers are creatures of habit and use the same perch day after day to dive for minnows and sticklebacks. You will certainly need a telephoto lens of 200 or 300mm, and possibly a

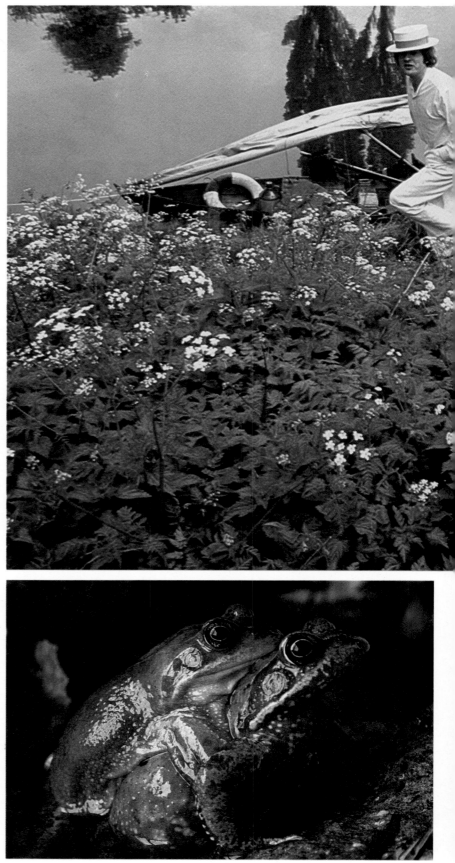

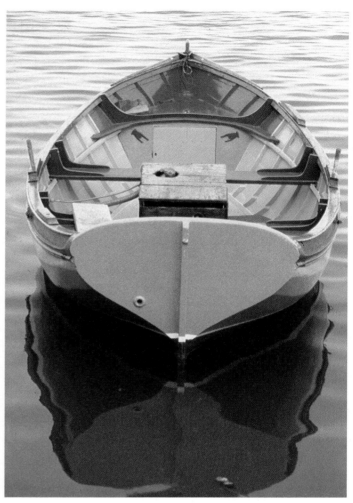

▲ A painted boat can add a touch of bright colour. For this shot Robin Bath used a Vivitar 70-210mm zoom lens for frame-filling impact.

▼ The reflection of a boat in the River Cam, Cambridge. Ken Gillham used a Pentax Spotmatic with 135mm lens for a straightforward shot.

▲ For this riverside shot, taken in the early morning by the Thames, Clay Perry used a wide angle lens to fill the foreground with the delicate flowers of cow parsley. Note the interesting relections from the trees growing on the opposite bank of the river.

◄ Most rivers teem with wildlife, from perhaps exotic birds such as kingfishers to ordinary water beetles. They can all be subjects for the camera—even ones that seem unlikely. A. J. Watson took this fine picture of frogs using an Olympus OM-1 with a 135mm lens and Kodachrome.

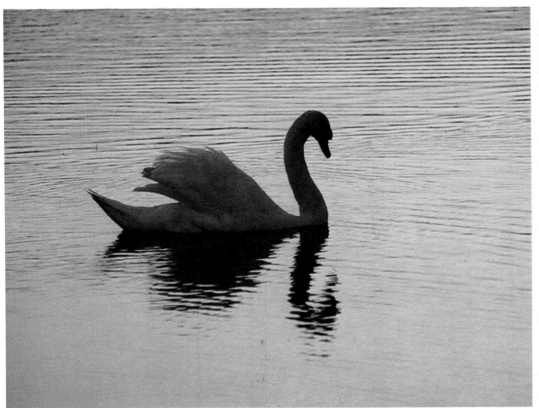

◀ Swans are large and so often tame they are easy to photograph. Graeme Harris used an 80-220mm zoom lens on a Nikon F2 to frame this passing swan just as he wanted it. Though shooting at sunset, he added a 30CC red filter to make the colour even warmer. He needed a fairly fast shutter speed to avoid camera shake, so his final exposure setting was 1/125 at f4·5 on Ektachrome 64.

▶ A beautiful closing shot in a river story shows the sun setting over the water. Sergio Dorantes took this example on the Thames near Richmond. He used a 20mm ultra-wide lens about 3ft (1m) from the ground, so the rail leads the eye into the picture. He set a small aperture for good depth of field and used a tripod to support the camera. The exposure was 1/2 at f11 on Kodachrome 25 slide film.

hide (see chapter on birds, page 166). Many other birds can be photographed on this and lower stretches of a river. Swans, some ducks, coot and Canada geese can be fairly tame, but others—such as Mandarin ducks and grebes—are shy and need a concealed approach. Birds are relatively small creatures, and you need to be closer than you think to fill the frame with them!

Swans, being relatively large and white, make beautiful subjects, especially if you can catch them preening or fluffing out their feathers. When they are against dark water, exposure metering can be a problem. As a rule of thumb, close the lens down by an extra stop to retain feather detail in swans. In the opposite case, if you are photographing a jet black coot, open up by one stop to retain feather detail. Incidentally, birds can be tamer in winter when they are not nesting and are easier to lure within range with food. If you feed the birds regularly from one spot, you will be able to attract large numbers in hard weather.

In the mainstream

As the river current reaches its slowest speeds the river travels through a wide 'flood plain'. Nowadays the river is not likely to flood. The plain makes rich farm land, so the river banks will be built up and the water levels carefully

controlled. Nevertheless it remains a fertile stretch of river.

There may be reed beds which support various sorts of bird including reed warblers and buntings. The reeds themselves can make interesting pictures, especially if you capture their reflections in the still water. There may be trees in large numbers, the most frequent being willows and alders, often planted in past years to help stabilize the river's banks. With all the plantlife, the river is naturally a haven for insects, which begin to appear in large numbers in May. Two rare and colourful butterflies found in these areas are the Swallowtail and the Large Copper. Many other sorts can be found. They need stalking, slowly, with a 100mm or 135mm lens with an extension tube fitted, to allow close focusing. If you have the patience to put up with frequent failures, you can get better pictures with a 55mm macro lens—but with this you need to shoot at a distance of about 6 inches (15cm). The last part of the approach must be taken very slowly! A telephoto zoom with 'macro' is an ideal solution.

Other possibilities are pictures of water beetles, dragonflies and other water life. Again, you need extension tubes or a macro lens to get close up. Relatively few mammals can be found by the river. You would be very lucky to see, let alone photograph, an otter. If you sit

quietly by their burrows in the banks, however, water voles can be photographed. They can be tempted within range of a telephoto with bits of apple tossed onto the mud at the waterline. Remember that mammals—unlike birds—have a keen sense of smell as well as keen eyesight. So if you hope to take pictures of mammals, either at bait or near their habitat, make sure that you position yourself downwind of them.

Down to the sea

Eventually the river widens to become an estuary. The banks may be raised high above the surrounding marshland as a defence against tidal surges. Where the fresh water of the river meets the sea the wildlife and scenery will change. Estuaries are favoured places for terns and gulls, which breed on the estuary gravels, and lap-wings, which squat on their eggs in the fresh marshfields. You may be lucky enough to spot some beautiful shelduck, and you may certainly see some oystercatchers. Winter is the best time to see and photograph swans, ducks, geese and waders. For more about photographing birds and using hides, see especially pages 166-169. Wherever you travel along the river, the scene is full of interest. Recording a river's 'life story', from head-waters to estuary makes a fascinating project, an extended portrait.

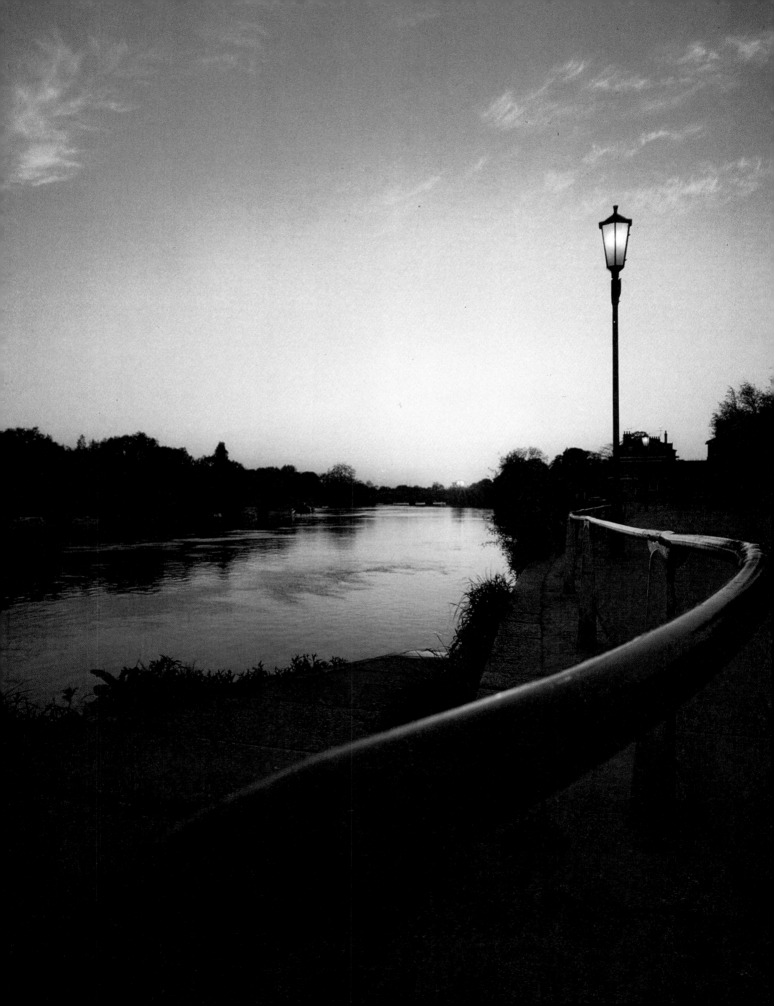

The sea shore

Wide horizons and spacious skies are a major challenge to everyone who sets out to photograph the sea. But they are not the whole story. Along the margins of the sea there is a wealth of life and detail: glistening shells and coloured pebbles of every hue, or sea-weed left high but not yet dry by an ebbing tide; secluded rock pools and the creatures that inhabit them.

Details like these can do more to recall the crunch of pebbles underfoot and the salt breeze than a grandiose view would. For hints on taking stunning photographs of underwater rock pool life, see page 212. If you want to tackle the open sea, see page 208.

Using the foreground

Open seascapes often lack a feeling of depth or perspective. This can be overcome by adding some foreground interest such as figures at the end of a pier, a dinghy on the sand or cranes on the waterfront. Or find a natural frame for your picture—the entrance to a cave, perhaps. Look at the reflections on the water too, and see if you can use them in your composition. Before you take a picture, decide what you want to show and how you can best achieve it. One rule of seascape composition, only very rarely worth breaking, is to make sure the horizon

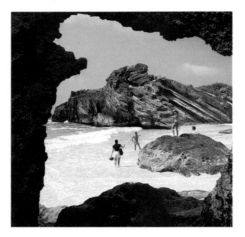

does not break the picture into two distinct halves but rather into a third and two-thirds. Similarly, if there is a boat on the water, choose your angle so that its position suggests it is moving into the picture, again avoiding the central position.

Viewpoints

Try different viewpoints for varying effects. A stormy sea should produce dramatic pictures but you need a very low viewpoint to catch the impact of a huge wave crashing against a rock. And as water moves very fast you will need a shutter speed of at least 1/250 to 'freeze' the spray. A long lens compresses distance and so can turn what might be a flat and ordinary distant view into a more dramatic one. An elevated viewpoint may prove more suitable when the storm subsides and you are left with the gentle ebb and flow of the water across the sand and through the rock pools. Look for patterns left in the sand.

▲ Finding a natural frame brings an extra dimension to this typical beach scene. Try moving your camera position slightly until the balance within the viewfinder looks right. *J Alex Langley*

▼ Contrast the dominant blue of seaside pictures with bright detail. The crab's vivid colour is shown up by a plain background. Sea creatures are elusive, so work fast and focus well. *Kenneth Fink*

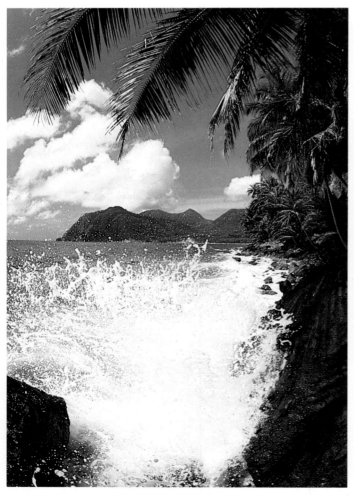

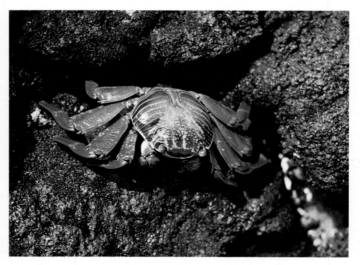

◀ The violence of a wave crashing on the shore is frozen by a short exposure and emphasized by strong sidelighting. *Adam Woolfitt* used a polarizing filter to darken the sky to a deep blue and to lighten the clouds.

▶ Here *Franco Fontana* breaks the rules to advantage. With the horizon in the centre, his upright format slices through the layers of texture and colour: sidelit ripples on the sand, white breakers and a deepening blue sky.

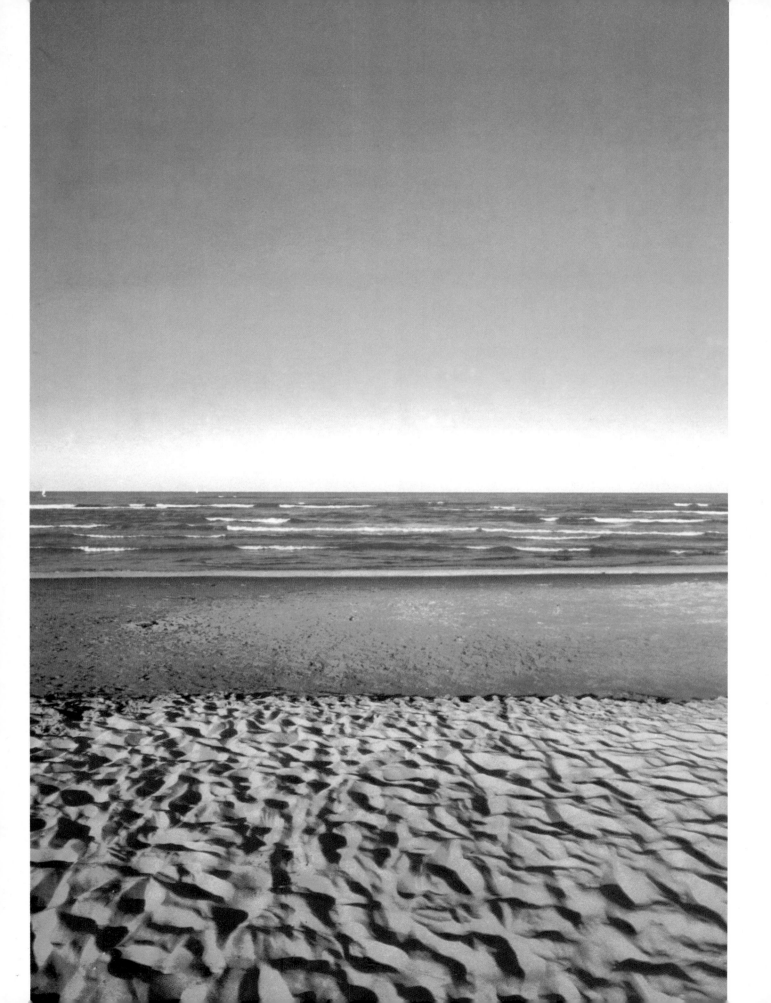

Special lighting

Sunsets, sunrises, the sun and the moon can all create dramatic pictures, especially over water. When the sun is low enough in the sky, it can be included in the photograph. Expose for the sun, so that the colour of the sun is retained; the rest of the picture will be under-exposed and in silhouette. If you want more even lighting, take your reading at an angle of about 30° from the line of the sun, so that you burn out the sun itself but retain more detail elsewhere.

To be absolutely safe, bracket your exposure (go one stop over and then one stop under what seems to be the correct setting).

Sunsets often take their drama and beauty from the colours in the sky. You may choose a wide angle lens to emphasize the expanse of sky, or a telephoto to concentrate the colour in the sun itself. If you use a long tele-photo lens—400mm for example— and take the lowest viewpoint possible, the sun will 'swim' on the horizon.

Pictures with the moon in them are best shot during early evening when there is still enough light to give substance to the sea and the sky. You need a tripod for your time exposure; the exposure you choose depends on the brightness of the moon and the speed of your film.

Work on a trial and error basis, taking an aperture of, say, f5·6 and varying your exposure from about 1 second to 2 minutes, increasing it by 15 seconds each time.

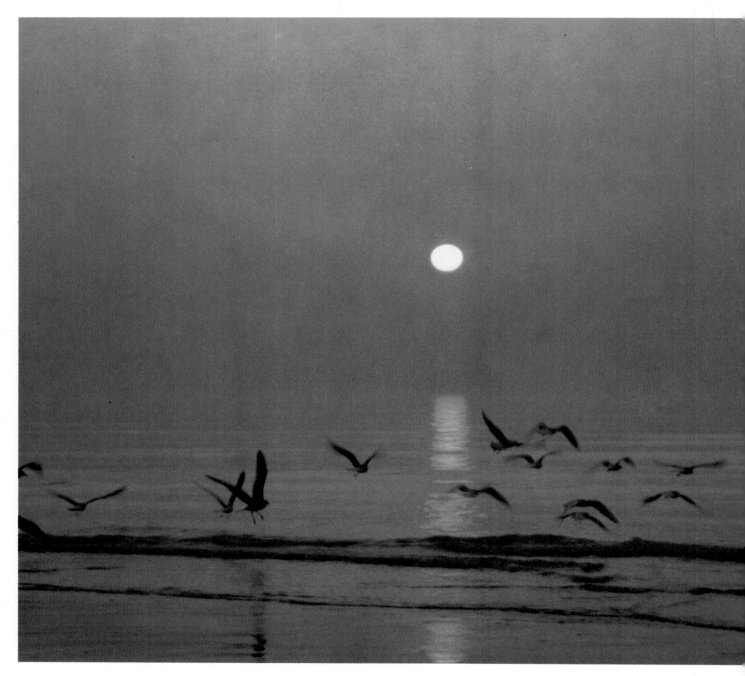

▼ Sunsets over water can produce spectacular effects, but they need careful handling. The great danger is over-exposure, which flattens the colour. For tricky lighting conditions bracket exposures to ensure the correct result and note down the f stops and speeds to compare afterwards. *John Garrett* caught the mood of this still, misty evening on Ektachrome with an 80–200mm zoom. Note the blurr on the gulls' wings, the result of his long exposure.

▲ A high shutter speed—at least 1/250—is necessary to freeze a wave like this. Here *John Garrett* used a 24mm lens to give greater depth of field and made use of the low afternoon sun to highlight the texture of sand and sea. By emphasizing perspective a wide lens exaggerates the wave's forward surge.

▼ Perspective is the key feature of this mid-morning beach scene. With a 300mm lens *John Garrett* compresses the distance between shore line and horizon, bringing lady and ship into almost uncomfortable proximity. The umbrella hovers between, bright from top-lighting which leaves the figure in silhouette.

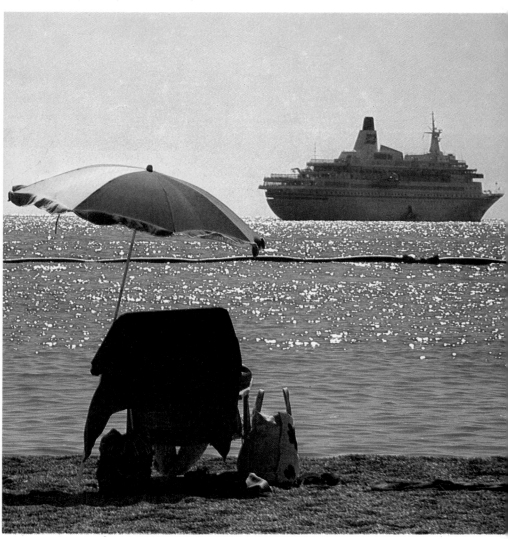

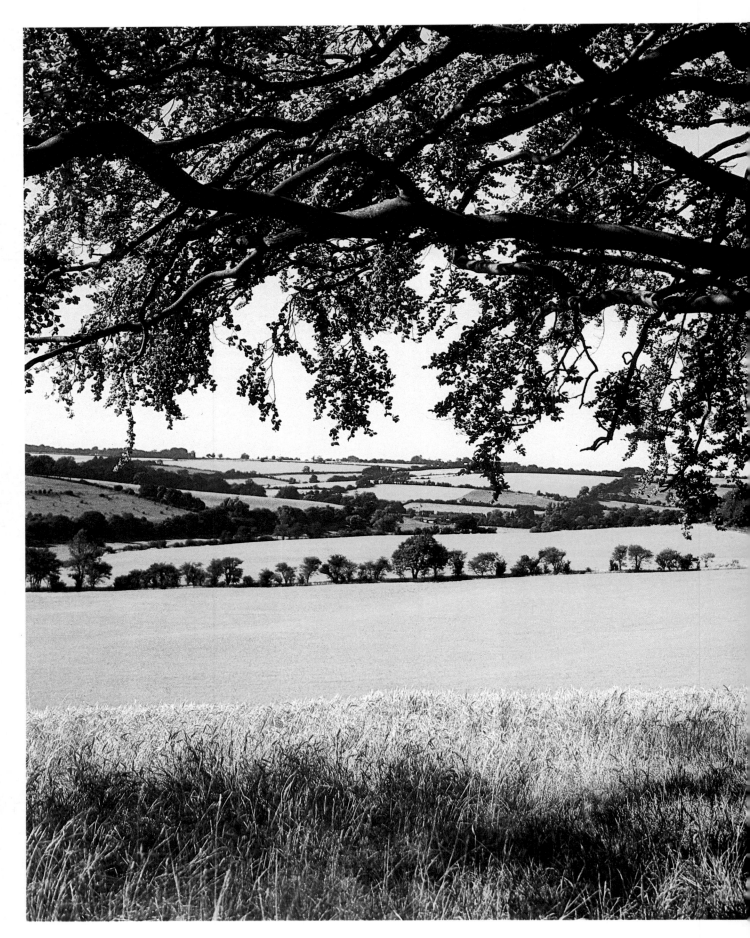

PERFECT LANDSCAPES

From the beginnings of photography, landscapes have been a popular subject. Sometimes you may simply wish to record a place visited on holiday, but with increased knowledge and experience you may feel a desire to evoke the spirit and atmosphere of particular landscapes. However, this is not so simple as it may at first appear.

This chapter shows you how to record landscapes so that people viewing the pictures share some of the emotions you felt when originally viewing the scene. Conveying an impression of depth is a valuable skill—the viewer should feel able to walk into the photograph—and the technical expertise required to achieve this effect is fully described. Landscapes vary enormously through the seasons and these variations are explained and illustrated with a wealth of ideas for the best pictures. Winter brings its own technical problems. You will find plenty of hints to help you make the most of this challenging season. Photographing in colour can cover a multitude of pictorial sins and when landscapes are recorded in black and white the bare bones of the composition are visible—excellent training for photographers as well as aesthetically satisfying.

This chapter also considers the equipment required to produce outstandingly good landscape photographs. Landscape prints are most effective when made in large sizes, so take care to produce a good original negative or transparency.

A wide-angle lens (60mm on a Hasselblad) was used
to frame this Hampshire cornfield with the old beech tree.

Equipment for landscape photography

What do you need to take superlative landscape photographs? All choices are a compromise between weight and performance. You cannot carry everything you might possibly need but having walked and climbed untold miles, the effort may be partly wasted if the right equipment is not to hand. Select equipment for the pictures envisaged. The absolute minimum is a compact non-reflex 35mm camera or a folding roll film type, but an SLR with a few lenses is much more versatile and you can build up from this, depending on how far you intend walking. Successful landscape photography depends on careful choice of subject matter, and careful planning of the picture, in terms of viewpoint, depth of field and so on. It depends equally, if not more, on the correct choice of equipment.

Dressing for the occasion

The best and most spectacular landscapes have a habit of being found half way up cliffs or on top of a mountain—pictures for which you are going to have to walk a fair distance carrying the equipment. Irrespective of the weight of your equipment, make sure you are dressed properly. If you are, you will be able to withstand changes in weather conditions.

The first requirement is a pair of sturdy shoes which do not leak. A parka, cagoule, or similar waterproof jacket with lots of pockets and a hood is ideal. The pockets can be used to hold useful items as the illustration (below) suggests. Light sleeveless jackets with pockets are obtainable for summer weather. A

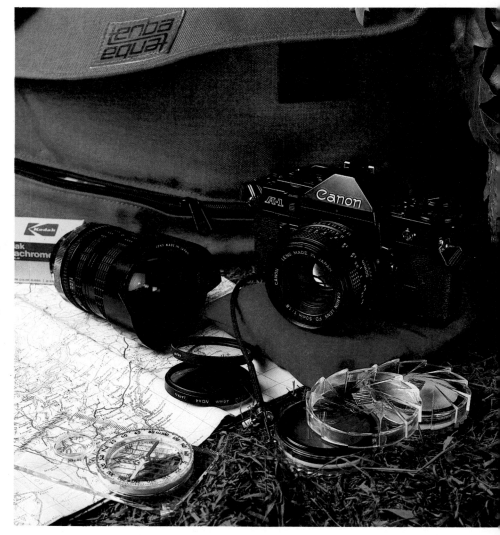

▲ Basic landscape photography kit: waterproof bag, 35mm camera, 50mm lens, wide-angle zoom, basic filters, long cable release, bean bag and film.

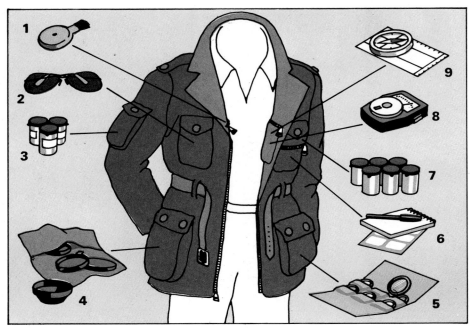

◄ Useful items for your pockets.
1 Blower brush for cleaning lenses and camera body.
2 Sunglasses. Polaroid, of course: handy substitute for a polarizing filter.
3 Pocket for exposed rolls of film. Make sure exposed and un-exposed rolls are kept in different pockets.
4 Lens caps and body cap. Always replace these when you have finished with a piece of equipment.
5 Filters.
6 Notepad and pen for recording any special exposure details and locations.
7 Unexposed film.
8 Exposure meter for checking exposures in difficult lighting conditions.
9 Compass to calculate where shadows will fall at different times of the day.

warm sweater or two is essential for cold weather, as are jeans or similar windproof trousers. Several layers of clothing are warmer than one thick one. If you are properly kitted out you can walk further and comfortably carry more equipment.

Carrying cases

For landscape photography a gadget bag or carrying case is one of the most important pieces of equipment. Choose one which will allow you freedom of movement. Having both hands free for clambering up rough slopes considerably lessens the chances of losing your balance—risking damage both to yourself and your equipment.

The best type of bag to have is one that can be carried as a back pack. There are many styles available. Choose one that is light, dustproof and watertight. A good way to carry the aluminium type case shown in the kit, (right) is on a rucksack frame. This distributes the weight evenly. It is much more comfortable when carried in this manner rather than slung over a shoulder.

With some rucksack frames you may have to add a support at the bottom of the frame to hold the case. Leather straps, or elastic ones with hooks at either end (often used to attach items to a car roof) are suitable for fixing the case to the frame.

If you find a hard case (like the aluminium ones) too heavy or too big, use a soft bag, although these do not offer quite as much protection. The Tenba range of bags is eminently suitable if a little expensive. There are many other similar and cheaper bags available although the Tenba range was specifically designed with the needs of open air photographers in mind. These bags are extremely strong and light and come in varying sizes, and can be carried like a back pack or slung across the chest, still leaving both hands free.

Camera choice

What goes in the bag? First of all, consider which camera format to use.

35mm For all round practicality and reliability a 35mm camera is the obvious choice. 35mm cameras are versatile because of the wide range of special purpose lenses which are made, and the whole system is portable and lightweight. The TTL (through the lens) focusing allows you to see exactly what the camera sees.

Most 35mm cameras have a depth of field preview. You do not often find this facility in other formats. The depth of field preview shows you how much of your picture will be in focus, which

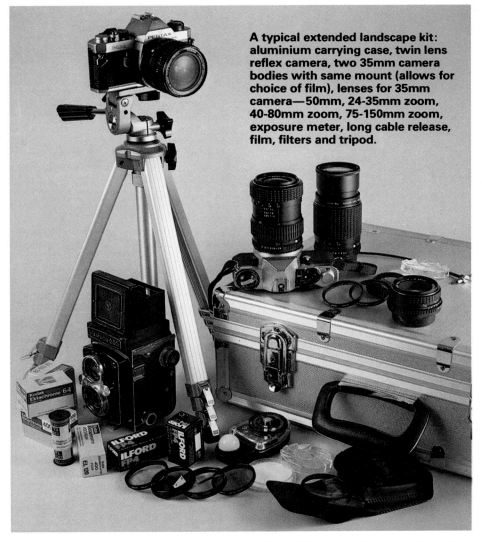

A typical extended landscape kit: aluminium carrying case, twin lens reflex camera, two 35mm camera bodies with same mount (allows for choice of film), lenses for 35mm camera—50mm, 24-35mm zoom, 40-80mm zoom, 75-150mm zoom, exposure meter, long cable release, film, filters and tripod.

is vital information for landscape photography.

6x6 (or 2¼x2¼) roll film cameras. Although compactness and portability is the appeal of the 35mm format, if you own both a 35mm and a roll film camera you may prefer the roll film camera for landscapes. The larger negative size gives better quality pictures, although you will have to sacrifice some convenience to get it. Also, the square format may be more suitable for some subjects. These cameras are bigger and heavier than 35mm, but where careful composition and fine detail are of prime importance a roll film camera is the best one to take.

Some roll film cameras do not have interchangeable lenses (like a Yashica TLR—twin lens reflex) and this is a disadvantage. Others like the Hasselblad do have interchangeable lenses, but they are heavy. Although there is a large ground glass screen to view and compose the image with a twin lens

reflex, this image is reversed, as in a mirror. The photographer soon gets used to this, although for some cameras an accessory prism viewer is available to turn the image back to normal.

Panoramic cameras like the Widelux or Technorama take 35mm film, but produce negatives which are much longer. These cameras are not cheap but they are worth considering for taking panoramic landscape pictures.

Inside a panoramic camera the film is curved round a drum. The lens pivots during exposure thus covering a very wide angle of approximately 140° without the distortion which a wide-angle lens would produce. This type of camera must be kept level. Any tilt produces strange and unattractive results.

View cameras If you are fortunate enough to own one and are prepared to carry it around with you, a view camera is another alternative for landscape photography. The flexible controls of the view camera allow you almost to

rearrange the scene before you, by using the movements. Your pictures can capture scenes that would otherwise be physically impossible. View cameras have negative formats ranging from 2¼x3½ to 8x10 inches. Some wonderful, sharp pictures can be taken.

Film choice

There is usually plenty of light when taking landscapes. When the light is dull, contrast tends to be low so you do not want a film with a tendency to flatness. Landscape photographs need fine grain. Since graininess always shows most in areas of light, even tone such as the sky, fast films—which tend to be grainy—are not the best choice.

For black and white prints, a medium speed film such as FP4 is suitable. The very slow films such as Pan F could give speeds which risk camera shake in dim lighting, while Panatomic X can prove too flat when the sun does not shine.

Colour prints are best made from one of the 80 or 100 ASA films as the 400 ASA ones give too much grain.

Colour slides can be from a fast film since there is very little visible difference on projection between 100 ASA and 400 ASA versions of most films. However, the faster speed is seldom needed and could be awkward in bright sunshine. The films using E-6 processing, such as Ektachrome, give brighter, more contrasty, pictures than Kodachrome though the latter is very reliable.

Camera supports

A camera support is essential for getting good pictures under bad lighting conditions when you are using long exposures. A camera support is also an aid for the careful framing of stationary subjects. If you choose a tripod for landscape photography it does not have to be large or heavy—some quite small tripods will be adequate providing they are sturdy. Tripods with 'U' form legs are light and sturdy. These are better than cheaper models with round legs. Make sure the one you choose is able to tilt in every direction. A pan-and-tilt head is better than a ball-and-socket type. Also, if there is a centre post it should be reversible, so that the camera can be mounted near the ground if necessary.

The camera support you take with you does not always need to be a tripod. In many cases all that is really necessary is a means of keeping the camera firmly in place during exposure. A large lump of plasticine (or a bean bag) can be used to hold your camera firmly to a rock, the top of a wall or whatever object is close by.

Fix the camera with the plasticine and make sure that it does not move. Then using a cable release you will be able to make quite long exposures without any fear of camera shake. If you are near the car, the same technique will work using the car roof. A long cable release (longer than 12inches) is best. Use it with a 90° bend in it so that any

movement or vibration on your part will not be transmitted to the camera.

Lenses

Focal length and aperture are the two important aspects to consider when choosing lenses and landscapes.

Focal length For most shots a lens with a focal length of 70mm or shorter will be the most useful and versatile for the 35mm format. Decide whether you prefer to use fixed focal length lenses or zooms, or a combination. Zooms are lighter and more versatile than a range of lenses, but fixed focal length lenses give better quality. The pictures on page 39 show the different effects

▲ **Do not be put off by bad weather. John Garrett braved a torrential downpour for this unusual shot. The light was low, reducing the contrast. In circumstances like this, Ektachrome film is more suitable than Kodachrome.**

▶ **The Brecon Beacons in Wales, taken by Colin Molyneux using a 55mm lens and Kodachrome 64 film. Shots like this often involve walking to get the best viewpoint—which means comfortable clothing for those landscape trips.**

achieved when a landscape is photographed from the same spot with different focal length lenses.

Aperture range Almost as important as the actual focal length of each lens is the range of apertures available to you. Many lenses do not stop down below f16. For some landscapes, where foreground detail is included to accentuate depth, the ability to stop the lens down to f22 to increase depth of field is valuable. With an aperture of f22 and slow film, a tripod or other support is essential. If you are planning to walk around you should find that two lenses will fit your requirements. On 35mm, a 24mm or 28mm and a 35-70mm zoom should

be adequate. On a 6x6 format a 40mm or 50mm lens and a standard (80mm) will cover about the same range.

Filters

A few filters in the gadget bag will give additional range to your photography without adding too much weight. You can also take other filters for special effects.

A neutral density filter can be used for both colour and black and white film to lower the brightness of a scene. You can do this to avoid stopping down and getting too much depth of field.

A skylight filter can be used on each lens to protect the front element of a

lens from scratches and dirt. It will also cut down excess blue haze which is frequently visible in a landscape.

A polarizing filter can be used to eliminate unwanted reflections and glare. This filter also darkens a blue sky. It works most strongly on sky when it is at right angles to the sun.

In colour photography a scene can be changed but not corrected by the use of colour filters, if it does not match the desired effect. In black and white photography, however, colour filters can be used to alter sky tone. For example an orange filter darkens the sky, but also affects the tonal relationships within the subject itself. (See page 80).

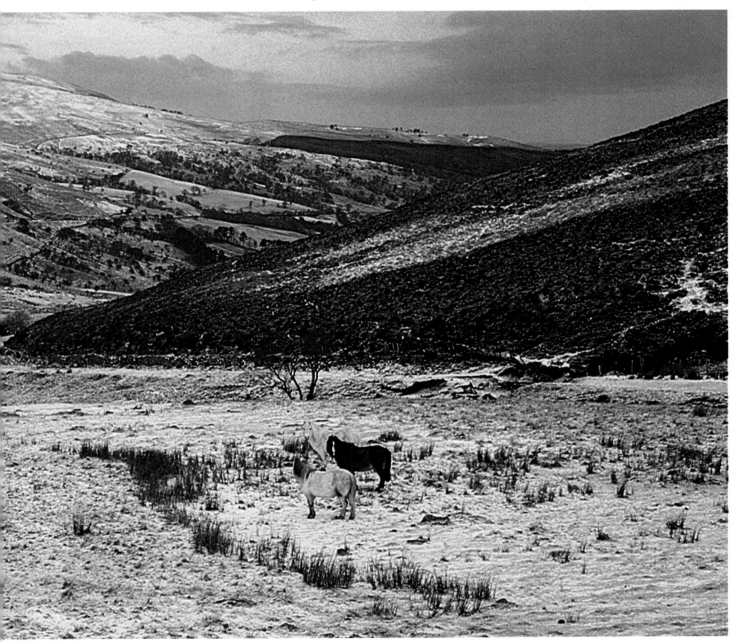

CHOOSE THE CAMERA

▼ ▶ **A Panoramic camera takes 35mm film but produces negatives which are 35mm x 6cm. Wide views are possible but without the distortion produced by a wide angle lens. Julian Calder—who took this shot and owns the camera— added the spirit level to the top of the camera to help ensure that it is level. Any tilt causes unattractive images.**

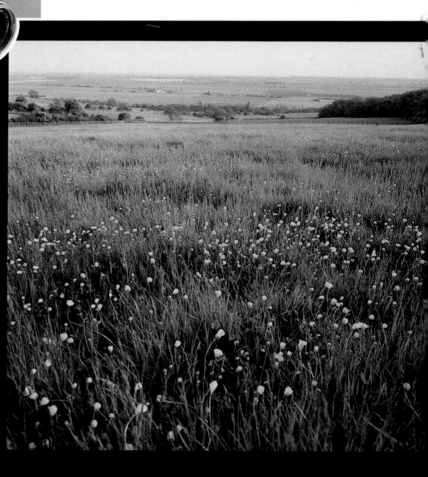

◀ ▼ **A 6x6 camera produces larger negatives than 35mm, and therefore better quality pictures, but the 6x6 cameras are heavier and more cumbersome to carry around. The square format is particularly suitable for some subjects. For example, this field of buttercups taken by Clive Boursnell. You can also frame the subject with the intention of cropping to a horizontal or vertical rectangle later. The negative size is large enough to allow you to do this. Enlarging a small part of a 35mm would give too great a loss of quality.**

▲ **A 35mm SLR is the most versatile and portable, but its light weight and small size are at the expense of some loss in quality. Ed Buziak took this shot on 35mm equipment.**

THESE LANDSCAPES HAVE BEEN BLOWN UP IN PROPORTION SO THAT YOU CAN COMPARE THE FORMATS.

CHOOSE THE LENS

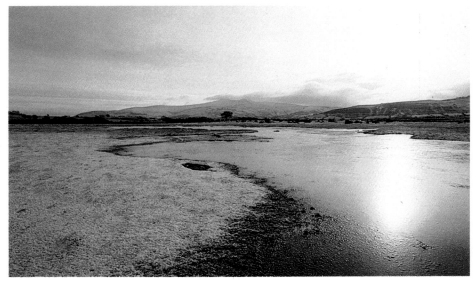

WIDE ANGLE LENS

A wide-angle lens allows you to record a lot more of a landscape than a normal lens. However, it also emphasizes the immediate foreground and appears to 'shrink' the distant scene. The wide-angle must therefore be used with care. It is often not suitable for distant mountains, but can give dramatic results with strong foregrounds which lead the eye into the picture. It all depends on the particular scene.

Colin Molyneux took all the pictures on this page on Kodachrome 25 from the same camera position, but with different lenses. For this first picture he used a 20mm ultra-wide lens. With the sun on the water, the foreground completely dominates the picture. Your eye is led by the stream to the tree which appears in the distance.

STANDARD LENS

A standard lens can be suitable for landscapes because it records the view in the same scale as seen by the eye. However to allow more variation in framing, it is often better to choose a zoom lens which has 50mm within its range of focal lengths. For example, a 28-50mm zoom gives a choice of composition from any given camera position. It also combines three fixed focal length lenses in one lens which makes it practical to carry when weight and bulk are important factors.

Colin Molyneux used a 55mm standard for this picture. The angle of view is much narrower than in the 20mm picture above. The effect is to reduce the importance of the foreground, and to bring up the distant hills.

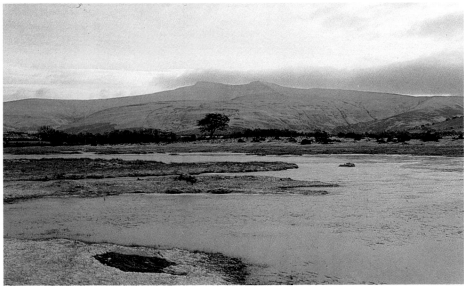

TELEPHOTO LENS

If you use a telephoto lens to photograph the landscape, it will tend to compress (or flatten) the perspective in the picture, and destroy any sense of scale or depth. However, it will also magnify the scene in the far distance, and this can produce very attractive results as here. Colin Molyneux took this picture from exactly the same spot as before, but this time using a 200mm telephoto. This has removed the foreground completely, and brought the tree and the distant hills (hardly visible in the 20mm shot) into frame-filling close up. With a range of lenses for landscapes, you can choose the precise effect you want.

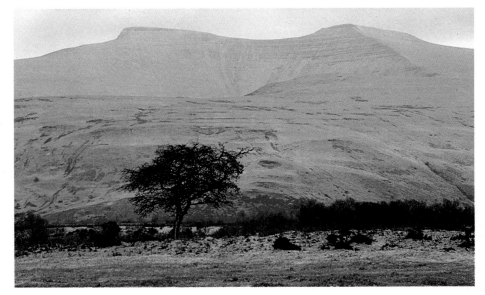

Making landscapes work

Ever since the earliest days of photography, landscapes have been a popular choice of subject. The reasons for photographing landscapes range from the simple desire to record somewhere visited on holiday to the powerful evocation of place and atmosphere evident in photographs like Bill Brandt's pictures of Yorkshire.

Yet for every successful record of a landscape most photographers take many pictures that just don't work out. This is often because what the camera can record in the confines of a rectangular frame seldom matches what the eye can see. On film the most stunning panoramic view tends to look flat and uninteresting and the grandeur of a tall mountain fades to a tiny speck.

Be selective

Part of the thrill of the landscape is to do with being there. What the landscape photographer has to do is find some section, some detail even, that can communicate this thrill to other people. Try the old painters' trick with your hands —make two right angles with your thumbs and first fingers and turn them into a rectangle. Through one half-open eye look at a landscape through the rectangle, varying the distance from your eye, and see how many completely different possibilities are available from one viewpoint.

Move the camera

There are two basic ways to vary the way you record a landscape. The

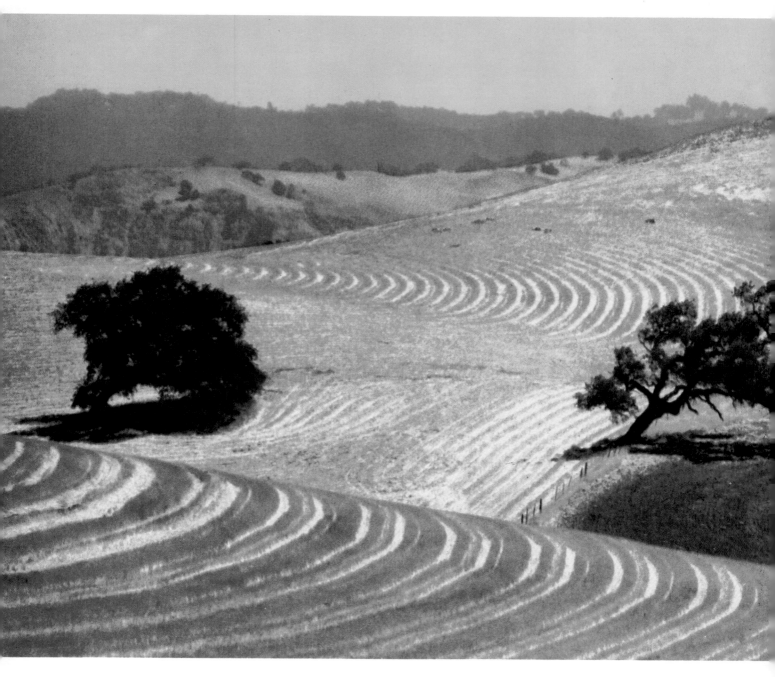

most important one is to move yourself and the camera until you find the best viewpoint. If, from the road, you see a landscape that cries out to be photographed, take some time exploring the location on foot. Just walking up a slope will frequently open up new viewpoints and can alter dramatically what is seen through the viewfinder. And always look out for details in the landscape—a wall, a clump of trees or a distant building that will give some point to recording that particular overall view. Often it is a question of building the shapes that make up a landscape into a photograph you will want to look at again and again.

Time of day

To catch a scene at its very best, be prepared to come back time after time A certain view seen at sunset may look very different from the way it looked in the middle of the day: not only does the direction of the light change, but the shadows and the colour of the light do, too. What appears a flat and featureless landscape at midday may look completely different early in the morning. When the time and the weather are both right then take a great many pictures. Some famous photographers of landscapes have earned a high reputation by following this procedure. The sun shines no more for them than others, nor do clouds come in the right places to please them, but when conditions are correct they take maximum advantage.

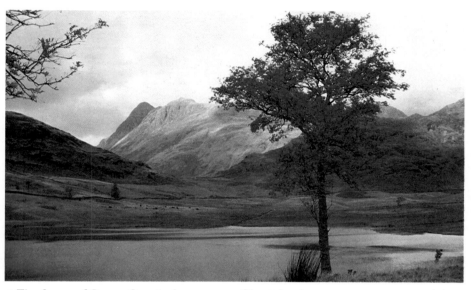

◄ The force of *Georg Gerster's* picture is in its composition. The ridges form a classic Z, from bottom right to the tree on the left, veering up towards the far trees, then into the blue beyond.

Changing lenses can move mountains. ▲ With a 50mm lens *Peter Goodliffe* keeps his background at a distance. ▼ An 85mm lens brings it closer, helped by a low angle which loses the lake, and the scene narrows.

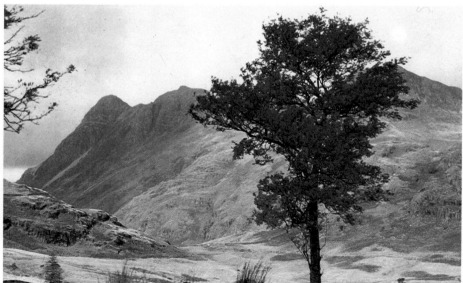

Weather

Similarly, watch out for sudden changes in the weather which can dramatically alter the appearance of a certain stretch of countryside. For instance, in the Lake District dramatic changes can happen within half an hour during spring or autumn, and in the Mediterranean a storm can quickly transform an unremarkable landscape into an unforgettable one.

And don't be put off by the problems of taking photographs in bad weather, as it is precisely these unexpected changes in light and visibility that can change the expected holiday view into something special.

There are certain practical things that the photographer can do to make use of these changes or to overcome the problems they create. Filters can be a great help here. In colour, a U/V filter reduces some of the problems of photographing through mist or haze. A polarizing filter helps to darken a blue sky. In black and white a yellow or orange filter accentuates cloud formations against a blue sky. A medium or deep red filter further increases the contrast between a landscape and a blue sky, producing an aggressive, dramatic image.

In certain light, distant views often look mauvy-blue. This is called 'aerial perspective' (see p. 72) and painters often use the trick of emphasizing the blue haze to create the effect of distance. Photographers can do the same by using a pale blue filter to accentuate the misty quality of the light.

The biggest single source of disappoint-ment in landscape results is the final size of the image. If the subject is too distant, the result on the print will be too small. The general panoramic shot is rarely successful unless some detail has been selected from it. The question of image size can be solved in one of two ways: either use a lens of longer focal length to select part of the panorama or, if you have only a standard 50mm lens or a fixed lens camera, move the camera closer to a detail.

What camera for landscapes

You can use any format of camera for landscape photography. Here the problem of size and portability is simply a question of convenience; the more cumbersome, large format cameras will give fine quality results, although slow 35mm films in both colour and black and white are capable of very acceptable image quality. It is the possibility of changing to another lens—with a different angle of view—that makes the 35mm SLR the camera used by most keen amateur landscape photographers. The telephoto lens (from about 105mm to 200mm) will allow the photographer to enlarge distant detail, making the background look imposing in relation to mid-distance objects. This helps overcome one of the main disappointments for photographers with fixed lens cameras when the view that looked spectacular ends up as insignificant in the final print. This ability of the telephoto lens to bring distant detail nearer makes it one of the most useful extra accessories for landscape work.

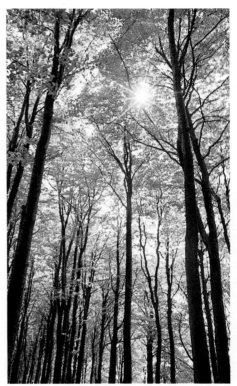

▲ **Distance—and perspective—lend enchantment to this wood. Here *Peter Goodliffe* uses a 28mm lens to exaggerate the height of the trees: the parallel lines rush away from the viewer, converging far more quickly than if they had been shot with a standard or telephoto lens. The wide angle lens also makes it easier to maintain focus throughout, and this, along with a sunburst placed high on the picture, adds to the towering effect. But beware: the results of photographing into the sun, even filtered by foliage, can lead to excessive flare.**

▶ ***John Bulmer's* landscape shows the opposite approach. Using a 180mm lens and framing his shot to exclude the horizon, he compresses distance. The farmhouse is drawn closer, and the fact that it is the only area in sharp focus, contributes to the illusion.**

◀ ***Barry Lewis* makes spectacular use of colour to show bizarre weather conditions. Using a telephoto lens (1/250 at f5·6), he balances the sunlit yellow fields with the stormy dark sky by positioning the horizon across the centre of the frame.**

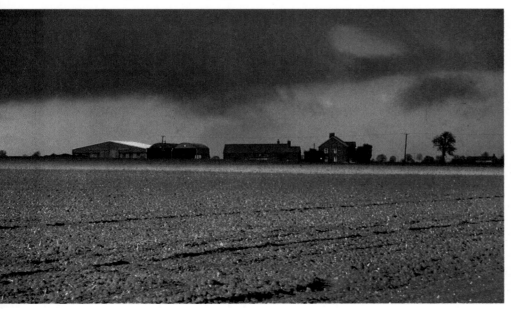

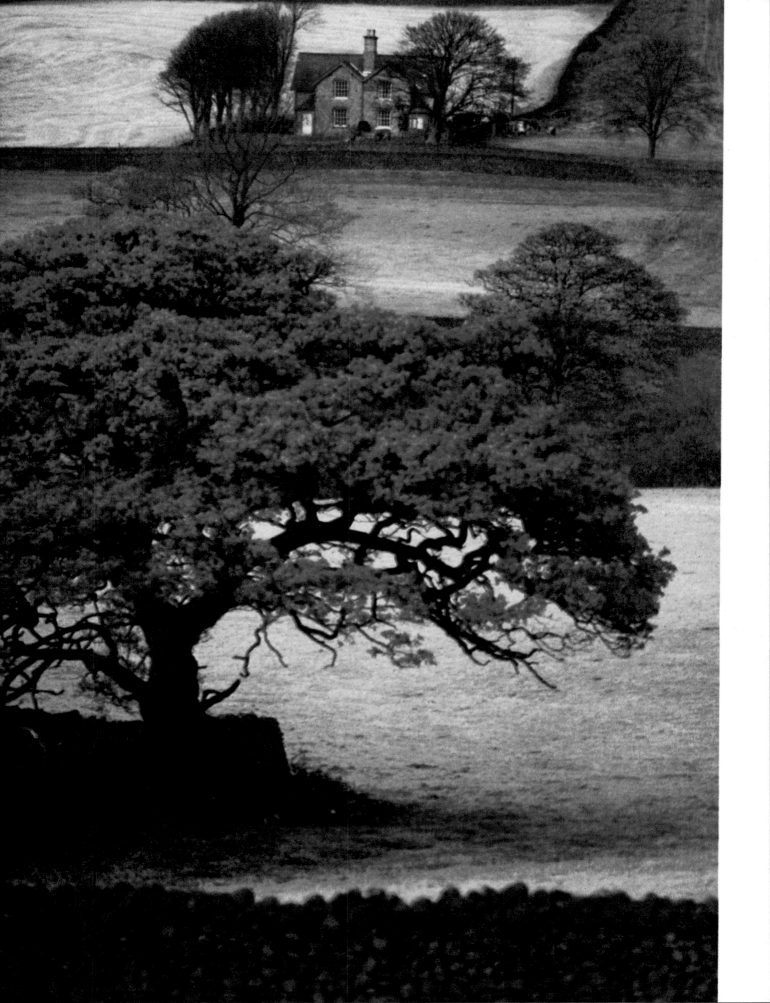

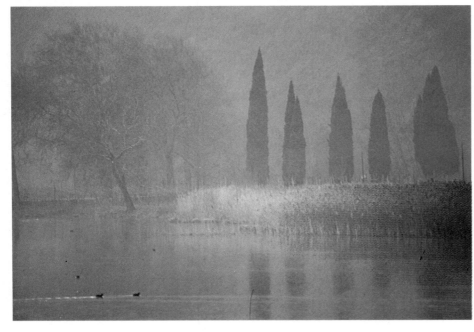

▲ Taken from a high vantage point and into the sun, *Bob Kauder's* landscape is rolled out like a map, the powerful effect of the buildings and walls caused mainly by the shadows they cast. He used a Nikon F with a 105mm lens and a UV filter, stopped down to f11, and Kodachrome 25 film.

◄ Contrast the stark lighting of the picture above with the misty quality of *Michael Busselle's* lakeside scene, taken after the sun had gone down behind the mountains. The dusk light was emphasized by a blue filter. There are no sharp shadows, and the fast grainy Ektachrome film adds to the atmosphere.

► Using a wide angle lens at f11, *Bill Colman* keeps sharp focus throughout, from the bright flowers in the foreground to the contrasting scene beyond.

Wide angle lens

But the other extreme of focal length
—the wide angle (28mm or 35mm)—is
equally useful in this type of photo-
graphy. It does the opposite of the tele-
photo lens—exaggerating the scale of
near and mid-distance objects relative
to background. For example, it will
allow you to work close to a deep valley
in order to emphasize its depth and
exaggerate the distance to the far
horizon.

Provided you can fill the viewfinder,
trees look taller and a valley will look
deeper than with a normal lens. But
it is easy to end up with an even smaller
image with this type of lens because of
the wider angle of view so make even
greater use of foreground elements.

Foreground

Foreground is of great importance in
landscape composition, because it helps
get over the problem of scale and depth.
For example, if you can place a tree, a
rock or a person in the foreground, you
give an idea of the scale of your subject.
Even if the foreground is out of focus it
can act as a reference point from which
to start looking at the picture.

Exposure problems

The other technical problem the land-
scape photographer must consider is
exposure calculation. It is not as sim-
ple as, say, measuring the exposure for
a single object 3m from the camera and
lit by a single table lamp. With a land-
scape the light may be reaching the sub-
ject in a number of ways; direct sun-
light, diffused by clouds, or as reflected
light bouncing off water, sand or light-
coloured buildings. The subject itself
may cover a very large area and parts of
it may vary widely in contrast—for
example, the difference between a
bright sky and a darker area of the
landscape, probably in shadow.

In this situation, the safest method is
to take an average of the meter readings
from the two areas, sky or land, then
decide whether one or other is more im-
portant to the effect of the picture. If
your camera has a TTL (through the
lens) meter, tilt the camera up and then
down to make the two readings—fill
the picture area first with sky, then only
land. If you consider that both areas
are equally important, set your expo-
sure for midway between the two. One
way to make sure of a satisfactory re-
sult is to bracket the exposures on either
side of the meter reading—a slightly
under-exposed foreground may give
a more dramatic picture anyway.

Photographing landscapes is not like taking portraits. Landscape features are fixed. You cannot just move hills or trees around to improve your pictures. You must move the camera and choose the best lens to suit the photograph.

And yet, to produce striking landscape pictures, the same sort of compositional rules must be followed. That is, there must be a balance between the light and dark areas of the frame, the colours must work together, the design should be clear and direct—and so on. There-fore you have to select with care just what you want to be included in your picture. You must also decide on the degree of emphasis you wish to give each component of the picture—in other words, ask yourself *why* you are taking it. And finally, you must try to exclude any ugly or irrelevant details from the shot. The only ways you can control these many different elements are–

1) careful choice of camera viewpoint (that is, where you decide to stand to take the picture);

2) choice of lens, which governs the 'angle of view';

3) careful framing of the subject, so that the picture includes all you want but excludes, or hides, unwanted details.

Unwanted details

Landscapes, however beautiful, are often spoiled by that over-flowing waste paper basket in the foreground. Tele-graph poles, electricity pylons and other man-made objects can also spoil a natural scene. Sometimes a slight change

ot camera position can place these either at the edge of the picture, or out of frame completely. By moving a few paces backwards or forwards you may be able to hide a pylon behind a tree. Quite a small tree in the foreground of a picture can hide much larger objects that are in the distance.

Trees, fences and other objects can also be used to direct the eye to the main interest of a distant landscape. They can act as a 'frame' and produce a strong composition, too.

An alternative is sometimes to use a longer focal-length lens. For example, change from a wide-angle or standard to a short telephoto (85 to 135mm). Instead of photographing the wide sweep of a landscape, be more selective. Isolate the main point of interest, while still excluding the telegraph poles or the pylons.

Brightness and colour

When looking at a picture, the eye is drawn most strongly to bright areas and brightly coloured objects. Any strong colour will attract the viewer's attention. These factors affect the whole balance of a composition. If the bright area or bright colour is the main attraction of a picture, then of course this is not a problem. However, landscape colours—being natural—are often fairly muted. Browns, greens and blues are the most common colours. Any bright colours are likely to be unnatural—for example, a brightly coloured car, which is reflec-

◀ **The land dominates this shot by** *Jean Bichet,* **with a high horizon delicately indicated by the line of trees. The eye is drawn into the picture down the furrows which lead to the dominant colour of the yellow field.**

▼ **Taken in Idaho, USA.** *Sergio Dorantes* **lay flat on his belly to achieve the low horizon in this shot. To emphasize the cloud detail and improve colour saturation, he used a polarizing filter on an 80mm lens. Exposure was 1/30 at f11 on Kodachrome 25.**

ting the sunlight. This may produce such a strong effect that it overpowers the interest of the natural landscape you are trying to capture.

Again, try to choose a viewpoint, lens and framing which produce the effect you want.

Every picture has a purpose, even if it is simply to record a beautiful scene. This purpose must always dominate your thinking. Successful landscape pictures are produced only when you *consciously* consider everything in the viewfinder in detail, and not just the overall effect. Observation of detail is what makes an excellent landscape photographer.

Placing the horizon

Almost every landscape picture will have a horizon. The placing of this horizon can make a considerable difference to the success or failure of the picture. Usually the horizon is placed according to the 'rule of thirds'—that is, it is placed one third from the top or one third from the bottom of the picture. This technique almost invariably produces a balanced-looking picture. Where *exactly* to place the horizon depends on the relative 'weights' of the land mass and the sky. If the sky is very light or plain, it will carry less interest than the landscape itself. Therefore if you include too much sky in the picture the balance will be wrong. A heavier sky (that is one with an interesting group of clouds, perhaps) can be used to good effect to take up a larger area of the picture.

If you are using a tree or some other

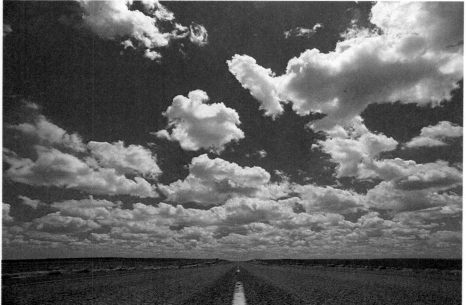

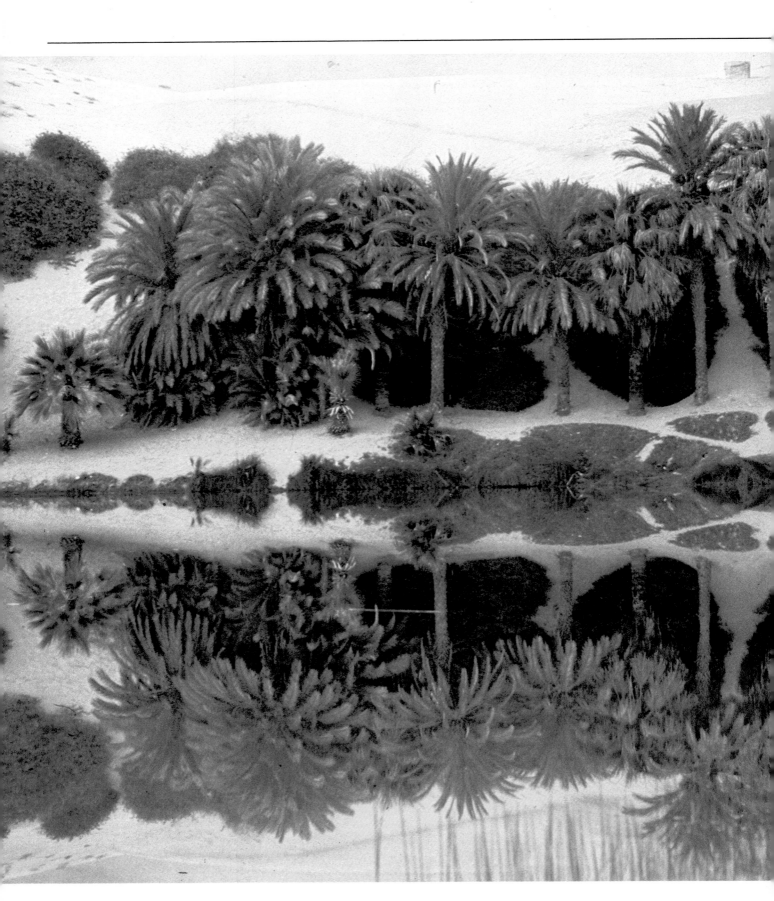

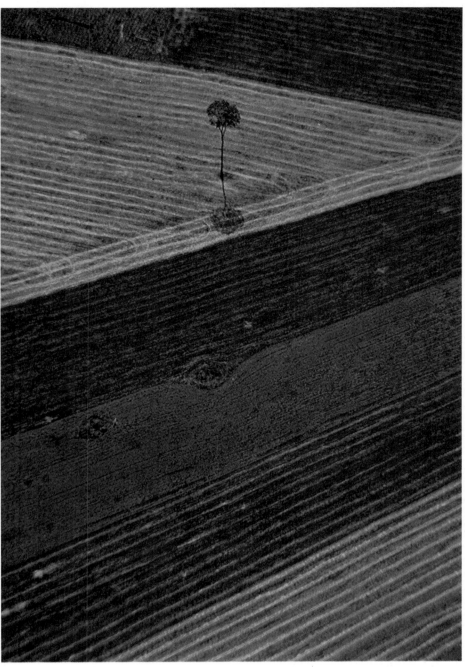

◀ A desert oasis on the coast of Peru. The sand is so white it almost looks like snow. *Timothy Beddow* used the reflection of the scene in the water to make a strong abstract pattern. The picture is symmetrical because the waterline is positioned across the centre of the frame. The absence of a horizon makes the design and pattern aspects of the scene very predominant.

▲ Landscape pictures without a horizon are flat and two dimensional. Here, *Joseph Brignolo* used a telephoto lens to isolate the lovely textures and colours of the ploughed earth, making a geometric pattern. Most landscape photographs contain large areas of green. In this picture only a tiny tree remains, almost symbolic of a part of nature untouched by the farmer.

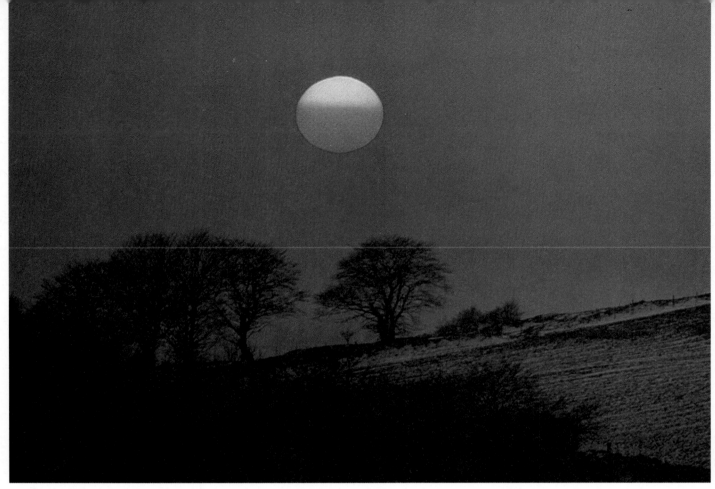

dark object as a frame, to provide a lead-in to the picture, this will increase the weight of the picture above the horizon. This allows you to place the horizon lower down while still keeping the overall balance right.

The horizon can also be placed very close to the top or bottom of the picture. This can produce a very dramatic effect, with the right subject. With the horizon at the bottom of the picture, the result is a cloudscape rather than a landscape. This can give a light and airy effect. With the horizon at the top of the frame, the result can be rather heavy unless the landscape itself is varied enough. The 'rule of thirds' is a good general guide to placing the horizon, but like all the 'rules' of composition, it can be broken if you wish.

Symmetry and balance

Putting the horizon in the middle of the picture seldom works. Similarly, if there is no horizon, placing the main interest of a scene in the centre of a landscape picture seldom works. Pictures like this may be symmetrical, but symmetry is not the same as balance. However, the 'rule of thirds' can be used again. If you divide each side of the picture into thirds, there are four points where these thirds intersect. Placing the main interest on one of these points—that is one third from the side of the frame—generally produces a

balanced picture, which is again satisfying to look at.

Again, the rule can be broken. It is possible for a perfectly symmetrical picture (such as a reflection picture) to be very effective. But such pictures are the exception rather than the rule. Remember in all cases that it is the total combination of all the elements in the frame that dictate the balance of a composition, and dictate whether the picture is a success or not.

Camera angle and position

When considering balance, consider also the way in which you hold and point the camera. Many otherwise excellent landscapes have been ruined by the photographer not noticing that the camera was tilted slightly to one side. This produces a horizon which is not level. If the picture includes a lake, loch or sea, this can give the unfortunate impression that the sea is running downhill!

Remember also that there are many good camera positions apart from the usual, eye-level view. You can sometimes improve a landscape picture by finding a higher viewpoint—even if this is only by standing on a wall. You can also lower the camera to ground level. This gives a feeling of greater involvement with the subject. You can also use any plants and flowers as part of a frame, or to hide unwanted detail. This

▶ This landscape has five elements blending together; the foreground tree (provides scale), the trees in shadow and those in sunlight, the rocks and sky. *G. Marshall Smith* chose a good moment to press the shutter, the lighting and colours lead your eye into the picture, among the trees and up to the rocks.

▲ *Colin Molyneux* took this picture late on a March evening in South Wales. He was on the opposite side of the valley with the camera and a 400mm lens on a tripod. The components of the picture balance each other well; the bushes (left) balance the field (right), and the sun adds interest to a plain sky.

technique can be particularly useful with a wide-angle lens.

Shape

The standard sizes of slides and prints need not limit the shape of your pictures. To be effective, a landscape picture sometimes needs to be square, or an unusual shape—such as very long but narrow. Some firms make non-standard slide mounts you can use to produce unusual picture shapes. Also, you can trim printing papers to suit the shape of the landscape. But for successful pictures of this sort, it is best to consider the final shape *before* you take the picture in the first place.

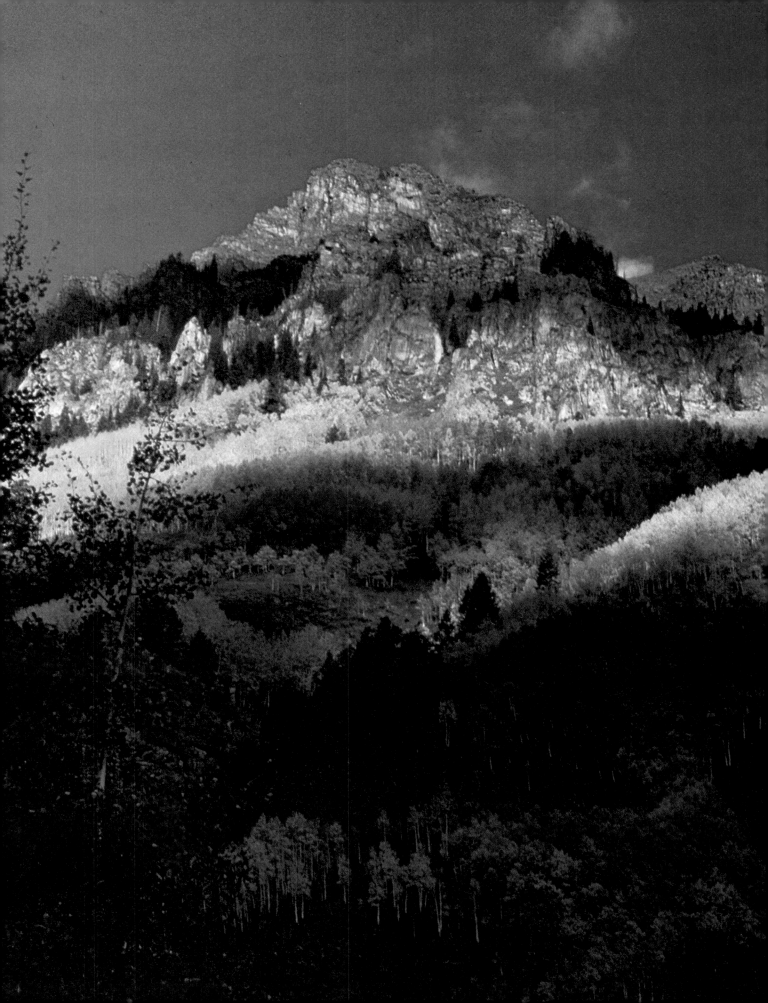

Landscapes in black and white

Landscapes are one of the most popular subjects for photography—and one of the most difficult. Often the most dramatic aspect of a landscape is its sheer scale. It is fairly easy to photograph a face, for example, and make a life-size print. Many small objects can be photographed larger than life. How can a camera capture the vastness of a panorama, especially in black and white? With careful technique, striking landscapes can be taken.

Without colour, landscape pictures rely entirely on the arrangement of shapes and tones for their success. The main problem is that you see the world in colour. Whether you are looking at a field of golden corn, lush green forests or mellow autumnal shades, the colour makes a big impression on you.

For good black and white landscape pictures you must forget that colour exists. Try to see everything in terms of black, white, and varying shades of grey and you will have more success.

The lure of colour

A beautiful subject doesn't always produce a beautiful black and white

▲ **An upright format gives equal weight to the Grand Canyon and the dramatic sky above it. Mark Edwards used a 28mm lens for a feeling of depth and a deep red filter to darken the sky.**

picture. If the colour of a landscape catches your eye first, then it often makes a poor black and white photograph. For example a breathtaking sunset with a vivid pink and orange sky over a broad expanse of hills loses all its impact when seen in tones of grey. So would fields of deep red poppies contrasting strongly with surrounding green grass.

Always remember that although two

▲ **In Fay Godwin's view of the Calder Valley the misty hills and silhouetted buildings become simple shapes. A low sun filtering gently through clouds adds to a tranquil atmosphere.**

colours may contrast strongly, this contrast is often lost completely when translated into black and white. Yellow fields of ripening corn interspersed by green meadows may be a striking colour contrast, but lose impact as two slightly different shades of grey in a black and white print.

You should aim for a pleasant combination of tones—some dark, some light and some in between. Keep in mind

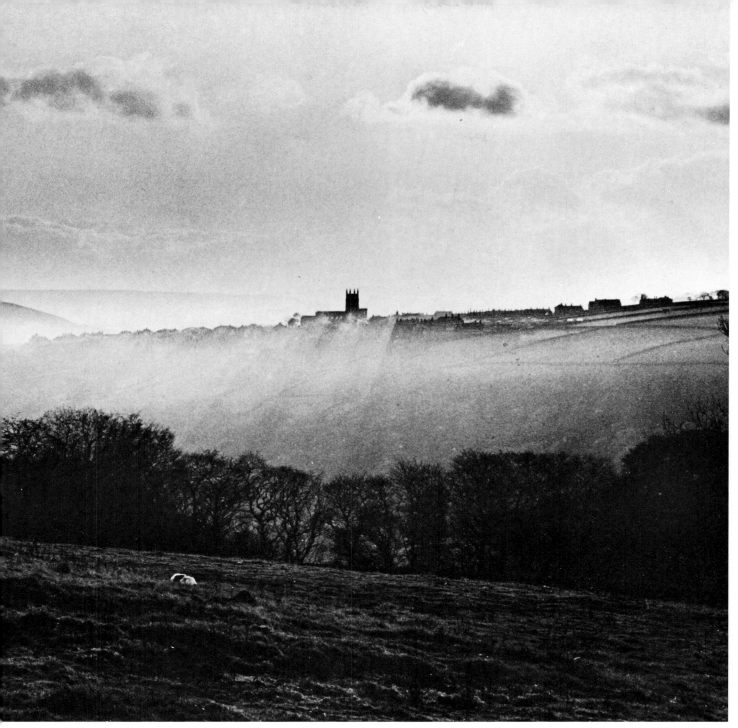

that medium greens, medium blues, browns and reds will all come out as similar medium shades of grey. This will help you to 'see' in black and white rather than being bowled over by colour.

Using monochrome

The most successful compositions in black and white landscapes are the simple ones. Avoid including fussy details and make every shape and tone in the frame justify its existence. If you want to feature the sky, for example, then you don't need to include acres of boring foreground. To convey a dramatic, oppressive feeling don't let a

pretty, blossom-heavy tree get in the way.

Let the black and white film work on your behalf. Slightly under-expose to fill in dark shadowy areas and increase an impression of stormy drama if this is your aim. Harsh contrast often emphasizes bleakness in a landscape.

With very light subjects like snow fields give a little more exposure than your meter suggests. This ensures that the snow comes out bright and white and gives detail in shadow areas.

Important elements

The composition of your picture is just as important when you use black and

white as when using colour, if not more so. The framing (horizontal or vertical), the viewpoint you choose and the lens on the camera are all important. But as it's the *design* which carries the impact in black and white, here are a few points:

Contrast Sometimes a high key picture (mostly light tones) or a low key picture (mostly dark tones) make successful landscape studies. But on the whole a landscape picture containing a range of tones works best. You can still use contrasting tones to your advantage. For example, there could be a pool of water brilliantly reflecting meagre sunlight forcing its way through dark clouds. Or depict barrenness by showing a dark

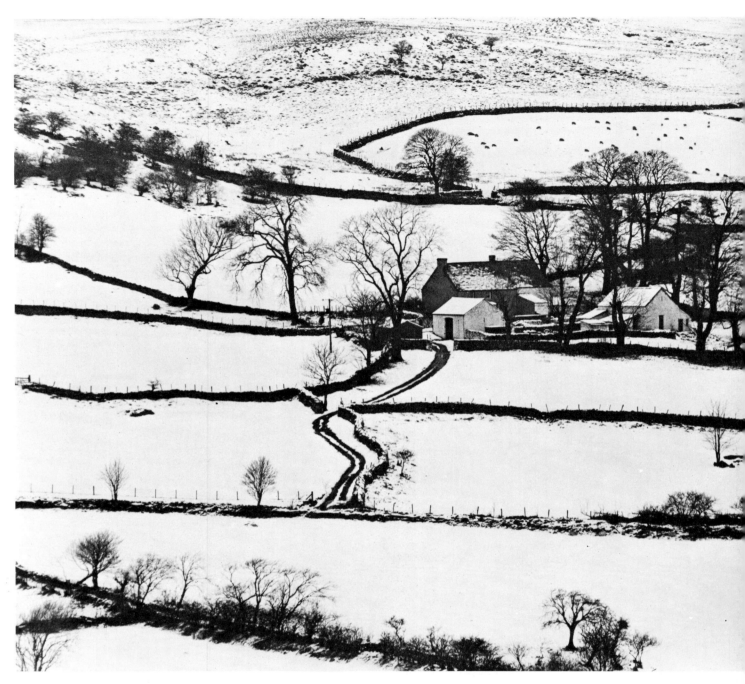

tree silhouetted against the skyline.

Shape Keep your pictures simple to emphasize shape. Lots of details will distract the eye. You can use aerial haze to show up the shape of hills. Ranges of hills become progressively paler as they disappear into the distance and look like flat, grey shapes. If you use a telephoto lens and stand a fair distance from a pale building next to a dark pine forest, then the perspective is flattened. Contrast in tones and compressed distance between building and forest simplifies the elements into flat shapes. A row of trees on the skyline become simple two dimensional outlines.

Patterns Black and white film is an ideal medium for enhancing pattern. The

angle of the sun and the strength of the light are very important. You need the light and shade produced by strong, directional sun to form the highlights and shadows often needed to bring out patterns. Ploughed furrows make distinct linear patterns which can be almost completely lost on a grey, overcast day, or when the sun is directly overhead. Shoot when the sun is at a lower angle. Keep your eyes open for strong patterns made by trees, hedges or roads, and by the rounded shapes of regular, rolling hills.

Simplify your approach to one of seeking contrasts, shapes and patterns. Wait for the right lighting to create a particular atmosphere, and you're on the way to outstanding landscapes.

USEFUL FILTERS

Ultraviolet or skylight: reduces haze a little and makes distant detail clearer (keep one permanently fixed to protect the lens).

Polarizer: reduces reflections and darkens blue skies slightly.

Yellow, orange and red: all three colours reduce haze more than a UV, darken blue skies and show up white clouds. Also good for enhancing stormy feelings. Red darkens skies more than yellow, and orange is in between.

Green: lightens green (foliage), gives more detail in fields and trees.

Blue: increase the hazy effect in the distance; lightens blue skies.

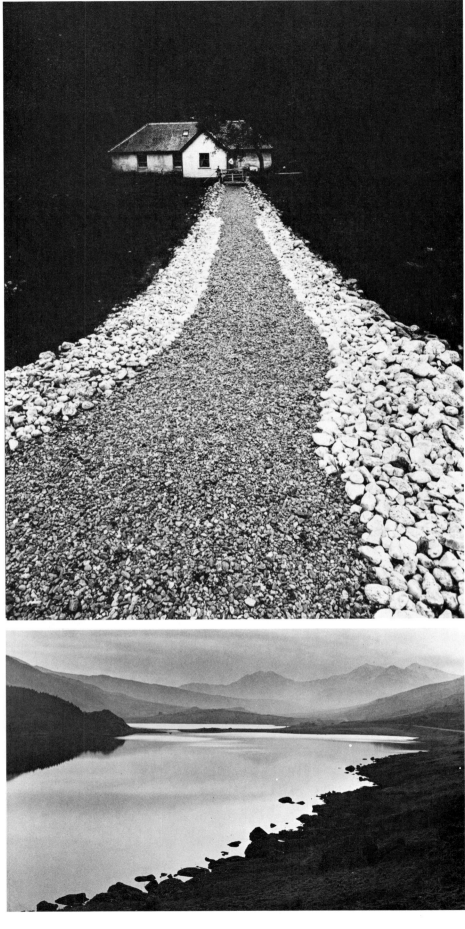

▲ Left: to show the pattern made by dark hedges cutting across snow in the Brecon Beacons, Colin Molyneux used a 105mm lens and left out the sky. Using 1/125 allowed a hand-held exposure.

▲ Right: a red filter darkens greens so much that the foliage merges into a dark mass, emphasizing the Scottish cottage and path. Graeme Harris used a 24mm lens and HP5 in failing light for a hand-held exposure of 1/60 at f5·6.

▶ Colin Molyneux quickly absorbed the sultry mood around Snowdon, Wales. He used a wide angle lens and stood on rocks at the edge of the lake. The sky was darkened further during printing.

Giving depth to landscapes

We see depth in scenes by stereo viewing, because we have two eyes. Each eye sees a slightly different picture and the brain compares the two to estimate depth. The camera gives only a one-eyed view. However, even with one eye closed we can still estimate depth by other visual clues, and the same system works with photographs, which are two dimensional. The ability to suggest a third dimension within the two dimensions of the picture is important to successful landscape photography.

The key to all this is perspective—the fact that we know that the further from us an object is, the smaller it appears. To make your pictures seem three dimensional, you have to make use of this fact. A picture must be composed so that the elements within it which denote distance and perspective are linked. By doing this, people viewing your picture should get the same sensation of depth which you experienced before deciding to take the shot in the first place.

The first thing you see in a good landscape photograph is that there is a *visual route* through the picture. In other words, careful composition draws the viewer into and through your picture until he has gained the full atmosphere and information which you received from the original scene. Planning that route is a matter of geometry.

If the geometry (the relative arrangement of all parts) of a picture is right, the balance of the composition will be right. If you study the geometry of good and bad pictures you will soon learn to recognize patterns which work and patterns which do not. By making use of a few compositional tricks, you can produce strong geometry which attracts the viewer to the picture, leads him into it and holds him there long enough to enjoy your composition.

Scale and perspective
Good use of scale and perspective is the simplest way of producing a lead into your picture. When you look down a road, the fact that distant objects seem smaller than nearer objects creates a

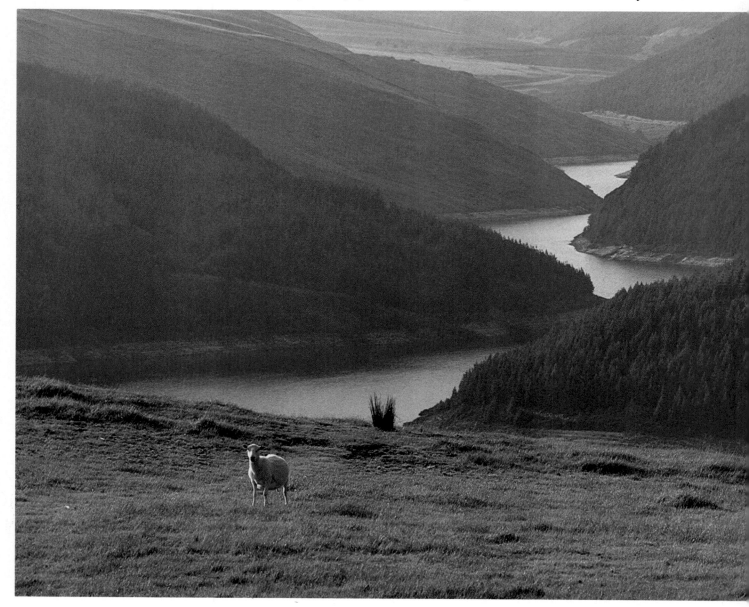

sense of *visual movement*. This movement occurs both in nature and in the somewhat artificial confines of a photograph.

Roads, fences, rivers or buildings can be incorporated into the composition to produce this movement. The eye will quite naturally move from a larger object to a smaller object and thus create a feeling of depth and movement. A large tree, as a frame, fairly close to the camera, and another as a small, distant object, will serve the same purpose. They will also help to focus attention on the subject in the middle of the photograph, and on the distance between this subject and the frame.

So the basics of a good composition can be identified within a fraction of a second: a lead-in, a well-defined route, and a scale device to produce depth.

Depth of field

Our eyes have a facility to see things in sharp focus — albeit only a section at a time. Your photographs must be pin sharp so that they appear as in nature. This means selecting the correct depth of field.

Always take a sturdy tripod when working on landscape. The tripod will serve a dual purpose. Firstly, it will allow you to use *the* most suitable aperture even if it does need a half-second exposure. Second, the fact that your camera is on a tripod will almost cer-

tainly make you view and assess the composition more carefully before releasing the shutter.

Many camera lenses have high optical quality even at open aperture, so that for everyday use shutter priority is satisfactory. For landscapes it may not always be so. Control of shutter speed plays an important part when movement (for example running water) is to be considered, but depth of field and, therefore, choice of aperture will play an important part in the sucess of every landscape photograph you take.

The increased sharpness provided by a large depth of field has drawbacks. Unwanted detail can be accentuated, which shallow depth of field might have obscured.

Camera position is therefore vitally important. A few paces to change a camera position can considerably alter the impact of a picture. A few minutes spent walking around selecting viewpoint, aperture, lens focal length and so on to suit the subject best will result in much more successful pictures.

Weather watching

A couple of minutes of observation can also radically change the balance of a picture, especially on windy days when clouds are moving rapidly and patterns are changing constantly. When you are shooting and the sun is high, the moving, changing cloud patterns can change the weight and balance of the landscape itself, as well as changing the weight and balance of the sky. Dark hills appear more distant than brightly sunlit hills, so the depth of the picture alters. A heavy sky above a sunlit landscape alters tonal relationships, so depth alters again and so does balance and weight.

Shadows can also be used to considerable effect in linking elements within the picture area. So the changing light throughout the day can offer different interpretations of the same subject. At certain times during the day, shadows can disrupt and fragment the movement within a picture. At other times the shadows can link and unify various planes within your field of view.

So the most important decision you have to make in any landscape picture is whether or not to press the shutter — whether or not the picture will be improved by a short wait for the lighting or weather to change. The more time you spend mulling over these decisions, the more involved you will become with your subject, and your pictures will improve.

▲ Taken in Newmarket, Suffolk, the trees and the tracks in the field provide a feeling of depth. The film was Ektachrome 64, and the exposure was 1/125 at f8. *T Wood.*

◀ The river and the hills, both diminishing in size, are the main perspective effects in this scene. They lead your eye into the picture. *Colin Molyneux.*

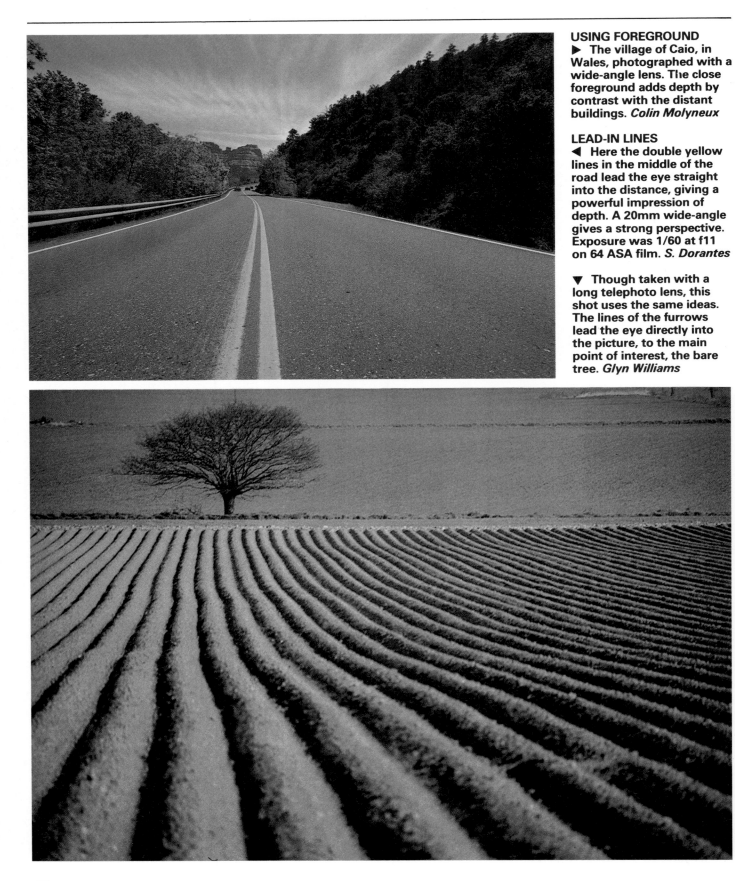

USING FOREGROUND
▶ The village of Caio, in Wales, photographed with a wide-angle lens. The close foreground adds depth by contrast with the distant buildings. *Colin Molyneux*

LEAD-IN LINES
◀ Here the double yellow lines in the middle of the road lead the eye straight into the distance, giving a powerful impression of depth. A 20mm wide-angle gives a strong perspective. Exposure was 1/60 at f11 on 64 ASA film. *S. Dorantes*

▼ Though taken with a long telephoto lens, this shot uses the same ideas. The lines of the furrows lead the eye directly into the picture, to the main point of interest, the bare tree. *Glyn Williams*

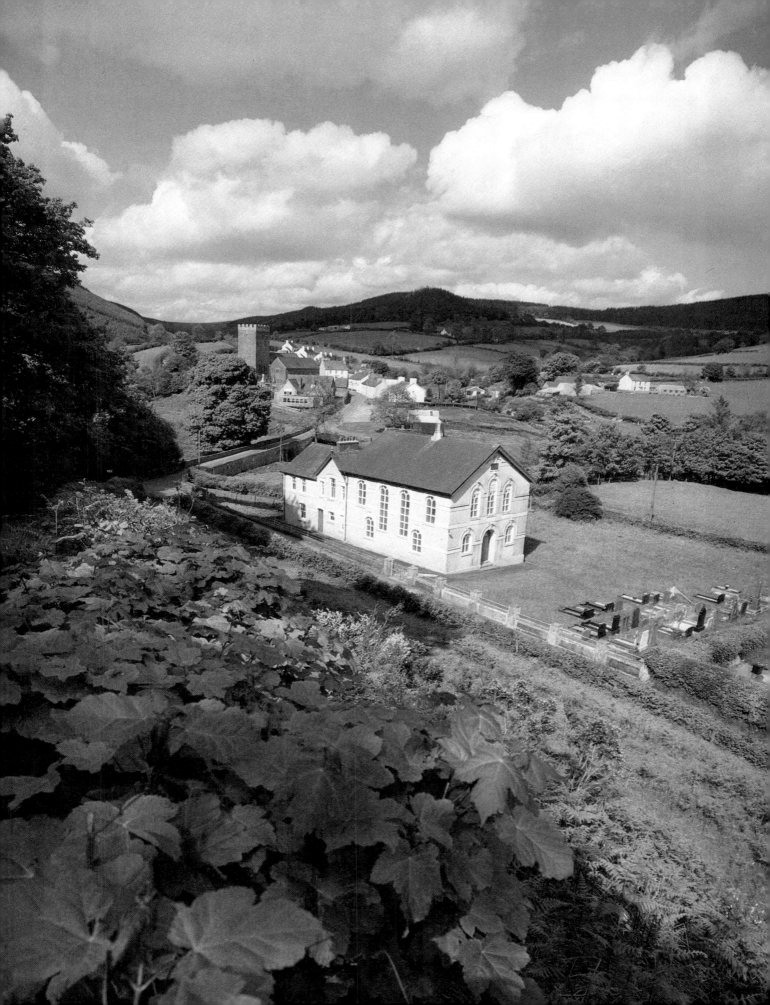

Seasonal landscapes

A simple way to show the passage of time is to take a picture of the same scene during each season—winter, spring, summer and autumn. An even better sequence is obtained by taking the same picture monthly. A series of 12 pictures reveals the most subtle and intimate changes which the eye might miss.

The most obvious subject for such a series is a landscape. Seasonal changes are most dramatically illustrated by the changes of nature. So a scene with hills, lots of trees, flowers, streams, *etc* will give varied and visible examples of these nuances. With such a series, it is a good idea to include some object which you know will change regularly. A forest edge with a stream or lake is a good example. The leaves appear in spring, change to autumn colours and then fall in winter. The stream may be full and gushing in spring, and frozen-over in winter. In a similar way an educational series of pictures of farm fields may be built up—showing crop rotation through the seasons.

A systematic approach

Pictures of the seasonal changes of nature require some self-discipline on the part of the photographer. They demand a professional, systematic approach, as there must be a number of constant factors.

If the same film is to stay in the camera all the year, then choose a stable type which need not be processed swiftly after exposure. Koda-chrome is useful for this purpose, preferably the faster version since winter light is dim. With 36 exposure film you can take three frames for ech month, perhaps bracketing the exposures to achieve better uniformity over the year or waiting a day or so for better lighting. With roll-film colour it would be better to change the film after each four-month period which again usually permits three shots per month. There are no keeping problems with monochrome.

The camera should always be in the same spot for maximum continuity. You may need a marker—say, a wooden peg—deep in the ground to remind you of your spot or a tripod looking out of a window, preferably from a seldom-used room. Note where some prominent part of the picture comes in the finder so there is not too much variation in what each picture includes. Large screens, such as those in twin-lens or field cameras can be marked to show where the horizon, and perhaps a prominent tree, come in the picture shape. With 35mm cameras a rough sketch is a help. It is best to have similar light angles for such a series . . . if possible, the picture should be taken at the same time of the day on each occasion. Early morning is best, say, two hours after dawn.

A 28mm wide-angle lens is good for landscape pictures, and should be used throughout the series. Film stock, also, should be the same throughout. The same picture taken on different films seconds apart can show startling colour variations. Other essentials include a tripod to steady your camera. You may need to use long exposures—especially in bad weather. Remember, the idea is to show the progress of time, and this clearly includes bad weather!

If it is wet you will need to protect your gear. A waterproof camera bag, polythene bags and an umbrella are necessities. You can buy special weather-protection covers for your camera, but it is just as easy to make your own. Prepare your polythene bag beforehand. Choose one big enough to fit over your camera with enough room for your hands. Cut a hole for the lens and secure the edges around the lens with a rubber band. You can also screw a tripod bush through the bag, cutting a small hole for the cable release if required. Protect the lens itself from bad conditions with a UV (ultra-violet) or Skylight filter.

By careful use of the depth-of-field scale on your camera it is possible to obtain pictures with the foreground and background in sharp focus. This is important if the foreground object undergoes vital changes. For example, a twig which will shoot, leaf, flower and finally become bare. This is achieved by deciding upon the aperture at which to set the lens and placing the infinity mark on the focusing mount opposite this aperture on the depth-of-field scale. It is then easy to read off the nearest distance of focus. Great depth of field necessitates long exposures and small apertures, so steady your camera on a firm tripod.

Closer views

Broad landscapes are not the only scenes that change with the seasons. Individual parts of the landscape change too. With a little planning it is possible to produce a broad landscape as well as a closer view of, say, a hedge, or stream, or a single tree, or even a single branch.

One of the simplest series in this vein can be obtained by photographing a deciduous tree at its various stages. In winter it is dormant and leafless—a gaunt skeleton against the sky. In early spring it gains a light covering of pale green leaves as the leaf-buds open. This extends to full foliage in mid-summer and may include flowers, later producing seeds or fruit. In autumn the leaves change colour and then fall. A series of monthly pictures will show these changes in striking fashion.

Variations on a theme

There are many ways of taking creative seasonal pictures. A series could be taken from the same spot using a zoom lens, focusing ever closer on an individual object. A broad sweep could end up with perhaps a single icicle hanging from a branch or a frost pattern on a window.

You might feel that different times of the day—rather than the same time—help accentuate the changing scene. Take the example of a series of a particular tree in your backyard. A late evening silhouette of the stark, bare branches of the tree in winter could be followed by soft pink twilight to accentuate spring flowers, the full noon sun during summer, ending with a misty autumn dawn. For broader landscapes, remember that slanting sunshine—that is, early or late in the day—brings out land contours. A range of mountains in the background may look dramatic in dawn light with the oblique rays of the sun casting each crevice or outcrop into bold relief. But this effect is lost in overhead 'noon' light. You may feel that what 'makes' the image of a season for you is purely personal and not fully realized in a series of pictures of the same scene. Summer may evoke golden beaches and blue sea. Autumn can conjure up visions of bonfires, golden leaves or morning mists. Winter can make you imagine a frozen lake, rows of glistening icicles, or a bleak view of snow-covered fields.

▶'The changes in a year's seasons are a captivating interplay between rebirth, flowering and decline' says Walter Studer who took this series from the window of his cottage in Emental, Switzerland. The one scene combines the elements of constant, evergreen forest, ever-changing tree, crops, fields and livestock to paint an informative and interesting picture of the seasons.

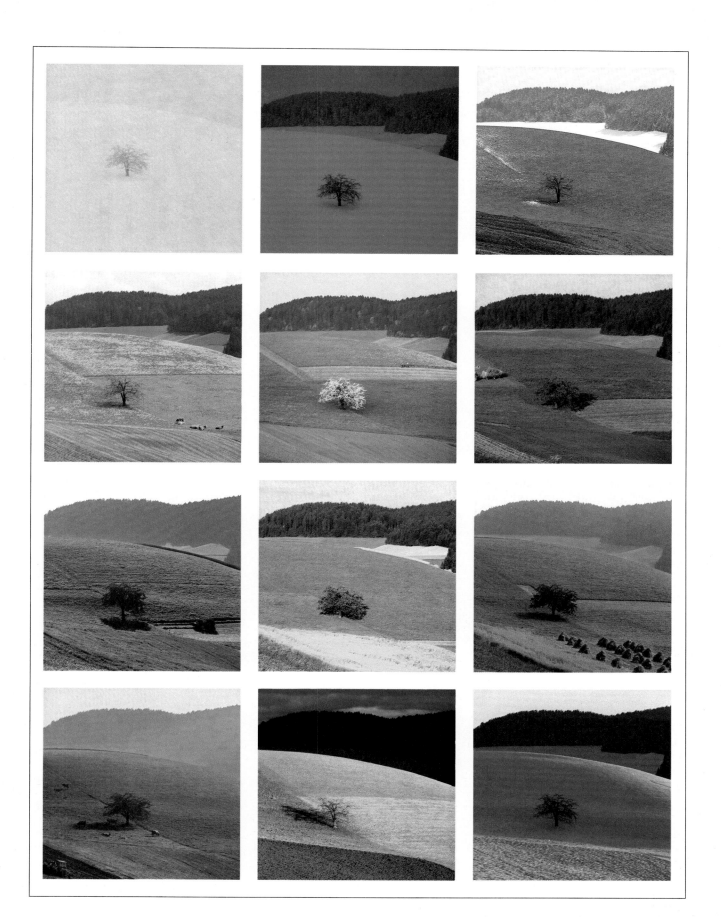

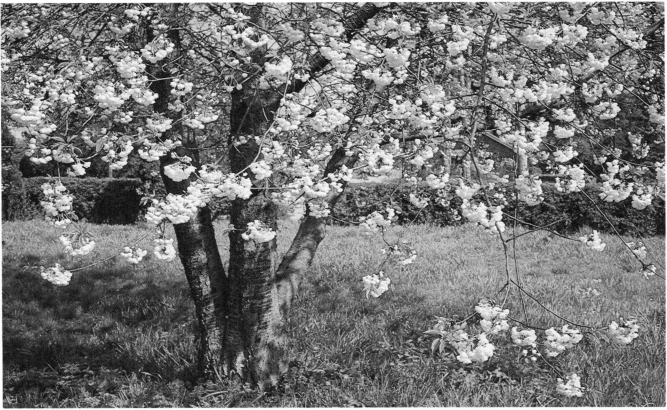

SPRING

A blossoming cherry tree represents spring to Raymond Lea. This shot was taken in the soft light of mid-morning with an exposure of 1/125 at f8 on Kodachrome 25.

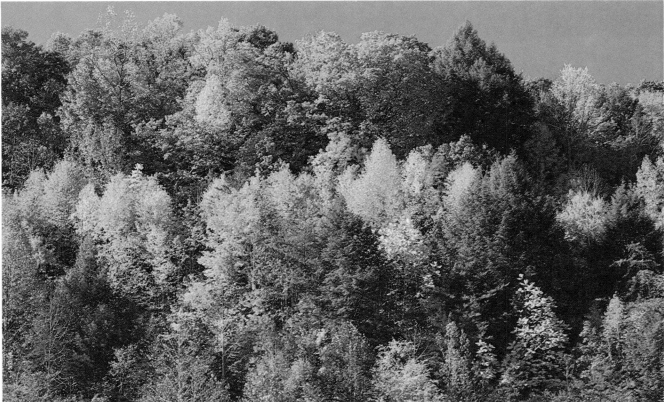

AUTUMN

A Kentucky hillside provided Graeme Harris with this superb autumn shot. He used an 80-200mm zoom lens and exposure was 1/250 at f8 on Kodachrome 64.

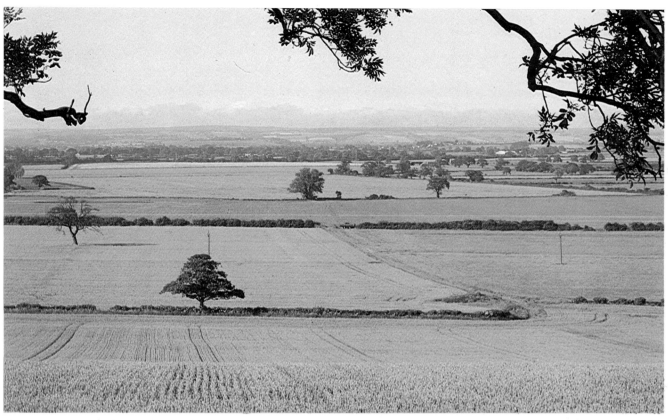

SUMMER

Colin Molyneux's early summer landscape shows trees clothed in their summer foliage and converging rows of young green corn.

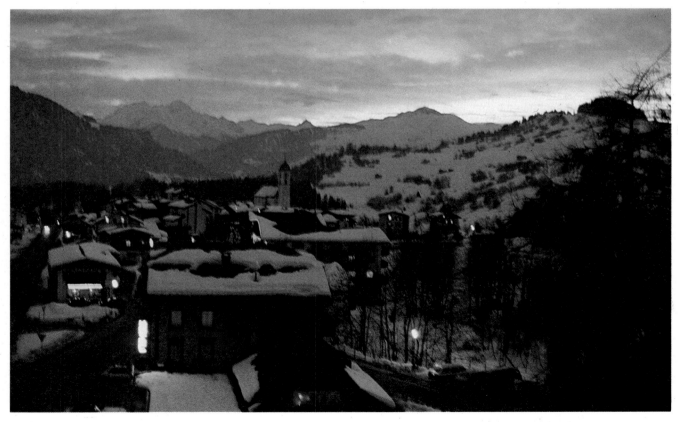

WINTER

Crisp, white snow means winter coldness, but the bright spots of yellow tungsten light add warmth and a cozy feeling. Stefan Bajic

Winter landscapes

Most people put their cameras away for the winter. But when the weather is at its worst, the countryside can be at its most dramatic. Bleakness, silence and isolation can provide strong themes to illustrate. Graphic patterns are formed by the branches of bare trees or the furrows of ploughed fields. There are scenes shrouded in mist or transformed by frost and snow. The landscape changes and can provide superb pictures.

In cloudy weather

Poor lighting conditions can be an advantage in landscape photography. The countryside is no longer subjected to the harsh light of summer which causes glare and sharp, dark shadows. The diffused light of cloudy weather blends the colours and reduces the contrast between light and shade, giving subtler tones.

Leaden skies cast no shadows and can give a diffused background. This allows you to photograph scenes close to the camera without distracting background detail and no sharp distinction between the horizon and the sky. Take advantage of this when you want to show the detail of a building in the foreground, for example. The soft light will show detail without glare or dark shadows to obscure it. From above, you can photograph roof-tops without reflecting the glare of the sun. Expose for the mid-tones, taking care not to under-expose and lose the delicate shading.

In mist

Mist further dissolves the background, muting the colours and flattening contrast. The white haze will fill all the shadows, and any impression of distance will be from aerial perspective—with objects becoming progressively paler with distance.

Distinctive shapes of trees, farm machinery or animals will stand out well against a background of mist or fog. Show them in isolation, with everything else enveloped in mist or gradually receding into the distance. The effect is enhanced when the subjects are backlit, silhouetting nearby objects against those further away.

Stormy weather

Storms produce dramatic effects on the landscape, and the changing light can result in truly exceptional pictures.

At the start of a storm, there are dark clouds bearing down heavily on the land beneath in dramatic contrast to the otherwise brightly lit landscape. Sometimes the oncoming storm clouds are

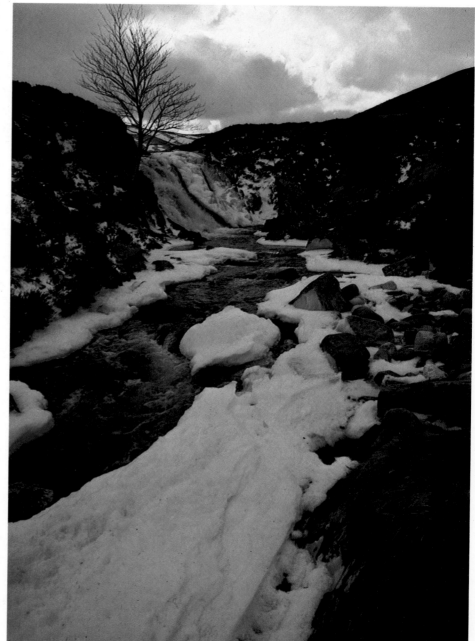

clearly distinguished, with a sharp edge that throws menacing shadows over the ground. At other times the storm starts as a broken formation of dark clouds and patchy lighting on the landscape.

Throughout the storm, breaks in the cloud can let in shafts of sunlight which are well worth photographing.

Expose for the highlights, to contrast them with the darker storm conditions. If you are shooting black and white, make your prints on a hard grade paper to further emphasize the contrast.

After the rain, everything shines as if coated with varnish. Stones, rocks, walls, paths and buildings are more colourful as a result. Grass and foliage also has an added sheen. Raindrops on branches and on grass make jewel-like foreground detail, sparkling with the sun after the rain.

Frost

You have to get up early to photograph the best scenes, when a hard frost has covered everything in pure, biting white crystals, and the sun makes them sparkle with light. By taking a low view-

◄ In the depth of winter, the landscape has been drained of most of its colour. To produce this picture, *Colin Molyneux* aimed for a strong composition. He used a 20mm ultra-wide angle to accentuate the foreground. he set f16 for maximum depth of field, and shot at 1/60 on Kodachrome 64.

► This snow-covered hill makes a striking picture due to the rim of sunlight marking its curve. *Tino Tedaldi* chose a low viewpoint for a diagonal composition, including the trees to echo the slant.

▼ Winter light can be very cold, giving blue results especially with telephoto lenses. For this picture, *Molyneux* added an A2 filter to warm the colour slightly.

point you can contrast branches encrusted with white against the clear blue sky that often accompanies a frosty morning. For colour pictures, use a polarizing filter to deepen the blue of the sky. In black and white, a yellow filter will darken the sky for better contrast. (See pages 52 to 55).

Snowscapes

While snow is falling you can shoot high key pictures, which consist mainly of light tones, since the light is diffused and shadowless. The flakes of snow will give a delicate impression if you catch them as they fall. A shutter speed of 1/125 will usually be fast enough to stop them, whereas 1/30 will blur each flake. If possible keep several feet between camera and snow to prevent nearby flakes recording as large fuzzy blobs.

After the snow has fallen there is often bright sunshine, and a gleaming contrast between the blue sky and the fresh snow. New snow clings to the trees on the side from which the wind was blowing: exaggerate this effect by silhouetting the bare bark against the bright snow-covered landscape. Half buried objects such as gates, farm implements, fences and telegraph poles make very graphic shapes. Pictures like this work well in black and white, printed on a hard grade paper.

In colour, the snow will reflect the blue of the sky and result in a blue cast, which can add to the cold atmosphere of a picture. You can exaggerate this with a cold blue filter such as an 80B or eliminate it with an 81A warm-up filter. Bring your snowscapes to life by including children—playing in the snow or sledging down the white slopes. If people are important to the picture, take your meter reading from a skin tone. Otherwise the glare of the light reflected from the snow can fool a TTL meter into under-exposing your subject.

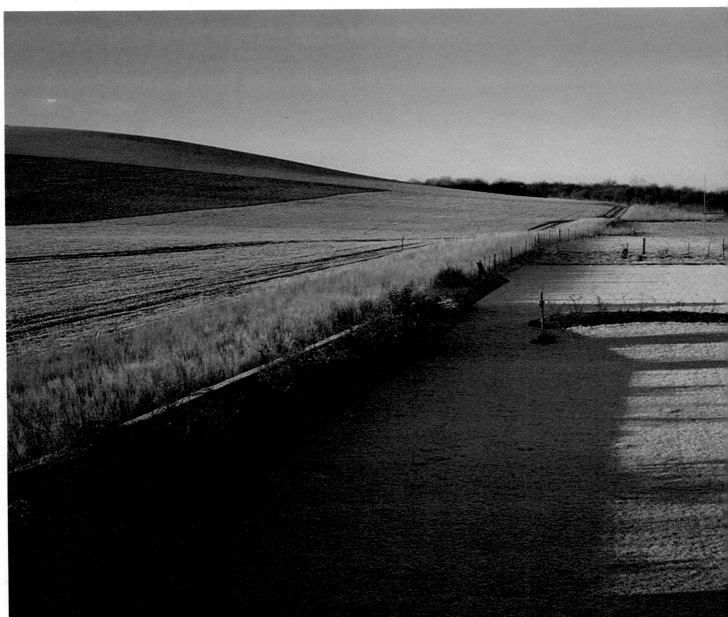

▶ Pictures of hoar frost are only for the early risers. *Gordon Langsbury* used the watery morning sun to backlight the frosty hedgerow without burning out the skyline completely.

▼ The low winter sun can transform a landscape. Without it, *Tessa Harris'* picture would have lacked the deep colour saturation and the long shadows that pick out the various textures of the ground.

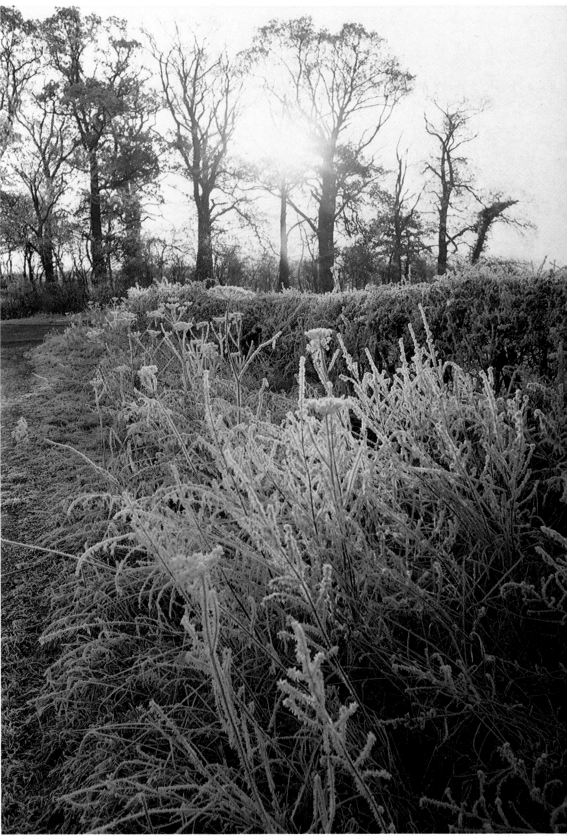

Look for sidelighting, also. A low evening sun can highlight the uneven mounds of snow and bring out any surface texture. Its warm light can also improve cold, bluish snow scenes.

Protect your camera

Your camera needs some protection against wintry weather. Keep it in its case, or under your overcoat.

If using it outside a lot, put your camera in a plastic bag with an opening for the lens. Keep a UV or skylight filter over the lens and fit a lens hood.

Most cameras work well in cold weather, but batteries can be a problem. If your batteries fail, transfer them to an inside pocket to warm up.

For winter landscapes, a pocketable compact camera can be just as good as an SLR, especially if it is easy to use while wearing gloves! You can take landscapes like these with any camera, so don't put yours away for the winter.

▼ One of the chief problems with photographing landscapes is that if you expose for the land the sky tends to be over-exposed—and vice versa. With snowscapes this happens far less. *John Bulmer* took this picture after a snowstorm. Old cultivation lines caused even troughs of snow to alternate with dark ground: these averaged out to a similar reading to the sky, so that *Bulmer* could get a correct exposure for both.

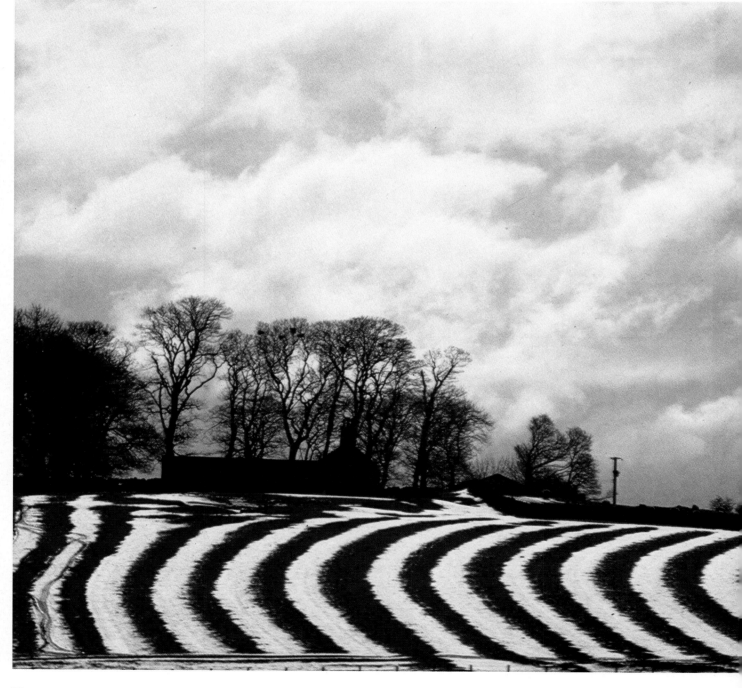

▶ Pictures of people in the snow are often at fault because the people are under-exposed. If you want the flesh tones to be correct, take your TTL reading from your hand, held just in front of the lens. *Tibor Hirsch*

▶ Bottom: filling the viewfinder with an 'average' foreground area— excluding shadows and highlights— *Robert Estall* took a TTL reading which he held after reframing the shot.

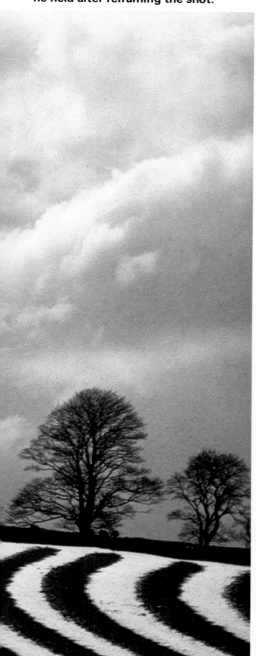

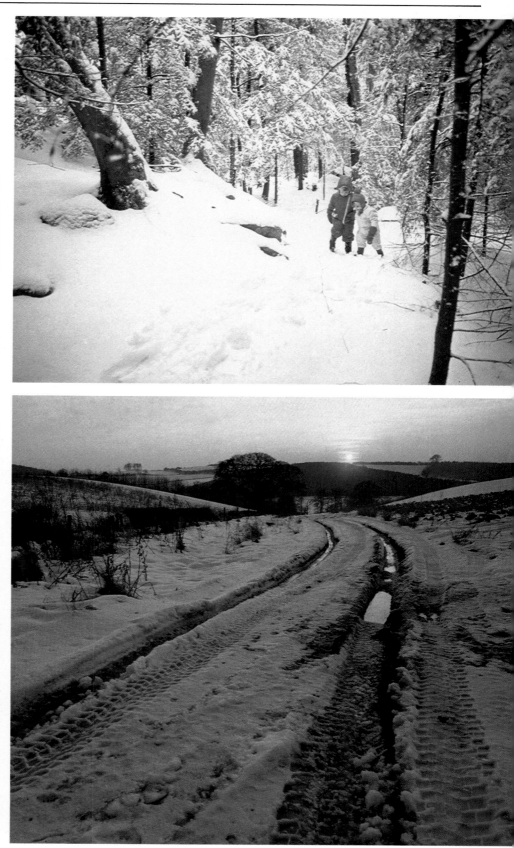

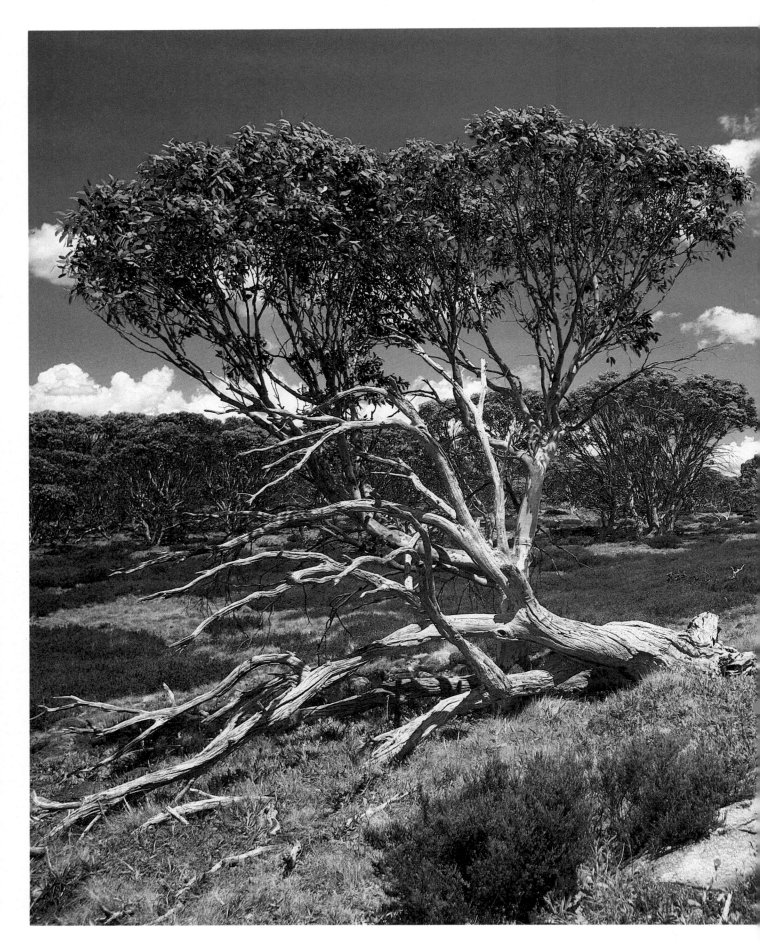

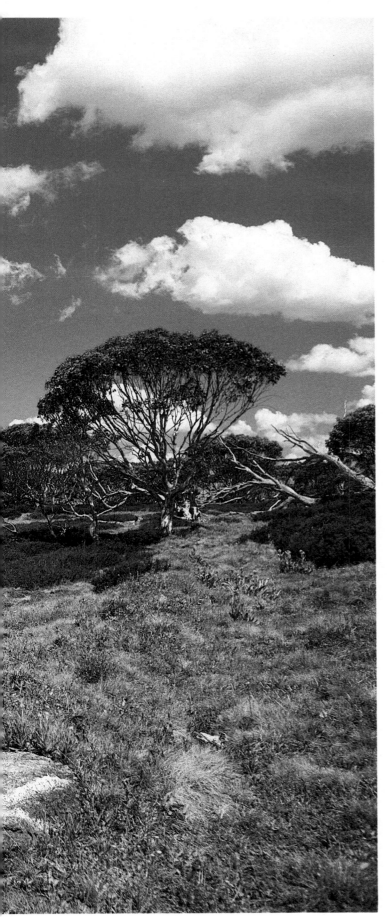

DEVELOPING YOUR LANDSCAPE TECHNIQUES

This chapter continues the theme of landscapes with descriptions of the techniques used by expert photographers to produce superlative results.

You can experiment with atmospheric haze to give an impression of distance. Or try using filters to produce dramatic landscapes and special effects with colour photographs or to control the rendering of skies in black and white landscapes. Mountains are subjects which present their own problems, and their own rewards when a photograph is truly successful. The best place to photograph a mountain is half-way up another one, but this is not always convenient so other ideas are suggested.

All-over sharpness can be particularly important in landscapes because they often contain much fine detail. When you have mastered lens settings —both aperture and focus—and film choice, you can achieve maximum sharpness in your negatives and transparencies.

One way to fill the frame with the desired portion of a landscape is to move to a nearer viewpoint, but this may mean walking many miles. Learn how to overcome this problem by choosing different lenses carefully—you can avoid a good deal of hard slog and carrying heavy equipment!

Old snow gums *(Eucalyptus pauciflora* subsp. *debeuzvillei)* near the upper limit of the tree line on Mount Gingera (1856m) in the Australian Snowy Mountains, were taken with a 20mm wide-angle lens and a polarizing filter was used to darken the sky.

Using haze to show distance

Aerial perspective is a term bandied about by photographers and artists but very often misunderstood. It does *not* mean perspective as seen from up in the air, from an aeroplane for instance. Aerial perspective is the effect of distance or depth caused by atmospheric haze.

Because the air contains impurities and minute particles of water, light travelling through it for any distance becomes scattered. The greater the distance and the more particles in the air the more the light is scattered, causing haze. The result is that objects appear weaker in tone and colour the farther away they are from your viewpoint. Contrast and detail are lost on distant horizons, there are no rich blacks and the colours appear increasingly bluer. *This* is the effect known as aerial perspective, and it is more noticeable at high altitudes and over water because more ultra-violet light is present in the atmosphere.

In photography this natural phenomenon is exaggerated because, whereas the eye cannot see ultra-violet radiation, all films are very sensitive to this part of the spectrum. Objects appear lighter in the distance, and the effect is often so great that a picture of a series of hills can look like a group of cardboard cut-outs.

Controlling haze

In black and white photography the effect of aerial perspective can be quite well controlled by a choice of coloured filters. A bluish filter intensifies the effect, giving more depth in a picture, while a red filter reduces the haze effect, the distant objects are seen more clearly. In colour photography, however, control is rather more limited. If you were to use a deep red filter to cut out the haze you would get a deep red picture as a result! You might have got rid of the haze but the colours would be unacceptable.

When there is not too much haze, the effect of aerial perspective can be reduced by using a skylight filter. This absorbs some of the ultra-violet light, but only works in mild cases. A polarizing filter can also be used. It deepens the blue of the sky and consequently makes the picture appear clearer near the horizon. The most effective control when working with colour, however, is making use of depth of field. If the foreground subject is in focus, it can be visually separated from the background by ensuring that the background is thrown out of focus. Even with a relatively close background the hazy impression makes it appear to be farther away, simulating aerial perspective.

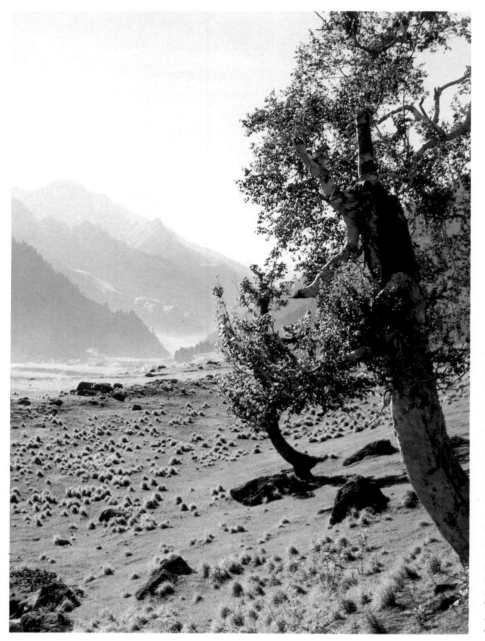

◀ The gentle blurring of distant details is part of the effect of atmospheric perspective. Also, land and seascapes turn bluer as the distance increases. These two effects work together, each assisting the other as in this picture of Kashmir. An ultra-violet filter can help to reduce haze, if wanted.

▶In landscape photography, the influence of aerial perspective on the feeling of depth in a picture is quite considerable, especially when working with colour film. It is not easy to control, but just being aware of its effect should increase the chances of getting predictable results. For the picture above *Brian Seed* chose to shoot towards the light. This has exaggerated the effect by creating strong silhouettes, ranging from black to light grey. For the shot below *Dennis Stock* picked a clear day to capture the crisp detail and strong colours.

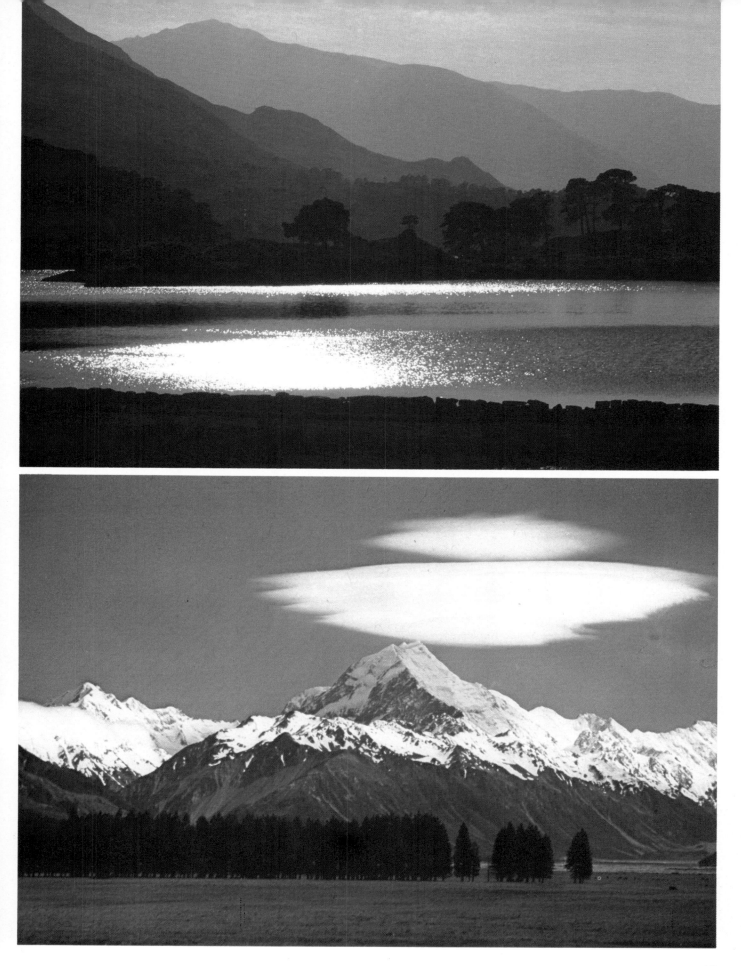

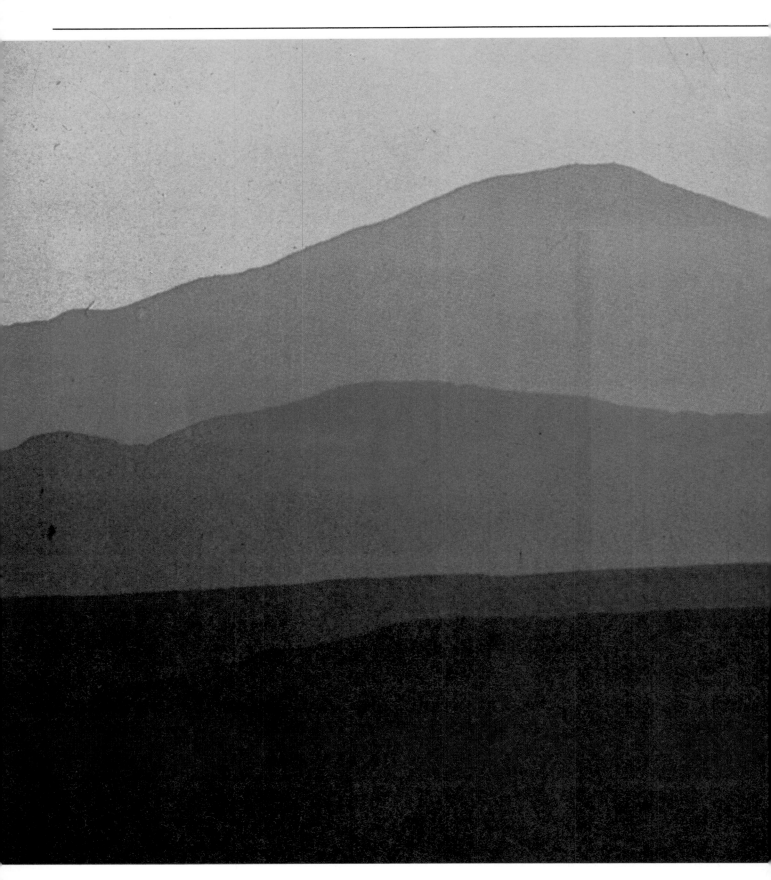

◀ The use of a long focus lens has exaggerated the cardboard cut-out effect typical of aerial perspective. *Cornell Capa*

▲ A graduated filter, deep at the bottom and lightest at the top, has been used here to simulate aerial perspective.

▼ Although not strictly aerial perspective, *Mike Sheil* has created a very similar effect by careful use of differential focus.

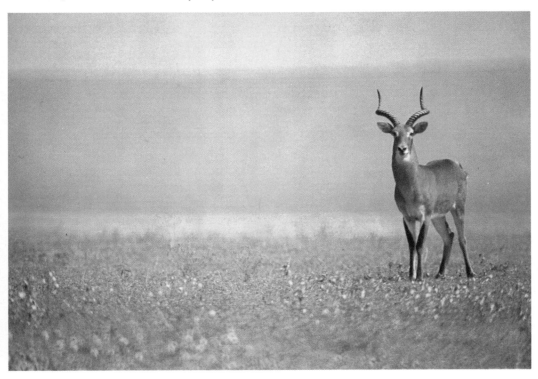

Giving sharpness to landscapes

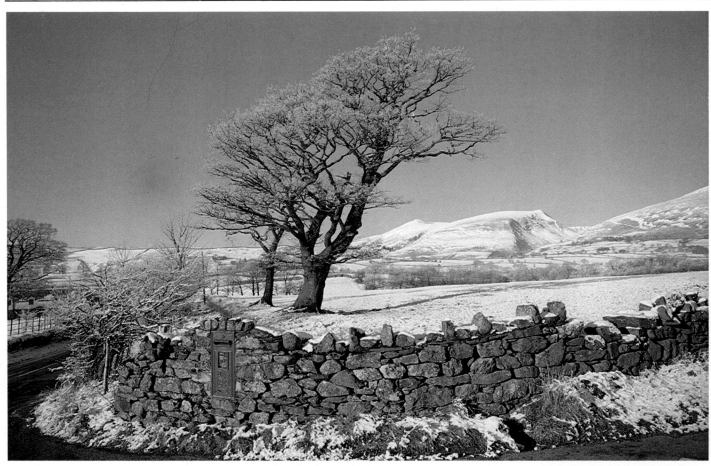

Landscapes which are sharp all over have a unique, visual impact. Instead of drawing your attention to one particular part, they allow you to take in the over-all view, giving as much importance to the foreground as to the middle and background.

In pictures taken with a 'pinhole' camera, for example, everything is fairly sharp—no focusing is necessary. The same result can be achieved using a small aperture with an ordinary lens. Instead of just one plane of sharp focus, the depth of field (the amount of the scene, from front to back, which is in sharp focus) greatly increases. Four factors affect depth of field:
- the focal length of the lens;
- the aperture or stop used;
- the distance from the subject;
- the point on which you focus.

Focal length
Generally speaking, the longer the focal length of the lens, the more shallow the depth of field, with the same aperture and subject distance. For example, by focusing a 100mm lens on a distance

of 10ft (3m) at f8, the depth extends from about 6ft to 20ft (2m to 6m), though the image is only a quarter of the size. Thus it is easier to obtain good depth of field with a wide-angle lens.

Most long-focus lenses can be stopped down to f22 or smaller. This is useful because such apertures are needed with long lenses.

Spectacular effects can also be obtained with ultra wide-angle lenses of 21mm or less. If an 18mm lens is focused at, say, 5ft (1.5m) and stopped down to f8, everything will be acceptably sharp from 2 ft (0.6m) to infinity. The human eye never sees everything sharply at the same time in this way, but the overall high definition and startling perspective can be fascinating.

Aperture
If photographing a flat surface such as a painting, your lens may give its best overall sharpness at around f8. But in a distant landscape, the sharpness of both near and far areas increases as you stop down further. At very small apertures, such as f32, the sharpness in

any one part of the picture may not be as good as in the narrower plane of sharp focus obtained at a larger aperture because of 'diffraction' (the scattering of light from the edge of an aperture with a very small physical diameter). However, the increased depth of field usually compensates for this. Unless working indoors with a powerful flash, a small aperture might call for a slow shutter speed, which may then introduce camera shake unless a firm support is used. It's pointless having good depth of field if the picture is fuzzy. Similarly, if using a fast film for higher shutter speeds, grain may stop you obtaining maximum sharpness and may limit the

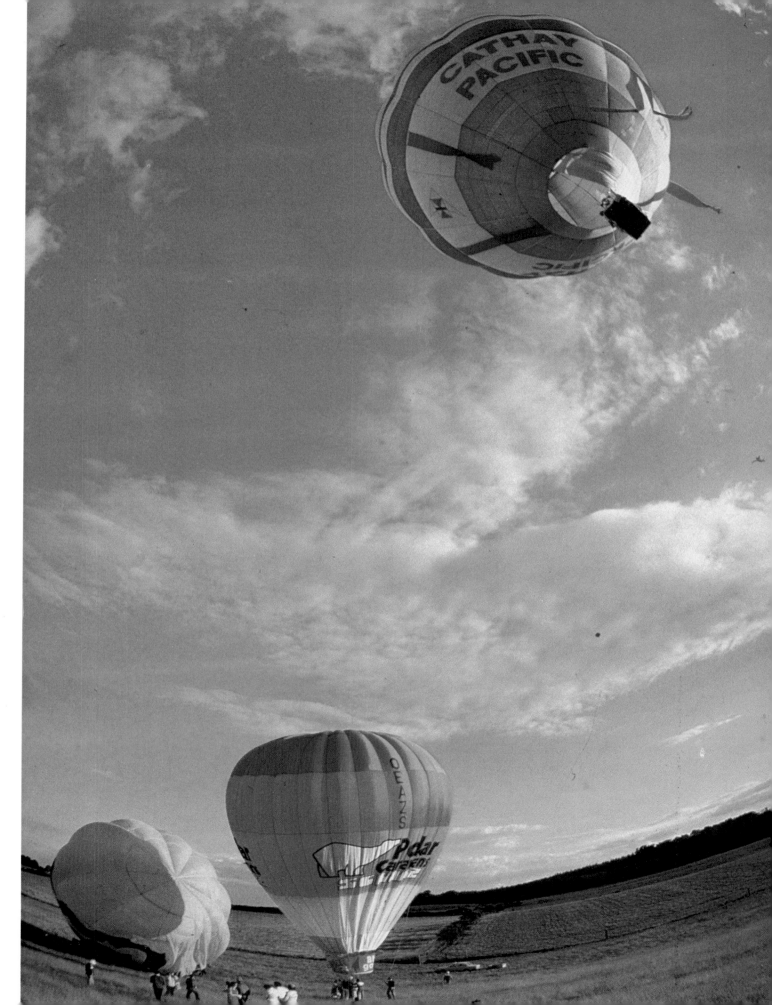

degree of enlargement. So, if you want depth and sharpness, the combination of a small aperture, fine grain film and a sturdy tripod is unbeatable.

Distance

With any lens, as you get nearer the subject, the depth of field decreases, so the need to use a smaller aperture increases. In macro photography, for instance, even at f22 the depth of field may not be sufficient to include all the subject; so lenses for extreme close-ups must be able to stop down at least this far. For example, suppose you are using a 50mm lens to photograph a small object at a magnification of half life-size. With an aperture of f22, the depth of field obtained will be only about 8mm! When taking close-ups of small objects, it is often better to use a telephoto lens, perhaps as long as 200mm, and stand well back, rather than use a short-focus lens at a close distance. This will achieve greater depth of field at a given aperture—the opposite to the effect produced at normal distance.

Hyperfocal distance

With many subjects, depth of field is not very important, but sometimes you will want nearby and distant objects to be sharp at the same time. When you want the maximum depth of field available, the way to get it is to set the lens at the 'hyperfocal distance' for the aperture you are using.

On the camera lens you will see that each aperture has equivalent 'near' and 'far' marks on the depth of field scale on either side of the focusing mark. By turning the focusing ring so that the infinity mark lines up with the far end of the scale for the chosen aperture, the lens is set to the 'hyperfocal distance'. The near end of the scale then shows the closest distance at which objects will be sharply focused. If the range does not include the closest distance required, stop down further and reset to the new hyperfocal distance. This technique is useful if you expect to be shooting quickly, without time to adjust the focus. The camera can stay set at the hyperfocal distance, and if you raise the camera quickly and shoot, the subject is still likely to be within the depth of field.

▶ **Far right: to get the right relationship between the mill and the background from the only viewpoint, Calder used a long-focus zoom. Since the ripples and image of the mill are not the same optical distance from the camera, a small stop was needed, plus a tripod to avoid camera shake.**

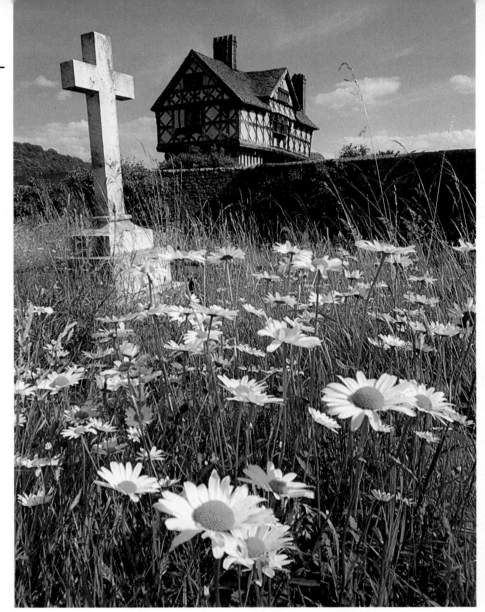

SETTING AND USING HYPERFOCAL DISTANCE

▲▼ **For this picture, Colin Molyneux needed the maximum possible depth of field to ensure that the foreground flowers, the gravestone and the distant house were all in focus. Setting the smallest aperture on the lens, f22, he aligned the far end of the depth of field scale with infinity, as shown below.**

▼ **From the lens you can see that the actual point of focus, the hyperfocal distance, is 3½ft (1m), giving depth of field from 2ft (0.6m) to infinity, and the best possible result at this aperture. Note that at 3½ft there is nothing in the picture that could have been chosen to focus on—only thin air!**

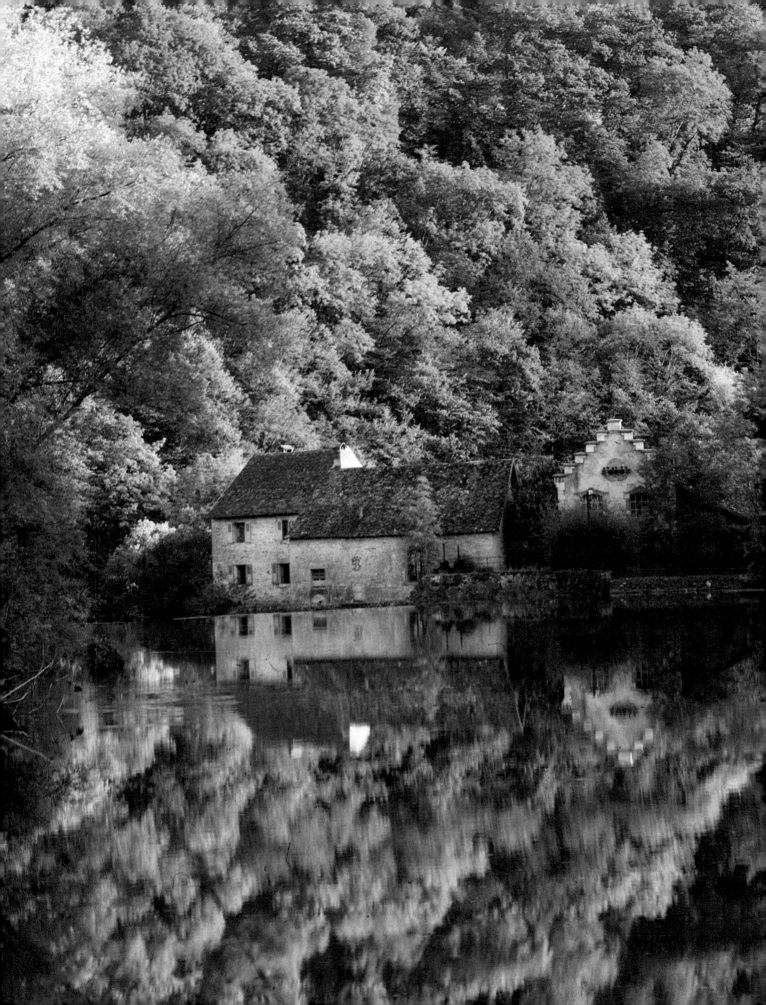

Filters for black and white landscapes

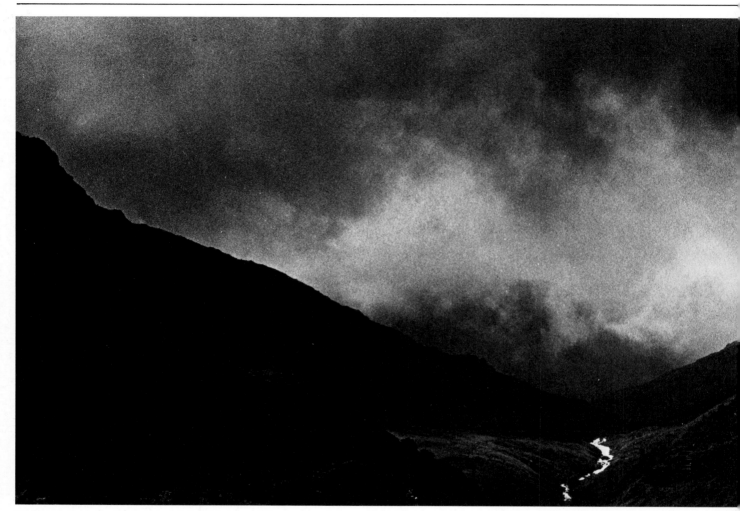

Black and white film, you might think, is altogether too drab to record a beautiful landscape. But with a comparatively inexpensive range of filters (some manufacturers suggest only five) many scenes can be turned into dramatic pictures full of interest.

Ordinary black and white film is called panchromatic because it responds to all colours of the spectrum. Careful manufacturing means that the grey tones that are produced by the film will have the same relative brightness as the colours they represent. For example, yellow is a light colour and a light tone. It will be recorded on black and white film as light grey. Navy blue, on the other hand, is a dark colour and a dark tone and will be recorded as dark grey. In black and white photography, *filters lighten their own colour (and colours in the same area of the spectrum) and darken the complementary colours (on the opposite side of the colour wheel).* This is the key to deciding which filter to use to get the effect you want.

Filters can be used in three ways in black and white photography.
● for colour correction
● for altering contrast, *eg* making a sky look darker than it actually is
● for bringing out detail, *eg* obtaining greater tone separation in subjects of almost uniform colour and tone.

Improving on nature
Atmospheric haze is something which often deters people from taking a landscape shot. However, you can control it if you wish (see also page 72).

Haze is the product of dust particles reflecting blue and ultra-violet (UV) light, to which black and white film is naturally over-sensitive. For this reason black and white film will record more haze than you can actually see. The usual correction recommended is a UV filter. However, as its name implies, this filter does nothing to lessen the blue content of the haze. A better solution is to use a yellow or red filter. Yellows are often called cloud filters because they darken their complementary colour, blue, and absorb ultra-violet light. The result is a darker sky that emphasizes clouds, especially the wispy ones that may have become swamped by the excess of blue. Stronger, more dramatic penetration of haze and clouds can be obtained with a dense yellow filter or an orange one.

The most startling effects can be produced with red filters. Clouds become stormy. Foliage, if caught being blown by a breeze, takes on a brooding, restless quality, which can seem eerie. The red filter's strong reaction to blue can also be put to good use in marine and water shots. It will darken any water that is lit by a blue sky. Waves and spray will be emphasized, like the clouds in a sky shot.

A polarizing filter can be used to saturate colours (tones) and reduce troublesome reflections. The combination of a polarizer and a red filter can produce such a strong interaction that the sky will appear black in the print.

▲ The moody, restless feeling of this valley was created by using an X8 red filter with Tri-X film. *John Wigmore* used Tri-X because the grain structure of the film adds to an angry sky.

Sunrises and sunsets are frequently photographed in colour, but not so often in black and white. With a strong yellow or red filter the contrast of the differing grey tones in the sunset can be increased, thus making them the main feature of the photograph. Autumn tints can be filtered with yellow or orange to bring out the differing shades of a dying and disappearing summer.

Foliage can be made lighter, and species separated, by using green filters.

Mist and fog reflect all colours almost equally, unlike dust particles which form haze and which reflect only one part of the colour spectrum. Consequently there are no filters to help penetrate mist or fog. The green filter restores the true tonal values of foliage as seen in daylight.

Filter check list

Yellow: lightens yellow, darkens blue. Brings out clouds in the sky by slightly darkening the blue. In snow scenes, adds contrast to blue shadows.

Orange: lightens orange, darkens blue/cyan. Produces strong cloud effects and a thunderstorm atmosphere. Makes distant views clear.

Red: lightens red, darkens cyan. Makes blue skies extremely dark, almost black. Makes green foliage very dark. Makes sunrises and sunsets very bright. Can achieve an almost moonlit effect in full daylight.

Green: lightens green, darkens magenta. Lightens foliage. Helps bring out contrast in fields and trees.

Blue: lightens blue, darkens yellow. Exaggerates haze.

Polarizer: saturates colours (tones of grey) to produce highly dramatic effects. Acts like Polaroid sunglasses in reducing reflections. When combined with a red filter, produces a very dramatic black sky, while leaves become white—an effect similar to infra-red film.

Ultra-violet (UV): cuts down haze. Can be used at all times.

Things to remember

Think about filter size, especially when buying a new one. If you have several lenses of different sizes try to buy a filter for the largest lens and a step-down ring to use with the smaller ones. Putting a small filter on a large lens will produce light cut-off at the corners. With square filter systems, all the filters are the same size and fit a standard holder. If you need a different size for a new lens, usually this just means buying a different adaptor to fit the lens to the filter holder. It is also a good idea to write the filter factor/f stop adjustment on the plastic case the filter comes in, and to record the filter's complementary colour on the case.

Good landscape pictures can be taken without a filter if the lighting conditions are just right. But don't be put off by seemingly bad weather. If the light is not as you want it, try using some filters. A landscape that you would otherwise have passed by as ordinary can lead to a worthwhile picture.

▲ NO FILTER—little detail shows in the sky. Exposure 1/125 at f11.

▲ YELLOW FILTER—sky darkened, clouds prominent. Exposure 1/125 at f8

▲ ORANGE FILTER—very strong cloud effect. Exposure 1/125 at f5·6.

▲ RED FILTER—blue sky dark and dramatic. Exposure 1/125 at f4. *R. Lea*

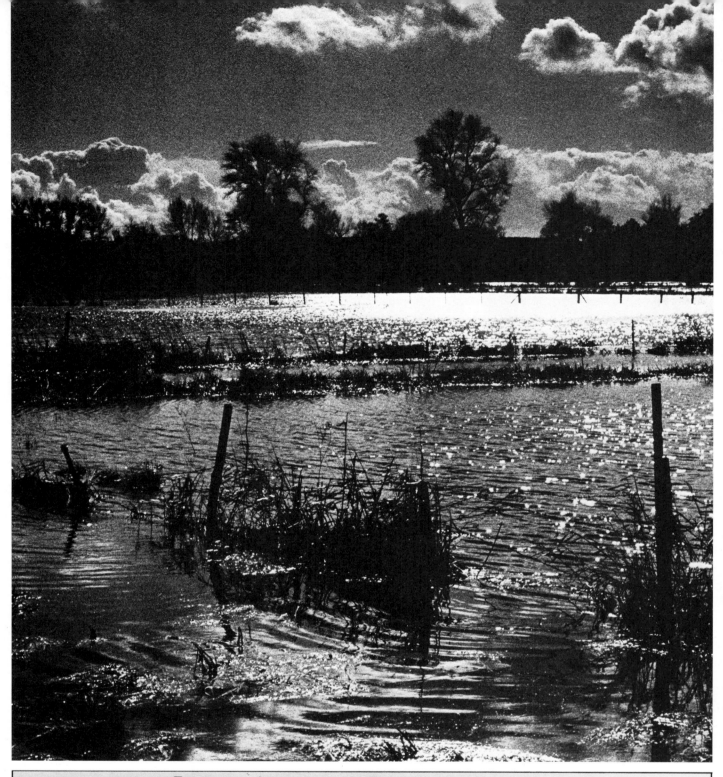

Exposure changes needed for different filter factors

Filters decrease the amount of light entering the camera, so an increase in exposure must be given.

As their name implies, TTL (through-the-lens) metering systems determine exposure by measuring the light that has passed through the lens. Therefore, even with a filter over the lens, the reading may be correct (although meter cells can be deceived by coloured light).

As a convenience, manufacturers provide all their filters with a filter factor. This indicates by how much the exposure has to be increased to compensate for the light loss caused by the filter. You can always meter the subject without the filter, and then adjust the exposure manually. This chart will enable you to tell what exposure adjustment you should make for different filter factors.

Filter factor	Increase aperture by
1.5x	2/3
2x	1 stop
2.5x	1 1/3
3x	1 2/3
4x	2 stops
5x	2 1/3
6x	2 2/3
8x	3 stops

◀ Floodwater scene, shot through an orange filter. The filter darkened the blue sky, emphasizing the cloud detail. It also darkened the water, bringing out the highlights on the surface. The use of the filter produces a dramatic shot. *Raymond Lea* used an Olympus RC compact camera and the exposure was 1/125 at f8 on FP4.

▼ This time, a red filter was chosen to darken the blue sky. As a result the clouds are more distinct, especially the wispy ones. To increase the overall contrast the print was made on Grade 4 (hard) paper, and given enough exposure to make the sky almost black. *David Kilpatrick* used a 20mm lens and FP4 film. and FP4 film.

HOW TO OBTAIN THE EFFECT YOU WANT IN YOUR LANDSCAPE PHOTOGRAPHS

Subject	Effect desired	Suggested filter
Blue sky	Natural	Yellow
	Darkened	Orange
	Spectacular	Red
	Almost black	Deep red
	Night effect	Red plus polarizing filter
Marine scenes when sky is blue	Natural	Yellow
	Water dark	Orange
Sunsets	Natural	None or yellow
	Increased brilliance	Orange or red
Distant landscapes	Addition of haze for atmospheric effects	Blue
	Very slight addition of haze	None
	Natural	Yellow
	Haze reduction	Orange
	Greater haze reduction	Red or deep red
Nearby foliage	Natural	Yellow
	Light	Green

Dramatic landscapes in colour

When you use filters for shooting landscapes in colour, they improve pictures in a different way from those used for black and white. The sky is still an area which needs controlling or emphasizing to suit the mood of the picture.

The greens, browns, rock greys and autumn yellows in the rest of the scene give the colour landscape its appeal. You will probably want these colours to remain as they are, but filters may be needed to correct or improve colours in all or part of the picture.

Correcting the colours

Colour correction means restoring a colour to its correct hue on the film when the prevailing light makes it look the wrong colour. One or two hours after sunrise and before sunset, for example, the sunlight is too red. You might like this effect on red-tiled roofs or a field of yellow corn, but technically it is not correct. On dark green pine trees or a pale blue lake the reddish light could destroy subtle or delicate colours. A pale blue compensating filter would be useful to restore light balance in these circumstances. Correction filters like this are made in gelatine squares as well as plastic or glass.

You are more likely to want to correct excessive blue light. When the sky is a cloudless blue, shadow areas which only receive light from open sky look very blue and cold. A 'warm up' correction filter (pale pink) makes the whole picture look more neutral. For a sunnier effect a pale straw (yellow) filter is better. Colours can be improved, or emphasized, by the reverse process. A sunset looks warmer and redder through the 'warm up' filter; a snowscape looks colder and bluer through the 'morning and evening' filter. A forest glade scene can look much greener and fresher through a pale green filter, and an autumn view is improved with a brown filter. For this, try an artificial-light film with a daylight correction filter, type A-D (light brown/orange).

But remember that you cannot bring out clouds with a red filter on colour film, as you can with black and white film. You just get a red photograph. On colour slide film, a filter gives a colour cast of its own colour. If you use a yellow, orange, red or green filter with colour *negative* film the printer may try to correct the result and the colour will be diluted.

Colour compensation filters

Gelatine filters—used to correct colour or make subtle changes—are made in

a whole range of colours and strengths. You can buy red, green, blue, magenta, yellow and cyan filters. They are identified by 'CC' strengths. 'CC' stands for colour compensation. 10CC is very weak; 20CC is stronger; 30CC needs half a stop extra exposure and has an even stronger effect; 40CC and 50CC should only be used if you want a big change. 05CC, the weakest strength, is only worth getting if you use professional colour film, as amateur colour film can vary by more than this to begin with, making it impossible to gauge.

To order colour compensation filters, ask for 'CC20R' (20 units red) or 'CC20B' (blue) and so on. These two are the most useful, for correcting excess blue and red natural light casts. Try a CC20R to make the colours of a sunset even warmer and startling or try CC30G for leafy scenes and CC10Y to make overcast days seem a little sunnier and brighter.

Improving colours

UV and haze filters cut out excess blue light and are essential for landscape work, especially at high altitude or on days with open blue skies. A haze filter is the most versatile, a UV filter may not warm up cold blue days enough.

Polarizing filters are invaluable for colour landscape work. Suitably rotated to obtain the strongest effect, they bring out the clouds against a deeper blue sky. Reflections are cut from water, and also from the surface of rocks, grass and leaves, so that the natural colours come through more brightly. Colour saturation is also increased. Do not use polarizers for 'against-the-light' scenes because sparkle may be lost.

Graduated filters are half coloured, half clear. You can use a single graduated filter to darken or colour the sky, especially on dull days with a blank featureless white sky. Line up the division between *colour* and *clear* with the

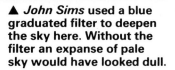

▲ *John Sims* used a blue graduated filter to deepen the sky here. Without the filter an expanse of pale sky would have looked dull.

▶ The New Bedford river in the Fens. *Robert Estall* used an 85B filter which created a warm atmosphere.

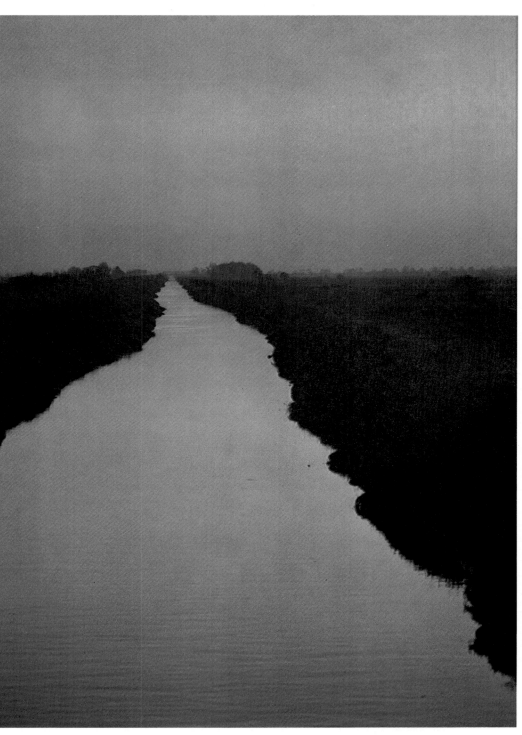

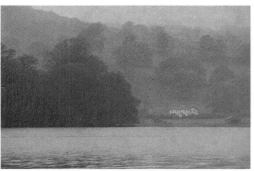

◀ ▶ *Graeme Harris* took both these shots in the Lake District. Different filters were used over the whole image to change the feeling and mood of the scene. A pale blue filter created a soft overall cast making this landscape look cold (right). A pale pink filter made the tones in the other shot (left) look much warmer.

A: without filter

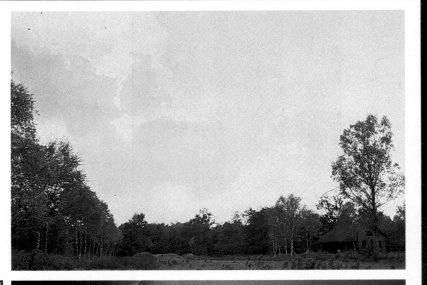

B: with grey graduated filter

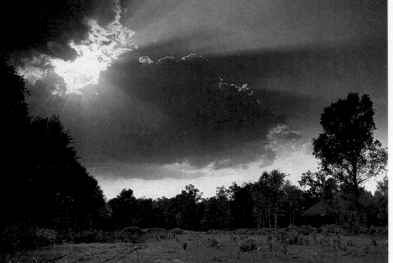

C: with tobacco graduated filter

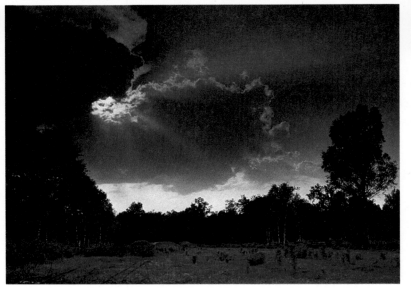

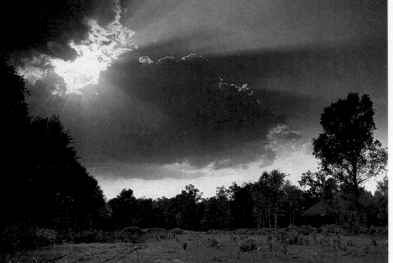

▲ Extra colour was added to this monochromatic scene by the use of a tobacco graduated filter. *Michael Busselle* placed the horizon at the bottom to emphasize the strong sky.

◀ These three pictures were all taken in the same place at the same time. The differences are due to using filters.
A: no filter. The picture looks empty and the sky looks uninteresting.
B: a grey graduated filter darkens the sky to bring out the dramatic effect of the sunlight from behind the clouds.
C: a tobacco graduated filter has the same darkening effect, but also adds a special colour interest. *Jean Coquin*

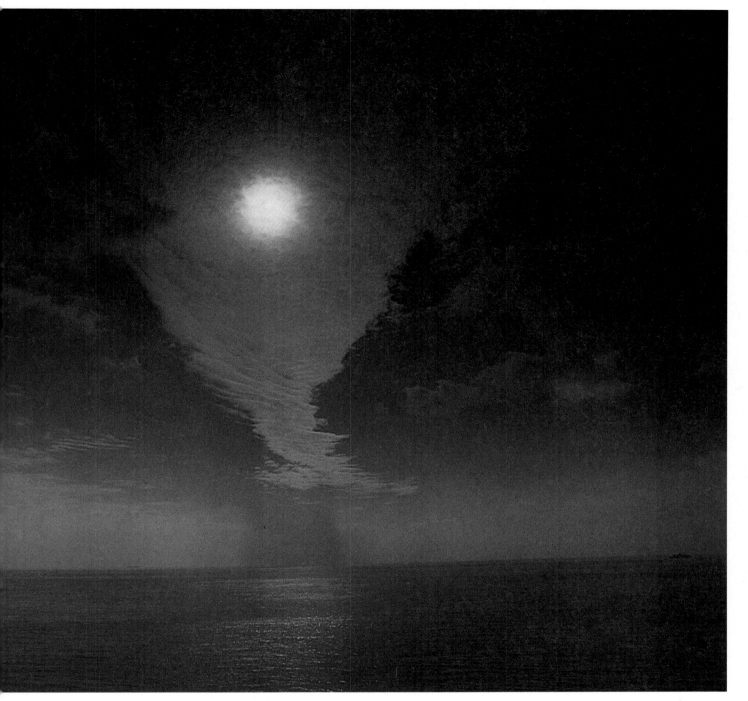

horizon, or just above. Dull winter days can be turned into 'sunny scenes' by using a warm-toned graduated filter over the ground area and a blue one over the sky area.

Graduated filters in rotating mounts only let you line up the angle of the filter with the horizon, so you must have the picture roughly half sky and half land. Graduated filters made for square filter systems (like Cokin) can be slipped up and down too. In this way low or high skylines can be matched up.

Graduated filter effects

Even though graduated filters have a gradual change from clear to colour,
the change-over area still becomes sharper at smaller apertures than it looks through the lens at viewing aperture. This is due to depth of field. Wide angle lenses give a very sharp division. Standard lenses give most control as they have the greatest aperture range and the filters are designed for use with 50mm lenses. A graduated filter may fail to work with lenses longer than 135mm unless you stop right down.

The most useful graduated filters to buy for landscape work are:

Grey 1 and 2: darkens blue skies, no colour change.

Blue 1 and 2: make pale or white skies blue.
Green 1 and 2: boost grass and foliage greens, sky unaffected.

Tobacco 1 and 2: warm brown tones to improve ground detail on dull days.

Red, pink, mauve, cyan and similar colours are mainly useful to make unnatural sky colours.

Exposure

When using colour filters with colour film for landscapes, do not increase the exposure too much, or the effect of the filter will be lost. Use a normal through-the-filter reading. With graduated filters, use the reading obtained *without* the filter in place for backlit scenes or views with bright white skies.

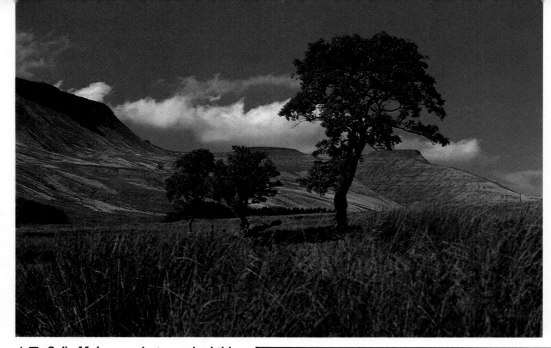

▶ *Bill Carter* created a surrealistic effect here by using a turquoise 'pop filter' over the whole of this image, changing it completely. The virtually symmetrical composition adds to the mysteriousness of the scene. The bird in the sky mirrors the creature in the water. When you are using coloured filters, remember to compensate for the filter in the exposure. The filter allows less light to enter the camera.

▲ ▼ *Colin Molyneux* photographed this spot in the Brecon Beacons on Kodachrome 25 using an 80-200mm zoom lens. Colin decided that the scene would be improved by the use of a polarizing filter. The result (above) shows a better rendition of tones, and better colour saturation than was obtained without the use of a polarizer (below). Using this filter meant a longer exposure. TTL metering was used. Exposure with polarizer, 1/15 at f11; without polarizer 1/60 at f11.

▶ Use this chart to decide which filters will give the effect you want in your landscape photographs.

FILTERS FOR LANDSCAPES IN COLOUR

Subject	Effect required	Filter/s
Pale sky with clouds	Darken but leave clouds bright white	Polarizer
Pale sky no clouds	Darken	Polarizer or Grey graduated
Sunset	Darken and boost blue Remove red colour cast Partially correct cast Boost red colours	Blue graduated CC50B CC20B 81A, CC20R
Snow scene	Cut excess blue shadows Restore white snow in morning/evening	CC20R CC20B
Forest, trees	Boost green colours	CC30G or Light Green
Overcast view	Create sunny day effect	Blue graduated on sky; tobacco graduated on ground area.
Sun in picture	Darken sky and keep ground exposure correct	Combined grey and blue graduated
Foliage, trees	Boost colours (especially in Autumn)	Polarizer
Autumn scene	Boost warm colours	Use A-to-D brown filter or Sepia filter
Any sunlit view	Create moonlight effect	D-to-A or strong blue filter plus one to two stops underexposure

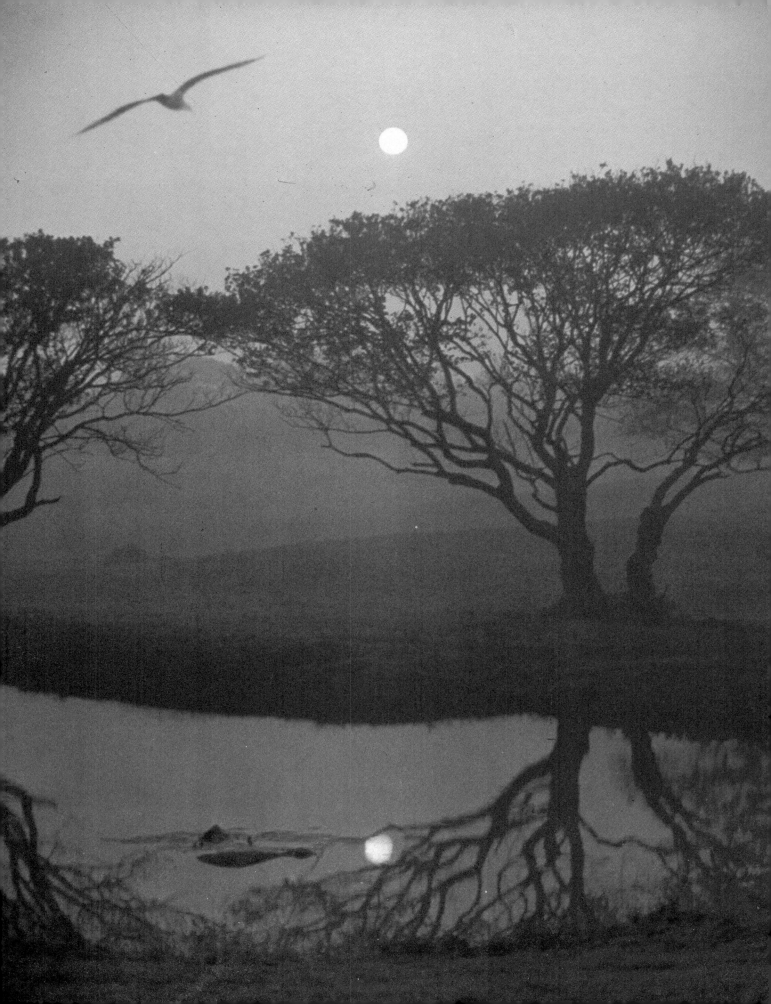

Using special effects filters

Why should a landscape picture always be green? Special effects filters allow you to change, falsify or dramatize colours, focus, visual effect or lighting in all or part of the scene.

There are different levels of special effect. For example, the scene can be left virtually unchanged except for the corners and edges. Or a monochromatic scene can be given an overall brilliant colour, instead of recording as dull shapes against a plain cloudy sky. Most of the filter effects mentioned here are available to fit all types of camera or lens, in both circular rim mounted types and square system filter holder types.

Colouring the whole image

Strong colour filtration, increases subject contrast as well as putting a colour over all the picture.

If you use colours which use only one of the film's three main sensitivity bands (red, yellow and blue) the contrast will be high and the picture may look stark. 'Pop' filters from Hoya and B & W include green, purple and other colours which contain more than one primary. Because these filters need two layers of the three layers of the film to reproduce their colour properly, you get more detail, saturation and shades of colour. **Split colour filters** create an effect similar to graduated filters, but much stronger. Instead of a gradual change to a muted tone, split colour filters often have one half a bright colour (such as yellow) and the other half a different bright colour (such as blue). There is a sharp transition between the yellow and the blue. You can make your own split filters by sticking coloured acetate or gelatin on to a plain UV filter. To avoid a sharp edge between two colours in the final picture, you have to use a wider aperture. 'Half and half', and 'radial thirds' are typical of the split colour filter types you can buy. **Colour spot** filters have a clear central hole cut through deeply coloured plastic or glass. They leave the centre of the shot normal, but give a pure colour to the surround. The size and sharpness of the central hole can be changed by varying the aperture. If you want an oval hole to match the 35mm format, you can cut your own from sheet filter material; only round central spots are made to be sold commercially.

Contrast and sharpness

For many people, images of spring and summer are nostalgic, especially where country scenes, orchards, woods, long lazy picnics, cool running streams and children are involved. Misty, soft focus, or diffused effects emphasize this feeling. Do not try to use a soft focus on a normal landscape with flat ground detail and a simple horizon—it fails! Use it instead where there are trees, preferably with light coming through them, or water with light sparkling off it. When combined with a half or full stop of over exposure, an ethereal effect can be produced.
Soft focus and diffusion filters alter the whole image area. Some types of cross screen or starburst filter also give soft focus to a slight degree.
Fog or mist filters (low contrast) put a veil of diffused light over all the image without affecting the sharpness. Unlike real fog, there is no increase in effect with more distant subjects, but the impression is realistic as long as no close detail is included.
Graduated fog filters give increased fog effect with distance. They are made like graduated colour filters. Neither type gives realistic results when used on a sunny landscape, as the appearance of sun penetrating fog is quite different.
Centre focus or sandgrain filters have soft focus, diffusion, or sand blasted surrounds with a clear spot or hole in the centre. They are most useful when some edge detail in a scene is out of place or too prominant.

Star-burst effects

There are several different effect filters which turn point sources into graphic bursts of light. In a picture, these bursts convey more of a feeling of brilliance than a simple spot of light.

With some lenses, stopping down to f16 will create a small starburst from the sun or water sparkle without using a filter. To imitate this with a lens which does not produce this effect, use a **Starburst** (six-point) filter. Two, four or eight longer lines of light are produced using **Cross Screen** filters. **Vario Cross** filters let you change the angle of a four point cross, rather than being stuck with a 90° version. These types are all made by ruling fine lines across the filter. The more lines, the stronger the effect, but with lower overall contrast and less sharpness.
Diffraction filters have rulings so fine that they cannot be seen with the naked eye. They make coloured light bursts from light sources. There are many different types—lines, radial blobs of rainbow colours, and repeated coloured images. The strongest effects have a marked 'fog factor' and degrade most of the detail in the picture.

▲ A dreamlike scene taken in the early morning in Malta. A Cokin graduated filter gave the bright orange colour in the sky. The low position of the sun turned the trees to silhouettes. The exposure was 1/6 at f8. *David Morey* used a 24mm lens.

▶ One of the Pyramids in Egypt. The first shot was taken without a filter. The other two shots are the same scene taken through dichroic polarizing filters. *Julian Calder.*

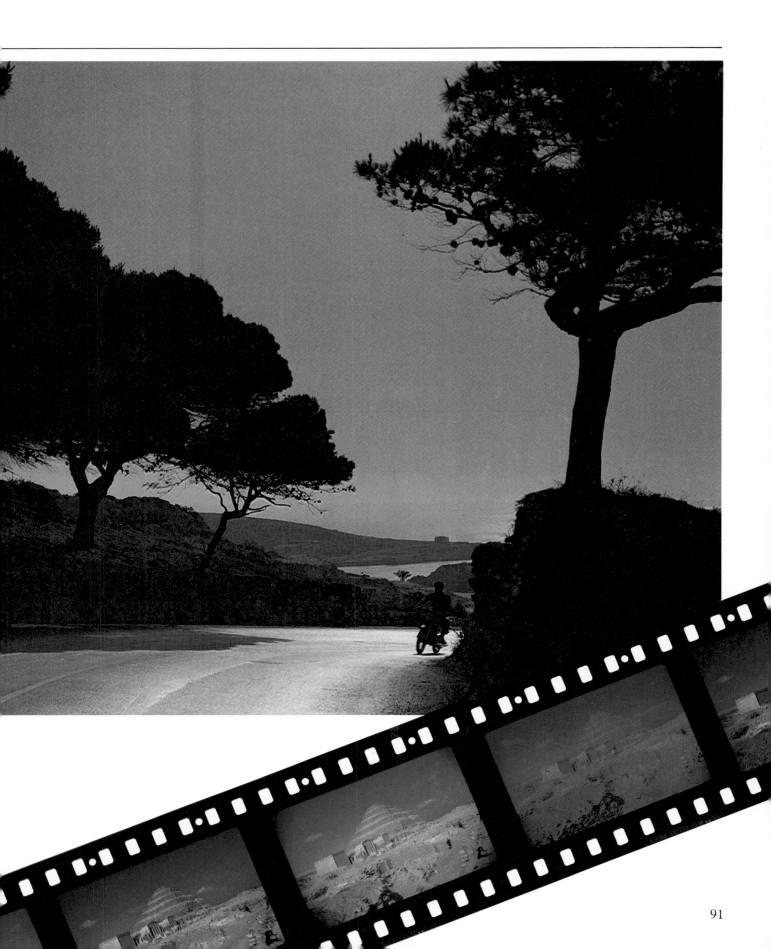

Multiple images

Prism filters make the image overlap in a series of repeated elements. As the sky in a landscape tends to be large, wherever it overlaps darker detail, the picture will show sky. So use prisms with care on landscapes with limited sky areas. Strongly silhouetted mountain skylines make good prism subjects. So do trees. **Radial prisms** give one central image surrounded by several slightly less-sharp images—three, four or five according to the design. **Linear prisms** give a main image at one side (or top or bottom) with a three, four, five or six secondary images stringing out from the main image like an echo.

Colour Polarization

Dichroic polarizing filters work like normal polarizing filters, but instead of just changing the brightness of polarized light, they change its colour. Various types are avilable (Chromostar, Color-Flow, Chromo Blend), and some are combined with diffracting or birefringent materials to create new effects. Typical results include coloured skies with different coloured clouds, coloured sparkle from water in a neutral scene, overall colour casts, and opposing colour separations. For example, with a red/blue colour polarizer, all non-polarized light may appear blue while all polarized lights record as red. To get the best out of these filters you need to experiment. They only work when polarized light is present (on sunny days, not overcast ones).

Split-field lenses

A split field attachment allows you to record both a near subject (for example a flower in the foreground) and a distant view in sharp focus. A split-field close-up lens has one half clear and the other half made from a close-up lens. With the lens focused on infinity, the top half can show a sharp distant view and the bottom half a sharp image at 30cm. Use a wide aperture to avoid sharp focus change between the two elements. Also as far as possible, place a division where there is a neutral part of the subject—such as plain green grass or plain sand—not a part with important detail.

Apart from using filters, there are other ways in which you can add your personal interpretation to a landscape. Using infra-red film produces unusual colours. You can hand-colour your prints, or use darkroom techniques like solarization or posterization. Experimentation is the best policy, the combinations are endless!

WHEN TO USE YOUR SPECIAL EFFECT FILTERS		
Subject problems	**Required result**	**Treatment**
View lacking colour	To add bright colour	Use pure colour filter, 'pop' filter, or pure colour polarizer
Small subject, poor surroundings	Loose surroundings, emphasize subject	Use centre spot, colour or centre focus
Telephone wires in picture spoiling sky	Lose wires, but keep tone correct	Use a graduated fog filter over the sky area
Sun in picture, causing flare	To convey sense of brightness	Use starburst, cross screen or colour burst
Boring foreground to distant view	To introduce a foreground subject very close to the camera	Use split field lens
No real impact or colour	To add bright colours	Use split-colour filter
Strong silhouette detail, but too simple or small for a good overall picture	Keep the bold silhouette outline but make a graphic pattern	Use prism filter
As above	Add colours	Combine prism filter with split colour filter

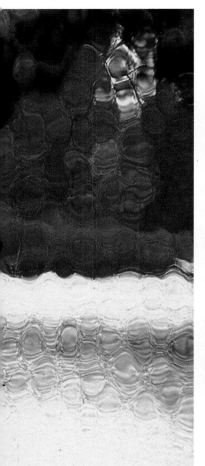

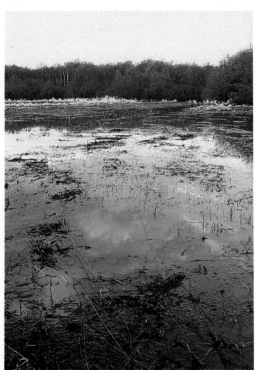

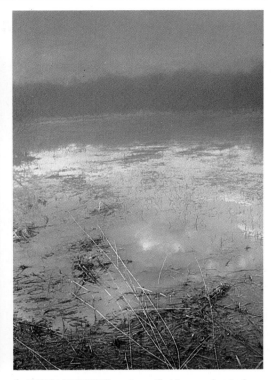

▲ **WITHOUT FILTER** — a straightforward landscape shot. This picture and the adjacent one are both successful pictures, but the subject has been interpreted in two different ways. *Jean Coquin*

▲ **WITH FILTERS** — two Cokin graduated filters, one fog and one pink, were used to alter the scene to create this effect. The foreground has been left relatively clear to contrast with the background.

▲ Originally this shot was taken as an ordinary landscape on Ektachrome 64, with a Vivitar 70-200mm lens set at 200mm. To get the impressionistic effect the picture was copied with a Bowens Illumitran copier. A piece of textured glass was placed between the copying film and the original slide when the exposure was made. *A J Bedding.*

▶ A prism filter with three faces was used for this unusual picture. Clear, prismatic filters are also available with three, four or five faces giving similar effects. The strange colours in the picture are from the type of slide film used — Kodak Infra Red Ektachrome — which gives false colours. Exposure was found by TTL metering through the prism filter. *S Kilpatrick*

How to photograph mountains

It makes no difference whether you are plotting an expedition up the nearest five-mile high mountain or ambling around more modest peaks. If you don't have a camera to capture the splendour of the scenery then you'll regret it. Mountains can be grassy, rocky or topped with snow and glaciers. Each type is so different that you could never run out of things to photograph.

The climber's kit

Dedicated mountaineers dice with death all the time. This means they must travel as light as possible. They often carry sturdy, compact 35mm cameras. But if your routes are less exacting you can afford to take a more versatile outfit.

Carry your SLR and team with it a wide-angle, standard and telephoto lenses, covering focal lengths from about 35mm to 135mm. This may mean you need only one lens—a mid-range zoom. However, take along some good close-up equipment as well. A 50mm lens and extension tubes means you can cope with anything from a tiny eidelweiss to the most splendid peak.

Many of the pictures you take will be in good light. This means that lenses with small maximum apertures like f4, 2x or 3x teleconverters and slow films can all be used yet you still get workable exposures.

The higher you climb the more blue and invisible ultra-violet light you need to cut out. It's a good idea to keep a skylight (1B) filter on the lens to reduce haze and improve colour pictures. For warming up very blue shadows use a 1.5x pink or amber filter. You will also find a polarizing filter invaluable to reduce reflections and glare. The way it darkens skies can create a vivid blue backdrop to white peaks.

Slow films up to about 64 ASA are particularly suitable for this specialized subject. Take lots with you and don't be frugal with it. You can't photograph

▶ **John Hannavy used a standard lens from the edge of Loch Achray as the sun set behind the peaks giving a calm, tranquil mood.**

▼ **Douglas Milner chose a high view (from a nearby rock) for this rocky crag. The far-off misty mountains add a sense of scale.**

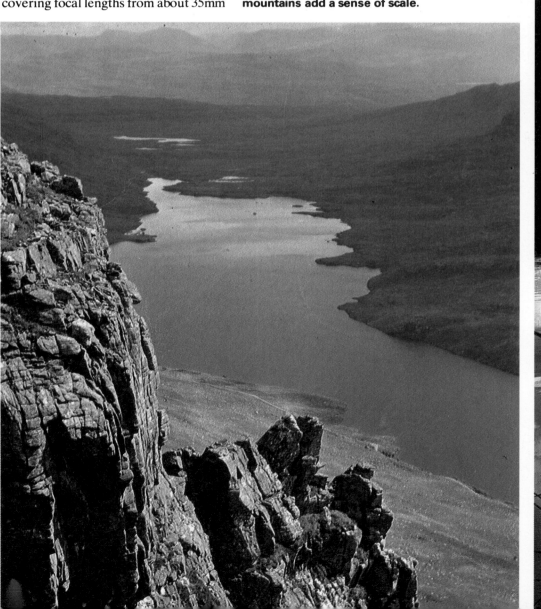

a memory, however glorious.

It gets rather windy on mountains so you may need to steady the camera. A full-size cumbersome tripod won't help you at all, but a table-top one might be useful. A better solution is to put your rucksack with its squashed contents on a rock. Rest the camera on top and, after you compose the shot, release the shutter with the delayed action timer.

Viewpoint

It's best to get out of a mountain valley to take many of your pictures, but not too far out. The best position to photograph a mountain is from halfway up another one nearby. You can take superb views from the summit, of course. But if you are not an expert climber and your legs won't carry you that far, you can always buy postcard views taken by the more daring.

Some elegant pinnacles in the Dolomites are vertical, but this is unusual. The average slope of the Matterhorn, for example, is about 45°. If you stand and point the camera up at this sort of slope, foreshortening badly distorts the grace and beauty of any mountain and makes the peaks look incredibly small and weak. The lower buttresses would more than likely hide the finer features. In the Alps particularly, the best views are from a 'shelf' walk just above the tree line. There you can include a few pines and valley meadows which contrast in colour and tone with the grim rocks and brilliant snows on the peaks. In Britain you can often take impressive pictures from a low viewpoint on the shore of a lake, especially in Scotland. Using a wide-angle lens would give a

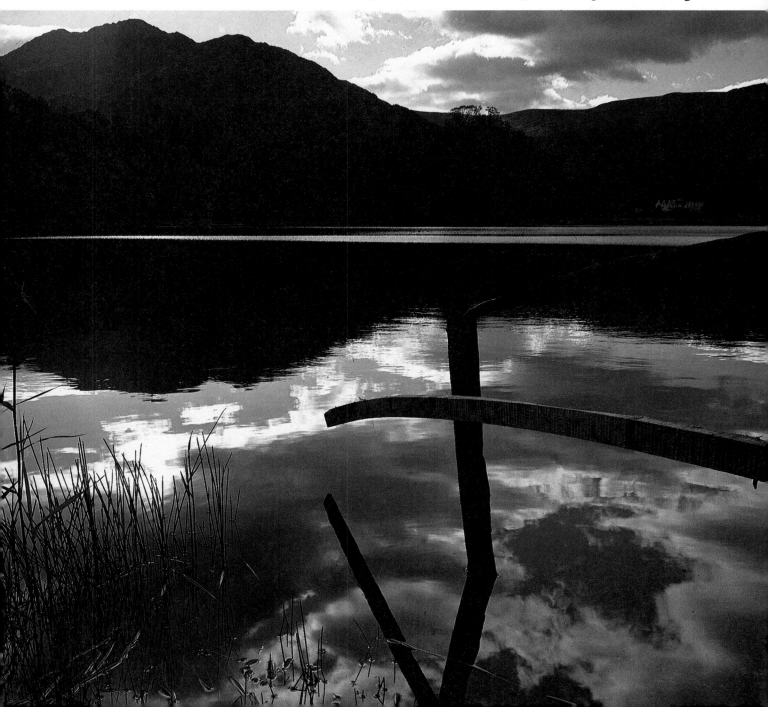

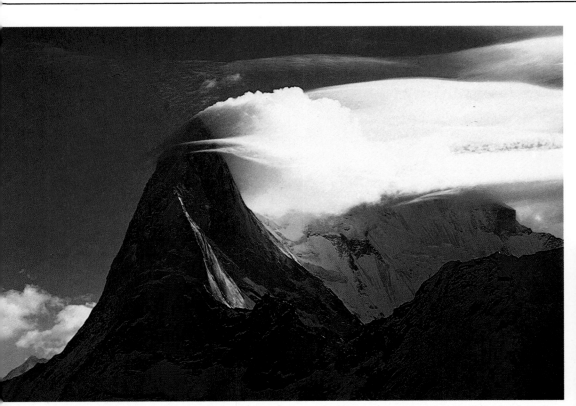

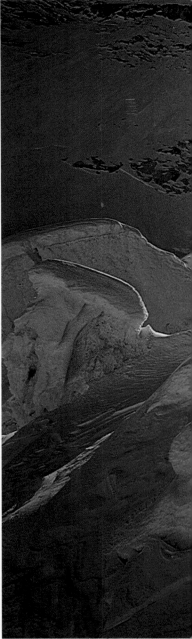

▼ An icefall on Everest is exhilarating to see after the event, but hardly something you'd want to be caught up in! Chris Bonington took this spectacular view with the sun shining down into his 28mm lens. A fairly small aperture, f11, produced the 'sunburst' and you can see the hexagonal shape of iris flare next to the sun. The blue-tinged shadows and the way the sun glances off the top of the ice give it an almost translucent quality.

▲ High peaks like this—Changabang in the Himalayas—often present lighting problems. Chris Bonington took this shot when the sun was low and to the right of the mountain. This means that some faces are picked out in bright white, but the side facing the camera is in shadow. The mountain's shape is emphasized simply. He used a 75–105mm zoom and exposed at 1/250 and f8.

▼ This is a typical Alpine ridge (Aig des Glaciers). The high sun to the left of the picture shows off the shapes and textures in the snow and rocks but the shadows are not so heavy that they distract the eye. Douglas Milner used a 100mm lens from farther along the ridge to slightly flatten perspective and to make the mountain look rather more imposing.

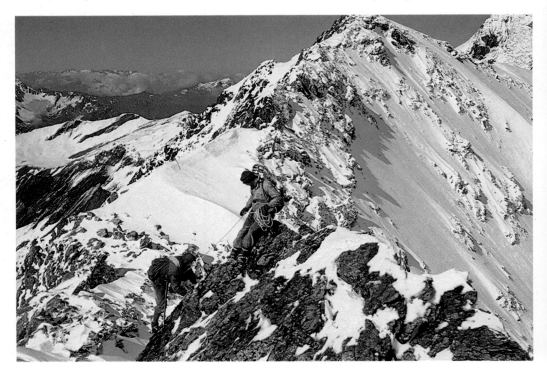

broad view of the area with the mountains in the background. If you use a telephoto lens try including something in the foreground—a tree about 20 feet away, for example. The flat perspective makes the mountain appear to rise steeper and look more overpowering.

Lighting

Mountains are nature's architecture, and, as with man-made buildings, the best type of lighting for them is the one that best reveals form and texture. Go for side lighting rather than head-on or dull, overcast light—unless you want the particular effects that they produce.

You can't ask a mountain to turn round to show its best side, so plan photographs to coincide with a suitable time of day. If the right lighting just happens to come in the early morning or late afternoon then you get the added bonus of rich, warm colour from the low sun. When the sun is high in the sky it produces a monotonous glare on snow-covered peaks. Although pictures come out bright and white they are by no means inspiring. The exception to this is a steep north face which is often the finest part of any huge mountain. The light it gets may be only a fleeting glance around noon—which would be the only

time to photograph it.

Some of your greatest successes may be when shooting into the light. Make sure that mountains in the background, and trees or rocks in the foreground, have interesting shapes because most will turn into silhouettes.

Don't confine your photography to clear weather. As a storm clears, the sun may gleam through a gap in the clouds and provide a moment of drama. Rather than a slick technique, there are three things you need to take good pictures of our splendid mountains: patience, persistence and an ever-ready camera.

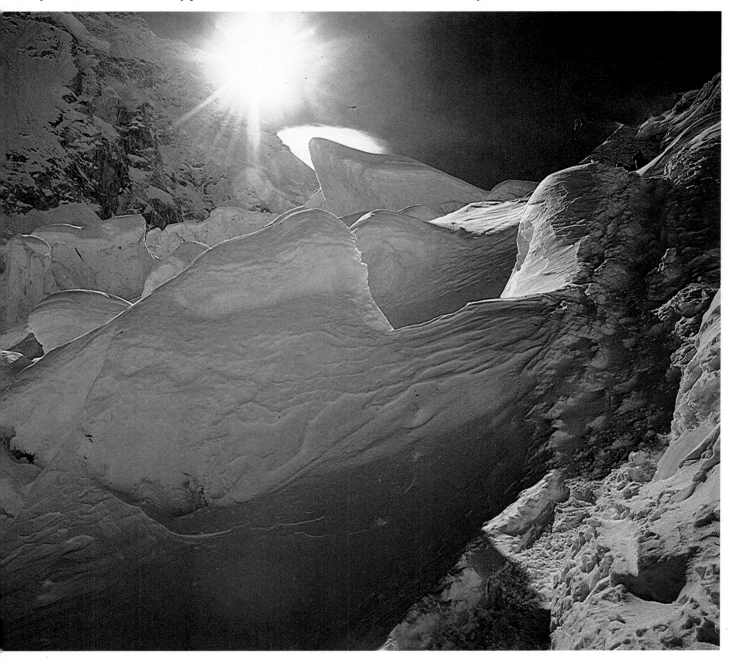

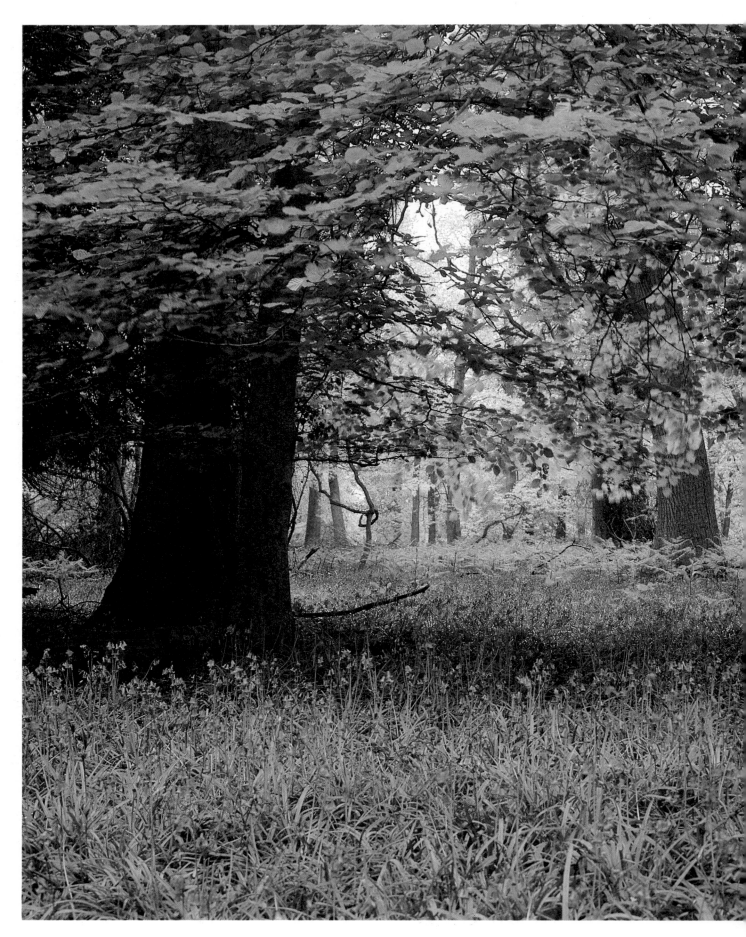

PHOTOGRAPHING FLOWERS AND TREES

Flowers can be photographed in countless ways. You can show a whole mass, an individual plant or concentrate on one feature such as a single bloom or even one petal. Similarly, trees can be portrayed as a forest, as a particular tree or a close-up of just one leaf.

This chapter explores the creative aspects of flower and tree photography, showing how to choose the best viewpoints and the appropriate camera-to-subject distances for the different shots. Lighting is particulary important. You will find that it varies through the seasons as well as during the day. Pictures and text help you to suit the lighting to the chosen subject for best results.

This an area where equipment counts. This chapter explains which lenses are suitable for the various purposes, especially for close-ups. Backgrounds, either natural or artificial, are essential to isolate flowers or portions of trees and emphasise their essential features. Choice and use of appropriate backgrounds can make the difference between an artistic photograph and a careless snap. Your aim should be to select, or provide, a background which enhances the main subject without distracting attention from it.

There are many "tricks of the trade" used by expert nature photographers which they have discovered through years of practice. This chapter reveals many of the most useful, giving you a short-cut to competent flower and tree photography and some striking pictures.

A 35mm lens was used to illustrate the carpet of bluebells flowering in May in a recently cleared area beneath beech and oak trees in the Forest of Dean.

Photographing flowers

Choose an expanse of flowers—it might be in a wood, a field or a flowerbed. Walk towards it slowly and watch carefully.

At first there is a blur of colour against sky, ground or foliage. Next, individual blooms become apparent, followed by the texture, tones and translucent qualities of each one. Go even closer and each flower will turn into a fantasy of light, colour and form.

This simple exercise will help you to decide how much detail should be recorded in a picture—a decision that will determine camera to subject distance, and what equipment and lighting to use.

Flowers in a mass

Photographing a mass of flowers is possibly the easiest way to tackle the subject, but care must be taken that the blooms are not visually swamped by their en-

vironment. Human perception is selective. It can concentrate on a small object to the exclusion of backgrounds and foregrounds, so make certain that the viewfinder is filled with flowers.

Virtually any lens from a 500mm to a 21mm is suited to some aspect of photographing large numbers of flowers.

Long lenses exaggerate the number of plants in an area because they appear to compress distance and make those farthest away look closer.

Lenses of 35mm or less can also be used to exaggerate the number of plants. These lenses have a wider angle of view than the eye, and must be used close to the plants if the frame is to be filled. The effect will be to exaggerate the distance of the farthest flowers and so suggest that the plants cover a larger area than they do. But be careful that some flowers are not so close to the lens that they are distorted.

One, two at a time

Always use a tripod when taking pictures of flowers close-up. Wind is the usual problem with this subject. It is a waste of time to wait for it to drop, the plant to fall still, and the photographer to ruin the shot with camera shake. Tripods are especially important with longer lenses of 85mm or more.

An unobtrusive background is essential to the photography of single flowers. The picture must concentrate on shape, markings and particular structure—for example, how petals overlap to form the flower. Distracting foreground elements, such as twigs or grass, should also be carefully moved or thrown right out of focus.

A simple, unobtrusive background is a sheet of plain coloured card, paper or cloth. Choose a colour that contrasts with the flower. Dark red and orange petals show up well against green. Blue

▲ A long lens and a small aperture captures the huge number of these Dutch tulips. The lens makes the crowded beds look closer, while the aperture gives enough depth of field to keep individual plants in focus. Accurate exposure on Kodachrome 25 ASA film has given good colour saturation. *Tsuni Okuda*

▶ *Valerie Conway* focused a long lens on a clump of flowers in a meadow, and used a wide aperture for an out-of-focus background. Again the picture suggests that the flowers cover a large area. In fact there is no clue to how many there actually are.

flowers look well against yellow, and vice versa. Light flowers generally look best against a dark background. Some photographers like to use the available green background or to paint a mottled effect on a card to imitate an uneven natural environment.

An artificial background can be leant against a studio wall. In the field, it can be held in position with two canes stuck in the ground behind it. A large sheet can also be curved round to shield the subject from the wind.

If the background is put out of focus, distractions become blurred and the flower's environment will look natural. This is called differential focusing. It is achieved by focusing on the flower (or part of it) and using a large aperture, say f4. Watch out for bright patches that may be made more prominent by being out of focus.

Depth of field is restricted further by using a telephoto or a zoom lens (say 85-210mm), a tele-converter, close-up lenses or extension tubes or bellows. A wide angle lens should not normally be used for single flowers: it will distort and its depth of field is too great. For more on close-ups see p174.

▲ A card of a suitably contrasting colour to the flower can be set up as an artificial background. The same device also acts as a wind shield.

◀ The light shines across the Coronation Gold blooms picking out their texture. It also shines towards the camera leaving the green background in shadow. A correct exposure for the flowers makes their bright yellow shapes stand out against the under-exposed, out-of-focus background. Unobtrusive backgrounds are essential if the outlines of individual flowers are to be shown clearly. *Brian Wood*

◀ The water lily's flower is a few centimetres above its leaves. The distance is enough to put the leaves out of focus. The soft, diffused light provides plenty of petal detail. *Timothy Beddow.*

▶ Both foreground and background have been put out of focus. Backlighting has caused a little flare but it has also picked out texture in the poppy petals. Take the exposure reading from a backlit flower by holding the camera or meter right up to it. Two or three centimetres from the flower should not be too close. *Ekhart Van Houten.*

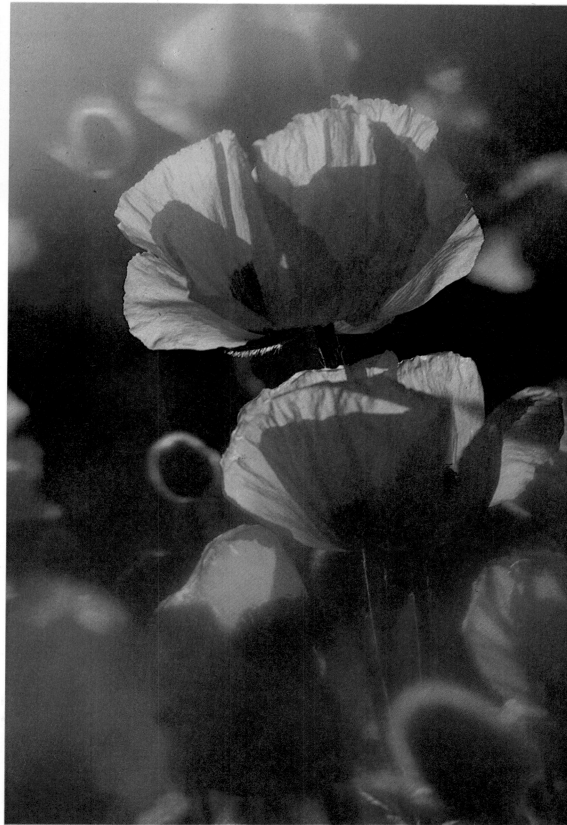

Lighting

Different qualities of flowers are brought out by different lighting conditions.

Side lighting shows texture. It will also show detail of form, colour and markings. In the field, the photograph can be taken with the sun to one side of the camera. Ideally this should be within one and three hours before or after midday to avoid direct overhead light and the strong colour casts of morning and evening light. If there are any dark shadows they can be filled in with light reflected from a white handkerchief, card or 'bounce board'.

In the studio, the light or flash gun can be positioned to one side. Some fill-in should be provided by placing the flower near a white card.

Back lighting, with the source shining through the petals from behind, will show the flower's translucency and delicacy. Take an exposure reading by holding the meter or camera (if it has a TTL system) as close as possible to the flower. Two or three centimetres may not be too close. Take close-up readings in the same way if bright sunlight is reflected strongly from the ground or surrounding foliage.

Diffused light provides pictures with soft graduated tones and hues which make flowers easy to identify and study. This kind of light occurs when the sun is hazy or hidden by light cloud.

Tips for experts

It is difficult to record the true blue colour of flowers such as gentians. Indeed, most blue flowers tend to photograph as a pinkish shade. This is because flowers reflect infrared strongly, to keep themselves cool, and the film records some of this radiation as red. So don't blame yourself if this happens! Usually colour negative film can give a better blue with flowers than colour slide material.

When photographing subjects such as the seeds on a dandelion, which tend to blow away easily, a squirt from a hairspray keeps them in place. To keep bees or butterflies in place on a blossom, put a tiny drop of honey on the anthers of the flower on which you have focused. The butterfly will soon find this and then stay several minutes while you take the picture.

Check list

A 35mm SLR camera is well suited to flower photography. Choose a macro lens or a set of extension tubes or bellows. If you have to settle for a single lens, a 100 or 135mm is a sensible choice.

Your tripod must work at low level. The ideal film is colour slide material but shoot on negative film if you prefer. Choose a sharp, fine grain, slow film (25 ASA) to show maximum detail. If it is windy then a shutter speed of 1/125 or faster may have to be used, which may mean choosing a 64 or 100 ASA film.

● Take notes to identify plants when the film is processed.

● Write the flower's name, and where and when it was photographed, on the slide mount or on a label stuck to the back of the print. It will help your enjoyment of flower photography.

● Use a small vase in the studio to hold flowers steady.

● Consider splashing or spraying water on flowers: it may enhance their textures and add a little sparkle.

● Do not, under any circumstances, cut or dig up wild flowers for photography. Even the most common varieties need protection.

● Read *The Nature Photographers' Code of Practice* on p234-5.

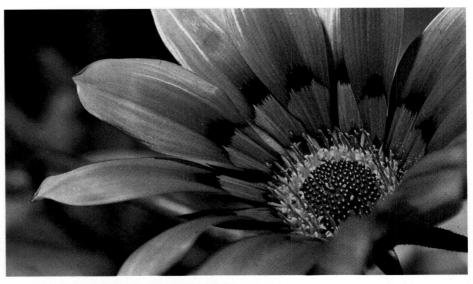

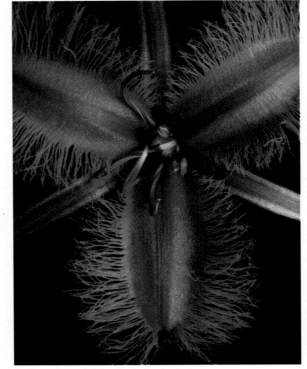

▲ Either a macro lens, extension tubes or bellows are needed to show flower details in close up. The actual size of this Gazania is about 7cm in diameter. *Helmut Gritscher.*

◄ *Eric Crichton* used a macro lens and an extension tube to photograph this Fringed Lily, which is about 3cm in diameter. It was lit by an electronic flash bounced off a card. The flower is on a long stem which made it easy to stop the flash lighting the background.

► Dandelion head taken with a macro lens. Most standard lenses with macro focusing will reproduce a subject at half life size on the film. Greater magnifications require an extension between camera and lens. *E A Janes*

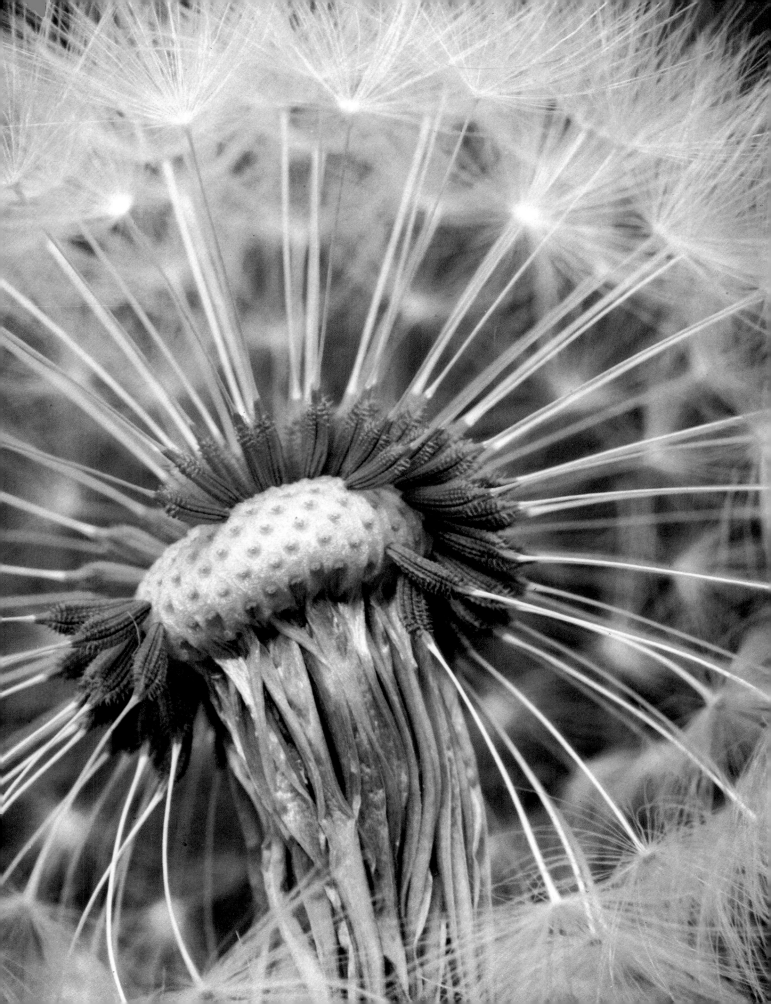

Photographing trees

Every tree is individual. Each tree is made of individual parts—trunk, bark, roots, leaves, fruit and flowers. And each part consists of unique individuals—no two leaves, for example, are ever exactly the same.

A tree changes with the seasons but each part changes at its own pace. The appearance of the tree changes with changes in the weather, from storms to bright sunny days. And finally, the tree looks different as the light changes in colour, quality and direction.

Stand close to a tree: every part is visible yet you can't see the tree as a whole. Walk away from it and the parts merge their identities into the whole plant.

Now look at the tree in its landscape or wood. As the individual tree changes so does the landscape in which it grows. Every one of these different aspects of trees represents an opportunity for photography. There are almost as many ways to photograph a tree as to photograph a person.

Trunks and bark

Tree trunks can vary in diameter from several metres to a few centimetres. A standard lens is suitable for photographing a trunk, but take care with focusing. Depth of field extends twice as far behind the point of focus as it does in front of it. So, focus about one third of the way from the front to the centre of the tree. Stop the lens well down and the whole of the trunk will be in focus. A tripod is often necessary because of the low light levels in woods and under branches. Trees with low branches will let very little light through in the summer. Deciduous tree trunks are more easily photographed in the winter, after the leaves have fallen.

If the camera is used for vertical shots then the trunk can be made to fill the frame. A horizontal format will usually mean showing some background each side of the trunk. Vary the trunk's position from frame to frame; don't always put it in the centre.

Tree trunks with interesting shapes can also be photographed in silhouette.

Choose a brightly lit background or photograph the tree against the sky. In either case, take a reading from the bright background to make sure the trunk is under-exposed.

Bark is also a subject that often requires a tripod for the camera. Go right in close to it, perhaps using a macro or close-up lens. Depth of field is smaller at close distances, and the curve of the bark makes focusing problems worse. This means stopping down for depth of field, which means longer exposures.

In close up, an older tree trunk will curve less than a sapling.

Bark may have a bold pattern or a strong texture, or it may be almost completely smooth. Photograph pattern

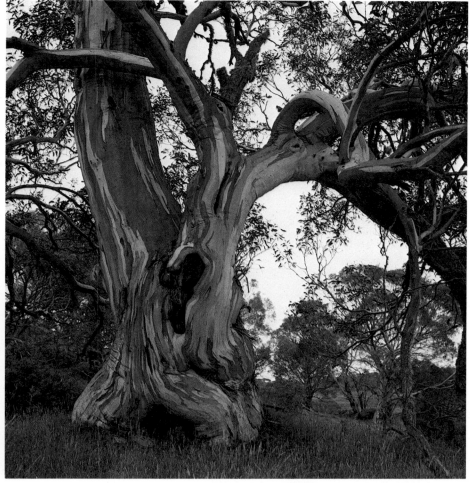

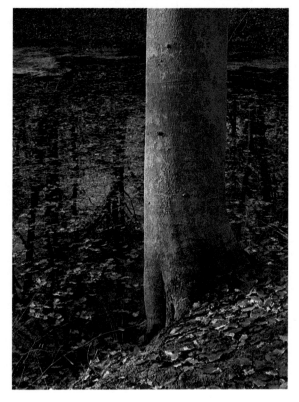

▲ The colours of the snow gum's bark appear equally intense because they are evenly lit by the overcast sky. There are no strong highlights or shadows so the pattern shows clearly. Shoot heavily textured bark in a directional light which comes from one side. *Heather Angel*

◀ Trees are always changing. An approaching evening storm gives the tree an appearance that may last only moments. A shutter speed of 1/60 adds blur to a few branches. Use a tripod and a slower speed in heavy winds to make all the branches blur. The trunk and background will stay sharp. *Anne Conway*

▶ Sidelighting shows the form of the beech. Focus slightly into a large trunk and stop down to get it all sharp. *Michael Busselle*

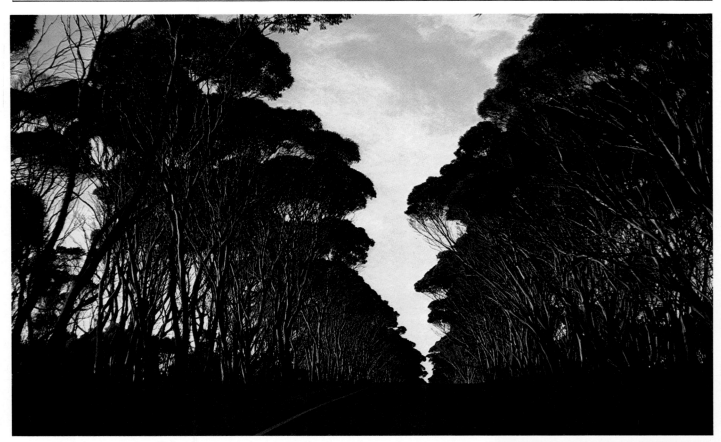

in an even, shadowless light. Smooth bark needs directional light from about 45° to provide a highlight. Texture needs to be cross lit. This kind of light occurs early in the morning or late in the day. Strongly textured bark photographs well in black and white.

Often you can get the lighting you want just by moving round the trunk.

Leaves and roots

Leaves are the most changeable part of a tree. With deciduous trees, they change with the seasons, from the pure, bright greens of spring to the rich browns and reds of autumn. Not only do their colours vary widely with the seasons, but they also change according to the angle of light.

Young, fresh leaves are a lighter colour and more translucent than mature leaves, and look their best when backlit. New leaves are also less likely to be insect damaged.

Look through leaves against a bright but indirect light and they will appear differently according to their age. Older leaves are more likely to appear in silhouette.

Colours are more intense where leaves overlap and one casts a shadow on

another. During the spring and summer this effect appears as shades of green. It increases the number of colours in the autumn because the leaves will be various hues.

Take an exposure reading off the shaded side of the leaves when photographing them against the light. If you don't do this they will appear in silhouette.

A tree may be at the height of its autumn colours for only a few days. The warm colours of the dying leaves can be exaggerated by photographing late in the day or by using a 5CC yellow or amber filter.

Thick, shiny leaves should not be photographed in bright, direct sunlight. They will have strong highlights which may spoil the picture. Either diffuse the light (pin tracing paper to a nearby branch) or wait until the light is naturally more diffused (when the sun is behind clouds). A polarizing filter can be used to control the highlights.

Tree roots are exposed occasionally by erosion or if the tree is uprooted. Exposed roots of a growing tree can spread over a large area. Photograph them in cross lighting with a wide angle lens.

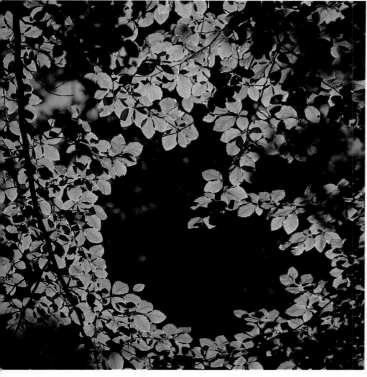

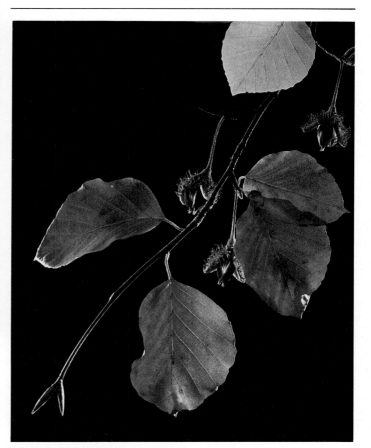

◄ *Steve Dicks* exposed the trunk highlights correctly. This turned the mature leaves into a silhouette. Evergreen or old foliage usually needs to be front lit to show its colour.

▲ Take exposure readings from the shaded side of backlit young leaves to photograph the hues made by the way they overlap. Take highlight readings to shoot silhouettes. *Heather Angel.*

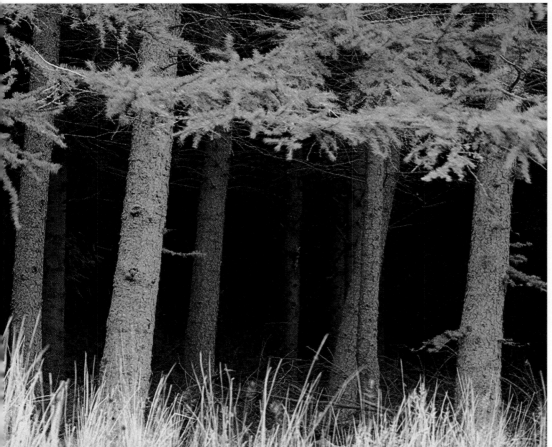

▲ Flash is used to record maximum detail for a scientific record because each gun can be precisely positioned. Two units were used to light this fruiting beech. Do not break off specimens for a studio session, or tie back branches to improve lighting, unless it is clear that no damage will be caused. *Heather Angel*

◄ Woods are dark and awkward places to photograph. Look for trees at the forest edge or in clearings. Wait until some trees have been cut out before trying to take pictures inside an evergreen plantation like this. Deciduous woods are brightest once their leaves have fallen. *Michael Bussell.*

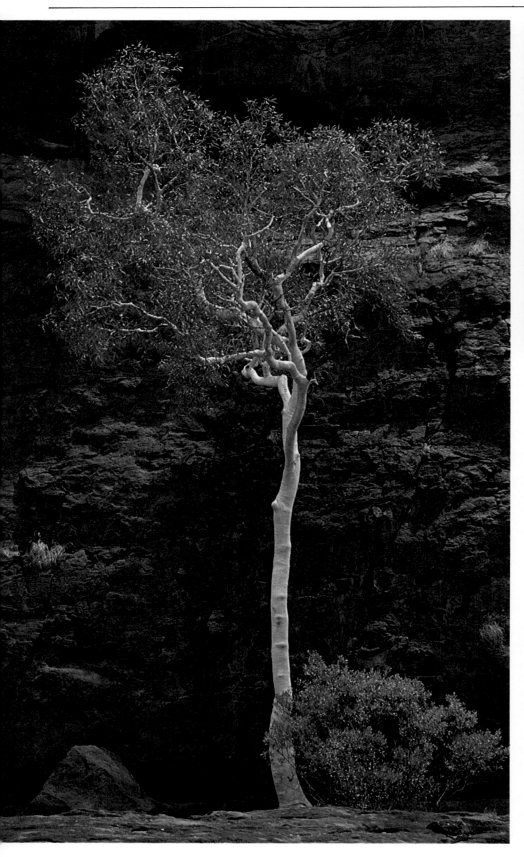

▲ Tree trunks appear to meet if the camera is pointed up at an acute angle. *P Goycolea* exaggerated the effect with an ultra wide angle lens.

◄ The noon sun puts few shadows into this ghost gum but the dark background shows up the bright tree. *Eric Crichton*

The whole tree

Trees can be found in city streets, planted in gardens, growing in lines in plantations, in the woods or in open countryside.

Wild trees in the open countryside can make more relaxing pictures than trees in lines or in streets.

It is easier to photograph a tree standing on its own than one in a wood. A free-standing tree can be approached from any direction. It will also be lit from various directions by the sun without being in the shadow of other trees.

Trees in woods are more difficult to photograph. Other trees will block the view as well as the light. Look for trees near clearings or at the edges of woods. If a wood is being coppiced or cleared then good specimens will almost certainly be exposed.

The appearance of a tree will vary according to the light. This in turn varies according to the season and time of day. Early morning and late evening are the best times to photograph a tree in silhouette. The low sun should not be allowed to shine into the lens. Shade it behind a branch or the trunk and

always use a lens hood.

Mid-morning and early afternoon sunshine will probably give the best modelling to a large tree. Midday sun in the summer is likely to be the worst light in which to photograph a tree. There will be little modelling, and great contrast between the highlights in the crown and shadows around the trunk.

If a series of pictures is taken of one tree, vary its position in the frame. This applies whether the series is taken from several viewpoints at the same time or the same viewpoint at different times of the day or year.

When pointing a camera up at a tree, an extreme angle will exaggerate perspective in the same way as does looking up at tall buildings. The exaggeration may not be noticed with one tree. If there is more than one, their trunks may appear to lean dramatically towards one another.

There are several ways of dealing with this problem. First, use a perspective control (PC) lens. A PC lens has a movable front which raises or lowers the image in the viewfinder. This means a whole tree can be included in the viewfinder without having to tilt the camera. Second, move back but include an interesting foreground.

Photographing autumn leaves

Most pictures of autumn leaves show several colours, some residual green, and a whole range of tints through yellows to russet reds. Maples particularly turn a brilliant hue. Try arranging your composition so that the sunlight strikes the outer branches only to create a pattern. The time for such pictures is after a hard frost, before strong winds blow the leaves from the trees, and when the sun shines to make the colours flow. The red light of sunset emphasizes such effects but do not wait until then—capture such scenes as you see them. Take a view of an autumnal forest from a hill. We are so used to looking slightly up at trees that we forget how effective such views can be.

MAKE A RECORD OF THE CHANGING SEASONS

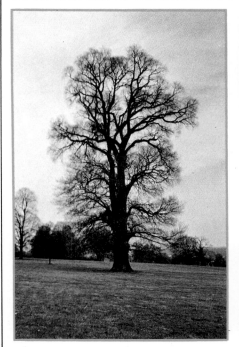

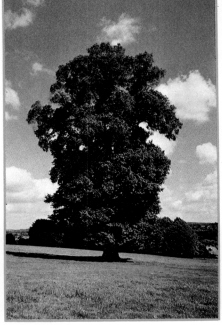

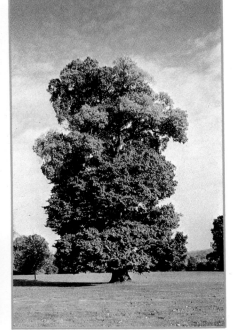

SPRING
Deciduous trees change dramatically during the year. Documenting these changes is an interesting exercise. Start with the spring. Pick a tree that you can easily return to, and make a note of the time of day at which you take this first shot.

SUMMER
The change between spring and summer is considerable. The skeleton is now clothed and the fresh green of new shoots has given way to the denser colours of mature growth. Take each picture at the same time of day using the same viewpoint.

AUTUMN
It is worth taking several pictures in autumn as significant changes can take place in just a few days. After a windy day, for instance, you might return to find the grass below carpeted in golden brown from fallen leaves. *Heather Angel*

Checklist

● Any format camera is suited to photographing trees. A 35mm camera may be easier to carry cross country.

● There is no particular advantage to using an automatic camera. Much better to take plenty of time.

● Always use a tripod and choose slow films to record maximum detail.

● Textures and shapes (especially in silhouette) can be as interesting in black and white as in colour.

● Branches can be tied back with ropes. They can be pulled into the light or away from the trunk to let light in, but, be careful not to damage the tree.

● Read *The Nature Photographers' Code of Practice* on pages 234-5.

▼ The rowan or mountain ash is among the most attractive trees, especially when it bears its wholesome red berries in the Autumn. The direction of the prevailing wind can often be judged by the shape of trees in exposed places. Low level side lighting brings the picture to life and the warm hue of the sun enhances the russet tints of the dying bracken. A low viewpoint brings the tree above the horizon and includes the small area of blue sky to emphasize the warm tones in the rest of the photograph. A fairly long focal length of lens helps to minimise the foreground and direct more attention to the tree—the real subject of *Heather Angel's* photograph.

▶ The intricate tracery of branch, twig and leaf shows well in silhouette. In such photographs exposure is best based on the sky with no attempt to show detail in the dark parts such as the tree or the strip of dark base which prevents the composition from being top-heavy. The most impressive skies tend to be found in spring and autumn. *Eric Hayman* took this shot during autumn in New Zealand, in the late afternoon when light still lingered. The broad band of blue makes a lively diagonal across the picture, echoing the shape of the tops of the distant trees whose foliage forms a fringe to soften the hard horizontal lines at the bottom of the photograph.

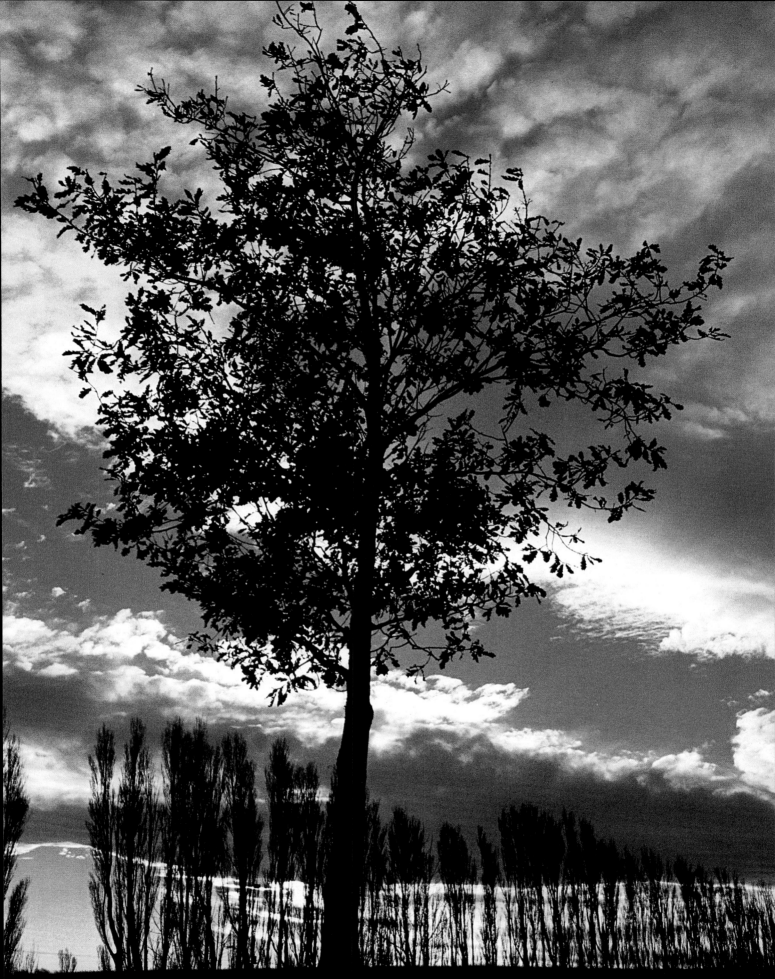

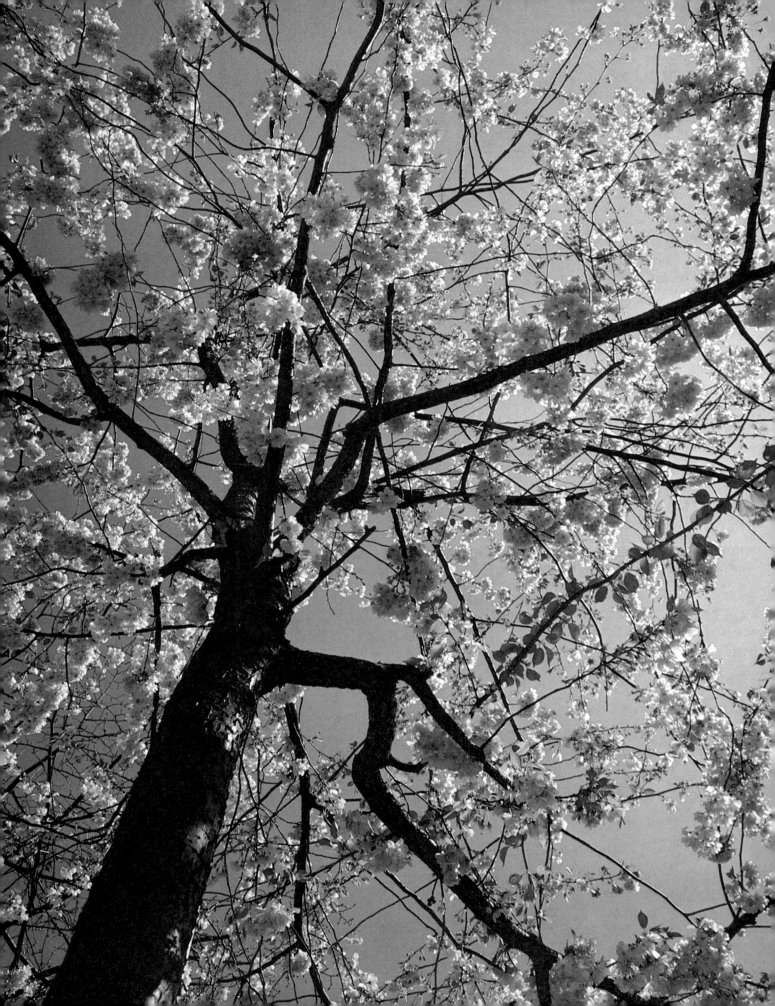

◄ Cut out any unwanted surroundings by shooting upwards at flowering fruit trees laden with blossom. A polarizing filter will make the sky appear a deeper blue and increase the strong colour contrast. *Sergio Dorantes*

► For a closer composition select a cluster of blooms and then find a camera angle that gives a suitably plain background as well as providing interesting lighting. The toplight here makes the petals seem translucent. *Mike Yamashita*

▼ The lighting in this beech copse is very contrasty. It is essential to give enough exposure to record detail in the shadows but not so much that the bright highlights burn out. One method is to measure shadows and highlights separately, then take an average.

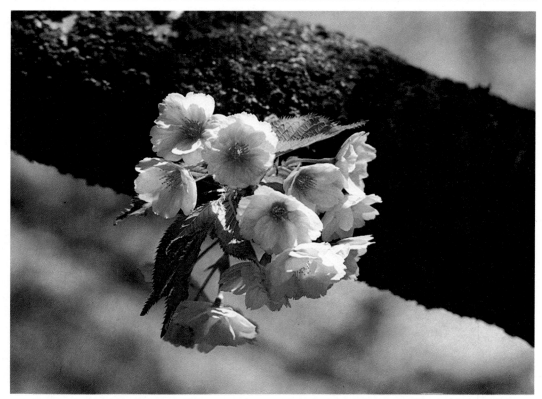

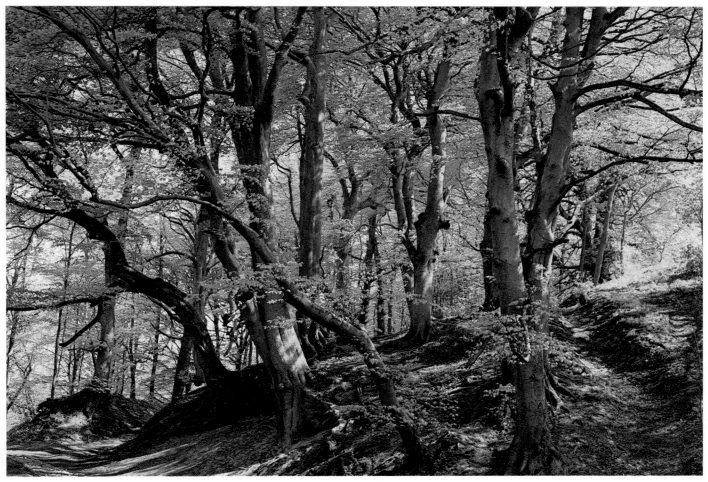

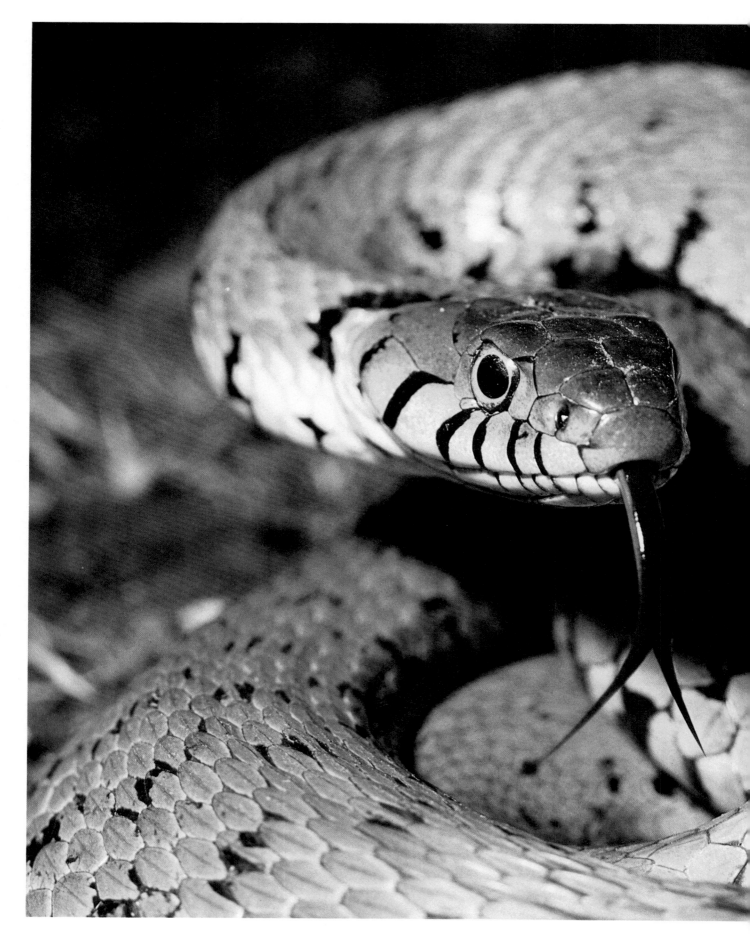

PHOTOGRAPHING THE WORLD OF ANIMALS

Animals are a lively and important part of the natural world but, being mobile and often shy of humans, can present more of a photographic challenge than plants, trees or landscapes. You must know where to find your animal and be in the right place at the right time—with the correct equipment.

This chapter begins by discussing equipment and in particular the long-focus lenses needed for the subject and the remote shutter releases which are valuable optional accessories.

Each kind of animal has its own habitat and its characteristic behaviour pattern with which you should be familiar in order to produce first-class pictures. For convenience, animals are divided into various categories beginning with domestic animals, cats and dogs, farmyard animals and horses and progressing to wild animals in captivity and animals with their young. Each needs a different approach and technique, which is described in detail.

Unusual circumstances require special skills so guidance is provided for more specialised cases such as photographing animals at night and on safari. You can take exciting photographs of fish in aquaria if you get the lighting and background right.

A single electronic flash was used to freeze the movement of the flicking tongue of a grass snake *(Natrix natrix)*.

Equipment for animal photography

Taking outstanding pictures of wild animals is mostly a matter of opportunity, being in the right place at the right time with the right equipment. Of course, you have to increase your chances by knowing where the animals are likely to be found and having endless patience. Try to be ready for the unexpected and keep the camera ready to shoot. Choose a versatile camera and accessories that enhance its versatility. Fixed lens cameras are frustrating: 110 types simply do not give sufficient quality, and while compact 35mm types are better in this respect, the wide angle of the non-interchangeable lens gives too small an image since animal pictures are often taken from a distance. Professionals often prefer 6x6cm cameras as the larger format provides better quality than 35mm. However for wildlife and animal photography you generally need long lenses. For 6x6cm these are very bulky, and so expensive that few amateurs could afford them. A manual exposure 35mm SLR is fine. But if you find it difficult to adjust the exposure controls quickly enough to get good pictures before an animal runs away, you may do better with an automatic camera. These quickly and automatically get the exposure right. You can then concentrate on focusing and composition.

Special points to look for Some cameras accept *interchangeable focusing screens*. You could then fit a plain screen when using telephoto lenses. This is easier to use than a screen with a split image and/or microprisms which often black out with long focal length lenses. You may well find it preferable to choose a camera which takes a *motor drive* or an *auto-winder*. You can use them to take sequences. But they are also the best way to take pictures when the photographer wants to be a long way away from the camera. You need to use a *remote release* (either a long air release or an electronic mechanism) too. With an automatic exposure camera fitted with a motor drive and a remote release, you can expose an entire film without going anywhere near the camera. If you can also use a wide angle this overcomes focusing problems because it gives extensive depth of field.

Lenses

For sharp, clear, detailed pictures you should buy the best lens you can afford. If you are trying to decide on the *one* most useful lens to start with, you could do worse than to buy a telephoto zoom

▲ Ian Beames has foxes which come into his garden, where he took this picture. So he can photograph them, Ian occasionally leaves food out. For this shot he used three flash guns, two to light the fox and one for the background. The camera was a Mamiya RB67 with a 180mm lens and Agfachrome CT18 film.

lens. Assuming you already have a 50mm standard lens, an 80–200mm zoom will make a good team-mate for it. The 80mm focal length is best for portraits of large tame animals. More timid beasts will fill the frame from a fair distance if you use the 200mm focal length setting. That still leaves all the in-between focal lengths for careful cropping of many different sized animals within the frame.

If you can afford more lenses, however a combination of a 80–200mm zoom, a 28mm wide-angle, a 300mm telephoto and a 2x tele converter will let you cover an enormous range of animals and distances. The 28mm (moderate wide angle) focal length shows animals in their surroundings and you can use the longer focal lengths on the zoom for character studies. The 300mm pulls you close to far-off creatures. For dangerous, shy or very small animals you can use the 300mm and 2x converter which gives the same magnification as a 600mm long telephoto.

When choosing a lens for animal photography bear a few points in mind:
1) It is often inconvenient to use a tripod so you'll need fast shutter speeds to prevent camera shake. A lens with as wide a maximum aperture as possible will make these fast shutter speeds more readily available. But most telephotos have only moderate maximum apertures like f3·5 or even f5·6. Buy the widest (fastest) maximum aperture you can afford.
2) When you're stalking animals you hardly want to sink into mud, weighted down by equipment, or fall over a huge long lens. Choose lenses which are as light and compact as possible.
3) Speed is important, so you don't want to waste too much time in focusing. For zoom lenses, those with zooming and focusing controlled by the same ring or collar on the lens ('one-touch') are quicker to use than twin-ring zooms.

▶ The bare minimum to take with you for photographing animals. You can see a 35mm SLR, an 80–200mm zoom, a 2x teleconverter, a UV filter, and both medium speed and fast film. Your 50mm standard lens might also come in handy for photographing animals in their surroundings.

▼ If you are planning on spending a whole day out photographing animals you can take more equipment. This picture shows a possible outfit: a 35mm SLR, 80–200mm zoom, 300mm lens, 28mm lens, 2x teleconverter, motordrive, UV filter, ND (neutral density) filter, polarizing filter, tripod, bean bag, cable release, two flash units with a slave, camera raincoat, medium speed and fast films, lens cleaning kit, a good book, lunch, and a fold-up stool to sit on while you wait for the animals to appear!

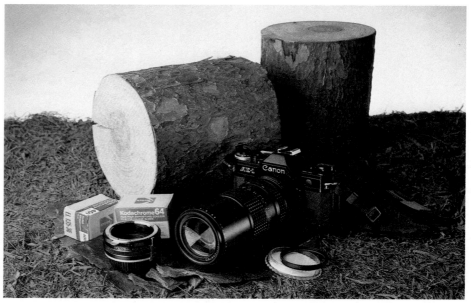

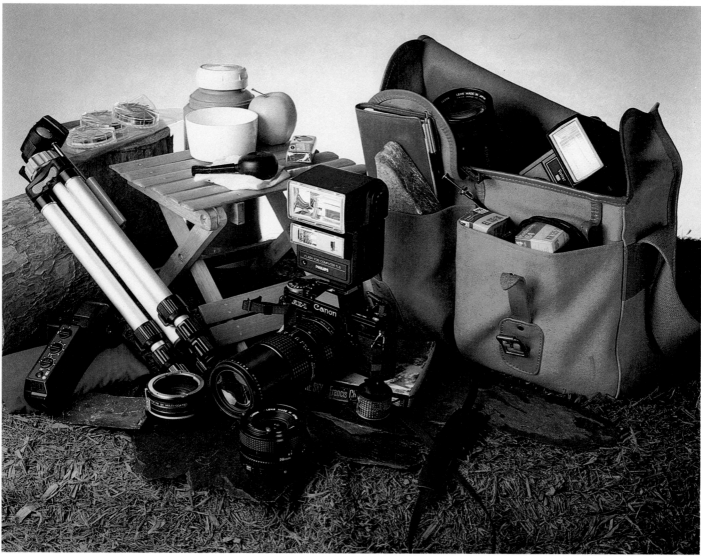

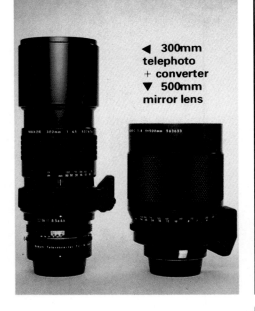

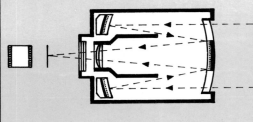

◄ 300mm
telephoto
+ converter
▼ 500mm
mirror lens

MIRROR LENS

LONG FOCUS LENS

◄ In a mirror lens, the light path is folded into three, so the lens can be made much shorter than a long focus lens of the same focal length.

LENS CHOICE

TELEPHOTO The natural choice, when you need a long lens for photographing animals, is to buy a telephoto. The telephoto uses a special design which makes it shorter than a long focus lens of the same focal length. A 300mm is a good choice. You can get extra focal length by adding a teleconverter, but this also cuts down the light. A 2x converter loses two stops of light, so a 300mm f4 lens would become in effect a 600mm f8. A teleconverter also reduces the optical quality of the image. However, the combination of a telephoto and converter is often smaller and lighter than a telephoto of the same focal length—and it is much cheaper.
▶ Graeme Harris used a 300mm lens with a 1.4x teleconverter (as shown above) for an effective 420mm focal length shot of deer in Richmond Park.

MIRROR LENS By using mirrors to fold the light path inside the lens, a mirror lens can be made up to a third of the length of a long focus lens of the same focal length. Mirror lenses are even shorter than telephotos, but they are fatter and can be heavy. As the weight is more concentrated, they can be easier to hold and handle than telephotos. Mirror lenses usually have a fixed aperture—about f8 for a 500mm lens. The reflecting mirror in the centre of the lens causes out-of-focus highlights to have a dough-nut shape.
▶ Graeme Harris took this shot using a 500mm f8 mirror lens (shown above) from the same position as for the telephoto. The mirror lens is slightly longer than the telephoto plus 1.4x converter, and makes the deer look a bit closer. You can see the dough-nut rings in the out-of-focus background.

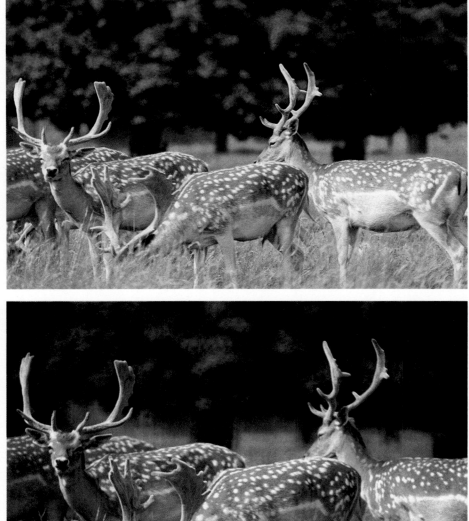

Some fixed focal length lenses have *internal focusing*.

Camera supports

With constantly-moving animals you'll find a tripod is a hindrance except on flat ground—at a zoo for example. A *monopod* is more convenient to use on rough ground to steady the camera. If you think you don't want to bother, think again! Camera shake shows up quickly with telephoto lenses. You can rest the camera on a bean bag or a rolled-up towel which you sit on a wall, branch or car roof. It slips into a bag between shots. Use a cable release to prevent blurred photographs.

Lighting

Most of the time use available light: it gives a natural effect. Besides, for all but docile and captive animals, artificial lighting may cause alarm.

Carry a small electronic flash with you,

▼ **Bruce Coleman photographed these otters in sunlight, which attractively highlights the water on their bodies. He used a Nikon FE with 105mm lens, and Kodachrome 25.**

however. You can use it to 'fill in' shadows or to light small, enclosed spaces. A flash is virtually useless in wide open areas.

In the studio, flash is much better than tungsten lighting. It's a cool light source and therefore won't make creatures feel uncomfortably hot. Set up the lights to give a natural effect. Flash heads with modelling lamps make this easier because you can judge the effect before you take the pictures.

Indoors, make the set look as natural as you can. Collect pieces of bark, dead leaves, moss, or whatever is appropriate to the subject. Let the animal get used to its new (temporary) home before you begin a photo session.

Film

Generally, medium speed films are the best choice because they give a wide range of exposure choices. They also have fairly fine grain which you need if you want to show plenty of detail.

In bright light you can often make the most of slow, fine grain films. Use them to show up finest details and subtle textures. Slow films are also best if you want to make big enlargements.

When you are using long telephotos with small maximum apertures, however, you may have no choice but to use fast film. If you don't and the weather isn't very bright, you will find that the shutter speeds you need will drop below 'safe' speeds for hand holding without camera shake. Fast films are almost essential for moody dusk shots and when taking pictures in shady groves. They also guarantee fast shutter speeds to freeze action.

Packing extras

On days out who knows what conditions you will encounter? Protect *all* your lenses from rain and dust by fitting a UV or skylight filter on them. Always use a lens cap when you aren't taking pictures, and take a lens cleaning kit just in case. If it rains keep equipment covered by polythene bags secured by elastic bands and keep the lot zipped away in your bag. If the down pour is not too bad you can use a camera 'raincoat' (Ewa make a reasonably priced one) to keep water droplets off.

Don't forget to take something to eat, and an interesting book while you wait for the animals to appear.

Photographing cats and dogs

Photographing pets is, in many ways, like photographing babies and young children. They will not always smile or look happy when you want them to. Nor will they sit or stand still on demand. This means you need a great deal of patience and quite a lot of knowledge about how the animal behaves—where his favourite haunts are, what sort of coaxing works, whether the animal will respond with an alert look to certain noises.

Be prepared to spend plenty of time on a session—perhaps an hour or two—and if the animal tires or loses interest, stop for a while and carry on later. There is no point in trying to force an animal to do something it doesn't want to do. The result will be an unhappy animal and unhappy pictures.

Equipment

This will obviously depend partly on what you have. But there are two lenses to avoid in certain circumstances. Don't use a wide angle lens for a head-on shot of animals with long noses, or you will get ugly distortion.

Don't use a standard lens for tiny animals or close-ups of a face unless your lens will focus closer than 1 metre. Otherwise, the animal will be too small in the finished picture.

An 85mm or 105mm lens can be useful if the animal is not moving around too much because it allows you to keep your distance and helps to cut out distracting background. Remember, though, that the longer your lens the shorter the depth of field. If you want depth of field, close the aperture up to f16 on a bright day and use a fast film.

Lighting and backgrounds

The garden is ideal for photographing cats and dogs. They will already feel at home there and it allows them space to roam around between shots.

Most animals have large shadow areas caused by noses, ears, tails and so on, so choose a shaded area or a bright overcast day. If you're shooting into a shaded area, expose for the shade. Keep the background uncluttered. For example, flower beds probably look too fussy but grass and blue sky make good backgrounds. Always focus on the animal's eyes and take your picture from a low viewpoint to avoid dwarfing the animal.

▶ Small animals look best against plain, contrasting backgrounds. Back lighting and a small aperture shows off the whiskers. *Sally Anne Thompson*

◄ A large aperture throws the background out of focus, but it also makes accurate focusing more critical. Always focus on the eyes. *Hans Reinhard*

► Cats seldom pose for the camera. You have to photograph them where you find them: be prepared for sudden movements.

▼ For action shots use a fast shutter speed (this spaniel was taken at 1/500) and focus quickly. If you can anticipate the animal's movements, set the focus beforehand and wait for the subject to come into view. *Sally Anne Thompson*

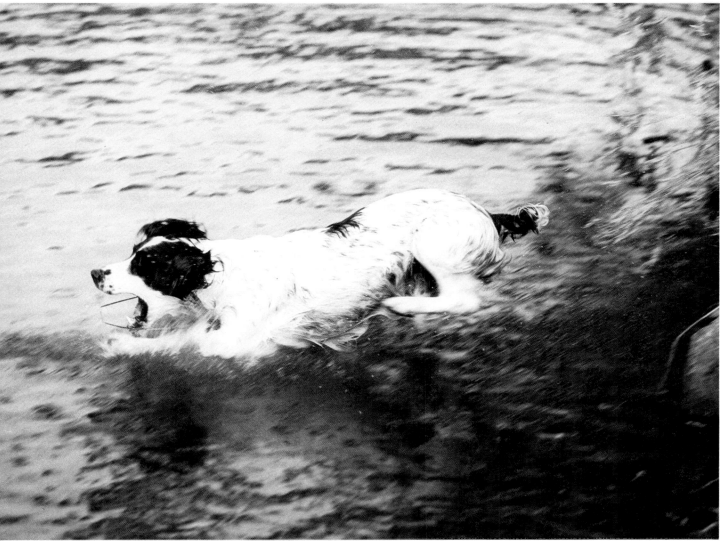

Indoors, try to position the animal close to a window or open door with plenty of daylight coming through. Animals move quickly so unless you want to express this movement, use a fast film and a fast shutter speed—at least 1/250. It will help you to keep the animal in one place if you have someone holding it. At least one helper is always useful; this allows you to concentrate on your equipment while the helper looks after the animal. A trick often used by the professional animal photographers is to pre-focus on something—a leaf or a coloured ball, for example. When ready, tell the helper to release the animal and shoot your picture when it comes into focus.

- **Cats** should be photographed where you find them. In other words, take the camera to them and not the other way round. Cats are particularly receptive just after eating, when they are feeling contented and relaxed. Cats are also natural climbers so photographing them in a tree gives the picture a good background. But the cat may be hidden by leaves and branches so wait until it is climbing up a trunk which is relatively free of foliage. Put a bit of food in a branch and choose your lens, viewpoint and exposure settings in advance. Gentle noises will persuade a cat to look towards you—but make sure they are gentle. Too much noise will make it nervous. A squeaky toy or a quiet voice should be enough. If you use flash cubes and bulbs it can make animals nervous. Electronic flash is usually safe. If possible use the flash off the camera. Cats like the

▲ It takes a quiet photographer and a long lens to catch a cat napping. Here the photographer used a Pentax with a 105mm lens on Kodachrome.

▶ Most animals resent being dressed up : your reactions have to be very quick to catch moments like this.
▼ You often need help to control your subjects, but make sure the helper doesn't overdo it. Animals are quickly bored and walk away if they see the same routine too often. Contain playful animals in something : a white bucket also reflects light on a dark coat. *Anne Cumbers*

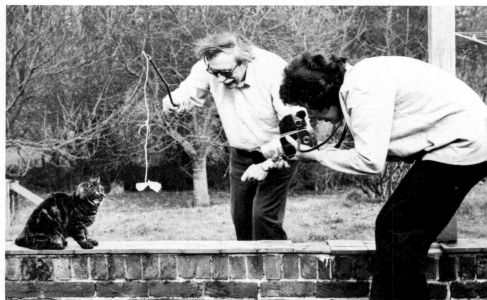

warmth of photo-floods so, if you can keep them in one place long enough, try some indoor shots with fixed lighting. And remember if you want to show your cat to best advantage, it will have its fullest coat of fur in winter. To photograph a black cat, you may need to increase the exposure by $1\frac{1}{2}$ stops. With a through-the-lens meter, take the reading directly on to the dark coat and fill the whole frame with the animal unless you are prepared to accept an over-exposed background. If you want some background, take a reading of both and expose mid-way.

● **Dogs,** particularly if they are well-trained, are the easiest animals to control. But this does not make them the easiest to photograph. Dogs are quickly excited and inclined to see the whole photographic session as a romp for their entertainment. This is, of course, particularly true of puppies. Try putting them into a container of some sort to confine them, or put them behind a log and be ready to press the button as they climb over the top. Dogs respond to a variety of noises and talking to them will often keep them still and attract their eyes to where you want them. A clicking noise from a window upstairs will generally win an alert expression. Don't try to tempt a dog with food or you will over-excite it.

▶ Here diffused light softens the background which, harshly lit, would be distracting. *Sheelah Latham*
▼ Fill-in flash helps to lighten dark fur, but it also pin-points eyes —especially of Siamese cats.

Photographing farmyard animals

Like children, animals are among the most appealing subjects for your camera, and though they may not respond so well to direction they are often more patient and predictable.

On a farm, the animals are usually quite quiet and docile, fortunately for the photographer. If you take your camera on a farm visit, remember to take plenty of film since you will find irresistible shots round every corner. But however photogenic your subjects may be, there are still some considerations that will improve your pictures.

The first is to ask the farmer's permission before you start. Farmland is private property, and once you have the farmer's authorization you will be free to concentrate on your pictures.

Lenses

Though most of your shots will be taken outdoors, you may well find yourself working in a confined space like a sheep pen or cow shed where a wide angle may be more use than a standard lens. A 21mm, 28mm or 35mm lens is also very effective when you want to show an animal very large in the foreground with a good view of the surrounding countryside spread out behind it.

Use a medium telephoto lens (100mm or 135mm) if your subject is very timid or very aggressive: it may save you from chasing your prey round a muddy field or from antagonizing it unnecessarily. When photographing an irate bull, a medium telephoto lens will allow you to shoot from the other side of a protective fence.

A long telephoto lens will be useful for 'head and shoulders' shots of even the more inaccessible creatures, and will also give you a bunching effect, useful for herds or lines of animals. As this type of lens compresses distance it will increase the 'huddle' effect of a tightly packed flock of sheep, for example.

Accessories

Because some animals are shy of humans, you might find a remote control device for triggering the camera very useful. An air shutter release is simply a length of thin rubber tubing which is attached to the shutter release at one end and activated by squeezing a rubber ball at the other. An infra-red shutter release is less simple, but it allows you to fire the shutter from a distance without any contact between yourself and the camera. With either of these devices you will be able to set up

▲ The power of *Julian Calder's* shot of a Hereford bull comes from the low viewpoint, the close-cropping, and the use of a telephoto lens, which makes the bull seem more solid and makes him stand out against a blurred background.

▶ Though less dangerous, geese can be equally bad tempered. *Robert Estall* spent half an hour with this flock: with his shutter speed set at 1/250 he followed them with a 135mm lens, talking to them to make them move on.

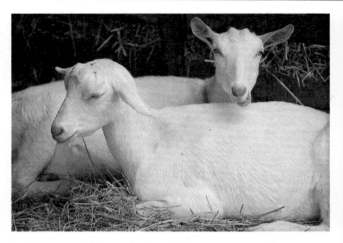

▲ For some indoor shots a flash gun may prove very useful but, wherever possible, it is better to use available light—if only so as not to upset the animals. *Michael Boys* used 400 ASA Ektachrome here, shooting by the diffused light of a skylight and warming the colours with an 81A filter.

▶ Backlighting in this picture brings out the softness of the lamb's wool. By framing the lamb within its mother's legs, *Hans Reinhard* also shows both its size and its dependence very concisely.

the camera close to a feeding place, for example, and retire to a safe distance. Remember that if you intend taking shots like this, you would be wise to take a solid tripod.

Use a tripod too if you want to take advantage of the delayed action mechanism on your camera and include yourself in the picture. Avoid the more frisky or unco–operative breeds, though: you could waste a lot of frames.

A choice of filters will vary the effect of your shots. With black and white film, for example, a yellow filter will accentuate clouds over a landscape and an orange/red filter will enhance the contrast of farm buildings. With colour photography, a polarizing filter will deepen the blue of the sky.

Most of your photographs will be taken in daylight, but it is worth anticipating some indoor shots—a calf in a dimly lit stall, for example, or a stable. Here you will have to choose between using flash or a fast film, possibly uprated.

A sudden flash could upset some animals—and therefore also the farmer—and would not be a good idea during milking or, say, the birth of an animal. The faster slide films, such as Ektachrome 400, can be uprated and 'pushed' during processing without affecting the colour balance too disastrously. Uprating, together with a wide aperture and a slow shutter speed should enable you to manage without flash in most situations.

Make sure that you keep the camera steady at speeds slower than 1/30 by using a tripod or bracing yourself against a wall or post. Also try to position yourself to avoid light coming straight into the lens from a door or window, which would cause flare and wash out the image.

At times when flash is acceptable, arrange the shot so that you can bounce the light off a white wall, a white coat or even a light coloured sack. This will soften the harshness of direct flash and give depth and more modelling.

Vary the viewpoint

Rather than sticking to the simple, head–on approach every time, look for different camera angles. Crouch down and look up at a bull—through a fence—and he will seem even more menacing. Or look down on a newly born animal to emphasize its vulnerability. It is worth climbing a nearby hill to get a bird's–eye view of the farmyard layout, and trying a few trough–level shots in a pigsty.

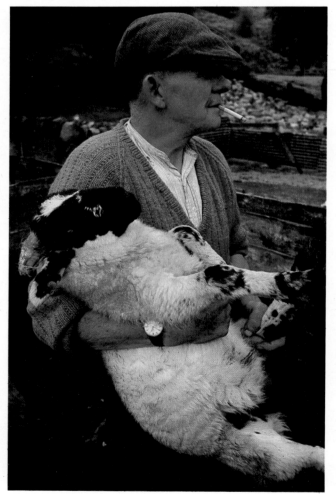

▲ On the bleak midwinter hillside these sheep could have looked flat and colourless. Backlit by the low sun, they are picked out by a halo of light. The yellow evening sunlight adds a sense of warmth. To compensate for the effect of backlighting, *Adam Woolfitt* opened up 1½ stops over his TTL meter reading, shading the lens with his hand to avoid flare.

▶ In spring, *Adam Woolfitt* was able to capture the new-born lambs and the colour of the daffodils by using a slow, contrasty film in the soft light from a bright cloudy sky.

◀ If you take pictures on a farm, don't forget the farmer, who will be involved in many interesting activities. *Graeme Harris*

Sequences

When you show your pictures to friends, either in an album or on a slide projector, you will find that sequences of shots tend to hold their attention more than a collection of unrelated photographs.

Make a sequence of shots of a particular animal by varying your distance: first a cow with its herd, for example, then on its own, and then finally a close–up of its face and ears. You can also build a sequence around a specific activity, such as rounding up sheep, showing all the important stages. Or take a sequence of shots throughout the day, starting with early morning mist and following through: towards evening, the warm light is ideal for pictures of sheep huddled together. The oblique

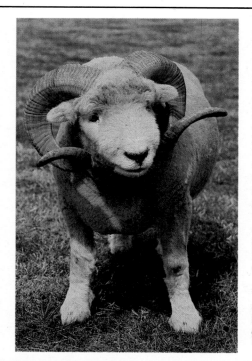

◄ **Few wild hill sheep would pose for a shot like this, even if you use a long lens.** *Sally Anne Thompson* **photographed this Exmoor Horn with a 100mm lens at an agricultural show.**

light can bring out the texture of their wool, or low backlighting will surround them with a fuzzy halo of light.

If you make regular visits to the same farm, you can also make more long–term sequences. Each season of the year has its own flavour: haymaking shrouded in dust with the sunset behind; the same bales of hay on the bleak hillside as fodder for the sheep in winter; a meadow full of new grass and clover for the young lambs.

Adding some action

Action often makes your pictures more interesting and there is always some activity to photograph on a farm. Apart from daily routines like milking, feeding, grooming and so on there are the special events like sheep shearing or preparing animals for a show. Besides giving the photographer an excuse to go out in the fresh air and get his boots muddy, photographing on a farm will also give him a fascinating set of pictures.

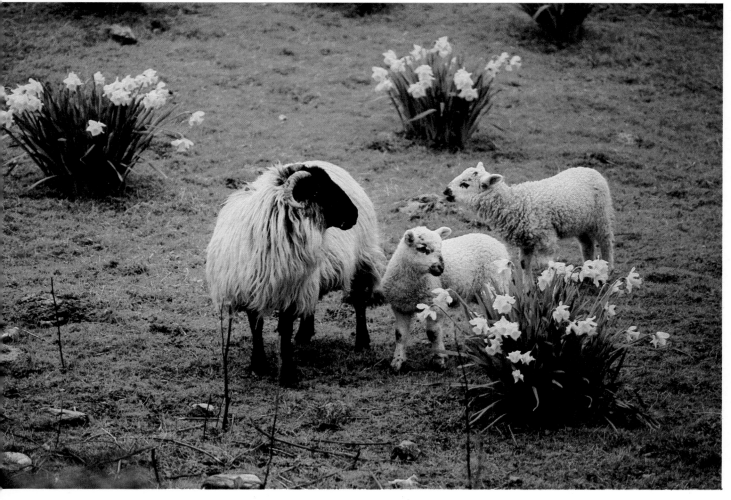

Animals and their young

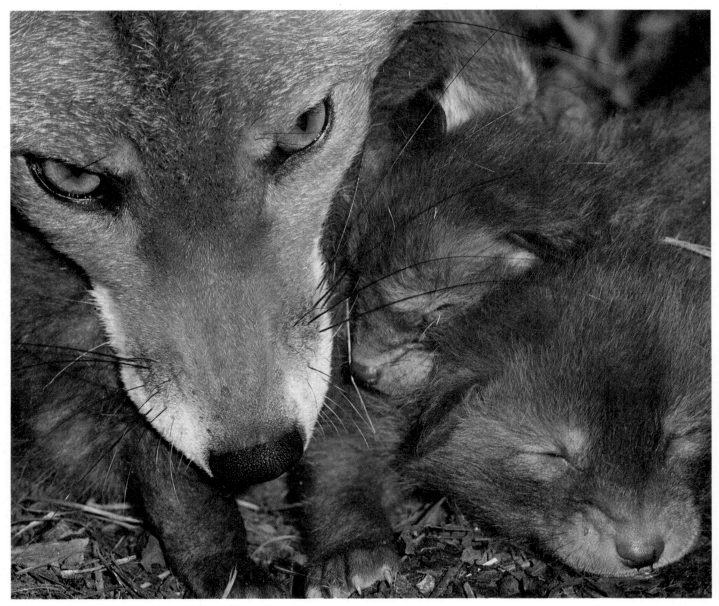

Young furry mammals are instantly and universally appealing. Apart from pretty girls and children, baby animals, when available, are probably the most frequently photographed creatures. In their first few days lots of animals are naked and blind. To some they may look rather ugly. But even so, pictures of young animals snuggled up close to the mother can warm the coldest heart.

Taking photographs of adult mammals and their young is surprisingly easy. It is often easier than taking pictures of the adult alone. This is because animals stay close to their young to protect them. Therefore it is dangerous to assume that all animals will react to photography in a docile way. Animals instinctively pro-

tect their young. But the alarming hissing and spitting of a domestic cat guarding her kittens falls a long way short of a wild and savage lioness fiercely protecting her cubs in the bush. Use your commonsense and always expect a parent to react aggressively.

Relaxed pets
It is fairly easy to take good pictures of pets with their young. They are used to humans and will not suddenly run away. Although puppies and kittens are photographed a lot, they always make attractive subjects. If you live in the country, pet foals and lambs are delightful and more unusual.

Whether you take a portrait or action

shot, top-class pictures are possible. Because a tame pet normally stays put, you can afford to take time over composing the picture. Experiment to find out the best angles to use, and add some helpful props. Baby animals are nearly always ready to play with balls, paper, wool and flowers for example.

Keep the pictures simple and fill the frame. Ensure that there are no unwanted objects intruding in the background. If you need flash, two flashguns provide even lighting with no heavy shadows. With only one flash you can bounce light from the ceiling to provide soft, even light. Most standard lenses have a wide maximum aperture making available light photography

◄ **This tame red fox vixen and her 14 day old cubs knew Jane Burton well and let her get close with a standard lens and extension tubes. One camera-mounted flash provided the lighting.**

▶ **Ian Beames used two flashguns to prevent deep shadows forming on the natural background. A telephoto lens kept a comfortable distance between the timid animals and the photographer.**

easy, but if you use a short telephoto, or a zoom lens which has focal lengths around 100mm in its zoom range, you will do better. A telephoto takes you a bit farther back so that you become less distracting for the animals. The long focal length gives a bigger image than a standard lens would from the same distance.

You need a telephoto for pictures of foals, lambs and calves out in the fields. A 70–210mm zoom (or similar) allows a wide choice of framing and image size. Although a tripod gets in the way indoors, you may find one useful outside to steady the camera. If you do not want to bother with a tripod look out for supports like walls or trees to lean on.

Pictures of a mother suckling babies are appealing but need to be taken with a lot of care and sensitivity. This is so even with your own pet who is used to your presence. Keep disturbance to a minimum. A picture can be taken very quickly with the blink of a flash, but use it with discretion if you suspect that flash would upset the animals. (Electronic flash worries animals much less than flash bulbs).

You can put baby pets into many funny situations which are appealing. A wild animal in the same sort of setting would look out of place. Be sensitive to what looks wrong or ridiculous.

There is no reason why you should not use the same equipment and techniques for successful pictures of more unusual pets, but they are harder to rear and to keep in good health. It is rare for exotic animals, like bushbabies, to breed outside zoos anyway.

In captivity

To widen your range of subjects, go to the zoo. You need to research when different animals produce their young. Most zoos have a press officer who can help with such information.

Animals in outdoor enclosures are easy to photograph by available light using

▶**John Garrett photographed this new-born lamb with its mother in overcast weather. It is as evocative of spring as any woolly lamb gambolling around a ewe in a sunlit meadow would be.**

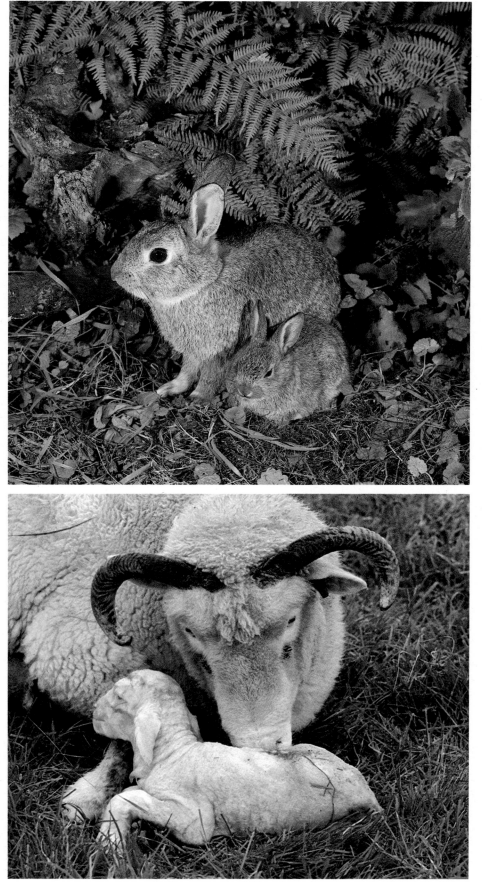

a telephoto. Blur any wire or bars by using the camera as close as possible and setting a wide aperture.

On a dull day, when an animal is close enough, you can use a small flash to improve the picture. It puts a small catch-light into the animal's eyes which helps the picture to come alive.

Small mammals with babies in indoor cages are often behind glass. To get a good exposure flash is almost essential. Ask the zoo staff if flash would startle timid animals. Two flash heads are better than one to eliminate deep shadows. The chances are, however, that you have only one flash. Put it against the glass if you can, or angle camera and flash at about 45°, close to the glass. This avoids both reflections and 'red eye'.

After several visits you can get shots of marmosets and small monkeys, bush-babies and lemurs. All of these carry their young most of the time, either at the breast or riding piggy-back on top. Small mammals like rats and mice usually leave their babies in underground nests, returning to suckle them at intervals. You can take good pictures through the glass, but you will probably need extension tubes or a macro lens to get close enough.

In the wild

Opportunities for taking pictures of baby wild animals are rare. Almost all need a careful approach, a telephoto of at least 200mm, and a camera clamp if you are in a car. During the day you may find squirrels, rabbits and deer. At night foxes and badgers are around, but you need to spend a lot of time (and money) for successful pictures.

Farther afield, the possibilities are almost endless. Remember that *all* large animals are potentially dangerous. Doubly so if they think that their young are threatened. You might be able to drive up quite close to a lone bull elephant in the African bush, but you would be charged at once if you tried to do the same to a mother elephant with its baby.

Baby wild animals are often left alone and it is tempting to get as close as possible. There are many stories of people picking up 'cute' lion or bear cubs only to be attacked by an enraged mother seconds later.

In the wild, use the longest telephoto lens you have and stay as far away, down wind, as you can. You need steady hands, cool nerves and quick reflexes for what are mostly unrepeatable shots. You may be sighting a lion cub climbing onto its mother's back in the Serengeti, or a baby squirrel clinging to its mother as she runs up a tree in the local park. You may never see it again. Be prepared!

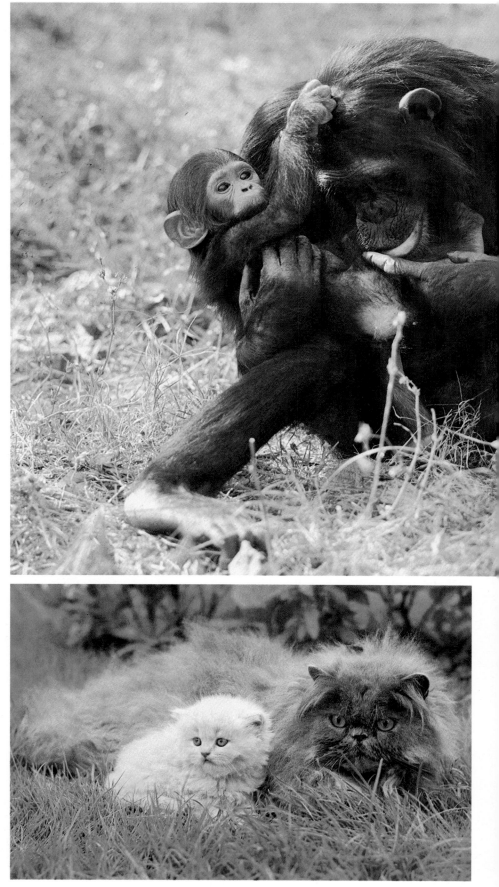

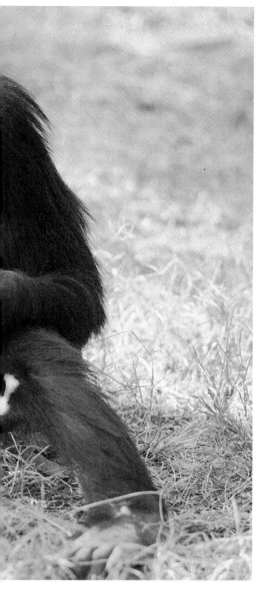

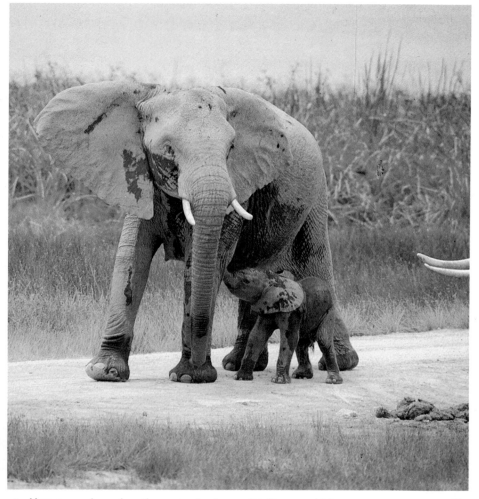

▲ However charming they may look, wild animals are at their most dangerous when guarding their young. Masood Quarishy was as fast and unobtrusive as possible when photographing these elephants. Always stand downwind.

▼ You could happen upon a scene like this almost anywhere and photograph it with simple equipment. Keep your eyes open and your camera ready. Raymond Lea used a 135mm telephoto to avoid approaching too close.

▲ Chimpanzees are irresistible and always draw huge crowds in zoos and wildlife parks, especially when a charming youngster is around to amuse onlookers. Part of the success of Helmut Albrecht's picture is the natural-looking background. The angle of the sun shows plenty of detail in the animals' faces and brings out the texture of the fur. A fast shutter speed froze the action.

◀ Not all pets are at their ease with humans. Anne Cumbers was a stranger to this long-haired blue cat and her cream kitten so she moved slowly and spoke gently to avoid frightening them. She used a telephoto lens to fill the frame from a distance. On this overcast day she used a wide aperture to ensure a fast enough shutter speed to prevent blur. The wide aperture also threw the distracting background out of focus.

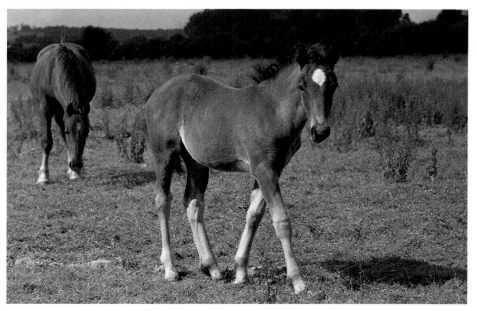

Taking pictures of horses

You can rarely make a horse look un-dignified in a photograph. Show horses, race horses, wild ponies and shires: all are impressive in their own way, and a little care with camera technique can make them even more so.

As part of a landscape, horses will always provide the photographer with beautiful shapes to conjure with. Come up closer, however, and you should begin to think rather more carefully about the lighting, the perspective and the angle that will flatter the animal most effectively. Add to this the fact that the horse is a domesticated animal and that you (or its owner) have the chance of posing the creature for the benefit of the camera and 'horse portraiture' begins to offer as many variables and opportunities as people portraiture!

On the move

Oddly enough, it is easiest to begin with moving subjects, particularly when the route the horse will take is predictable—as it is at an event like a show or a gymkhana. Unless you are panning your shot to get a blurred background, you should never set a shutter speed slower than 1/250. (This is true even when the horse is standing still: they can be un-predictably 'twitchy' animals.) To guarantee speeds like this, use a high or at least a medium speed film.

Find a camera angle which shows the horse either travelling across your view-finder or towards you at an angle—on a turn is often a good point. The subject, should be lit slightly from the side to show the detail and gloss of its coat. You will not have time to focus carefully as the horse passes by, so prefocus on a tuft of grass along its path and release the shutter as the horse comes into view. If the horse is travelling along an arc which is about the same distance from the camera, you might prefer to 'pan' with the animal, though the background will remain fairly sharp unless you use a shutter speed slower than 1/60. You will rarely get the picture you want at the first attempt, so take several shots, and bracket your exposures one stop either side of the TTL meter's recommendation.

At a jump

Station yourself at a jump—this is a relatively simple way to get dramatic horse pictures. Apart from the occasional 'upset', the most arresting pictures will be those taken as the horse

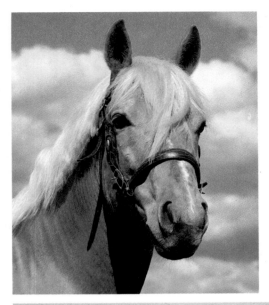

PORTRAIT OF A THOROUGHBRED
◄ Fritz Prenzel photographed this Palamino stallion against the bright background of the sky by following the maxim 'move in and go down' to make the head seem more impressive. Unless you know a great deal about horses, it is best to get the owner's help for a shot this close, for your own and your camera's sake!

AT A CANTER
► For this shot Prenzel panned the camera with the moving horse, using a shutter speed of 1/30 to blur the background. With practice a shot panned like this will keep the body quite sharp, though the legs, mane and tail—which all move at odd angles and speeds—still show movement blur.

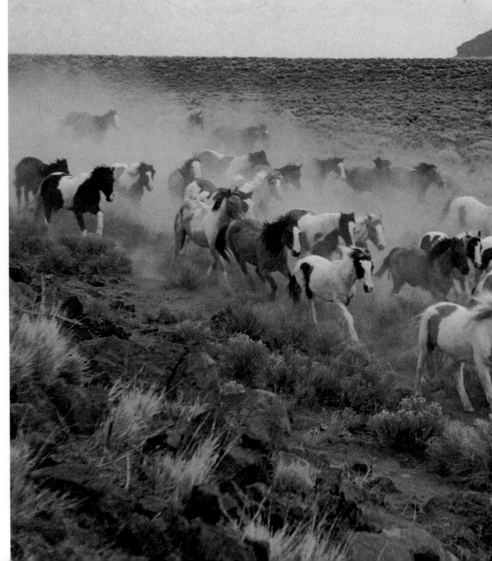

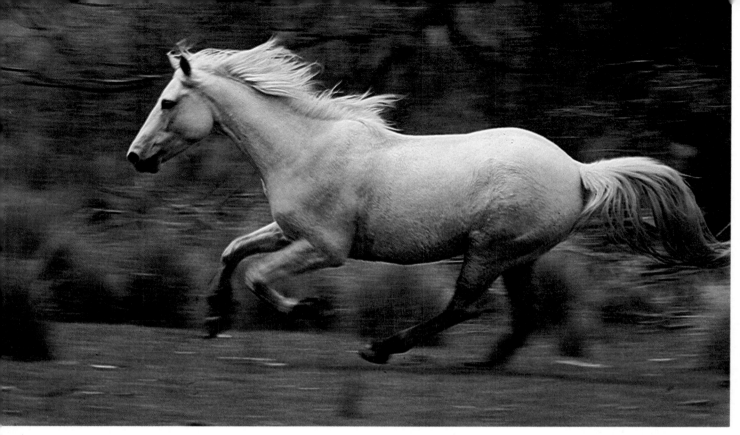

IN THE WILD

◄ Joe van Wormer waited on a rocky ledge for this herd of mustangs to thunder by, framing his shot so that the stream of horses would flow diagonally across the picture. The dust thrown up by their hooves obscures more and more of the detail towards the back of the picture: this aerial perspective helps to give the picture depth. Shots of galloping horses need a shutter speed of at least 1/250 to freeze the motion. The wide angle lens and the bright light here meant that Wormer could still get enough depth of field to keep the landscape sharp.

HORSE AND RIDER

▼ Nothing pleases a proud owner more than a portrait of the horse and rider. But for the photographer it is twice as difficult to flatter both at the same time! M P Kahl took up a position which would give a foreground of bright flowers and asked the rider to make several circuits of a prearranged course to make sure of a picture which would be technically correct from both the photographic and the equestrian point of view. The strong sunlight helps the picture by giving rich colour, though it casts harsh shadows over the faces.

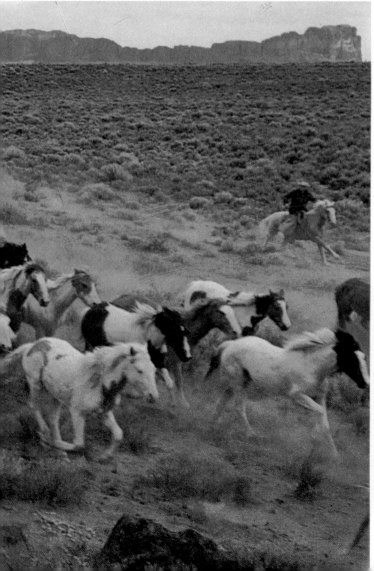

◀ Using a wideangle lens at close quarters in an Australian bar, Tom Nebbia broke the rule of horse photography 'Never use a wide lens too close' to advantage. Emphasizing the long neck, it makes the foal look more gawky.

▶ The dressage champion 'Monaco', behind the scenes with his 'dresser' at Goodwood, Sussex. Homer Sykes took his meter reading from a mid-grey area to get the right exposure for the white horse against a shadowy background.

▼ To show horse and rider turning through 180°, Eric Crichton took a high viewpoint and used a 135mm lens in order to lose a distracting background.

goes through into the jump. This is the time when the horse is showing its power, with the hind legs bunched underneath. It is the time when both the animal and the rider are at their most compact. Once the horse parts its front feet to land the picture may become untidy, and the rider is momentarily off-balance.

Either take a side-on viewpoint or, if the fence is too thick (in open countryside, for example) go slightly forward of the jump. As he takes the jump, the rider will incline his face to one side of the horse's neck: if possible, find out which side he prefers and position yourself accordingly.

All horse pictures, whether they're running, jumping or standing still, look better if you follow the maxim 'move in and go down'. By kneeling or sitting you are less likely to startle the creature anyway. The low viewpoint also tends to give you an uncluttered background and makes the subject stand out in the frame. At jumps, it can give a particularly dramatic effect.

At a show or a gymkhana, don't confine your picture-taking to the ring itself. Prowl around the horse lines and warm-up area for pictures of foals grazing over doors, and horses being schooled, groomed and scolded. The practice jump is an ideal place to learn the camera rhythm essential for good show jump shots.

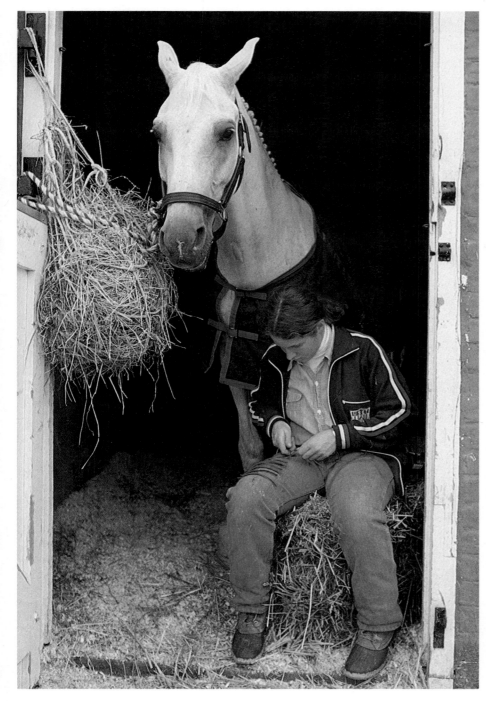

The classic portrait

A horse looks good from most angles, but the classic shot—the one most likely to please the proud owner—is a fairly formal side-on picture which shows its proportions well. The length of the back, the shape of the hind-quarters, the length of the neck and the size of the head are all important points to show for the expert.

Owners also like to see the quality of the coat, so you must avoid flat, over-the-shoulder light. Slightly more than three-quarters front light is best, with the horse's head turned towards the sun. This will show both a shaggy or a glossy coat off well.

The classic portrait involves the cooperation of several people. Start by finding the best spot for the picture with the lighting and the background in mind. If the ground has a slight slope so much the better. Facing uphill the horse will seem more alive. Then clear away any thistles or rough grass that will make the picture untidy. The next step is to lead the horse to your chosen position, or preferably have the owner do so. Once the horse is still, the owner should touch the forelegs with a stick or lead the animal on half a pace until the legs are in the traditional 'show' position, with the weight evenly distributed on all four.

The owner then slips off the bridle and backs away, talking to the horse all the time to keep it still.

Conclusion

The perfect horse portrait is a real challenge for the experienced horse photographer and gaining that experience can be fun. Go at dawn to the New Forest or Exmoor to stalk the wild herds of ponies and you can come away with pictures that convey the raw beauty of the animal before it was groomed and polished for our benefit. Visit heavy horse events trials and pony trekking centres, County Shows or meetings of the British Driving Society.

Wherever there are horses you will find a rewarding subject for the camera. The essential contributions that you must make as the photographer are plenty of patience and lots of frames.

Photographing animals in captivity

Few of us can afford to go on camera safaris to deepest Africa, and so zoos and safari parks offer the only opportunity to photograph exotic wildlife. Here, the city-bound photographer can record on film the weird and the wonderful, the ferocious and the mighty. Even better, from the photographer's point of view, the animals are in a confined area, usually within easy reach of the camera. No one need worry that some lethal beast will come sneaking up behind with thoughts of lunch uppermost in its brain.

Because zoos are more confined than safari parks, the animals are more accessible. There is, however, the perennial problem of bars, wire mesh and glass enclosures, all of which, if you are not careful, make it clear that the photograph was taken in a zoo.

In a safari park, where the photographer is caged in his car and the animals roam free, it should be easier to photograph the animal in a more natural environment. Here, though, the problem is how to photograph an animal, possibly some distance away, from a car with the windows wound up.

In both zoos and safari parks, the objective should be to get pictures that do not look as though the animals are in captivity—unless, of course, you want to use bars to emphasize the restrictions imposed on a particularly wild animal. Many zoos today have tried to introduce more natural environments for their animals, using moats or high walls to keep them in instead of cages, and building walk-through aviaries full of foliage.

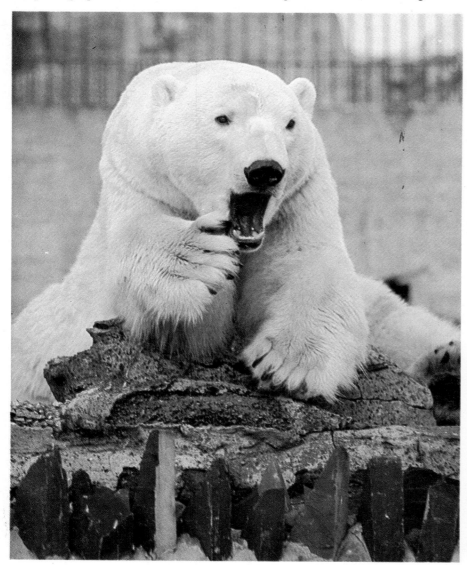

▲ Cages are a perennial problem, especially when it is difficult— or too risky—to lodge your lens between bars. Try photographing as close as possible, at maximum aperture, to put them out of focus. *Eric Crichton* took this picture 1·3m from a 5cm mesh wire fence.

▼ Carefully positioning his 105mm lens up against the open mesh of the aviary, *Ron Boardman* was able to lose the wire altogether.

◀ Dangerous animals are kept at a distance, so for these a long lens is useful. With a 200mm lens *Ron Boardman* could concentrate on the bear by blurring background detail.

▶ If a close shot is impossible, look for a natural frame. This picture, taken with a standard lens, uses the well-designed enclosure.

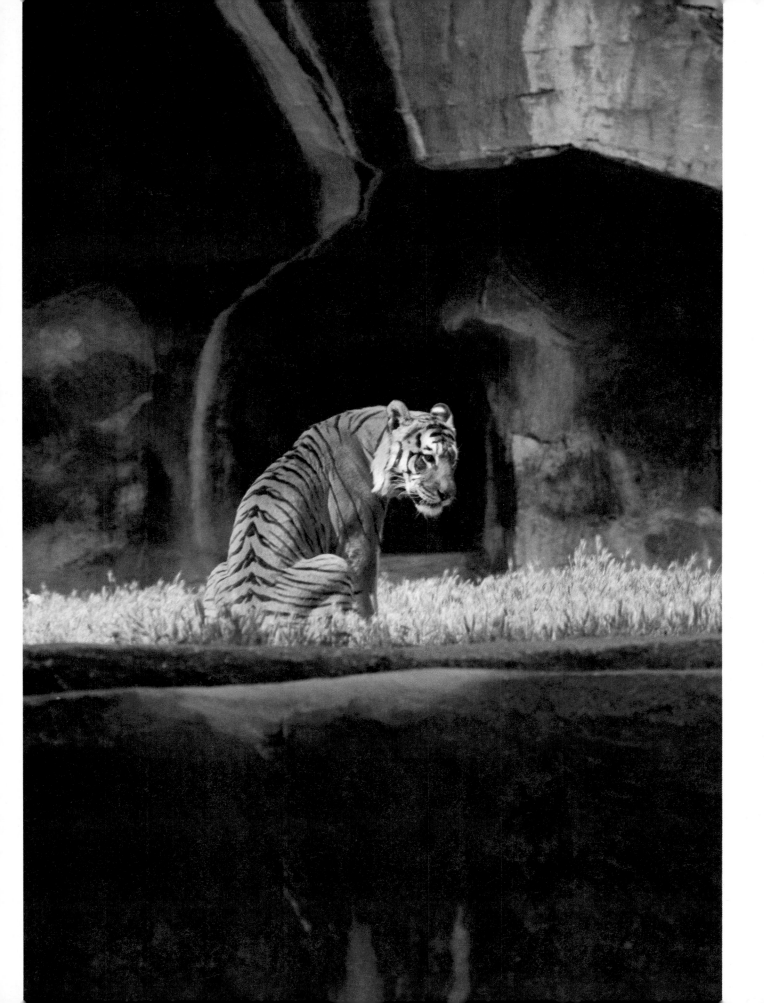

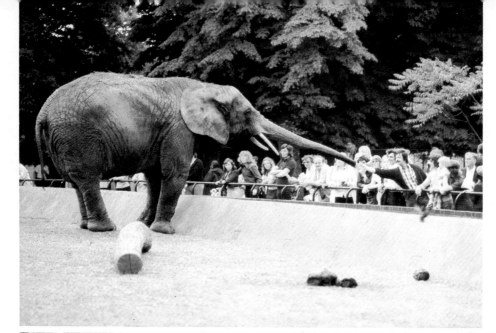

◄ If you cannot avoid including other visitors, make sure they contribute to your pictures: without spectators, it would be difficult to show the size of this elephant. *Jim Calder* chose his moment with care, waiting till watchers and watched made contact.

► A zoom lens is useful for photographing highly mobile creatures, enabling you to crop the picture in the camera. *John Garrett* followed focus on the underwater shadow of this sea-lion, ready for the instant it broke the surface.

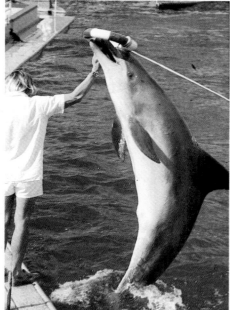

▲ Watching from the top of the stadium through a 300mm lens, *Ron Boardman* studied the dolphins until he could anticipate their movements. To photograph this leap he prefocused on the zoo-keeper, using a shutter speed of 1/250 at f11.

► *Ian Yeomans* came close up to the gorilla for this portrait, taken on a Nikon F with a 105mm lens. Although he was using high-speed Ektachrome film, the poor lighting meant that he had to use a very wide aperture— f2·5—and make sure he focused accurately on the face.

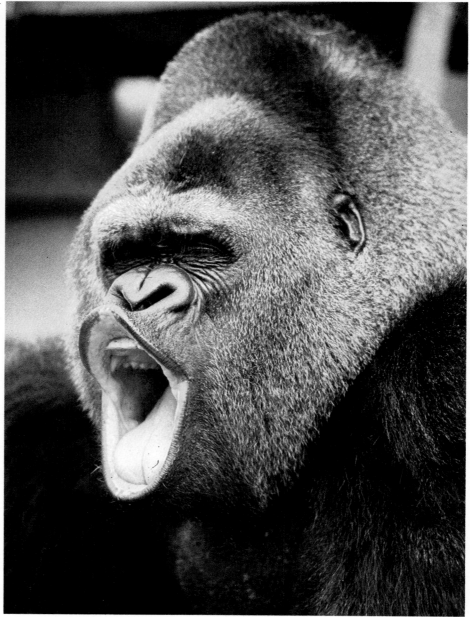

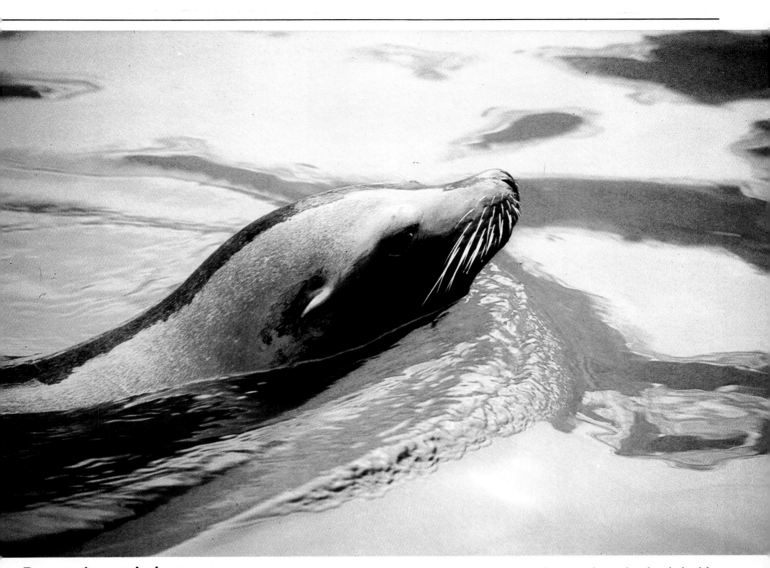

Bars, wire and glass

Where traditional enclosures are still used, there are several techniques the photographer can use to lose them in his pictures. If it is safe to do so, hold your camera between the bars to take the photograph. Putting the camera right up against wire mesh will put the wire out of focus. Do the same with glass, using a rubber lens hood if possible—these are more flexible than metal and so will not slip.

If you are photographing through glass, it will help to stand in a shaded area so that the light outside is less than that inside. Using slow film such as 50 ASA means that a large stop can be used (f2·8 or f·4, say) at a comparatively short distance. Accurate focusing concentrates attention on the animals and lets all extraneous items like bars and feeding bowls disappear in an out-of-focus fuzz.

With some tight cropping at the enlarging stage, you have an animal portrait that might well have come straight from the African savannah.

Getting rid of the bars in front of the animal is one problem. Eliminating bar shadows which fall across the animal is another. The only way to do this is to choose a time of day when the subject is backlit and then arrange some illumination from the front. Do not use flash, however, since that will only produce its own shadows. If the animal is quite close, use a well-spread white coat or even a newspaper.

Equipment for zoos

Animals in a zoo may be tiny or massive, distant or close, indoors or outdoors, so the equipment you need may be quite complex. Ideally, you should take two camera bodies, one loaded with slow film such as 50 ASA

for outdoors and another loaded with a fast film such as 400 ASA for indoors, and a macro zoom lens. But with a bit of organization one camera body with a couple of lenses—an 85 or 135mm, for example, plus one longer lens—should be ample. Tour the ground outdoors first and take all the pictures you want with the slow film, then change to fast film and go indoors.

Studying the animals

It is tempting to start taking your pictures as soon as you arrive at the zoo. You will get better results, however, if you stop and study the animals first. The great cats are largely nocturnal and tend to drowse the day away. This can be recorded and can be amusing but not very exciting. They come alive about half an hour before feeding time and then there is the lion, tiger or leopard we have always

imagined—alert, bright, wild-eyed and full of power.

The movement behind the bars is a problem but there are moments when the animal comes to an impatient halt and glares at the place where its meal comes from. Be ready for those moments and again for the tearing apart of the much awaited food.

Lighting

Be prepared, too, to wait for the right light. Fur should be shown to be soft, hair to be hard, feathers should look like feathers. What you should be looking for is a soft, cross light well relieved from the front and you may have to keep going back till you get it. A slow film in not-too-bright light gives opportunities to exploit movement. Use 1/15 or 1/8 to show the movement of the eternally perambulat-ing bears or the slightly mad, con-trolled rage of the mountainous gorilla. The camera must be held still, pre-ferably supported on a tripod or a wall.

Safari parks

Safari parks have their own special problems and some common-sense precautions are needed. Above all, make sure that you have everything you need beforehand, and then stay in the car. On no account should you even wind down the windows: a slightly open window might just invite an enquiring muscle-packed paw from a completely silent animal just out of sight.

Before you drive into the reserve, make sure all your windows are clean inside and outside so that you can photo-graph through them. Only keep essen-tial equipment with you so that you can move easily from one side to the other as the picture you want presents itself. Use the side windows as these are not usually very curved, and keep the lens hood, preferably a rubber one, pressed right up against the glass to avoid reflections.

Equipment for safari parks

An eye-level camera is a must and so is a long focus lens. Again, a zoom—an 85–250mm, say—is an ideal choice. Use 50 ASA film and shooting at f5·6 or f4 at 1/250 will give you ample scope. Engine vibrations are a problem, particularly with a long lens. Most safari parks will allow you to stop the car, but only very briefly, so you need to be quick. Some reserves have walk-through areas—though not for the big cats or the baboons—from which you can photograph animals.

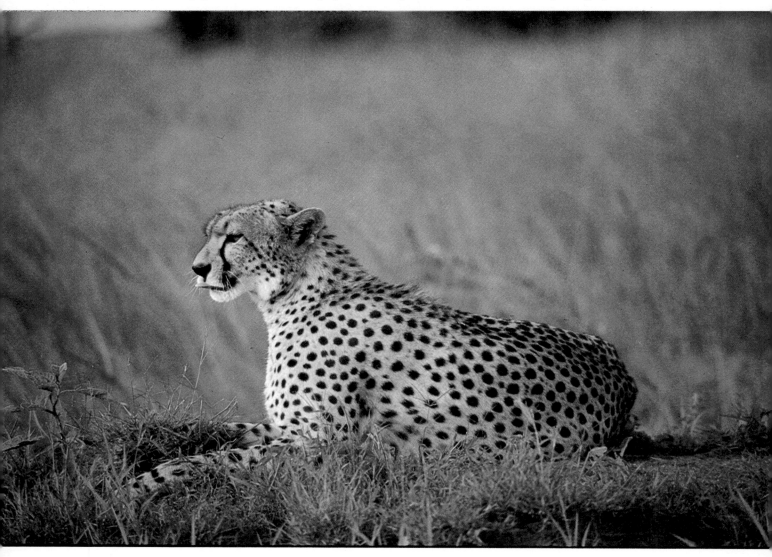

▲ At a safari park it is the people who are caged, and must remain so: check you have everything you need before you go in. Clean all car windows thoroughly and use a rubber lens hood pressed to the glass to eliminate reflections. *Sverre Borretzen*

◄ Not all wild animals care to mingle with the visitors and a telephoto lens may be the only way to capture subjects like this wary cheetah. Find out beforehand whether you can briefly turn off your engine to avoid vibration. *John Garrett*

► Safari animals, designed to blend in with their surroundings, can be hard to spot. Here the photographer is at an advantage— particularly if he has a telephoto lens—as he can use selective focusing to pick out his subject. *Clare Leimbach*

▼ Harsh side lighting exaggerates the gaunt shapes of these flamingoes, but it makes correct exposure more difficult. Here *Ron Boardman* took overall readings from his hand and from the grass and shot at 1/60 and f9.

Taking your camera on safari

Many amateurs keen on photographing animals dream of a photographic safari. For some the idea will remain a pipe-dream, but for those who do decide to go, their first trip will probably take them to East African game parks where the game is varied and plentiful. The local tourist industry there is well organized, too, with either pre-arranged package tours or the chance to hire one of a variety of vehicles on a more individual basis to take you safely through the game parks.

Wary animals and excitable companions make African big game photography a matter of working quickly with telephoto lenses and fast films. The opportunity for a picture may present itself for only a few seconds, even to the most patient photographer on the best organized trip.

Developing 'bush eyes'

The number and quality of sightings depends on the skills of your driver and guide. It takes a newcomer time to distinguish animals at a distance, which is why a guide with 'bush eyes' is essential. Big and small game is

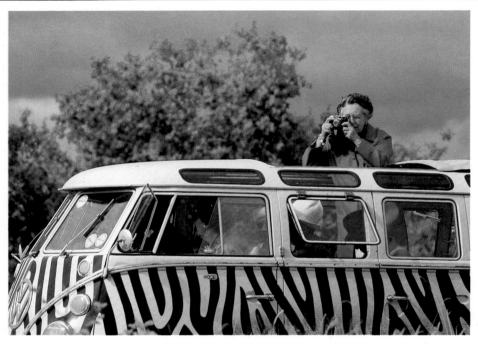

▲ For your first photographic safari, an organized tour providing a minibus and a bush—guide as its driver is simplest and cheapest. *Ian Berry*

▼ The more elusive species may be more difficult to find. *Ernst Haas* photographed this hippopotamus with a long lens from a boat on the Nile.

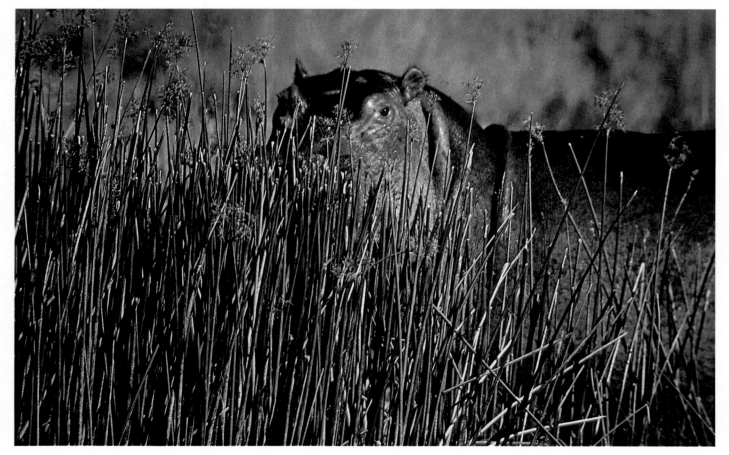

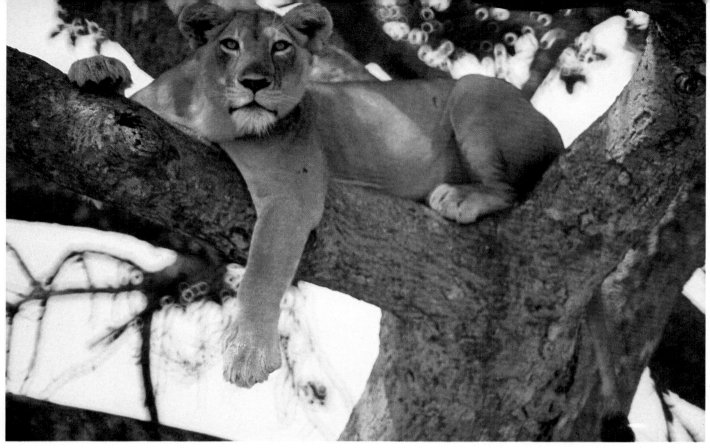

superbly camouflaged — contrary to the impression given by television and cinema — and a rhino can look very like a boulder, or a distant elephant can be indistinguishable from the surrounding terrain, especially after a mud bath.

A good driver, your own Land-Rover and enough time will virtually guarantee you a look at a particular beast, but it is an expensive way to travel. Hiring a minibus in a group or joining an organized safari is far cheaper, but it has disadvantages. The vehicle's observation hatch may suddenly become crowded with excited people at the appearance of an elusive animal.

The right approach

Game should never be approached head-on. This scares the animals and makes photography very difficult. Squealing brakes and the noise of an engine starting up also puts many animals to flight, although in the most frequented areas the game has become used to visitors and even the thumping of a car door or the sound of a hooter will scarcely make an individual from a normally shy species look up. These more sophisticated animals will often employ an even more frustrating technique: just as a car draws within photographic range they will slowly turn their backs on any camera in sight. Park rules forbid visitors to leave their vehicles for their own safety: sometimes they also forbid vehicles to

▲ In the heat of the midday sun, this lioness looks deceptively docile. *Mike Sheil* came as close as his Ugandan guide allowed and used a 500mm lens.

▼ Early morning and late afternoon are the best times to photograph animals on the move. Like the tourists, they rest during the day. *Ian Berry*

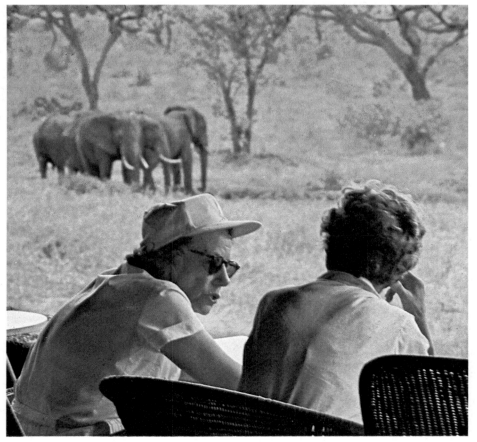

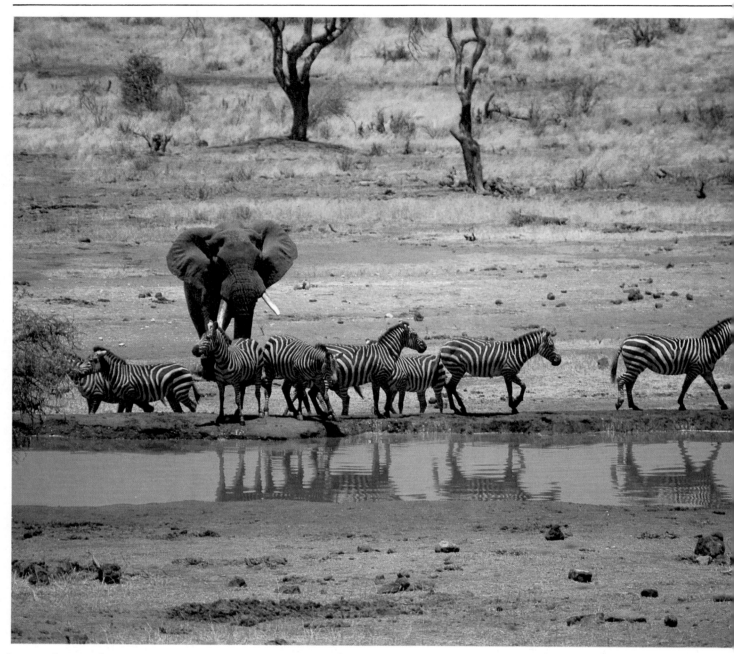

leave the roads, which means that photographers have to wait for the animals to come within range.

When it *is* possible to follow animals in your vehicle, it is difficult to judge how close to go without scaring them. The best approach is to drive around them in an ever decreasing spiral, so that the individual animal or the herd has the impression that you are driving past.

Not all game is so wary though: vervet monkeys and baboons can make a nuisance of themselves clambering all over cars and trucks — which makes them all the more difficult to photograph. Zebra, dik dik and other small antelopes and ground squirrels occasionally come close enough to be taken with a 135mm lens, and individuals of many species will often happily co-operate. Thirsty game, on their way to a water hole in the evening, may be bold enough to pass within a short distance.

Equipment

The equipment for your first photographic safari should be based on a 35mm SLR with a 300mm lens and 400 ASA film. Telephoto lenses are used for almost all big game pictures to close in as tightly as possible on the animal. Although low light is seldom a problem on safari, fast films give the greatest leeway to stop well down for maximum depth of field and to use the fast shutter speeds necessary both to stop the movement of the animals and to lessen the effect of camera shake on the long lenses. And the 35mm camera has the flexibility to cope with fast-changing situations.

A bean bag or a clamp is very useful to help support the camera and long lens on the edge of the window of your car

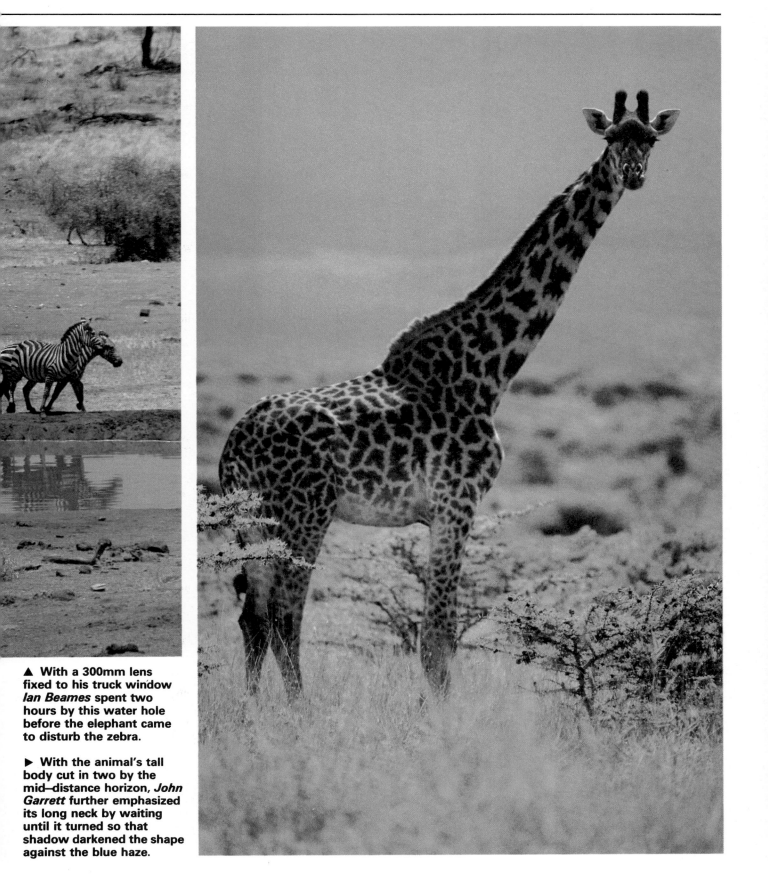

▲ With a 300mm lens fixed to his truck window *Ian Beames* spent two hours by this water hole before the elephant came to disturb the zebra.

▶ With the animal's tall body cut in two by the mid—distance horizon, *John Garrett* further emphasized its long neck by waiting until it turned so that shadow darkened the shape against the blue haze.

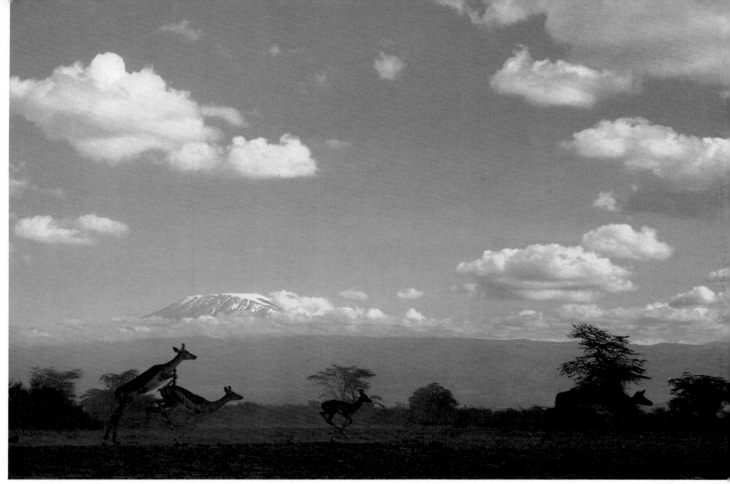

or on the observation hatch and does a great deal to minimize camera shake. But take along a tripod as well: it will be no use to you in the vehicle, but may prove indispensable if you stop for a while near a water hole.

Though you will be using mostly long lenses, pack a standard and a wide angle lens as well, for shots of the animals' habitat, the plants and the general scenery. UV filters are a practical choice to protect the lenses from dust and to cut out the effect of haze. Keep a UV filter on each lens: there will normally be no time to change filters while shooting. Lens hoods, a standby exposure meter, extension rings, a jeweller's screwdriver to tighten up equipment (it gets very bumpy in the bush) and plenty of film should also be included in your camera luggage.

Dust and heat, especially in the dry season, are ever present problems, and make lens and body caps, blower brushes and a good supply of lens cleaning tissues essential accessories. Car tyres throw up clouds of dust, so if another vehicle approaches yours, close all the windows until the ensuing dust storm has subsided. Keep your gadget bag as cool as possible: leave the bag open, covered with a cloth and stow it away under a car seat. This will protect it from the dust and also from the feet of your companions as they

▲ **When animals are travelling as fast as these impala, shutter speed must be your first concern.** *Tom Nebbia* **exposed at 1/500 on Kodachrome 64, which still allowed enough depth of field.**

clamber on the seats for a better view. It is important to devise a foolproof system of keeping exposed and unexposed films unmistakably apart. It is all too easy to reload exposed film in the heat of the moment. Load your film in the shade — even if only in the shadow of your own body — and never leave the rolls of film in the sun or in a hot parked car. Put the film away in the boot of the car until you can store it safely in your suitcase back at base.

On a short trip, it is best to leave the processing of your materials until you return home: avoid luggage scanners at the airport, and insist on keeping your precious film with you at all times.

Seizing your opportunities

The safari photographer has to be opportunist about his pictures, working fast and under tricky conditions. Light in the tropics changes suddenly, especially around dawn and sunset. If you are not using an automatic camera, it is essential to take a basic exposure reading, set the camera at that, and then check exposure levels regularly. If necessary, shoot first and question the exposure afterwards, bracketing if you

▼ **For very shy animals you need a long lens.** *Mike Sheil* **shot these Ugandan buck cob with a 500mm mirror lens which is easier to hand hold since it is more compact than a normal telephoto.**

find you have time. An automatic camera can help with exposure problems, but it is better to use a camera you are familiar with for fast work than to buy or borrow an unfamiliar one.

Most of the pictures you come back with will be simple shots. It is unlikely, though not impossible, that one short visit will be enough to get pictures of any complex behavioural patterns. The person with the most successful shots is likely to be the photographer who has the quickest reactions, as well as a feel for animals and plenty of patience.

▶ **Selective focusing makes it easier to distinguish camouflaged animals through the viewfinder than with the naked eye. As with portraits, limited depth of field makes it crucial to focus on the eyes.** *Pierre Jaunet*

▼ *Jen and Des Bartlett* **had to wait by the water hole until the sun was low in the sky before the elephant arrived. The hard sidelighting picks out the rough texture of their hide.**

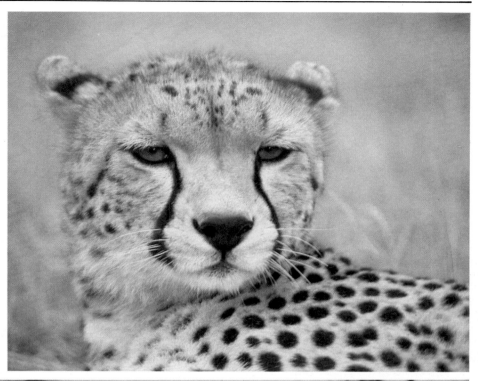

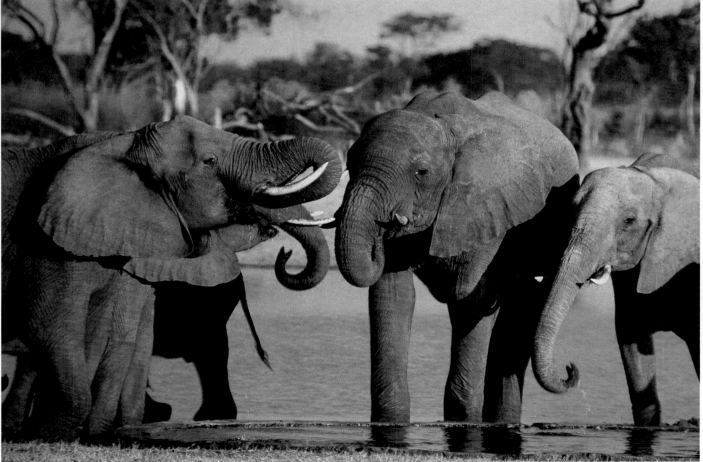

Animals at night

Many animals shun daylight and emerge only after dark. They feel safer when they cannot be seen by dogs, hawks, or man. Some, like foxes, can be found by night or day, bats are usually seen at dusk only, hedgehogs, 'freeze' in light. At night the shy creatures emerge.

A photograph of a nocturnal creature is a prize to be treasured. However long the night, you should not expect to come away with more than one photograph worth showing. The rarity of these pictures makes the challenge exciting.

Why are night creatures so hard to photograph? Partly, of course, because you cannot see them. And partly because, even if they cannot *see* you, they have the advantage of their other keen senses. They can smell and hear you. Unless you have a thorough knowledge of your prey you will not even find it, let alone photograph it.

Night mammals

It is essential to read as much as you can about the lives and habitats of the animal you want to photograph—and then go out and look for yourself. The best time of year to find tell-tale signs of habitation is in the early spring, before too much vegetation has grown up. A fox earth or a badger sett, for example, is easier to find at this time of year—and you will not have to wait many weeks before the young begin to emerge from it for the first time. Before they do, however, you should spend several nights merely watching. Find out where the creatures habitually enter and leave, and the best location for your camera when the time comes. Arrive at the site an hour before dark and

▼ **It pays to learn the habits of the creatures you want to photograph.** *Hans Reinhard* **studied the route this polecat took across a stream for several weeks, then caught it mid-leap with flash.**

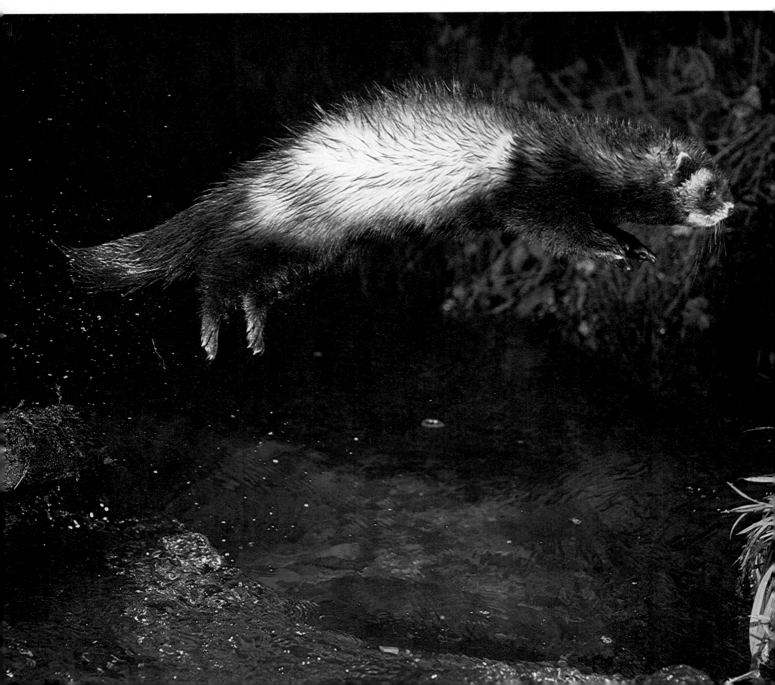

simply sit, wait and observe. Use a small folding stool and lean back against a tree—both for comfort and to break up your human outline. Stay at least 20 yards (20m) from the habitat and *learn to keep very still*. A calm, still evening is best, but if there is a breeze make sure it is blowing away from the habitat and towards you, so that the animals do not catch your scent. Burrowing animals have many entries and exits to their habitats, and one whiff of human scent down any of these holes will mean a fruitless night. Some animals—like foxes—will even move to a new home if they feel disturbed enough.

Setting up

After a few nights' research you are ready to take your photographs or, more likely—photograph, since once you have fired a flash gun the animals will vanish at top speed.

You can choose one of three main ways to release the shutter. Either release it in the normal way, use a long air/cable release or employ an automatic photo-electric trip.

The first method is the most satisfying. It is also the most difficult, because you need to be so much closer to the animal you are photographing. Even if you are using a 200mm lens, you will need to be as close as 20ft (6m) for a big enough image of your subject.

A 10-metre cable release makes the photography easier, but the sense of achievement can be less. The camera is set on a tripod, and aimed at a point the animal must pass. The shutter is released from further away using the remote release cable.

Shooting in the dark, however, you may not be able to see clearly enough to get a well-framed picture of the animal when it arrives at the predetermined spot. This is where the third method—using an automatic, photo-electric trip—really scores. The shutter is fired by the animal itself, when it breaks the photo-electric beam.

Flash

Flash is essential for night photography of animals. They will steer clear of any other form of photographic lighting. It is possible to get most nocturnal animals used to a *low* level of lighting, however, provided it is built up slowly from a small, red-filtered torch bulb. Most nocturnal creatures seem to be insensitive to red light, and this can be used as an aid to focusing.

For your photographic light, flash bulbs have the advantage of providing a lot

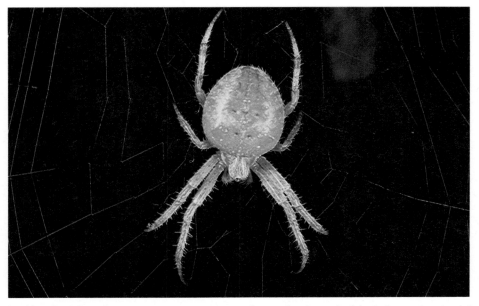

▲ *Heather Angel* went out with a torch at night to find subjects to photograph in the Dordoigne, France. She shot this spider in its web with a 55mm macro lens and twin flash guns — held on a bracket either side of the lens and a few inches from it.

of light over a wide area, but they are likely to scare the animal more than the quick blink of an electronic flash-gun. With these it is essential to run one or two test shots beforehand in night conditions, since guide numbers are rarely realistic in total darkness. Take pictures of a teddy-bear at 20ft (6m) in the dark. It would be a pity to spend weeks preparing for your first picture of a wild badger, say, only to over- or under-expose it badly.

Electronic flash normally stops the movement of the animal and makes it easier to use more than one flash head. On-camera flash can make the animal's eyes glare unnaturally red in the picture. With only one flash, also, you will get

deep shadows behind the animal and the texture of its fur may vanish completely. Two heads will give a more balanced light, and with electronic flash-guns you can use a slave cell to set them off simultaneously.

Shooting in the dark

It is important to arrive for your night's photography a little before the light fades, so you can see to set up your photographic equipment.

Start by putting a light-coloured stone or stick to mark the spot you expect the animal to pass. This gives you something to focus on, and a memorable marker for when you are shooting from a distance.

▼ This brown kiwi had to be encouraged to appear with bait. *Heather Angel* prefocused on the bait with a 135mm lens by torchlight and then settled down for a wait of several hours. She used a flash gun held above and to the side of the camera on a bracket.

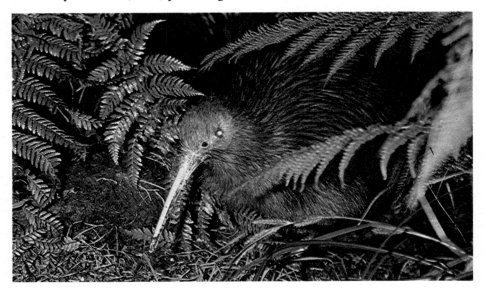

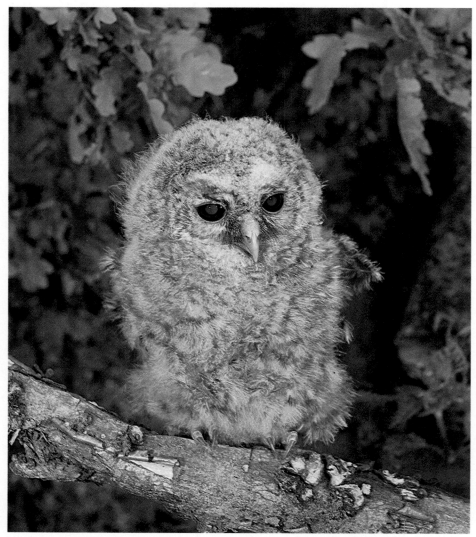

◀ For photographs of a family of tawny owls, *Ian Beames* set up a hide in their tree several weeks in advance. He set up his RB67 camera with a 180mm lens on a tripod, using a powerful Metz 402 flash gun supplemented by a smaller flash gun from a different angle. For this shot of a young owlet he added extension tubes to the lens.

▶ *Hans Reinhard* managed to photograph this family of badgers from spring through to autumn. For a project like this, you must take great care not to disturb them and put them to flight.

They also like sweet things: biscuits coated with honey and peanut butter. Some even prefer chocolates. The adults are usually too wary to be used in this way, however.

Animals are creatures of habit. Either by carefully observing their habits, or by creating new ones for them by means of bait, you can predict their movements and set up the ideal conditions for your photographs.

Birds at night

Like mammals, night birds are easiest to photograph in their habitat, while they are feeding their young. Unlike many mammals, birds have extremely keen eyesight in the dark and this means that you will need some kind of hide to photograph from (see page 166).

A short period of watching is necessary to establish how the adult bird enters its nest and where it habitually perches on the way. Low sites are best as you will need to build only a small frame for your hide to rest on. Construct your platform and hide by stages over a period of four or five days. When you arrive at the hide at dusk, you will need someone to accompany you into it and be seen by the birds to leave giving them the impression that the hide is completely empty.

Remember that in Britain you need a licence from the Nature Conservancy Council to photograph some species (the Barn owl, the Short-eared owls and Long-eared owls, for example). This is only given to people who can show that they know what they are doing, and will not put the creatures at risk. This illustrates the most important part of this section—you must be photographing your subject because it interests you, so make sure you do nothing to harm it in any way. Move slowly and carefully—both for the sake of the creatures you want to photograph, and for the sake of your pictures.

Set the camera on a tripod, frame up and focus on your marker. Set up your flash gun on another tripod or fasten it to a suitable tree branch, or whatever. Make sure the camera is wound on and the flash switched on ready to fire. All you have to do then is wait for your subject to appear.

When you see the animal arriving at this spot, you will be ready to release the shutter. Do not be too disappointed if you miss all or part of the animal, however. How well you frame the shot will depend not only on your camera technique but also on how well you know the animal and its characteristic movements. Both of these improve with experience.

One way of getting your subject to be in the right place at the right time is to use bait, providing food to bring the animal regularly to one spot. The important word here is *regular*. The food must appear every night for the technique to be reliable. From a naturalist's point of view, too, the food should be regular and during the winter months you should continue to provide it even after your photography is over. In winter an animal may starve if a reliable source of food is suddenly withdrawn.

People often discover the value of 'baiting' quite by accident in their own gardens. Scraps put out for the birds will attract hedgehogs, foxes and badgers as well as local cats. With a little ingenuity you can induce the fox to come within range of your camera: a week's baiting and the chances of an exciting picture are good.

Foxes, especially suburban ones, will come to find meat and kitchen scraps, and so will badgers. Wild badger cubs can be persuaded to approach within two or three feet (1m) if you place a line of food from the sett to the camera.

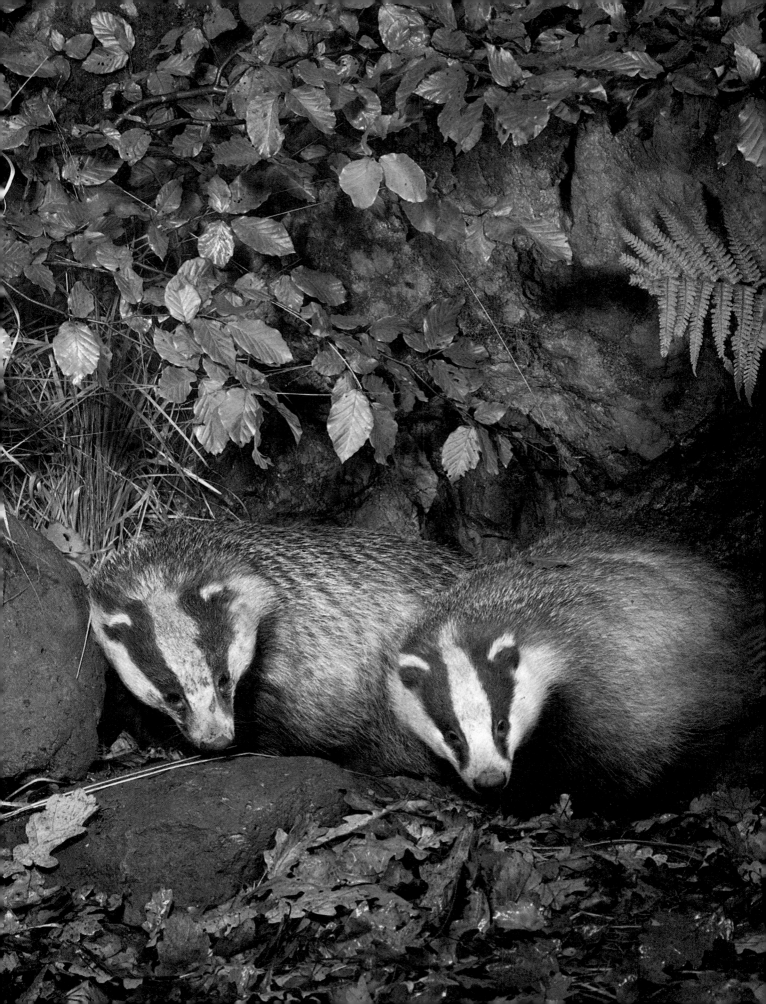

How to photograph aquaria

You can't really compare photographing tropical fish in an aquarium with the wonder of seeing them in tropical seas, but it is a useful way of getting to know more about underwater life—much of which is very colourful. In fact, often the only way you can take well-lit, sharp close-ups of small aquatic life is by confining their movements to small aquaria containing the clearest possible water.

Equipment

An SLR camera is ideal because you can easily keep a moving subject in the viewfinder as you follow it around the tank. A close-up lens or extension tubes are needed for all but large fish. You don't need a tripod when you photograph active animals swimming around a large tank because you want maximum mobility, but it's essential for critical close-ups.

Main problems

Most problems arise because you're shooting through glass. Ghostly images of hands and face can show on the glass, as well as shiny parts of the camera. You could drape a black cloth over yourself and the camera but a much neater solution is to attach a sheet of matt black card to the front of the lens. Simply cut a hole in it for the lens to poke through!

You can't possibly use on-camera flash without getting reflections (unless the flash is against the glass, which is rather restricting). Use the flash at an angle. Move it to one side of the camera at an angle of 45° or less to the glass. Most cameras have a flash sync socket. Use a sync cable between camera and flash so that you can get more flexible movement of the flash to either side of or above the camera. Buy an extension sync cable for more versatililty. If your camera has a hot shoe only and no sync socket buy yourself one of those fairly cheap hot shoe adaptors which has a sync socket outlet, then attach the flash to it.

Lighting

Static subjects such as a flat fish resting on the bottom can be photographed using the aquarium display lighting. However, even artificial-light colour film may not reproduce true colour unless you use filters to compensate for the unnatural colour (on film) caused by fluorescent aquarium lighting. A light pink filter usually helps.

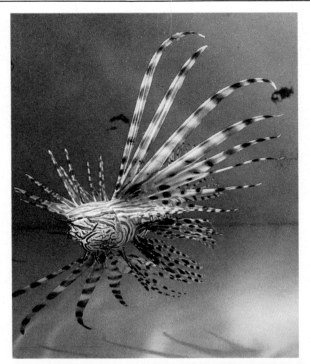

◄ Eric Hayman used a flash against the glass to avoid reflections and got close in with a 50mm lens to fill the frame with this lion fish.

► The veiltail goldfish is basking in warmer, oxygenated surface water. Jane Burton used two flash heads either end of the tank, level with the water surface to light the red lilies and fish equally. She used a short telephoto to fill the frame.

▼ These striking regal tangs are swimming in front of coral rock which can be found in pet shops. Jane Burton used two flashes above the water and one close to the camera. She used a short telephoto lens plus an extension tube, and mounted the camera on a tripod to steady it.

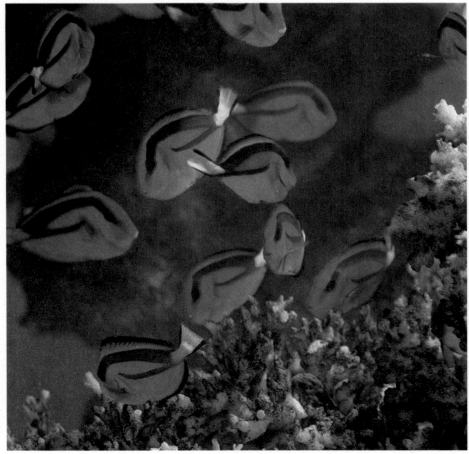

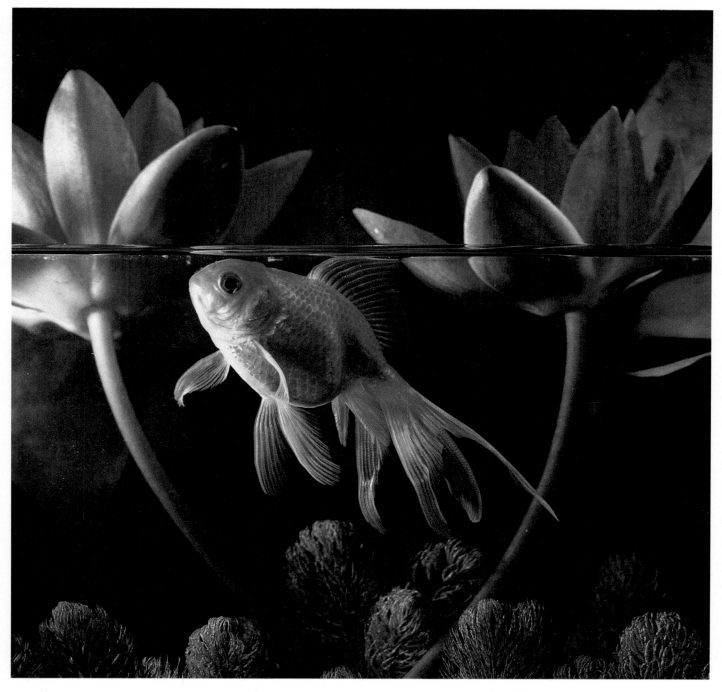

Photofloods are not suitable for aquarium photography since they generate a lot of heat. Unless special heat filters are used, the lights warm the water which makes the fish behave abnormally or, at worst, can kill them.

Electronic flash is undoubtedly the best choice since it is a cool light source and flashes so quickly that it stops movement. Using two or more flashguns gives better lighting effects. It's a good idea to attach slave units to trigger them, otherwise trailing sync cords may get tangled.

Exposure

If you are using aquarium lighting or daylight in an open air tank with underground viewing windows then you can take standard TTL (through-the-lens) meter readings.

For flash-lit photographs using manual units it's mainly a matter of trial and error. You can use automatic flashguns, but with flash off-camera the flash sensor can't be relied upon to give correct exposures—unless you use an accessory (remote) sensor on the camera's hot shoe.

Public aquaria

Be sure to get permission to take photographs first. Some keepers object to the use of flash with timid subjects, or they may prefer you to work at times when there are few visitors. Photographers working on a small tank will obscure the view for others.

Before exposing a single frame walk around to view all the tank. Check that the front glass has no obvious scratches or distortions in it, or algae growing on the inside.

Fish can't be told what to do but they

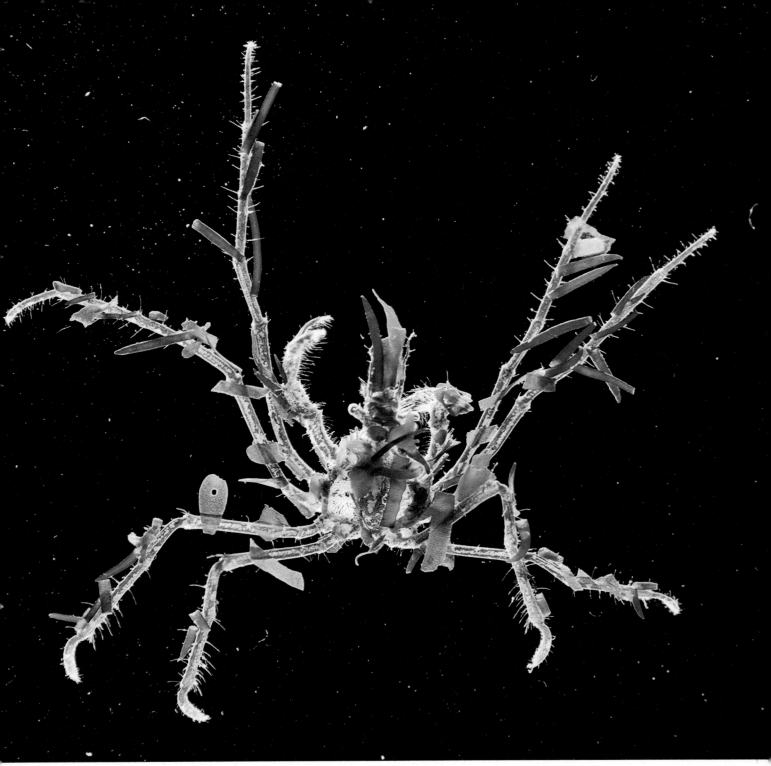

may have regular habits so try to spend time observing the behaviour of individual fish. Do they lie on the bottom, do they rise up to the surface, or do they swim around and around the tank? Some fish show distinct territorial behaviour such as rushing up to an intruder with erect fins—an exciting picture to capture.

The main problem with large public tanks is that there is little scope for creative lighting. The only direction the flashes can be angled in to the tank is through the front. A single flash would only light one side of a fish swimming head-on towards the camera so a second flash—and a means of supporting it—is essential.

Home aquaria

There are many advantages in photographing your own aquarium. You can choose the subjects, the material on the bottom, the background colour and, most important, the type of lighting. You can also make sure that the front glass is clean and free from scratches, and that the water is crystal clear by

▲ Heather Angel used two flashguns placed on either side of and slightly behind this spider crab to show its translucency and the hairy legs it has camouflaged with seaweed.

filtration. Perspex tanks are not ideal for photography since they are more susceptible to scratches than glass.
Sun shines down on oceans and rivers from above so the most natural way to light a small tank is from overhead. This also overcomes any problems of light reflecting on the front glass. Lighting

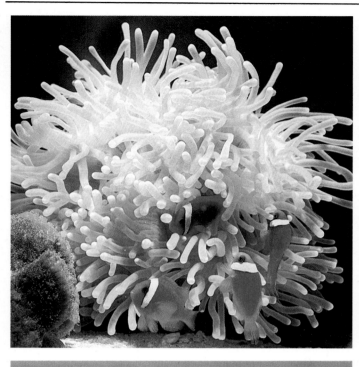

▲ Top: the red clown fish and sea anemone were lit by flash high and to the left of the shot. Heather Angel

▲ Try to keep all backgrounds natural. Heather Angel made a freshwater environment for these great pond snails.

▲ The pale blue plastic background dropped into the tank contrasts strongly with the black lace angel fish and so shows up the tail structure. Jane Burton put lace agate and South American plants in the bottom, then used flash above the tank and at one end to prevent background shadows.

through the side walls also gets rid of the reflection problem. However you still need a matt black mask covering the camera to prevent reflections of your hands and face.

There are no special techniques needed for taking pictures of marine animals, but remember that sea water is highly corrosive to metal and care must be taken not to spill any on equipment. This is doubly important for the exposed connections of flash sync leads because you can get a nasty electric shock. It's a sensible precaution to cover them completely with insulating tape beforehand.

The most attractive images result if you plant the tank with aquatic plants several days before a photographic session. Make sure that they remain healthy looking. If not then they should be replaced, since it's pointless wasting film on prize fish when the surroundings are not attractive.

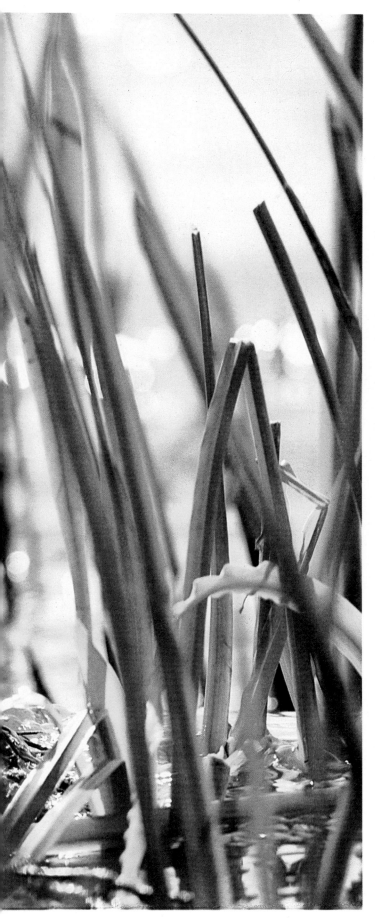

HOW TO PHOTOGRAPH BIRDS

Birds are often considered to be the most exciting subjects to photograph in the whole world of nature, but they are certainly volatile! Modern advances in cameras, lenses and films have made the task progressively easier for the amateur but the photographer must learn and understand the techniques used.

This chapter explains the most successful ways to photograph birds, dividing the subject into categories. You can bring the birds in your garden to a pre-arranged position by regular feeding. You can pre-focus the camera, preferably using a long-focus lens, and an air release fires the shutter. For photographing birds in the wild, a hide is an extremely useful piece of equipment. The chapter shows you how to build one, introduce it into its setting and then take photographs from inside.

Taking pictures of wild birds without a hide is more difficult. Shutter speeds, apertures and lens choice are discussed for the various types of shot. The most challenging task of all is to photograph birds on the wing, but the stunningly beautiful results can be well worth the effort.

This great crested grebe *(Podiceps cristatus)*
had built its nest at the edge of a pond so close to the road it could
be taken without a hide by using a 200mm lens.

Bird photography in the garden

Of all the branches of natural history photography, probably the most exciting is the photography of birds. Many have the idea that it is also the most difficult, with a mental image of a dedicated professional travelling to remote parts of the globe laden with expensive equipment.

Such people undoubtedly exist, but in fact the overwhelming majority of bird photographers are amateurs with fairly basic equipment. And whilst a photographic safari would be very exciting, a wide variety of birds can be found in your own garden—and may be photographed without even going out.

Encouraging the birds

Before attempting any photography of birds in the garden you must get them used to visiting the part of the garden you intend to photograph. Birds are easily encouraged by a regular supply of food, especially in winter when there is little natural food elsewhere. Place the food on a bird table, in a nut bag or even on the ground: different species will be attracted by different food and also like to feed in different ways, so experiment with different positions.

Some foods are better than others—both from the point of view of the birds and photography. White bread, for example, looks unattractive in a picure and whilst many birds will eat it readily, it is not very good for them. Peanuts are an excellent food in winter but should not be put out during the breeding season in spring, as many baby birds find them indigestible and may choke on them. In fact the breeding season is not a good time for bird table photography: the middle to the end of winter is the best time.

The siting of the food will also influence which species of birds arrive at the bird table. A nut basket will encourage the acrobatic tits, but birds such as jays and many thrushes prefer to feed on the ground. Nearly all birds, however, will use a bird table if there is little alternative.

Putting food out for birds may also attract other animals, some more welcome than others. Squirrels often raid bird tables for food and though bird lovers may object to their presence, the photographer may regard them as a bonus. Cats may also be attracted, either by the food or by the birds, and should be discouraged.

You may have to wait some time after putting out the food before the birds get used to your chosen spot. Often it takes several days, though if there is

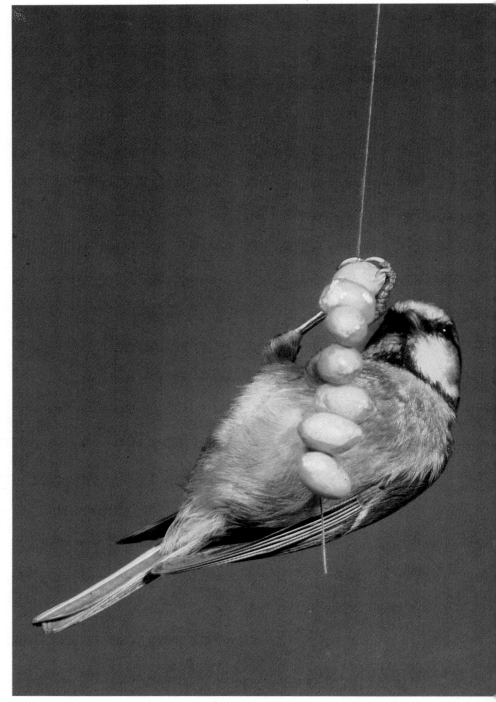

snow on the ground covering all normal food, a few minutes may be enough.

Equipment

Having brought the birds down, the simplest way to photograph them is to use an air release to take your pictures from a distance—hidden in a shed, for example. The air release is similar to the more familiar cable release but is

much longer—usually about 6 meters—and fires the camera shutter pneumatically. Air releases are fairly inexpensive, costing no more than a couple of rolls of slide film. If you are operating your camera from a distance you will need to support it in some way and a sturdy tripod is best.

It is also possible to take pictures of your bird table with the camera in-

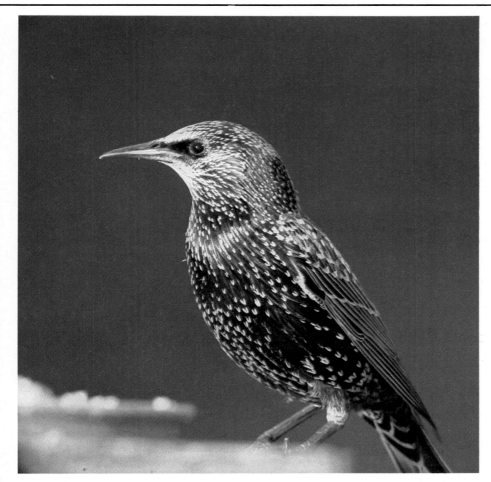

be noticeable, however, provided the window is clean and the lens hood is pressed to the glass to avoid reflections. Choosing the right lens is very important. For shots of an entire bird table a standard lens will probably suffice. However, with a standard lens the camera will be close to the table and shutter noise may scare off the birds—at least at first. A telephoto lens is best as it enables the camera to be further from the table. For shots of a whole table a lens in the order of 100–135mm (on 35mm format) is ideal, while for the close–ups of individual birds use something slightly longer—say 200mm. Even with telephoto lenses the camera will often need to be no further than 1·5 metres from the subject, making extension tubes or bellows essential with some lenses.

Operating the camera from a distance creates the problem of how to wind on the film after each exposure. Going to the camera each time to wind on the film will scare the birds away and they often take progressively longer to return every time they are disturbed. A power wind to advance the film automatically is now available for a wide variety of cameras, and is the best way of overcoming this problem. A few power winds will not work with a cable release, but electrical devices to operate camera and autowind together are available for certain systems.

▲ Once birds are accustomed to a safe, regular feeding place they become quite fearless. *Jane Burton* photographed this starling on her kitchen windowsill, on the second storey, with the camera propped over the sink and a flash gun on either side. Here she used an extension tube.

◄ Different birds will come for different food. Acrobatic blue tits—this one was taken with flash—like to feed from strings of nuts. *John Markham*

► If a bird is startled at the bird table, only a very fast shutter speed will stop the movement. *Tim Cook*

doors. Birds will still come down to feed providing the photographer remains very well hidden, and having the camera indoors allows adjustments to be made to focusing and exposure without scaring off the birds. However, shooting from indoors does create added problems. Window glass is not perfectly flat and a slight loss in optical quality is inevitable. This is unlikely to

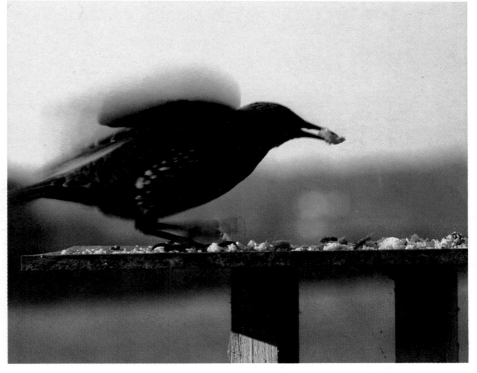

Flash

Electronic flash is by no means es-
sential for bird photography in the
garden, but it can vastly improve re-
sults especially with the smaller birds.
Many professional bird photographers
use a powerful electronic flash with two
or even three flash heads.

There are two basic reasons for this: in
winter natural lighting tends to be
rather flat, and with experience it is
possible to position the flash heads to
give the effect of a sunny day. Ideally,
one flash head is positioned as high as
possible to one side of the camera (to
simulate the sun), another is positioned
the other side of the camera to fill in
any shadows produced by the first, and
a third may be used to illuminate the
background. The second reason for
using a flash gun is that the very brief
duration of the flash helps to stop the
extremely fast movement of small
birds.

Whilst such equipment may be beyond
the reach of most amateurs, several
small electronic flash guns, with those
away from the camera being fired by
light sensitive 'slave' units, will produce
the same effect. Even a single flash
gun, mounted above and to one side of
the camera, will make an improve-
ment. However, though electronic
flash will synchronize with between–
the–lens shutters at any speed, with
many focal plane shutters it can only be
used at 1/60. In bright sun this may
result in over–exposure from the day-
light, even with the lens stopped right
down, so flash is best used on dull days
or in the shade.

Setting up the equipment

Whether you decide to photograph the
bird table with the camera indoors or
outside operating an air release from a
convenient hiding place, pre–set the
controls in the same way. Put your
camera and lens on a tripod and focus
on the chosen spot. Most of the pioneer
bird photographers used the smallest
aperture available to them, despite the
long shutter speeds necessitated by the
slow films that were then available; and
certainly an aperture any larger than
about f11 is unlikely to give sufficient
depth of field to get the whole of a small
bird in focus.

▶ *David Sewell* had focused on a nut
bag hanging in a tree when this green-
finch came down and at the same time
the bag swung out of frame. The shot
was taken with flash at 1/8, giving
enough time for daylight to register.

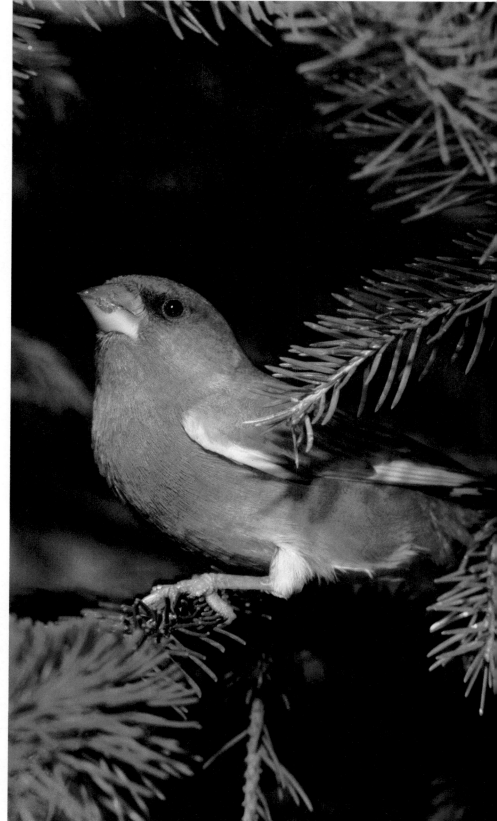

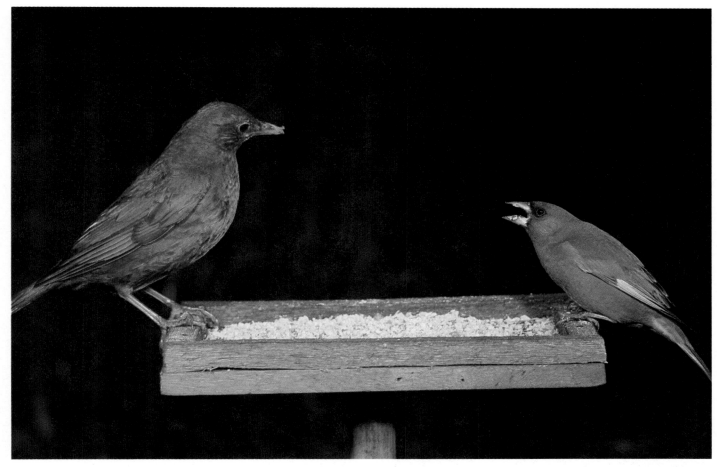

▲ Birds will get used to the sight and sound of inanimate camera equipment —even flash—as long as it is operated by an air release, not a human being.

▼ Two flash guns were used for the picture above: one off the camera, high and to the right, and one close to the camera, diffused with tracing paper.

The shot was taken in daylight but the exposure, set for flash, was not sufficient for the natural light to register the background. *John Markham*

A fast shutter speed does not necessarily help to stop movement of the birds if they are nervous of the click of a camera. In fact if a bird reacts at all to the noise of an SLR (probably the noisiest type of camera) it reacts to the noise of the mirror going up, and is already moving by the time the shutter opens, so a faster shutter speed may still fail to stop the bird. However, birds soon become used to camera noise and after a few exposures usually tend to ignore it, as they do the brief, intense illumination of electronic flash. When flash is not being used, the ideal lighting is a weak, hazy sun throwing soft shadows. Strong sunlight will cast harsh shadows, whilst on an overcast day modelling tends to be poor. Generally speaking, the light source should be behind the camera for bird table photography, although shooting against the light will produce some interesting effects.

Birds around the garden

Having tried some photography of birds at the bird table a photographer may decide to go for more natural looking shots.

Most small birds approach the food source from a bush or tree in a number of small hops, coming lower as they get closer, so that if you set up a perching point in a direct line between the nearest bush and the food—slightly lower than the bush but higher than the food—it is likely that a fair proportion of birds will perch on it, and you can pre–focus on that perch. Birds are always most likely to perch on the highest point, so bear this in mind when you are pre–focusing.

You may improve your shots by adding an artificial background behind the perch—a sprig of greenery, some dead leaves or anything that both looks natural and complements the subject. If well positioned, an artificial back-

▶ **Like this Burchell's coucal, many birds are luckily so startled by flash that they freeze during the long exposure needed to register background.**

ground need not be very large—about four times the size of the bird is usually adequate—and can hide any distracting features, like a concrete path or a fencing post for example. It is often better to place the food on the ground rather than on a bird table when photographing with a special background. Use something like a small log for the perch and set up the camera so that it is pointing down slightly to lose any distracting background.

The birds that come into a garden vary from area to area; and even within the same area individuals of the same species will vary widely in their reaction to the camera. As in all other fields of wildlife photography, those who are both patient and willing to experiment will always produce the best results.

◀ **Large birds have a slower metabolism and move more slowly, giving the photographer more time to compose his shots. If your camera is limited to a slow shutter speed, stick to larger species.** *E.A. Janes*

▶ **Because jays are comparatively nervous birds, *David Sewell* went out to photograph this one in the quiet of the early morning. The picture, taken in natural daylight on 50 ASA Agfachrome at f5·6 and 1/60, shows the long shadow thrown by slanting sunlight.**

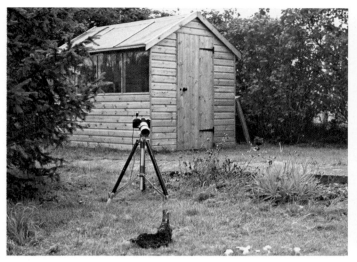

▲ *David Sewell's* camera set up for taking pictures of birds on the ground; note the air release running back into a convenient garden shed. He positioned the log several days before shooting to get the birds accustomed to it.

▲ Shooting with the camera set up as on the left, he introduced more foliage for this shot, and added two flash guns: one low and to the left, at the base of the tripod, and one on the right, higher and closer to the camera.

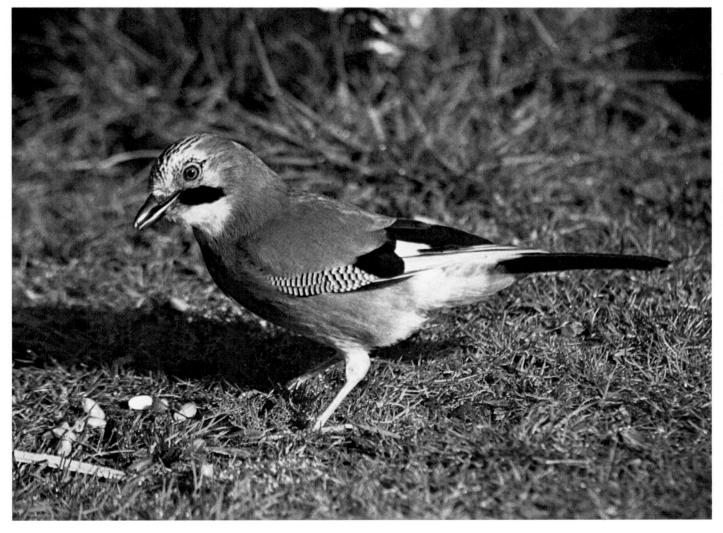

Photographing from a hide

A hide is the wildlife photographer's greatest asset if he is in search of shots of wild creatures that are wary of man and have very keen eyesight.

Mammals with a strong sense of smell will steer clear of a hide if the wind is in the wrong direction and they scent the human being inside it, and for small creatures that show little fear of man—such as newts and toads, moths and beetles—a hide is unnecessary. For bird photography, however, a hide is the photographer's ideal cover.

The hide, or 'blind' as it is called in North America, originated in Great Britain at the end of the 19th century when the Kearton brothers—Richard and Cherry—observed how little notice birds took of everyday countryside objects and reasoned that they would take equally little notice of a photographer if he was disguised as a cow, a tree trunk or other appropriate object. In fact, it soon became clear that most birds would accept an object of almost any shape provided it was introduced into the vicinity gradually and did not flap about in the wind, and soon hides like those in use today had evolved.

It is possible to use an ordinary tent, or even a car, as a hide, but for those who wish to construct one, details are given below.

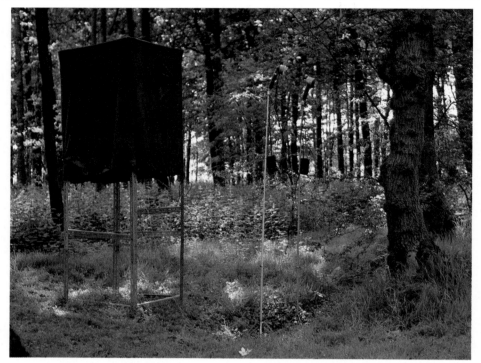

▲ A platform hide, built by *Eric Hosking* to photograph a Great Spotted Woodpecker: from about 2 metres he used a 135mm lens, with two flash guns halfway between the hide and the tree.

▶ Taken from the hide shown above: on Kodachrome 64 with an aperture of f16, the shutter speed synchronized for flash was not long enough to register any daylight in the background.

Constructing a hide

A simple hide for use at ground level consists of a frame of four sturdy uprights driven into the ground (1), linked at the top with four cross-pieces (2) to make a box shape with sides about 1 metre wide and 1½ metres high. Over this is a covering which may be of any waterproofed opaque material (3) with a funnel for the camera lens (4) and peep holes so that the photographer can see what is going on all around him. A ground hide like this is quite simple to make, and there are also some excellent commerically-made hides on the market.

For the more experienced bird photographer, building a hide in a tree or on a cliff face is a good test of ingenuity. For photographing nests up to about 3 metres above ground level, a platform made of Dexion is ideal. Dexion is intended for use in storage systems and resembles a child's construction toy, but on a very large scale. Several types of Dexion are available from builders' merchants or large ironmongers, and the type known as Dexion 225—the lightest available—is especially useful for building hides.

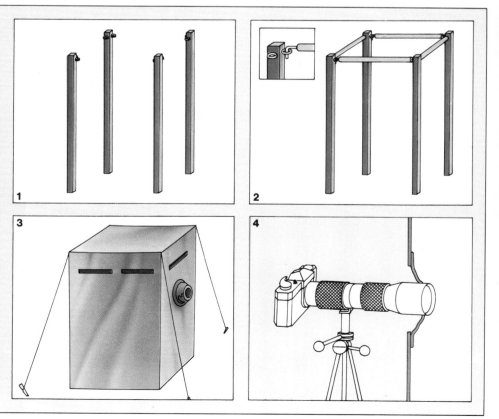

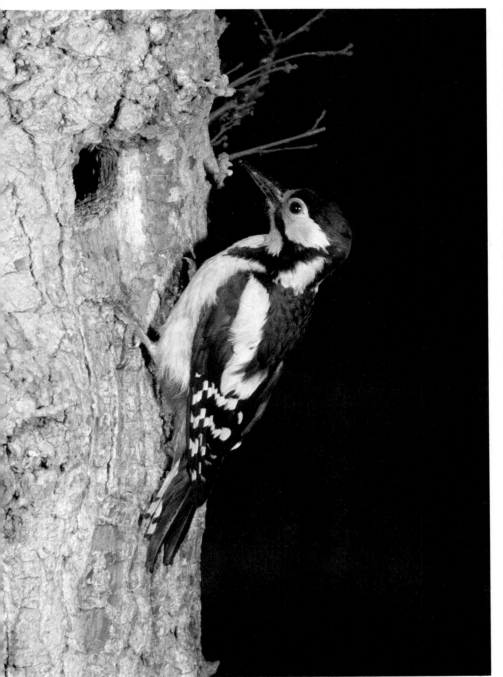

part of your hide until it is complete. Whichever method you use, make sure that your subject has accepted the latest measure at every stage.

Some form of camouflaging is useful, more to disguise the hide from onlookers who might create a disturbance than to deceive the creatures themselves. Some wildlife photographers use camouflage netting to disguise their hides and others cover them with vegetation. Because of the risk of being disturbed by other people, it is best to keep to private ground for hide work.

Excess vegetation can be removed from the area, but in order to protect your subject such 'gardening', as it is called, should be kept to the minimum. At the end of the session it is vital that the surroundings should be returned as nearly as possible to their original state. When your hide is complete, it is important that you are 'seen into' it by a companion who then walks away so that the birds and animals in the vicinity believe that there are no longer any human beings present once you are discreetly hidden inside.

Photographing at bait

'Bait' can mean anything from bacon rind on a bird table or a saucer of milk set out in the garden for a hedgehog to the carcass of a rabbit slung out on to a mountainside to attract carrion birds. The type of bait will depend on what you hope—or can expect—to attract near your hide. And in the hard winter months, when food is scarce, your bait may attract more than you expect. Mammals which normally give a hide a wide berth may overcome their fear of humans enough to take your bait: mice and squirrels may appear at the bird table, or stoats arrive to feed off the rabbit's carcass. One way to encourage this is to arrange the bait upwind of the hide so that the mammals are less likely to scent your presence; another is to leave at least six metres' distance between the hide and the bait and use a long lens—say a 300mm.

Photographing at the nest

Any photographer who cares enough about birds to want to photograph them will realize that this is an area which must be approached with a great deal of caution and considerable knowledge of the subject. It is important to take extra care when introducing the hide so as not to disturb the nesting birds; it is also worth making the hide a fairly sturdy construction since once it is there you may want to use it for several weeks as

Working from a hide

Any hide must be introduced very gradually on to the scene, giving the wildlife in the area plenty of time to accept it and realize that it is no threat to them. Trying to rush this part of the operation will result in no pictures—and with nest photography it could easily mean a deserted nest as well.

There are two methods of getting your hide into position. The first is to erect it as much as 70 metres from the nest and then move it closer day by day: to photograph a nest in open grassland, for example, the nest might be moved to within 35 metres on the second day, then 15, 10, 5 and then into the working position.

In areas of thick vegetation or above ground level where this technique is impractical, an alternative is to start by introducing some alien object—like a rag tied to a stick—into the eventual working position and each day introduce

the young birds in the nest develop. Before even beginning to take pictures from a hide at nest, wait a while and look for the places where the parent birds perch on their way to the nest. These positions will be used again and again, and knowing where they are will make focusing a great deal easier.

'Wait-and-see' photography

Wait-and-see photography often demands more patience than other types of wildlife photography: indeed, on occasions it can seem to be all wait and very little see. The hide should be set up on a likely site, such as the edge of an estuary where ducks, geese and waders feed regularly, and the photographer simply watches for what comes along. Very long waits sometimes prove rather arduous with this type of hide photography, but patience will be rewarded more often than not.

Because of the time involved in hide work it is best to be as comfortable as possible inside. The photographer needs a reasonably comfortable seat and the camera needs a tripod. In cold weather an insulated flask of soup or a hot drink should also be regarded as an essential item of equipment.

Camera equipment

Choosing the right lens to suit the subject is of paramount importance. For wait-and-see photography a powerful telephoto, perhaps a 500 or 1000mm mirror lens, is the most useful, with a shorter focal length lens as a back-up in case some animal or bird wanders within a few feet of the hide. To be unprepared

for this after hours of waiting would be frustrating to say the least.

There is a divergence of opinion among wildlife photographers as to which lens is best to use for bait and nest photography. Some like to work fairly close to their subject using a medium telephoto lens—about 135 to 200mm—while others prefer not to risk disturbing the subject and use a 300mm lens. In fact, different lenses suit different subjects: often, because of the surrounding vegetation, it is impossible to get very far back from the subject, and when building a hide in a tree you seldom have a choice how far you will work from the nest. In many ways a zoom lens is best, covering perhaps the range from 80 to 250mm, or 100 to 300mm.

Lighting and exposures

For larger birds and animals daylight is perfectly sufficient. A shutter speed of 1/125 will be enough to freeze small movements, although 1/250 is better, coupled with a small enough aperture to give good depth of field—preferably at least f8. Where poor lighting makes it

necessary, sacrifice shutter speed rather than depth of field, and wait for the creature to pause for a moment. Shutter speeds as long as ¼ second are possible with a tripod: indeed most early wildlife photographers worked regularly at these speeds.

Small, quick creatures, especially birds at their nests, are often in dark places, and flash may become essential. Birds tend to show little reaction to electronic flash which—to avoid harsh shadows—should be provided by at least two flash heads. Ideally, the more powerful flash head should be to one side of the subject, facing downwards to simulate sunlight, with the weaker light source on the other side to give some fill-in. In practice, however, it is often necessary to compromise because of the surrounding vegetation, and the most common solution is to site the flash heads on either side of the lens at about the same height.

Fieldcraft

Although wait-and-see photography tends to be subject only to the normal laws of the land, nest photography is now restricted in the case of rarer species in many countries. For both your own and the birds' sake, therefore, you need a good knowledge of ornithology and the law or the help of an experienced ornithologist before you begin to photograph a nest.

Finally, remember that the overriding rule in wildlife photography is that the subject comes first at all times, and that if ever the subject shows signs of distress it is time to put away your cameras, pack up your hide and go home.

IMPROVISING A HIDE

▲ **Your own car can serve as quite an effective hide.** Once you have pulled up in position, arrange the camera and equipment—here the photographer is using a cushion to support his long lens on the edge of the window—and keep very still. If it presents no threat to them, the creatures in the vicinity will gradually accept the presence of the car.

► **Mammals tend to be more wary than birds:** many have a keen sense of smell which alerts them to the presence of even the most well-hidden human being. Try using some suitable bait to tempt them to come closer, or, as *E.A. Janes* did with this grey squirrel, learn to anticipate their habits. When you have a good idea of where your subject might appear, always position yourself downwind of the area.

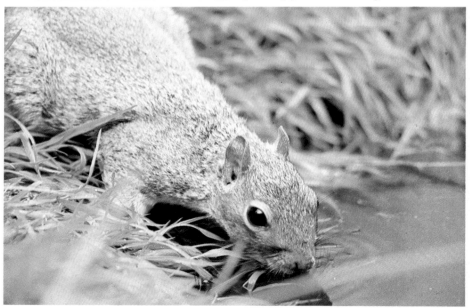

CHOOSING A LOCATION

▲ For this precarious shot of a gannet and its young, *Alfred Gregory* used a 200mm lens. Shooting downwards against a dark blue sea, he had to take care not to over-expose the white feathers: on Kodachrome 25 his exposure was 1/125 at half a stop below f8.

◄ Photographing at a nest is one of the most rewarding ways to use a hide but it can also be the most awkward. This commercially made hide has pockets at the bottom to hold stabilizing rocks and stones if the ground is too hard to drive in tent pegs. However tricky it is to build your hide, cause as little commotion as possible or the parent birds may abandon the nest entirely. It is worth taking trouble over building a hide at nest so that you can return to it several times to photograph the developing chicks.

Birds in the wild

The would-be bird photographer has to make one of two basic choices. Either the birds must come to the camera or the camera must go to the birds.

Going after birds can be easy or very difficult. It is simple to take pictures of peacocks and sparrows, say, in a park. It is difficult to stalk wild birds in the field.

Fearless birds

There are still places where birds show little fear of man. These isolated areas are mainly in the Arctic or Antarctic. Birds have yet to learn to be nervous of man on many oceanic islands such as the Galapagos or the Shetlands.

In many of these places it is possible to do a day's photography using just a standard lens. It is preferable to use a short telephoto lens to avoid disturbing the birds.

Birds in other spots have been tamed by constant contact with man. The obvious example is waterfowl on a duck-pond or lake, which have been conditioned by constant feeding.

A bag of bread will entice an abundance of subjects. The best technique is

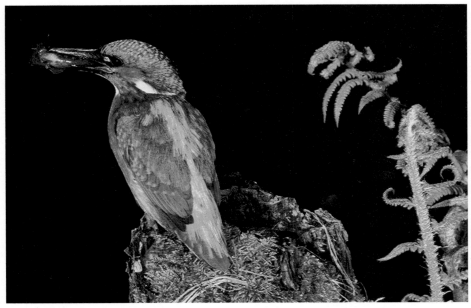

▲ The kingfisher is a very shy species that is often hard to see unless it is flying. Focus on a regular perch which it will land on having caught food or before entering the nest. *Ian Beames*

▼ Some common birds, like the wood pigeon, are relatively fearless of man. They can be attracted within range of a 135mm lens with some grain or a supply of bread. *E A Janes*

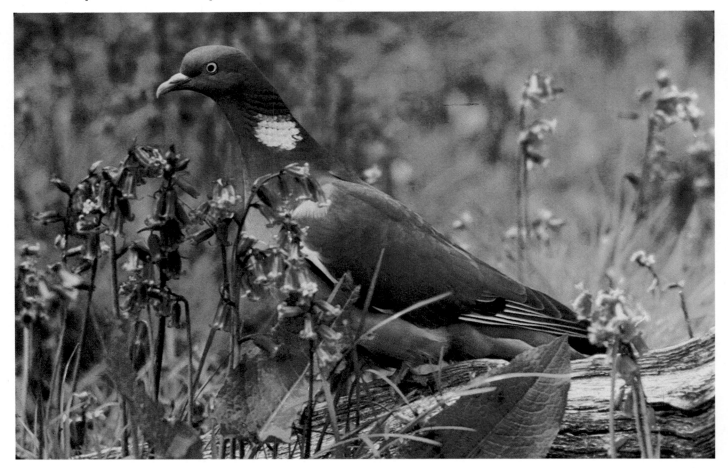

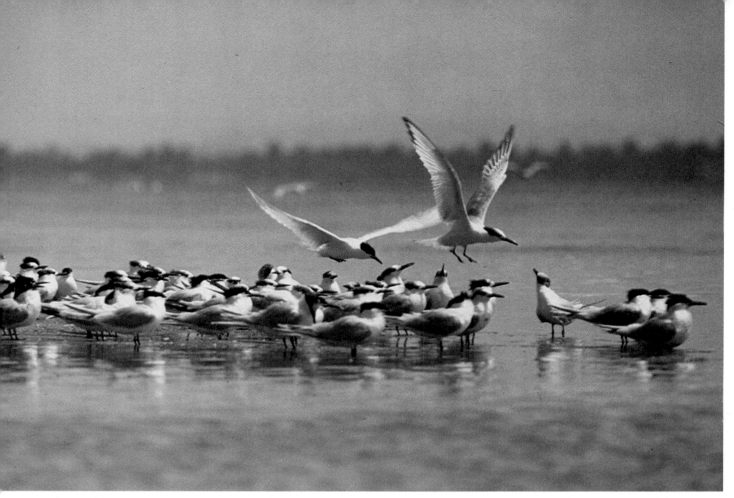

to throw in one or two pieces at a time. Throwing large quantities results in a flurry of movement, usually too fast for the camera to capture.

The same technique can be used on sparrows and pigeons in parks and gardens. More nervous birds will come within camera range if the photographer is out of sight in, say, a car or shed.

A lens in the range 135mm to 200mm is usually long enough for this type of photography. Car parks at wildlife reserves are particularly likely to be good places to work.

Speed and aperture

Bird photographers disagree about the best shutter speed and aperture combination to use. Some prefer a short exposure and a large aperture. This helps to freeze movement and to make the bird stand out from the background. It can also create a distracting out of focus foreground.

Others, arguing that the bird should be shown in its natural habitat, use a small aperture. This means using a longer exposure which wastes many shots due to movement blur and/or camera shake.

The camera should be supported whichever combination is chosen. It is usually possible to wind the car window down and rest the camera on a window ledge. Use a soft support such as a bean

bag to place the camera on.

This technique can be used in other places. A boat, for example, might replace the car. It is quite possible to photograph normally nervous water birds by keeping low and quiet.

Flying birds

Photographing birds in flight presents a great challenge. For many years flight photography was restricted mainly to large birds with comparatively slow wingbeats. Electronic flash systems have been developed with sufficiently short flash duration to freeze wings in flight. Specialist firms should be consulted.

There is an added complication that many small birds can only be photographed in flight, in captivity. It is illegal in most countries to trap wild birds without a permit. So, for the time being at least, this is not a field for amateurs.

Larger birds present fewer problems. A short shutter speed will freeze the wings (although a slight blur at the tips can help to give the impression of movement). Use a speed of 1/250 for a slowly gliding bird, 1/500 if it flies towards the camera and 1/1000 if it crosses the field of view at right angles. Birds flying away from the camera generally do not look interesting.

Many sea birds in temperate climates

▲ **For birds in flight you need a fast shutter speed to 'freeze' the action, and a wide aperture to throw the background out of focus.** *Per Eide* **used the technique for these terns.**

can be photographed with a 200mm or 300mm lens, as can the occasional crow, heron or wader.

It is best to pre-focus the lens rather than to attempt focusing on a rapidly moving subject. Release the shutter a fraction of a second before the bird flies into sharp focus.

Finding a suitable subject is often the most time-consuming part of taking bird pictures. Seabirds such as gulls are found in any sea port or harbour. They are most easily photographed in flight from a ship. Large flocks of gulls follow ships for hours after leaving port. They glide behind at approximately the same speed as the vessel.

Birds in flocks

Birds in large flocks, flying or on the ground, can make spectacular pictures. Photographing flocks in flight requires the same techniques as taking a picture of an individual on the wing. The size of a flock makes it possible to work from a far greater distance from the subject. Of course, the individual birds will appear much smaller, but approaching the flock is less of a problem.

Depth of field is usually a more important consideration than shutter speed when photographing flocks. Using a large aperture will keep only a few birds sharp. The rest will be a disconcerting blur. Small apertures, say f16 or f22, will bring most birds into focus but the exposure will increase.

Autumn, when birds migrate, and winter are the best times to look for birds in flocks. Swallows on telegraph wires are often easily approached. Other birds — like geese — stay in flocks right through the winter.

Stalking

Attempting to take photographs by stalking is like shooting. The major difference is that the photographer carries a camera instead of a gun.

The equipment can resemble a gun as well. A 300mm lens may be long enough to stalk a few species, something more powerful is more practical. Most stalkers use lenses of 500mm or longer. Some prefer to use mirror lenses because of their lighter weight.

Lenses of this length require some sort of support. A tripod is usually impractical in heavy undergrowth. A monopod is more useful, as is a shoulder support or rifle grip.

A camera on a shoulder support should be raised, focused and then lowered

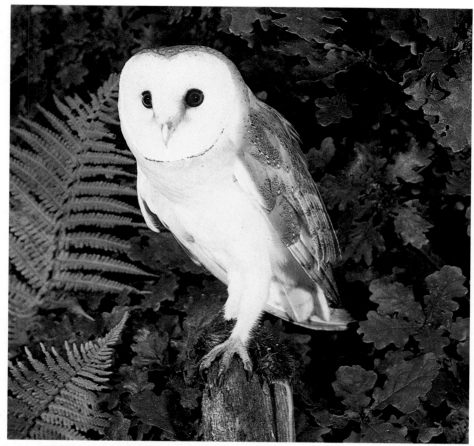

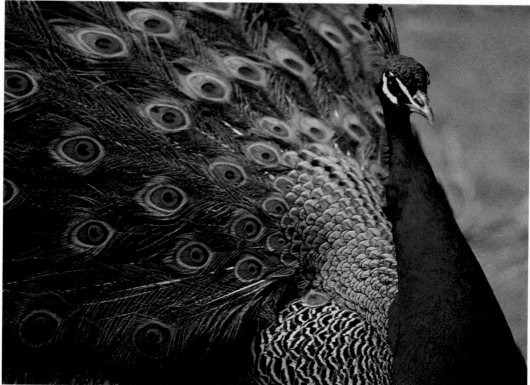

▲ This barn owl was taken on a 6 x 7 roll-film camera with a 180mm lens. (This is equivalent to using a lens of about 105mm on the 35mm format.) The owl was lit by two Metz 402 flash heads. *Ian Beames*

◄ Exotic birds like the peacock can be found in many parks and gardens. They are quite often tame enough to be photographed with a standard lens. Close-ups of their colours and feathers can be shot with a short telephoto lens. *John Garrett*

► Large numbers of birds may be photographed from a greater distance than an individual. It is more important to get plenty of depth of field than to use a fast shutter speed when taking pictures of groups like this gannet colony. *Heather Angel*

slightly. The photographer should rest for a moment and then raise the camera, frame the picture and take it. Holding a heavy lens and camera up for more than a few seconds makes the arms shake.

Birds have excellent sight and good hearing. Move quietly and keep talk to a minimum. Better still, stay silent. Wear colours that blend in with the background. Greys, greens and browns are excellent. Bright red or yellow anoraks are useless. Avoid appearing on the skyline and make use of whatever cover is available.

Stalking is undoubtedly one of the most difficult aspects of bird photography. It can also be the most productive. The stalker stands a chance of recording birds' daily lives, including feeding and courtship displays.

Equipment

Light, small cameras and lenses are best if the phtographer is to go after the subject. A 35mm SLR is adaptable and easy to carry. There are also some light-weight models available.

It may not always be possible to use a tripod but some kind of support is always necessary with long lenses. A tripod is best. A monopod is a less-cumbersome alternative.

Finally, read and observe the *Nature Photographers' Code of Practice* before attempting stalking. It has been reproduced on pages 234 and 235 of this book, and contains many important recommendations relating to birds.

Wildlife of any kind should never be damaged or destroyed for the sake of photography.

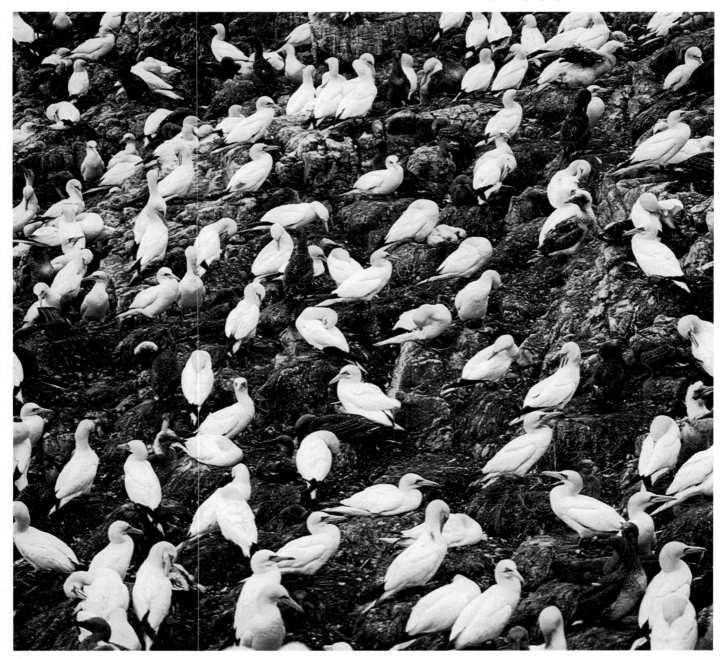

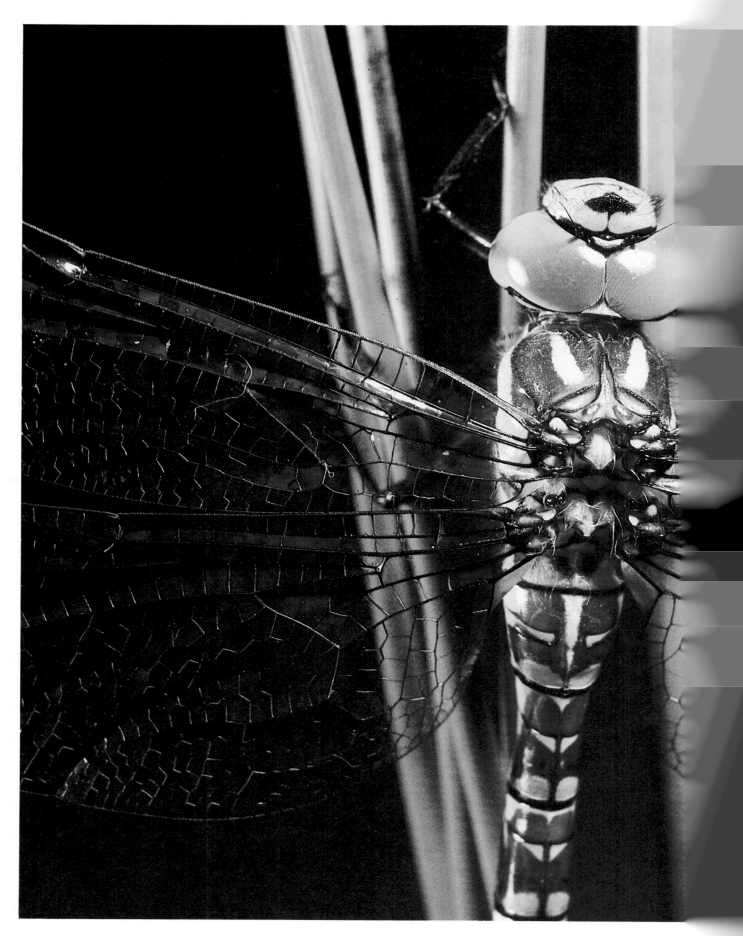

NATURE IN CLOSE-UP

With all living creatures, whether plant, insect or animal, the closer one gets to the subject the more detail is revealed. With man-made objects, coming too close can reveal the imperfections of the subject; in the world of nature the nearer the approach, the more intricate and beautiful the patterns seem.

This chapter shows you how to photograph small natural objects and creatures at close range, and how to do it well. There are various ways of achieving close-up photography. Lenses are of particular importance and other technical aspects, such as exposure determination and depth of field, need re-examination under the special conditions of close-up photography. The modern fast films on the market are invaluable.

Subjects abound. Choose plants in your house or garden, fruit and vegetables in your kitchen, seed-heads and fallen leaves from roadside verges, the bark of trees or a spider's web jewelled with dew. The choice is endless, and looking closely at these things reveals a world of beauty previously unseen. Butterflies, beetles and bees are obvious choices, so are the brightly coloured creatures like dragonflies, but the less flamboyant moths can be very striking, so try photographing these. An even closer approach with a microscope allows photographs of such fascinating subjects as the scales from a butterfly's wing or the hidden beauties of individual snowflakes.

Two flashes were used for this studio shot of a
recently emerged female southern aeshna dragonfly *(Aeshna cyanea)*.

Equipment for close-up photography

If you want to be able to photograph small natural objects and creatures at close range, and make a good job of it, you need a few extra pieces of equipment which magnify your subject. These should help you produce much better pictures than if you were just using a standard lens. They should also make your subject fill the frame instead of being out of focus and lost somewhere in the distance.

No-one has to move far afield to find natural history subjects for close-up photography. They are all around us—in the garden, in woods, in meadows and even in houses. Fallen leaves, shells on a beach, and mossy carpets are all easy to photograph because you can take plenty of time to compose the picture. Low-growing carpets of flowers such as alpines or violets make colourful close-ups, as do fungi, insects and rock-pool inhabitants. By getting in close more impact is gained: it concentrates attention on detailed pattern, shape, form or colour.

A single close-up picture used out of context from the whole plant or animal may confuse and serve only as a puzzle picture. A close-up used in conjuction with the complete specimen can often provide additional information which is not otherwise apparent.

Choice of camera

The ideal camera for close-up nature photography is undoubtedly the single lens reflex (SLR), since the precise field of view can be seen in the viewfinder via the sole lens. On the other hand, twin lens reflex (TLR) and rangefinder cameras, are more difficult for close-ups. The reason is that the area seen in the viewfinder is not identical with the area recorded on the film. Therefore, anyone who wishes to concentrate on nature close-ups would be wise to use either a 35mm or a 6x6cm SLR camera. The advantages of a 35mm system are that it is lighter in weight and usually considerably cheaper than a 6x6cm system. Also a variety of macro lenses of different focal lengths are available only with 35mm systems.

Getting in close

What do you need to take close-up photographs? Essentially there are four basic ways of getting in close;
1) putting a close-up (supplementary) lens in front of the camera lens;
2) inserting extension tubes in between

▼ The items in this picture are the 'essentials' belonging to one photographer who specialises in close-up photography. You can see an equipment bag made by Tenba, a Nikon FM with 55mm f3·5 macro lens and MD12 motor drive, a Lunasix 3 exposure meter, a Metz 402 flash unit + a twin head, 14mm and 28mm supplementary lenses, 105mm f4 Nikkor macro lens, a cable release, a Novoflex bellows, a Minicam ringflash and a Gitzo tripod. You could start off with just one or two items apart from the basic SLR to begin close-up photography. (By the way, the fungus in the background is Dryad's Saddle or Polyporus squamosus!)

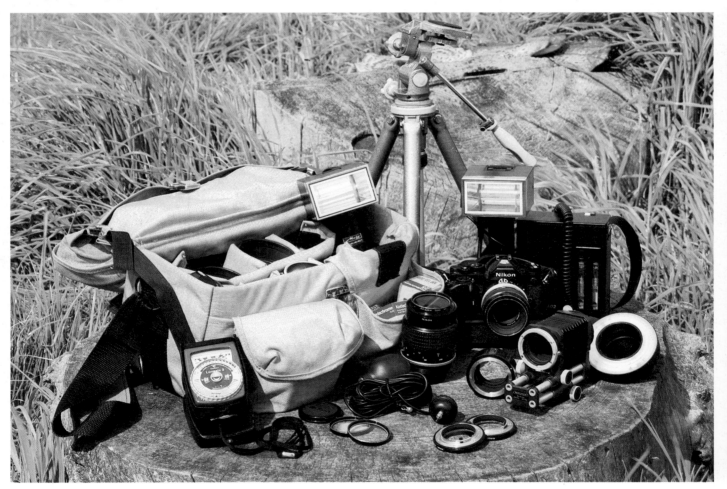

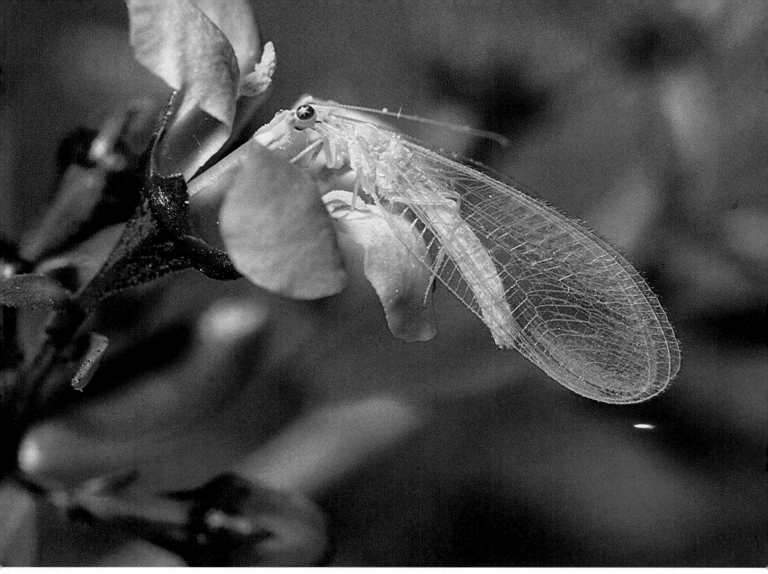

a prime lens and the camera body;
3) inserting bellows in between a prime lens and the camera body;
4) using a special macro lens in place of a standard lens.

Close-up lenses are by far the cheapest way of taking close-ups. Their cost is only a fraction of the price of a bellows unit or a macro lens. For fixed-lens cameras, this is the only way of getting in close. As the diameter of all close-up lenses is not constant, be sure to check the diameter of the front lens mount on which it is to be used. This will be the same as the diameter for filter mounts.

Close-up lenses are light, quick to use and have the great advantage that they do not reduce the amount of light reaching the film. They are made in a range of dioptres (a dioptre is a unit of power of a lens). A +2 dioptre lens magnifies twice as much as a +1 dioptre lens. They work in the same way as a far sighted person wears glasses to focus on near objects.

With all these advantages why is it that serious wildlife photographers do not favour using close-up lenses? The main reason is that close-up lenses do not permit a really close approach—the limit is usually around 8 inches (20cms) or so. A single close-up lens covers only a limited magnification range. Also, any lens placed in front of the main camera lens will detract from its optical quality; the stronger the lens the greater the loss of image sharpness, especially round the edges, even with the prime lens well stopped down.

Extension tubes and bellows. SLR cameras which have interchangeable lenses enable extension tubes or bellows to be used for close-up photography. Extension tubes are cheaper and more robust than bellows and so are more suitable for field photography. Unfortunately, they are also of predetermined lengths so they do not provide a continuous range of magnifications. In addition, you have to take apart and use different amounts of extension for different magnification. Originally, both extension tubes and bellows were non-automatic. This meant that the lens had to be stopped down manually to the preselected aperture before a close-up picture was

▲ Mike Anderson took this picture of a Lacewing fly with a CSR Cosina Camera and a 90mm Vivitar macro lens. He used a single flash gun with a reflector to soften the light and an aperture of f16. The film was Kodachrome 25.

taken. It then became very difficult to see if the subject remained in focus, so a tripod was virtually essential. At the present time most extension tubes and bellows are fully automatic. This ensures the lens diaphragm is stopped down at the same time as the shutter is released.

While tubes and bellows give much greater magnifications than most close-up lenses, they both effectively reduce the amount of light reaching the film. Either a bigger aperture or a slower speed must be used to correct for this.

A macro lens is a lens designed *especially* for close-up work. Therefore it is a better choice than a standard lens with extension tubes for anyone who wishes to concentrate on close-photography. Most SLR 35mm systems have a 50mm or 55mm macro lens with their own

CHOOSE THE LENS

STANDARD LENS
With a standard (left) you cannot really take a close-up of a small subject. Most standard lenses have a minimum focusing distance of approximately 20 inches (50cm) without extra equipment, and you only get an image about one ninth of its original size. The series of three shots here (right and below) taken by Eric Crichton are all of the same piece of gorse. After the standard lens shot (right), Eric moved in using a macro lens, and finally the macro lens combined with a bellows. For the standard lens shot the lens was set at its minimum focusing distance. The film was Kodachrome 25 and the exposure 1/60 at f8 using the existing light.

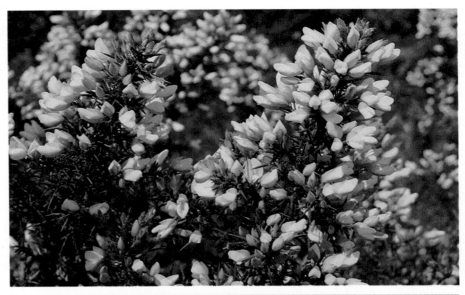

MACRO LENS
Macro lenses are specially designed for close-up work. They are available in various focal lengths and can be used in combination with other close-up attachments. Eric Crichton used a 55mm micro Nikkor with a Nikon FM for the picture here (right) taken at half life-size (1:2). The exposure was 1/60 at f22. For this and the picture below Eric had to use flash instead of available light. At these magnifications flash was needed for a smaller aperture to ensure that sufficient depth of field was achieved.

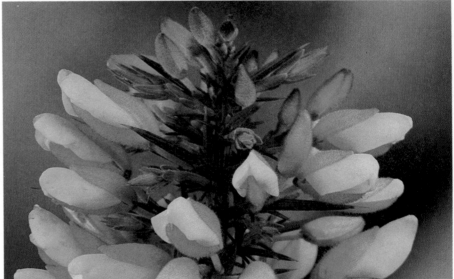

BELLOWS
A bellows in between camera and lens makes extreme magnifications possible. Bellows cover a range of magnifications so it is easy to switch from one to another, rather like a zoom lens. A 55mm macro lens with bellows was used here. With flash, the exposure was 1/60 at f8.

built-in extension, which allows for a continuous focusing range from infinity down to half life size (1:2) without any accessories. As with a standard lens, greater magnifications can be gained by using extension tubes, bellows or close-up lenses. Macro lenses with longer focal lengths are also available. The advantage of the 105mm and 200mm lenses is that the working distance between the camera and the subject is increased. In this way active insects, such as butterflies, are less likely to be disturbed. Also, the photographer is less likely to stop light from reaching the subject. However, longer lenses are less easy to hand-hold without fear of camera shake in available light.

Exposure for close-ups

Most SLR cameras now have a through-the-lens (TTL) metering system. This allows for quick exposure adjustment when using extension tubes and bellows, but depends on the subject being evenly lit all over the frame. If the camera has precise spot metering, close-ups with large shadow areas or sun spots will not present problems. Cameras which give an overall average TTL reading will not give an accurate exposure reading for difficult lighting. You can calculate the exposure increase required from the tables supplied with the extension tubes or bellows (for example, an increase of one stop is required when a 25mm extension tube is used with a 50mm lens, and two stops when a 50mm extension is used with the same lens). Alternatively, you can change the camera position so that it can meter a larger area of a similar intensity to the subject itself. For all cameras without TTL metering the exposure will have to be made with a separate exposure meter and the exposure increase calculated for a given amount of extension and a given focal length of lens.

Depth of field

The zone of sharp focus in front of and behind the plane in which a lens is focused is known as the *depth of field*. When using a wide-angle lens and a small aperture, the depth of field extends over many metres at normal focusing distances. For close-up work depth of field is measured in centimetres; and at magnifications greater than life-size (1:1), in millimetres. Therefore for most close-ups it will be necessary to stop down the camera lens as much as possible so as to increase the depth of field, and thereby bring more of the subject into focus.

▲ **If you use a tripod and a long exposure, you can set a small aperture and get a completely sharp picture like the leaves here. (Make sure you choose a day that's not windy.) Heather Angel used a Nikon F2 camera with a 55mm micro Nikkor lens plus a tripod. The film was Kodachrome 25 with an exposure of 1/2 at f11.**

With static close-up subjects, the extent of the depth of field at different lens apertures can be checked by using the preview button available on better SLR cameras.

Camera supports

One of the most common faults with close-up photographs (not intentionally taken with a soft-focus lens!) is that they are not sharply defined.

The reasons for this unintentional soft focus may be due to sloppy focusing, camera shake and subject movement (apart from using too large a lens aperture instead of stopping down). A firm camera support is much more important for close-ups shot with available light than it is for more general shots. Whatever means is used to support the camera, it must be rigid. A tripod with wobbly legs is a complete waste of time, not to mention film. A conventional tripod, with the head fixed to the top of the three legs, will not provide much versatility for close-up pictures. For low-level photography it is essential to find some means of supporting the camera near to the ground. A tripod which allows the head to be screwed on to the base of a central column, so it is between the legs, is much more useful. However, shadows cast by the legs on a sunny day can create problems. A ground spike made either from a metal tent peg, or a series of nails projecting from a small piece of wood are cheap and sturdy low level camera supports. Both can be topped with a ball and socket head. A pan and tilt head costs more but works better. Such supports are suitable for all but rocky terrain.

Tree clamps and chest pods are other possible supports for close-up work. Tree clamps seem a sound idea when sold by a slick salesman, but when taken out into the field, there is rarely a branch in a convenient place!

Extras

When using a tripod, or any other camera support, it is sensible to avoid even the slightest camera shake by

using a cable release. Other useful accessories are a reflector and a large plastic bag. Aluminium cooking foil makes an effective cheap reflector and can most easily be wrapped around a piece of card. The lightweight survival blankets with an aluminium coating on one side (originally sold in camping shops but now available in photographic dealers) make invaluable large reflectors which can boost exposure by at least a full stop. Plastic bags are also useful—both for protecting a camera on a tripod during a rain shower and also for kneeling on wet boggy ground.

Differential focus

Although the essence of a close-up is that it concentrates attention on the subject, care must be taken to avoid distracting backgrounds which compete for attention. A useful technique is to make sure the background is thrown out of focus by controlling the depth of field so that only the subject is sharply focused, either by using a larger aperture or by increasing the magnification.

BACKLIGHTING
▲ A red campion flower photographed by Geoff Doré with a 50mm lens plus an extension tube. The backlighting shows up the tiny hairs of the stem of the plant, and by throwing the background out of focus ensures our attention is not distracted by it.

SIDE-LIGHTING
◄ 'Painted ladies' taken by Heather Angel with a 50mm lens on Kodachrome 64. The exposure was 1/60 at f11. A meter reading was taken from the sunlit side of the flowers. A reading which included the dark background would have resulted in over-exposed flowers.

SHALLOW FOCUS
▼ Sergio Dorantes took a close view of these tulips, but from a distance with a 500mm mirror lens! Close-ups are possible with long lenses, but depth of field is limited. The exposure was 1/8 at f8 on Kodachrome 64.

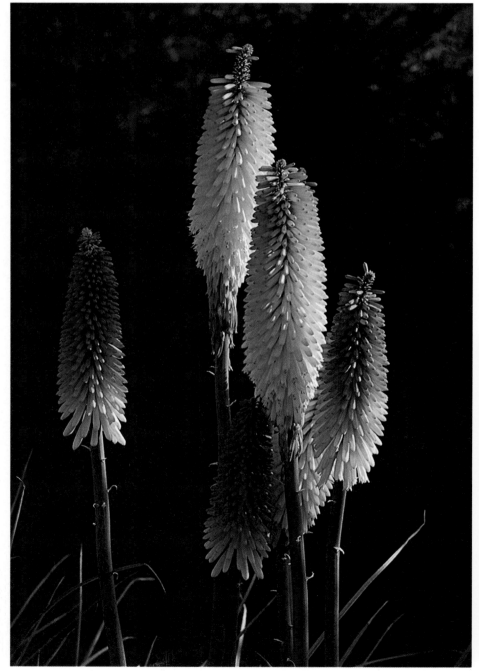

Films

Fast negative films—colour or black and white—show more graininess than slow ones, so do not use a film that is faster than you need. For general work a medium speed film (80-125 ASA) is best. In good lighting, you can change to a slower film (25-64 ASA).

Slow colour slide films also have finer grain than fast ones, but with this material, differences are so small that faster film can give sharper results because there is less shake, more depth of field at smaller apertures and stop-ping down improves lens performance down to about f11.

The Ektachrome (and other films for E6-type processing) give the brightest, most saturated colours. They can be uprated, but remember that a 200 ASA film gives better results than a 64 or 100 ASA film uprated. Similarly, use a 400 ASA film rather than uprate a 200 ASA type. Before sending it for processing be sure to mark the film as being uprated so that the development time can be extended. (The processing charge will also be increased!)

The Kodachromes are relatively slow and modern types are more pastel than Ektachromes. However, they are very reliable, can be kept longer before processing and are less susceptible to fading afterwards. Some people find 25 ASA Kodachrome gives the best high light rendering with flowers—but you have to be very expert to see the difference.

So, branch out! For a modest expend-iture you can widen the scope of your photography and see the world of nature around you.

USING FLASH
There are so many light-weight electronic flashguns available that carrying a single flash adds little weight to a gadget bag. But is a single flash ideal for close-ups? Used as a direct light it can create additional problems. For critical close-ups of insects and flowers, a twin flash system—where each flash is mounted on a bracket on either side of the camera—is useful. To synchronize both flashes use either a twin flash connector on the camera's flash socket, or use a slave unit on the second flashgun.

A ring flash is designed to encircle the front of the lens. While this enables record shots to be taken quickly, the uniform lighting gives little scope for creative close-ups. However it is particularly useful for photo-graphing deep-throated flowers.

▶ **Heather Angel used a Nikkormat Ftn and three Vivitar 273 flashguns (one in front and two behind) for this shot of an 'Earth Star' dispersing its spores. The lens used was a 55mm Micro Nikkor and the exposure was 1/60 at f16 on Kodachrome 25.**

Nature's patterns in close-up

The natural world is not random. Look around you: everything in nature has some sort of pattern. The shapes are so familiar that we tend to ignore them: the segments of an orange, for example, or patterns of sand on a beach. So take another look. You will begin to find fresh subjects with ready-made designs for your photographs.

Finding patterns

The simplest patterns often give the most striking results. The sweeping spiral of a Nautilus shell or the graceful curve of a feather speak for themselves. Crop in tightly on shapes like these so

that there is nothing to detract from the shapes themselves.

You do not have to look far. The plants in your house or garden, the fruit and vegetables in your kitchen are full of intricate design. With objects like this you have the avantage of control over the background and lighting. Even the markings on a tabby cat are a complex pattern—though this may be a more difficult subject to control! Try being adventurous and grow crystals like copper sulphate for their pure colour and for their clearly defined pattern.

Taking your camera into the countryside you will find patterns on a much broader

scale: patterns in the sky, in rock formations, in windswept reeds or grasses. A ploughed field has a very strong design: find a high vantage point to make the effect stronger. From an aeroplane the landscape falls into neat patterns that you would never even guess at from ground level.

It sharpens your observation of patterns in nature to follow a theme. Look at the similarities between different objects, like tree rings, ripples forming rings on still water, a sliced onion, your own fingerprint. Or photograph one particular theme on different scales—from one pine cone to a whole forest.

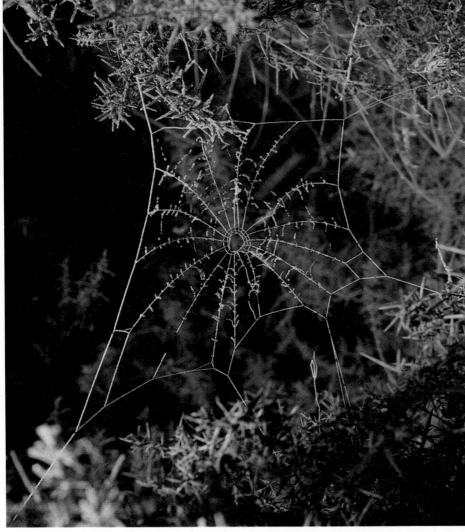

▲ The intricate design of a spider's web, picked out by hoar frost. *Heather Angel* used a Hasselblad with an 80mm lens and 21mm extension tubes. The lighting was flash, held to one side to leave the background dark.

▶ The centre of a Southern Chilean Bromeliad. Here *Heather Angel* used a Nikkormat with a 55mm micro-Nikkor lens. By available light, she needed a ½ second exposure to get an aperture of f11 on Kodachrome 25.

If you include several separate objects—such as a cluster of leaves—pay attention to the spaces between them and use these areas to balance the composition. Make use of shadows too. The overlapping leaves will make one pattern, and the shadows they cast will echo it.

Making the most of patterns

Different subjects call for different approaches. The compression effect of a telephoto lens tends to emphasize pattern by reducing three-dimensional subjects to two dimensions. It will also isolate a subject and appear to bring it closer. From a distance you can concentrate on one particular pattern, leaving the foreground and background to contribute to the picture only as an out-of-focus blur of colour. With a telephoto zoom, you can frame inaccessible objects accurately—even when your movement is restricted.

A wideangle lens, which in practice has the opposite effect on perspective, can also help to isolate a subject—this time by maximizing the difference in scale of near and far objects. It will also place greater emphasis on lines of perspective that run away into the distance, such as the ripples of sand on a beach or the lines of grain in polished wood.

Smaller, more intricate patterns, like those on individual petals, are best dealt with by a macro lens, extension tubes, bellows or some other close-up attachment. If you do not have TTL metering, don't forget that you will need more light and more exposure to compensate for most close-up equipment.

The exact amount will depend on how much the image has been magnified, which is in direct proportion to the length of the tubes. Depth of field will be limited, which may be useful for blurring a distracting background. Always use a tripod for macro work and stop down as much as possible. Use a

REPEATED SHAPES
▲ As on fabric or wallpaper, repeated shapes form a strong pattern. Close together, the shadowy bases of these plants show up the well-lit leaf formations on top. *Eric Crichton*

SYMMETRICAL SUBJECTS
▲ Nature seldom creates *perfect* symmetry. If you do come across a symmetrical subject like this, manipulate the light to make the best of the pattern. *Eric Crichton*

fine grain film for maximum detail and quality. Kodachrome 25 is best for colour and Panatomic-X (32 ASA) for black and white. For less contrasty results use a 100-125 ASA film. Working on a tripod and with long exposures, use a cable release or the self-timer to avoid camera shake. If necessary, fix your subject firmly with double-sided adhesive tape or plasticine.

Experiment with a magnifying glass when photographing small subjects, too. This will distort the patterns around the edge, often giving them more interest.

Lighting

For patterns in a flat plane, direct front lighting is best. To show texture, as with the gnarled bark of a tree, light your subject from the side. For patterns that look best in silhouette, like the skeletons of leaves in winter, backlighting will give best results. Use backlighting for translucent subjects, too. It will give clear, saturated colour with subjects like petals or thin slices of fruit. The light source does not have to be

◄ *Heather Angel* **chose this viewpoint so that the angle of the light would show up the identical rounded forms of these Sulphur Tuft fungi. She boosted the light with a silver reflector, shooting at ¼ at f8 on Kodachrome 25.**

▶ **Strong back lighting shows up the fan-shaped venation of this coco-de-mer palm leaf.** *Heather Angel* **fills the frame with the varying shades of green to create a striking abstract design.**

FLOWING DESIGNS
▲ **Patterns are not always symmetrical. The folds of this red cabbage—taken in the kitchen with flash and extension tubes—echo each other in a flowing design.** *Heather Angel*

VARIATIONS ON A THEME
▲ **Backlighting picks these kidney ferns out from their background. Similar, though not identical, they show variations on the same basic pattern.** *Heather Angel*

directly behind the subject. It can be positioned so that the object catches the light leaving a dark surround. Use the same technique for rim lighting to show the tiny hairs on the edge of a leaf or something as fine and delicate as a spider's web.

A sheet of glass or perspex can be useful if you are backlighting your subject. Place your subject on the glass and position your flash gun behind it. You can cut out a piece of black card to control the effect of the light.

A flash gun can be useful if you are looking for patterns to photograph outdoors as well. Use it as fill-in light for backlit subjects, or use it off the camera to give rim light or create a silhouette.

Why photograph patterns?

To come across definite patterns in nature—like the wings of a butterfly or a ring of toadstools in a field—is a delight. It is a pleasant reminder of the order which governs the natural world. Photographs which show this order have the same effect—from awe-inspiring landscapes to the microscopic detail of an insect's eye.

Patterns are compelling for their own sake, too. The bright colours and leading lines inside a foxglove are there to draw the bees towards the nectar. They have a similar effect on human beings, leading the eye towards the crucial centre more effectively than the most brilliant man-made designs. By framing and lighting to make the most of them, you can take advantage of these natural designs. After all, patterns in nature were fulfilling a function and creating an impact long before photography was ever invented.

EXTREME CLOSE-UPS
▼ *Nigel Coulton* took this picture of a butterfly's wing with a 55mm micro-Nikkor lens with bellows for an extreme close-up. He used flash and an aperture of f22 for the best possible depth of field.

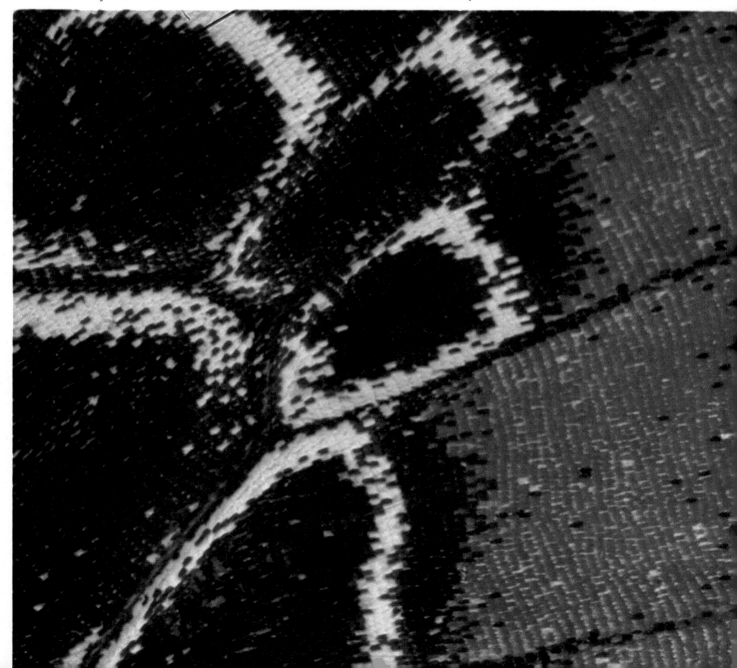

◀ Window light, shining from behind this plant on the windowsill, clearly reveals the veins of the leaf. *Nick Boyce* used a 55mm micro-Nikkor at about 2in (4cm) from the leaf. On Kodachrome 64 his exposure was 1/15 at f16.

▼ To show the tiny hairs on this peacock's feather in detail, *John Brown* used strong top lighting. The angle of the light also reveals the lustre on the turquoise area.

Close up on insects

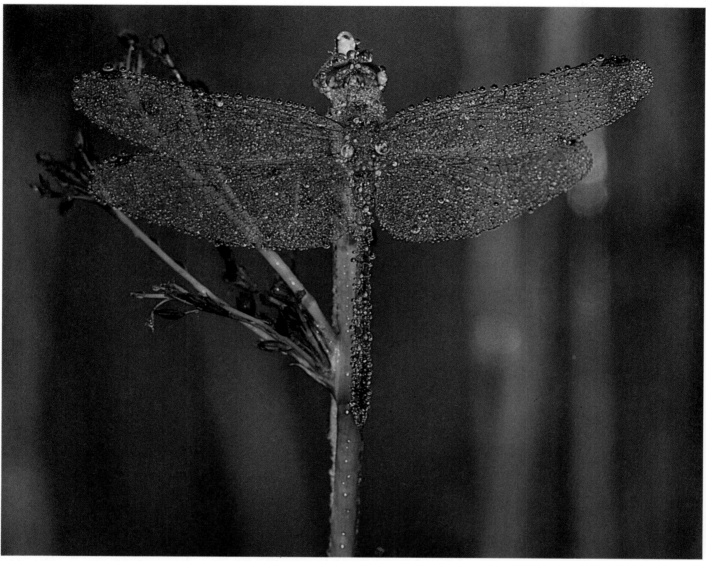

Insects are the most prolific creatures—both in terms of species and of numbers. Because they are so numerous there are always some close to hand, which makes the garden an ideal place to begin insect photography.

Further afield, ponds and canals are good sites for dragonflies, and butterflies appear in woodland clearings. Flowering meadows provide food for a variety of other insects like bees, beetles and flies.

Knowing where and when to look for particular insects is vital to their successful photography. Look up the time of year that adults of a given species are on the wing and find out their favoured habitat.

Butterflies, moths and dragonflies tend to be the most popular subjects to photograph because they are large and col-ourful. They are also active insects, which creates problems for the photographer working in close-up with a macro lens or extension tubes. Move up to the subject carefully and slowly. Avoid jerky movements. Focus by moving the camera. This is quicker than adjusting the lens, but the degree of magnification and focusing distance must be chosen before approaching the insect.

Equipment

A 35mm SLR camera fitted with a macro lens of about 105mm focal length is the ideal basic equipment. It is ideal for stalking larger and more wary insects: it allows rapid and precise framing and focusing without any fumbling for the correct extension.

The SLR will take interchangeable lenses and extension tubes without the problems of parallax error. A standard lens (50 or 55mm) plus extension tubes can also be used to photograph insects. A medium long focus lens (90, 105, 135mm) used with the same extension is better because it increases the camera to subject distance.

A bellows unit gives a greater range of magnification than extension tubes but it is less robust. In either case, choose a unit that automatically couples the lens and camera.

Depth of field is greatly reduced at magnifications greater than life size (1:1) and focusing becomes critical. The photographer must then choose between using a tripod or a flash gun to obtain smaller apertures.

More exposures of insects are discarded because of unsharp or blurred images than for any other reason. Tripods are

◀ **There are always insects about. Some, like dragon-flies, are active only at certain times of year. If you want to photograph a given species find out where and when the adults will appear.** *John Shaw* **got up early to photograph this dew-laden dragonfly.**

▶ **A 35mm SLR with a 105mm macro lens is ideal basic equipment for insect photography. It will allow the photographer to keep well away from the subject. The lens has a shallow depth of field which helps to separate the insect from its background. This marbled white also stands out because the back light gives it a bright rim.** *Heather Angel.*

▼ **Use a shoulder stock or monopod and focus by moving the camera. The focus and magnification must be set before approaching the subject smoothly and slowly. Extension bellows or tubes are usually necessary to get images of half life size or larger. The depth of field will be even less than with a macro lens.** *Eric Crichton*

often more of a hindrance than an asset in insect photography. A steadying monopod or shoulder pod are more convenient and will allow a slower shutter speed and a smaller aperture to be used than if the camera is hand held.

Film and exposure

The choice of film will depend on the lighting. If electronic flash is chosen, then slow films (64 ASA or less) can be used. If insects are to be photographed in daylight, then 64 ASA film can be used on sunny days but dull days will require films of 200 or 400 ASA.

Use through-the-lens (TTL) metering where possible. By the time a reading is taken on a separate meter and transferred to the camera the insect may well have gone. TTL metering is also convenient for fluctuating light levels—such as happens when a cloud crosses the sun.

Techniques

Decide whether the insect should fill the frame, so that no surroundings are visible, or whether to move back and show some habitat.

The decision may be governed by the way in which the photographs are to be used. If the pictures are for identification purposes, then as much of the insect should be in focus as possible. The magnification of the insect on the transparency should also be noted; this can be read off a macro lens or from tables supplied with extension tubes and bellows.

If your interest is in insect behaviour, then an action picture will be more important than a pin sharp portrait. A head-on view of a butterfly or moth gives more impact than a side view but with limited depth of field it is impossible to get an insect in sharp focus from antennae tips to back wing margins.

Careful field observation will help you to anticipate an insect's action and so produce a better picture than one taken at first sight.

Critical appraisal of the background is as important as the composition in a close-up. A correctly exposed, accurately focused photograph can be spoiled by distracting background, such as out of focus stems. Brightly coloured flowers can lead the eye away from the subject. If the background is distracting, close in and fill the frame with the insect. Many SLR cameras have a depth of field preview button. Use it to check the effect of varying background sharpness. (Always keeping the background sharp can lead to stereotyped pictures.)

Electronic flash

Flash has four main uses
● to allow photography in poor light
● to freeze movement of active insects (although not all units will stop the wings of bees and flies)
● to eliminate camera shake when a tripod cannot be used
● to allow smaller apertures to be used.
Careful positioning of light sources is important in macro-photography.
Small, pocket flash guns are powerful enough for the task. A single head can be mounted on a right-angled bracket and used as a direct source. If it is the sole source the light will be harsh and the subject will have a deep, side shadow.
Harsh lighting can be softened by using a white card as a fill-in. Alternatively, use two flash heads, one each side of the camera. Use one head as the main source and the other as a fill-in. The power of the fill-in flash can be reduced with muslin or a piece of white opal glass or perspex.
Each head can be mounted on an angle bracket and the two screwed together with a tripod retaining screw. A lighter support can be made from a strip of aluminium sheet with the camera mounted in the centre. The aluminium arm each side of the camera should have a flash ball and socket head attached so that the head can be adjusted.

▲ **Flash allows small apertures to be used for close ups where minimal depth of field makes focusing critical. Flash also eliminates camera shake. The simplest arrangement is to have one gun mounted on a camera bracket, with a white card held to fill in the shadows. This Australian diamond beetle was lit with a gun positioned left and front of the lens. A fill-in card was placed to the right. Flash exposures should be measured by experiment. Shoot a series of exposures for given magnifications. Choose the exposures you like best and stick to them in the field.** *Heather Angel.*

The flash guns can be synchronized by a slave unit or by plugging both leads into the camera synchronisation socket via an adaptor. A single flash head attached directly above the camera is not enough for macro-photography.
The correct flash exposure for macro work is best determined by experiment. Take a series of pictures with the flash units and brackets, with film, lens and extension for one magnification kept constant. Vary the aperture in half stop steps from an estimated two stops under-exposure to two stops over-exposure. Repeat the series for different magnifications. After processing choose the exposure which you think is correct for each magnification. Draw up

▲ **This background was chosen to isolate the subject, and show its colour as clearly as possible.** *Jeff Foott* **had to adopt a low viewpoint to position this monarch against the sky. This is a useful addition to the more common technique of using a large aperture to throw the background out of focus.**

▶ **In this case the background is needed to show how the buff-tip moth's camouflage system works. It can easily be mistaken for a broken twig. If the moth was photographed against a plain background, this important point would have been lost.** *Heather Angel.*

a table of exposures and magnifications and stick to it in the field.

Hints and tips

● Insects are less active in the morning than in the heat of the day.
● A low viewpoint will isolate an insect feeding on a flower against the sky.
● Hairy subjects, especially caterpillars, show up best when back-lit.
● Try not to use direct flash on beetles with shiny wing cases. They reflect light into the lens.
● Remember to check that the shutter speed is set to synchronize when using electronic flash.
● Read *The Nature Photographers' Code of Practice* (see p234-5).

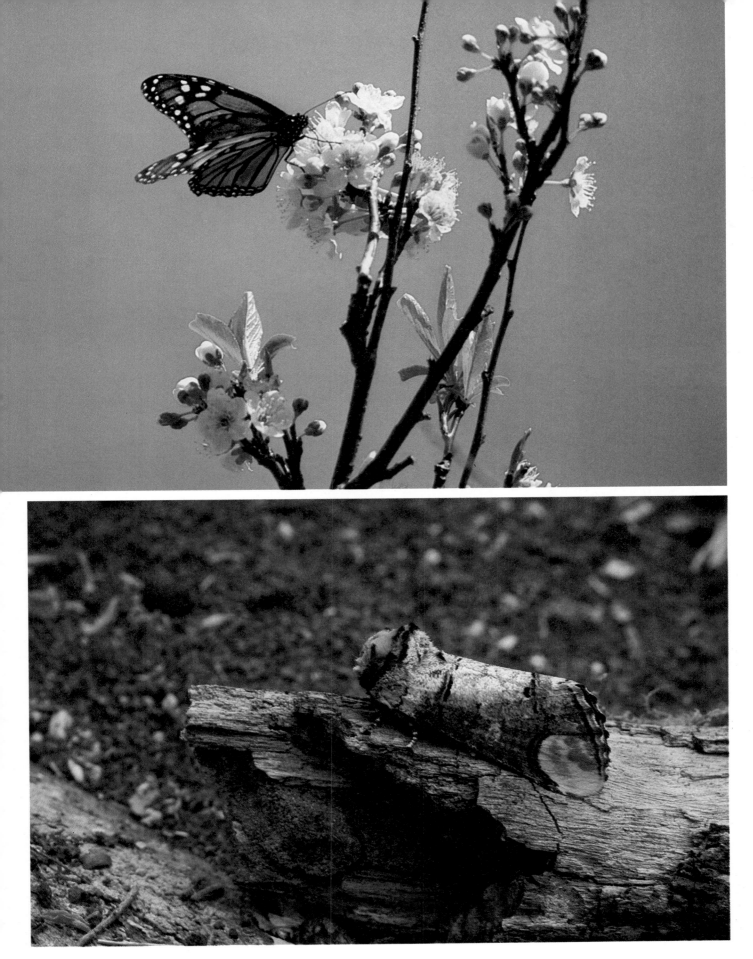

Photographing moths

Everyone tries to photograph butterflies—only experts try for moths. Yet these shy dwellers in the dusk have their own charm and attraction. Some can almost be mistaken for butterflies, except that their antennae are feathery instead of bearing little knobs.

Sometimes moths appear spontaneously, fluttering round a lamp at night, or they can be seen on the outside of windows. A few enthusiasts even raise the caterpillars in captivity and observe the eventual chrysalis so they can photograph the moth in all its stages.

'First catch your moth' may seem to be stating the obvious, but it is the first and probably most important part of the exercise. Of course, good photographic technique with careful thought and preparation, is also vital to get sharp, well-lit pictures. But you can never rely on your subjects simply flying into your home, so the first step in moth photography is to set a trap.

Moth traps

Most moths are nocturnal, though a number—the Burnet moth, for example—are daytime fliers. With a suitable trap you will be able to collect quite a few varieties during the peak moth season from May to September. The best times to choose to trap your subjects are still summer evenings.

There are two main methods of catching moths. The first uses light to attract the moths, the second uses scent. Ultra-violet light attracts moths more than the rest of the spectrum, though if you have no UV lamp a household light bulb will also work. Put the lamp inside a cardboard box along with some egg-boxes scattered inside. Leave the cardboard box open at the top. The moths will fly in, attracted by the light, and then will normally take refuge from the glare under the egg-boxes. Some moths will not behave like this but will simply fly off into the night, so it is as well to be on hand with a net. But be careful: some high-pressure mercury vapour UV lights can damage your eyes so wear protective goggles.

Some entomologists concoct a preparation from beer, honey, herbs and other such ingredients to attract the moths by scent. They spread this over bushes and trees. It is a more difficult technique than the light trap, but in the right hands it can be very effective.

When you have caught your moths, let them settle down overnight before you start photographing them. Some species are particularly lively and need a short spell in a refrigerator to slow down their metabolic rate. Otherwise you can anaesthetize them with a whiff of ether. In the interests of conservation, try not to harm the moths and let them go as soon as you have photographed them.

Backgrounds and props

It is best to photograph moths against a background that resembles their natural environment. If you want to be entirely authentic, find out the natural haunts of each species and gather leaves and twigs accordingly. Many species use camouflage, like the Buff Tip moth and the Puss moth.

A black background also works well with these night creatures. You can either use a black background cloth or paper for this, or—if you are shooting during the day—you can adjust your exposure to eliminate the daylight. Make sure the exposure you use is in sufficient for normal daylight conditions by stopping down, and use the correct flash setting for the stop chosen.

Macro equipment

For close-up photography of insects you will need macro equipment of some sort. A macro lens will enable you to photograph at magnifications up to life size. The main factor to consider when buying a macro lens is the distance at

▲ A home-made or commercial flash bracket provides a repeatable set-up, so successful flash exposures can be worked out manually and used again.

which you will be working. Choose one with a long working distance so that you can position your flash without the risk of casting a shadow from the lens onto the subject. This will also decrease the risk of disturbing your subject by coming too close. A 90mm or 100mm lens is ideal.

If you do not have a macro lens and do not feel justified in buying one, a standard lens with either bellows or extension tubes will serve the purpose. The only point to bear in mind is that 50mm lenses are designed to give their best performance at normal distances and

BLACK BACKGROUND
▲ Photographing a White Ermine moth indoors, Mike Anderson chose a black background cloth to simulate night conditions. It also helps the shot by making the subject stand out.

NATURAL BACKGROUND
▲ A background of greenery is more difficult to photograph, and can distract the eye from the subject. For both shots Anderson used a Cosina CSR and a 90mm Vivitar macro lens.

▲ The Burnished Brass moth gets its name from its gleaming wings. Mike Anderson took care to arrange the lighting for this shot to show that iridescence. He used a single flash gun held on a bracket above and to the left of the lens. He then added a white card as a reflector at an angle on the other side. This filled in the shadows on the right of the frame, and provided the pale highlight that gave the wings their shine.

▶ Like flowers and foliage, moths can sometimes appear translucent when lit with a bright light source from behind. This picture by Helmut Gritscher was taken by natural daylight. The exposure was chosen for the highlights however, so that the lower levels of light in the background did not register at all, and the picture looks as if it was taken at night.

become progressively less sharp towards the edges of the frame as the aperture becomes wider. To avoid this do not open up wider than say f11.

Depth of field is very limited in close-up photography. For example, for a life-size picture (1:1), the depth of field at f22—using a lens of any focal length—is about 3mm. At f11 it is halved to only 1.5mm. For really sharp pictures, therefore, you must use the smallest possible stop and take great care to see that the largest possible area of the subject is in focus. For moths which rest with their wings horizontal, the camera should be as near parallel to the plane of the wings as possible. A tripod is almost essential for such critical focusing, though with practice you may learn to do without it.

Lighting

Flash is almost always necessary because of the small apertures you need to get good depth of field—and because of the need for fast shutter speeds to freeze any subject movement. With electronic flash, it is usually better to use manual control than an automatic mode, which may be inaccurate at short distances. Exceptions are those cameras which meter the flash via the camera lens, such as the Olympus OM-2.

When a lens is focused very close, the image is widely spread and only the centre is recorded. For same-size images you have to compensate by up to 2 stops for the loss of light. In practice, however, as the flash also comes closer to the subject the light is more intense so you may need only half a stop extra.

Two flash heads are far better than one and give better modelling and less contrast. Use one on the hotshoe and one higher up and to one side to fill in the shadows: this can be set at a half or a quarter the power of the main flash. An alternative is to use a bracket—either home-made or purchased—to hold two flash guns either side of the lens. If you have only one flash gun, you can get good results by substituting a white reflector to fill in the shadows.

Use slow, fine grain film for its better quality and colour. On 25ASA film with a medium size flash gun (GN 50 feet at 25 ASA) you will be working at f11 to f22—ideal for good depth of field.

Finally, bracket your exposures generously by plus or minus two stops at half stop intervals for example.

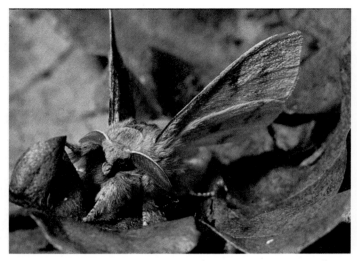

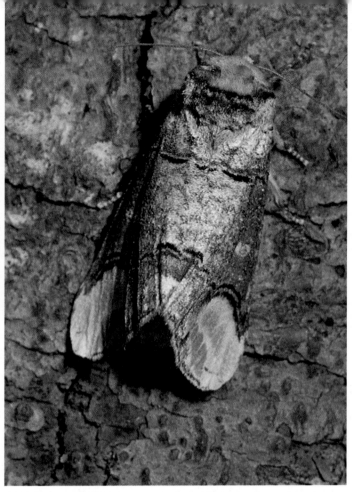

▲ With 2-3mm depth of field, you can only keep sharp focus shooting from above. Here Mike Anderson sacrificed focus for impressive composition.

◄ The Burnet moth is a daytime flier. Mike Anderson photographed this one by daylight, hand-holding the camera at 1/125 and f8 on Kodachrome 25.

▶ Some moths protect themselves with camouflage. Mike Anderson used some Silver Birch bark for the matching background in this shot of a Buff Tip moth.

▼ This demonstrates the effective camouflage of an Angle Shades moth. Geoff Doré took the shot by natural light at 26 seconds at f11 on Kodachrome 25.

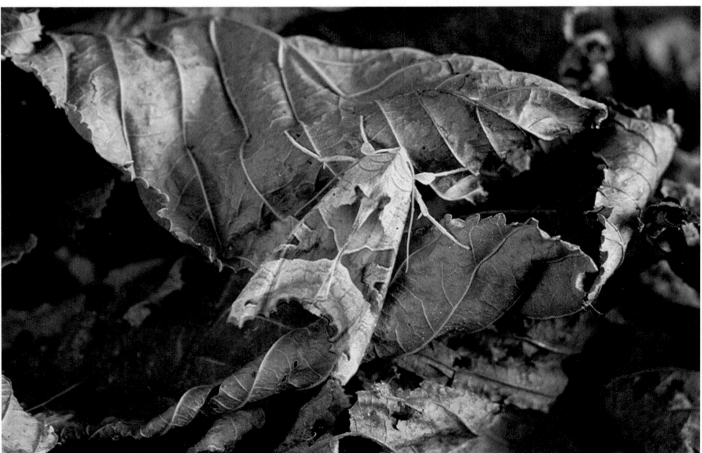

Photomicrography

Taking photographs through a microscope is called photomicrography. It is not beyond the capabilities of most photographers, provided their interest is great enough and their working methods are careful and accurate. There is certainly no shortage of subject matter. You can find suitable specimens in the woods and garden, or indeed almost anywhere you look. For successful pictures through the microscope you need three basic pieces of equipment: a microscope, a light source and a camera.

Microscope

For your first experiments in photomicrography there is no need to spend a fortune on acquiring a superb instrument unless you really want to—even low-priced models are adequate.

Before committing yourself to a purchase perhaps you can arrange to borrow a microscope from a friend, or from a school or college during the vacations, or to hire one from a reputable dealer. This way you can find out what suits you best, and if your interest is deep enough to buy equipment of your own. The simplest type of microscope consists of the following basic parts:

- eyepiece
- tube
- objective
- stage
- sub-stage condenser
- light source

Eyepiece: At the top of the microscope is the eyepiece which allows you to view the microscope image. For photomicrography you must use a 'flat field' eyepiece to eliminate fuzzy edges which would occur with ordinary eyepieces. Choose one or two with magnifying powers around x6 and x8.

Tube: The tube is simply a piece of cylindrical metal which separates the eyepiece from the objective. The tube length is not unlike the focal length classification of a camera lens.

Objective: The microscope lens. The objectives are often sold separately from the microscope. You need one or two objectives to begin with. Magnifying powers of between x5 (five times magnification) and x20 (20 times) all give interesting views of simple structures. The most common objectives are called 'achromats'. These are the least expensive type and are perfectly adequate for the beginner. If and when your interest deepens there will be time enough for you to invest in more expensive objectives with greater correction of image distortions.

Lighting

To produce a good photomicrograph you need a good light source. Whatever source you choose it should be bright enough to allow reasonably short exposure times.

A 100W tungsten lamp is a suitable light source for black and white pictures. For colour slides you might prefer to use a photographic lamp (colour temperature 3400K) to ensure correct colour reproduction with tungsten balanced film.

Special microscope lamps are also available. They usually have an iris diaphragm which can be adjusted to control the size of the light beam.

Although you may have limited success by using daylight, its colour quality and brightness are variable. You would not be able to take pictures in the evening, and the unreliability and unpredictability of daylight causes problems. You would find it difficult to estimate exposures in different weather conditions, and colour reproduction will vary.

Flash is consistent in quality and can be useful when you are photographing living, moving specimens and want to freeze the motion. But unless you can adapt the flash head to fit a modelling light inside it you will find it difficult to judge the lighting effect.

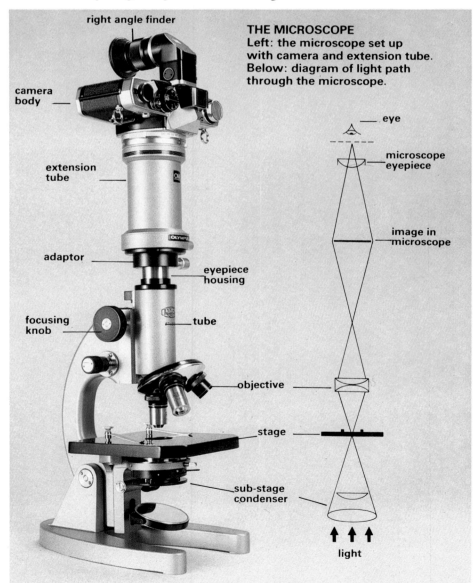

THE MICROSCOPE
Left: the microscope set up with camera and extension tube.
Below: diagram of light path through the microscope.

right angle finder

camera body

extension tube

adaptor

focusing knob

eyepiece housing

tube

objective

stage

sub-stage condenser

eye

microscope eyepiece

image in microscope

objective

stage

sub-stage condenser

light

▲ Photomicrography can reveal the uniform patterns of nature.
Heather Angel's detail of a pheasant feather is shown about 60 times life size.

Stage: The stage is a platform on which the subject is held firmly in position (by clips) at right angles to the objective. The subject is a microscopic specimen mounted on a small glass oblong—called a microscope slide. The stage has a central hole to allow light to pass through from below.

Sub-stage condenser: a system of lenses below the stage which focus light intensely on the subject.

Light source: Only more expensive models have a lamp built-in below the stage. Simple microscopes use a swivelling mirror under the stage to reflect light up through the subject and into the objective. The mirror is often double-sided—flat (or plane) on one side and concave on the other. It can be swivelled to select either surface.

Camera

A single lens reflex camera is by far the most suitable type to use. Its versatility allows eyepiece adaptors and magnifiers to be fitted, and some allow you to replace the standard viewfinder and/or focusing screen with others more suit-

▲ DARK FIELD: light the subject from above the stage. Angle the lamp and move it in close.

◄ With dark field a pale subject stands out against a dark background. Pollen dispersion: *Heather Angel*

▲ BRIGHT FIELD: using light reflected from the mirror through the subject.

◄ Use bright field for thinly sectioned subjects which are translucent and three dimensional.

▲ A simple and fairly inexpensive bench lamp for photomicrography.

▼ The mirror swivels to direct light up through a subject on the stage above. The filter holder swings into the light beam.

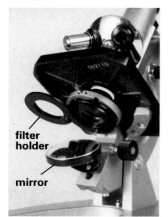

filter holder

mirror

able for microscope work.

You can either use the camera lens to photograph the image produced by the microscope, or you can attach the camera body (without lens) directly to the microscope.

● If you use the camera lens always focus the microscope image first, and use the camera lens set on infinity. When the camera is positioned above the microscope at the point of focus of the microscope image, the picture will be in focus. You can find this point by moving the camera up and down until the image in the viewfinder is sharp.

● If you use the camera body only, you focus through the camera viewfinder by adjusting the focusing knobs on the microscope. When the image in the viewfinder is in focus, your picture will be sharp. By using only the microscope optics in this way you minimize distortions which can be exaggerated by the camera lens. This enables you to produce high-quality photomicrographs.

Supporting the camera

It is impossible to hand-hold the camera over your microscope eyepiece. You need a means of securing the camera in position, such as an enlarger column (without the enlarger head), a table-top tripod, or a copying stand.

Many SLR manufacturers supply microscope adaptors which enable you to fix the camera in the correct position. The camera body, with an extension tube attached, is connected to an adaptor ring around the microscope eyepiece.

An even better idea is to support the camera and adaptor independently of the microscope. Using a heavy, rigid stand minimizes the possibility of vibration being transmitted from the camera to the microscope. When you are photographing at such large magnifications (much larger than life-size) even slight vibration results in blurred pictures.

If you use this system, you must prevent light from reaching the film except through the camera shutter. You can make a light trap by using two lens hoods or two tubes of black opaque card which slot one inside the other.

Film

Special photomicrography films are made, but they tend to be more expensive than ordinary film and your local dealer may be reluctant to place a small order. You can achieve good results with a medium contrast, fine grain film. The speed of the film regulates grain size, and for first-class photomicrographs

choose a medium speed film to enable fine detail to be recorded. Films like Kodak Plus X and Ilford FP4 are suitable black and white negative films. For colourful subjects use a colour slide film (such as Ektachrome 160 or 200) or colour negative film (such as Agfacolor CNS).

Colour balance: if you use colour slide film for your photomicrographs make sure you match it to the light source. You can use tungsten balanced film with tungsten lamps (3400K). If the light source does not match the film use the appropriate colour conversion filter between light source and subject.

Exposure

If your camera has through-the-lens (TTL) metering you can use it as a guide, but the best method for determining exposures is by trial and error. Keep your lighting constant and make a series of exposures through the entire shutter speed range, including long exposures such as 2, 4 and 8 seconds. Use a cable release for the long exposures. Remember to make comprehensive notes.

Once the film is processed study the results, referring to your notes. You can then determine the correct shutter speed for the particular film, lighting conditions and subject. If you change films or use any form of filtration then exposures must obviously be adjusted. It may be better in the long run to invest in several rolls of film of different speeds and expose them all under the different conditions you think you will encounter.

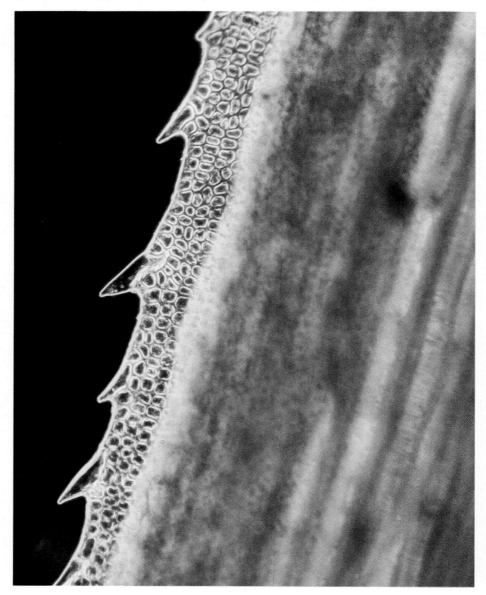

▲ *David Parker* dissolved some citric acid crystals and placed a tiny drop on a glass slide. He used two polarizing filters to reveal these vivid colours.

◄ This is the edge of a hair moss leaf photographed by *Heather Angel* using dark field lighting. The fine structure is magnified about 250 times.

▼ A few drops of pond or sea water will hold a myriad of tiny organisms like this. Allow a small drop of water to evaporate and slow the motion of a live subject; use dark field. *John Walsh*

Polarizing filters

You can use polarized light to show up otherwise invisible structures, particularly with mineral specimens such as rock sections and crystals. These structures are revealed in vivid colour, and you will therefore prefer to use colour film.

First position your light source and angle the microscope mirror until you see a bright, even patch of light through the eyepiece. One polarizing filter is then placed in the light beam below the microscope stage, and a second polarizing filter above the eyepiece. Rotate one or other of the filters until the patch of light seen through the eyepiece goes dark. When you place the specimen slide on the stage you will see multi-coloured shapes and structures which would have otherwise remained unnoticed.

Subjects

You can buy ready-prepared microscope slides from a dealer for your trial runs, or you can make your own specimens by cutting thin sections through plant stems. They are good subjects on which to practise because they yield contrasty photographs. If you can see the outline of cell walls and other structures clearly then you have the makings of a successful photomicrograph.

A drop of pond water is a prolific source of material. Movement of a live organism may be too fast for you to capture unless you wait until the drop of water has almost evaporated. The subject will then be trapped motionless.

You can make microscope slides suitable for polarized light photography by dissolving commonly available compounds such as table salt and citric acid. Dissolve the crystals (in water or a suitable solvent) and place a tiny drop on a glass slide. Warm it *very* gently. Crystals will begin to form, and may change as you look at them. The shapes and colours produced—which you can only see by polarized light—are never the same for different substances.

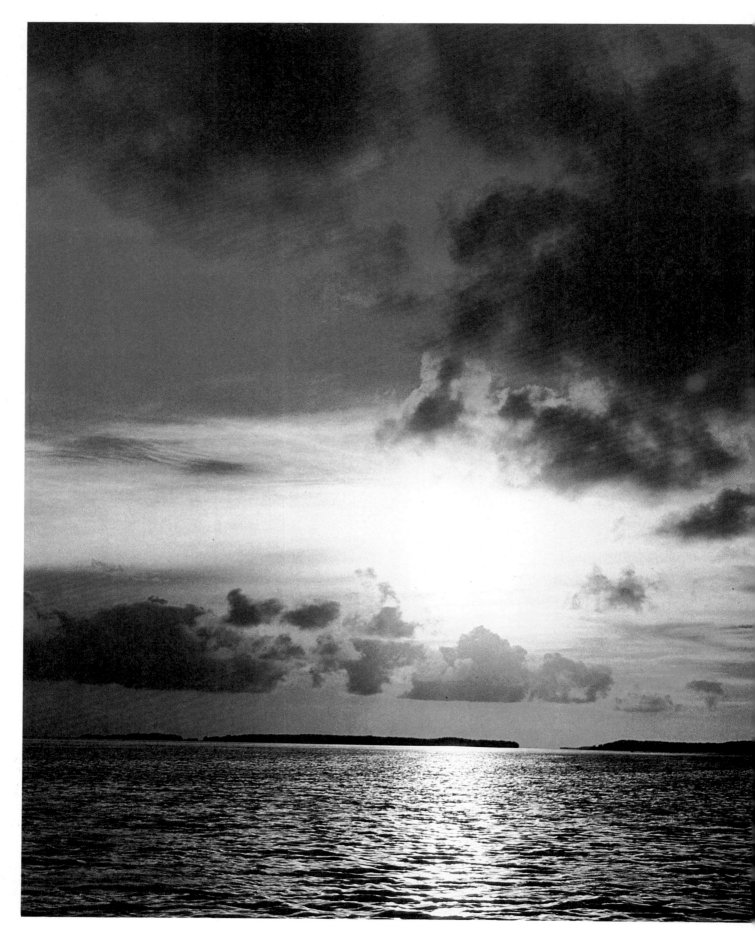

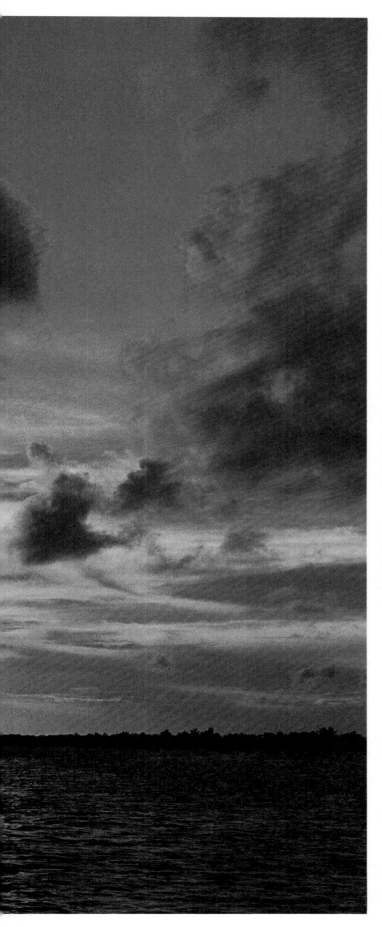

PHOTOGRAPHING THE ELEMENTS

Water and air are the lively elements of nature. Their capricious, ever-changing aspects can contribute to spectacular photographs.

Every photographer will, at some time, succumb to the lure of the sea. This elusive, though rewarding subject is fully discussed—with hints on how you can best protect your equipment. For the really intrepid photographer there is an introduction to underwater photography.

Skies form a major part of many seascapes and landscapes as earlier chapters have shown. This chapter investigates more deeply, including the sky as the sole important element of the photograph. Sunsets are always popular, while rainbows are a bonus in any skyscape. Lightning is one of the most spectacular visual effects that the sky can offer; it is unusual since a good photograph can show more than the eye can see when nature's electronic flash is fired. Clouds are yet another subject in their own right. Each one is a unique and swiftly-changing blend of shape and light for the photographer to capture.

Finally, there is the night sky. The moon and stars make exciting photographic subjects. This chapter concludes with information on using a telescope to capture far-flung parts of the empire of nature such as the planets or even more distant nebulae.

This sunset over Florida Bay, dramatised by the dark clouds against the pale sky, was taken from a boat on the seaward edge of the Everglades.

Capturing the moods of water

Many of the moods and characteristics of water are a combination of effects of season, time of day and place. Equally, many landscapes owe their appeal solely to the presence of a stretch of water.

Each season changes the appearance of water in a different way. The autumn provides deep colours to reflect in it. Winter freezes water into frost and icicles and makes the air crisp. Spring swells streams and lakes and in the summer, the sun sparkles off the water.

Time affects water because it reflects colour. As the day progresses, and the light shifts from blue to neutral to red, so its surface varies subtly.

Water can also be portrayed as part of its surroundings. Hills and mountains may stand around a lake with their feet in the water and their reflections floating on it.

Mood, feeling and scale

Colour has a huge impact on the mood and feeling of water—an impact which is most obvious in conditions of mist, light fog or even high humidity.

Water droplets in the air diffuse and scatter light. If the light is a particular colour it may become so diffused that a scene appears almost monochromatic.

A morning mist, for example, might exaggerate the effect of the early, blue light. Later in the day, a scene might appear in a yellow glow if the sun shines through a light fog towards the camera.

These diffused light impressions are subtle. If you wish to use a filter of the same colour to add to the effect, choose a fairly weak one of 5-10CC. Anything stronger may look unreal.

Sometimes a blue haze appears in a picture that was not apparent over the original waterscape. This is known as aerial perspective. It is caused by haze scattering large amounts of ultra violet light, invisible to the eye but to which film is highly sensitive.

Aerial perspective makes far off objects indistinct. The effect is exaggerated in long-distance views. It is lessened

▶ **The sidelighting on this choppy water in the Lake District combined with the flurries of spray from the gusty wind gives a very dramatic effect and produces highlights all over the surface. Cover the highlights with your hand to see how much they contribute to the picture.** *Heather Angel*

▼ **The water adds interest to this shot because it echoes the autumn colours in an abstract way. Slight turbulence in the water has broken up the reflection.**

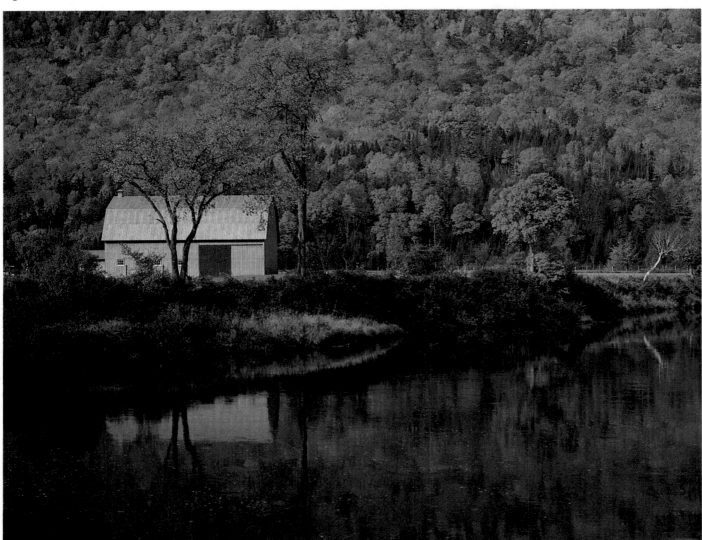

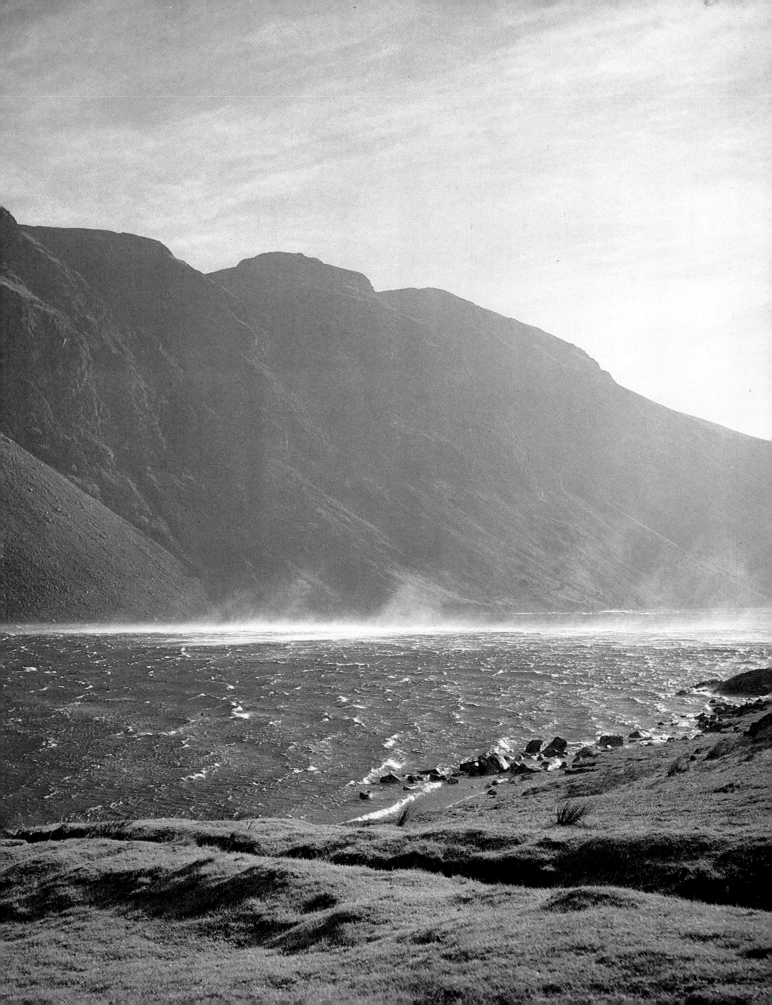

or removed by fitting a UV or skylight filter. Use a red, orange or yellow filter with black and white films.

Choosing a long rather than a wide angle lens may solve another common problem. The human eye is very selective. Make sure that only the part of the subject which you are looking at appears in the final picture. The easiest way to do this is to take advantage of a long lens' narrow angle of view.

Another way to draw attention to one part of a waterscape is by suggesting a sense of scale. This can be done by including an object in the foreground. Try to find something with a simple shape.

Be careful not to draw attention away from the shot's mood and atmosphere by having an unnecessarily sloping horizon. The only sure way of getting a flat horizon is to use a tripod and a spirit level to level the camera.

Exposure problems

The brightness of sunlight or sky reflected off a lake, river or sea can fool an exposure meter. The water surface may be, and specular highlights will be, as bright as the sun or sky.

This is a problem if the subject is a swimmer, a boat or anything near water on a bright sunny day. It is also a difficulty in frost and snow scenes over water and pictures of partially frozen lakes.

The meter will read the glare from the water instead of the light coming from the subject. Usually it is sufficient to take a general reflected reading and to increase the indicated aperture by two stops.

There are more accurate methods than this. One is to take a reading off the subject and as close to it as possible. Take care that the meter points directly at the subject. If it points down it will catch the glare from the water. If it points up, it will read the sky.

Another way is to take two or more readings and average them out. Take one off the darkest area, perhaps some trees, and one off the water. The correct exposure should be somewhere between the two. It will be closer to one reading if that reading is off the most important part of the picture.

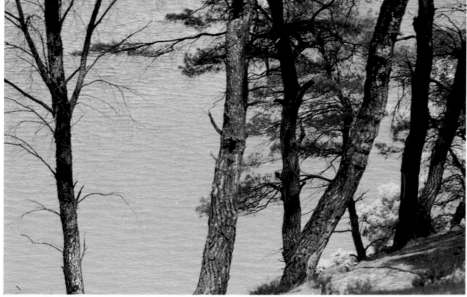

◀ Water has colour of its own. If the water is clear, its colour will change with increased depth, angle of light, and whether it has sand, rock or other material at its bottom. *Bob Davis*

◀ Opposite page. An ugly, incomplete concrete frame is made interesting by being reflected. Turn the page upside down to get an idea of how dull the original scene might have been. The figure adds scale. *Robin Bath*

▼ The exposure has been made to reveal maximum details in the sky and clouds and to under-expose the trees, throwing them into silhouette. The strange colour of the sky is amplified by being reflected. *Michael Salas*

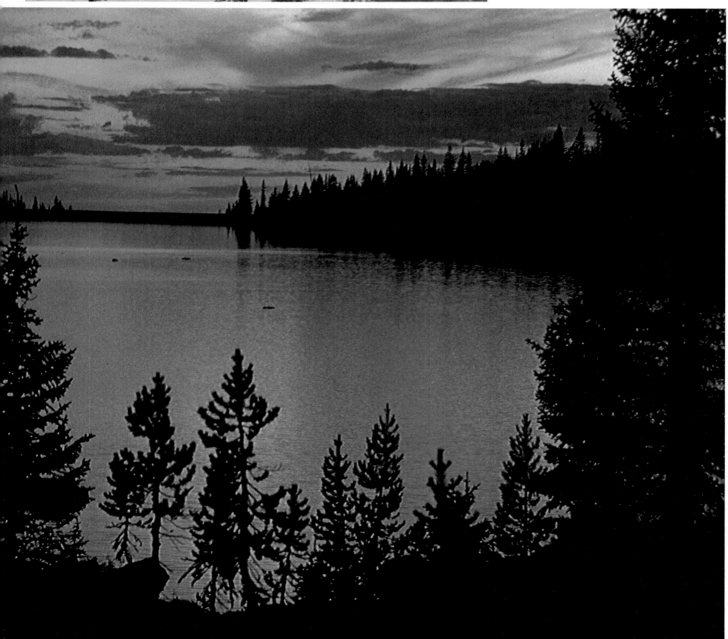

A third way is to take a reflected light reading and an incident light reading. The exposure should be halfway between the two. The reflected reading will be basically a highlight reading. The incident reading will be slightly biased towards the shadows. Use this method when photographing water into the light.

Filters

One way to avoid glare in bright sunlight is to use a polarizing filter. This is especially effective if most of the picture is water. The filter can control reflections and give the water a colourful, solid appearance.

The polarizing filter also deepens the colour of a blue sky. Another way to deepen the sky, and to help avoid over-exposing it, is to use a graduated filter. These filters are coloured at the top and gradually pale to clear glass at the bottom. Their advantage is that the coloured part can be placed over the sky and the clear part will let through the natural colour of the water.

Position a graduated filter carefully. Try to place the changeover (from colour to clear) on a line in the subject. Ideally, this line will be the horizon. Blue is an obvious choice because it will give the picture a bluer sky. A red one might give the appearance of sunset, even in the afternoon. It will exaggerate a real sunset even more.

Pictures may look flat and uninteresting on a dull overcast day. Try using an 80B blue filter in these conditions. Blue is a cold colour. It will emphasize the coldness of the water and the day so bringing some extra feeling to the shot. If there are any highlights you could try using a cross screen filter instead.

Shutter effects

Water can be 'frozen' in mid air with a shutter speed of 1/1000. This is usually fast enough to show a multitude of individual drops.

Moving water can be photographed as a blur by using a slow shutter speed. Often 1/60 or 1/125 is the slowest that can be used with colour film of 64 ASA in sunlight. If you wish to completely blur the water a speed of 1/15 or slower will have to be used and the camera put on a tripod. If the light is strong,

use a slow film to avoid over-exposure. Sometimes waterfalls are surrounded by trees, and so require faster films; beware of slide films giving a greenish picture as leaves transmit green light. You can correct negative films in printing.

These slower speeds are easy to reach on dull days or in deep shadows. The alternatives are to use a 25 ASA film or to fit a neutral density filter. (A neutral density filter reduces the amount of light entering the camera without affecting the colours.)

The use of multiple exposures and slow speeds give water a mood that depends on its own qualities and not on those of its environment.

▼ **Showing movement in a still photograph sounds like a paradox, but can contribute to very effective pictures of streams and waterfalls. Here** *Andrew Evans* **set a long exposure of 1/8 second to record the movement, giving it extra emphasis by framing carefully with a medium telephoto zoom lens to contrast the fast-flowing water with the motionless rocks in the foreground.**

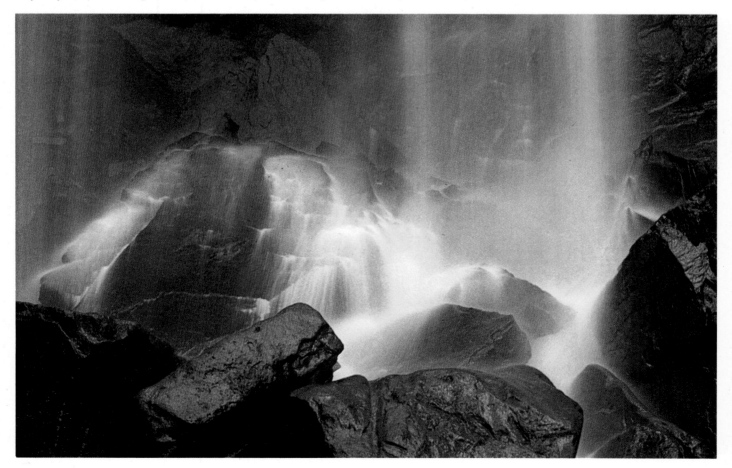

SHOOTING THROUGH COLOUR FILTERS

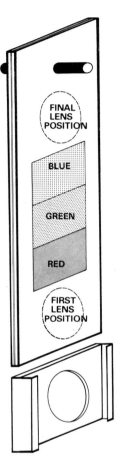

FINAL
LENS
POSITION

BLUE

GREEN

RED

FIRST
LENS
POSITION

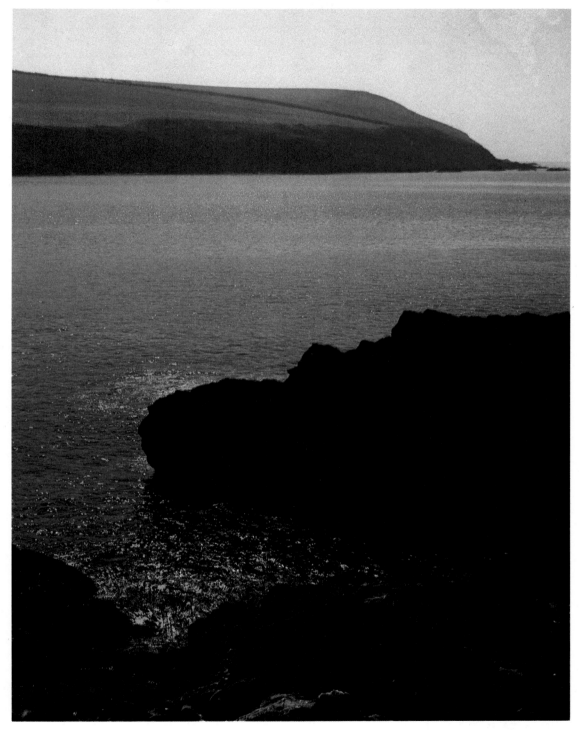

One way to shoot an effect like that on the right is with a home made multi-filter. Choose a strip of plastic or stiff card that will slip through a filter holder. Cut a hole in the card and stick some filters in as shown. Open the shutter on 'B' with the card completely covering the lens. Let the card fall so that the filters pass over the lens in turn and the stop catches the camera body. Close the shutter. To start try f11 on a sunny day with 50mm filters.

▲ A multiple exposure through (in order) red, green and blue filters produced this effect in the moving water. As these colours of light add up to make white, the colour of objects that did not move during the exposure were unaffected by the process.

Moving objects, especially if they have strong highlights will be in a different spot and will reproduce as a different colour with each exposure. Choose filters of the same density so every exposure can be one third of the correct (unfiltered) exposure for the object. *Fred Dustin*

Photographing the sea

Every photographer will, at some time, succumb to the lure of the sea. He will want to capture that vast, shining expanse and take it home in his camera, or to pry into the secret seashore world uncovered by the falling tide. And he will often have to face disappointment too; the sea is a notoriously elusive subject. The shore has already been looked at on pages 28 to 31, here the open sea is considered. Taking pictures of seascapes presents many of the same problems as landscapes—and some extra ones as well. There is the same difficulty of capturing the grandeur of an expansive view in the confines of a rectangle. And your responses are often coloured by your other senses. With a sparkling expanse of blue sea goes the sound of the birds, the smell of the brine, the warm sea breeze. Without these what you thought *looked* marvellous often turns out to be a rather dull picture—just a mass of blue sky and sea and very little else.

Photographing the sea has its practical problems too: your first precaution must be to protect your equipment from seawater and from sand.

Protect your camera

Sea water can be fatal to your camera. A camera that falls into a puddle of salt water, let alone into the sea itself, may be beyond repair. Even spray and sand can do a great deal of damage. So keep your camera strapped around your neck at all times and change film in a sheltered spot away from both sand and spray.

One way of reducing the risk is to

▼ Nothing destroys a camera quicker than salt water and spray. Before you take your camera to the sea, enclose all but the lens in a plastic bag.

put your camera in a polythene bag (below) and keep it there even while you are taking pictures. Cut a hole in the bottom for the lens and use a rubber band to seal the bag around the lens. Fit an ultra-violet filter to protect the lens itself and cover both lens and filter with a lens cap between shots.

If your camera does fall into salt water, rinse it in fresh water, dry it with a soft cloth and take it to a reliable camera dealer straight away—but be prepared for expensive repairs or even a complete write-off.

Dealing with reflection

Water is a powerful reflector of light—as strong, sometimes, as snow. There are a number of precautions that the photographer needs to take to get over this.

● Keep a lens hood fitted at all times to stop stray light falling directly on to the lens
● Avoid the use of the very fastest films for this subject
● Take a light reading from the brightest part of the picture, unless dark parts are more important.

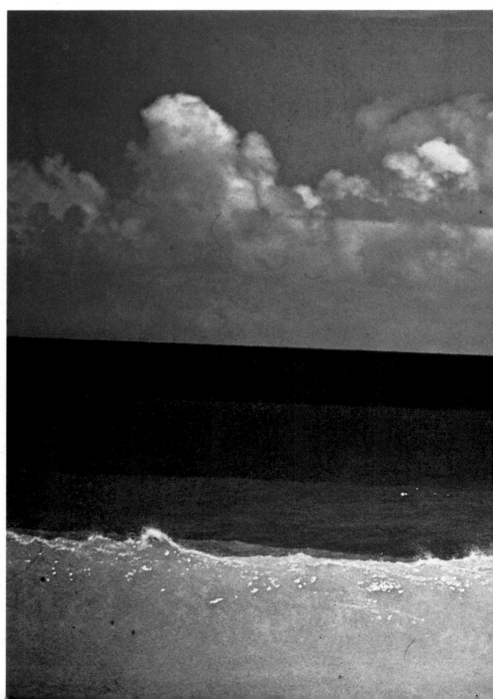

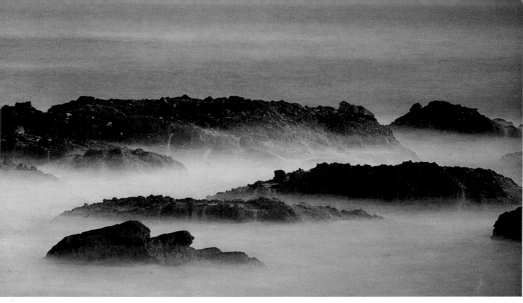

▶ A slow shutter speed, inevitable in poor light, softens spray into a sombre mist. *Chuck O'Rear*

▼ From *Ernst Haas'* photographic illustration for his book, *The Creation.* He took the picture '. . . when the sun had begun to reappear following a thunderstorm. I used a 180mm Sonnar lens and an exposure of 1/500 sec at f2.'

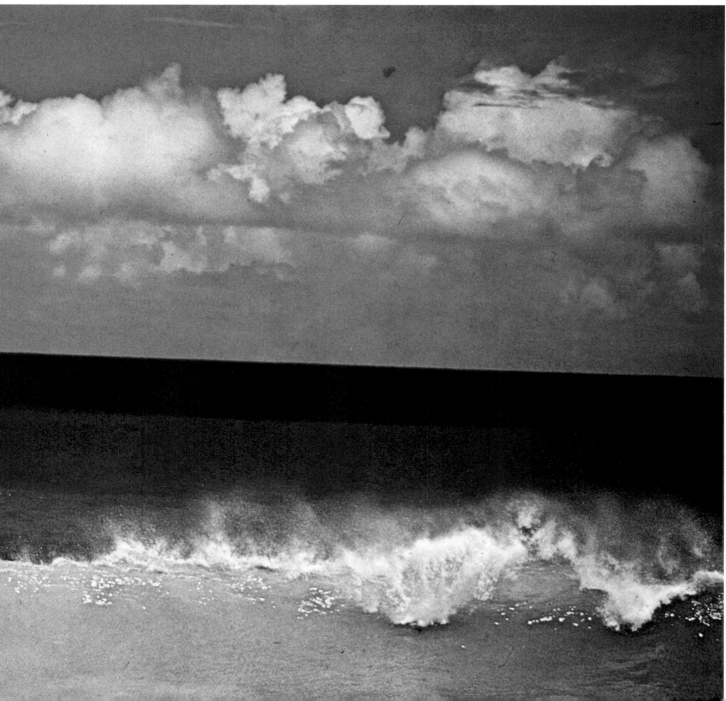

- If you are taking a photograph of a person against the sea, take your light reading from the person's face close up. If you take a reading on the face from a distance, the meter will pick up reflected light from the water and the result will be an unsatisfactory half-silhouette. (If you want a complete silhouette, you will need to expose for the highlight area.)
- Check your exposure every 15–20 minutes, particularly if you are shooting at sunrise or sunset. Light changes quickly at these times and the change is intensified by its reflection off water.

Using filters

You may be able to improve the effect of a seascape with a filter to add contrast, reduce haze, or bring out the colour. An ultra-violet filter, for example, produces more contrast, giving your picture greater clarity. A polarizing filter intensifies the blue of the sky, and cuts out glare and haze. Other filters can be used for varying effects. If you are using colour film and the sea looks grey and colourless, you could try a pale filter for a gentle tint or a deeper filter for a strong, overall effect. To give the water more sparkle, you might try a starburst filter, which splits light into stars and emphasizes the glitter of the sun on water.

If you are taking black and white pictures and want to bring out the sky, you can heighten the contrast between the sky and the clouds with an orange filter. Some filters cut down the amount of light reaching the lens so you will need to make an exposure adjustment: for this consult the instructions that come with the filter: these will tell you how much exposure adjustment to make.

Photographing from a boat

If you are photographing the sea from a boat, there are special problems of movement and engine vibration. Always use a fast shutter speed— 1/500 or 1/250—and position yourself as far from the engine as possible. Wait until the boat gets to the top of a wave before squeezing the shutter gently: at the top of every wave there is a moment of comparative stillness before the boat lurches downwards. Don't rest your elbows on a railing or any part of the boat when you press the button. And consider using some part of the boat in the foreground—a lifebelt as a frame, perhaps, or an open porthole.

◄ *Alastair Black* used a Nikon F2 to photograph *Bay Bea* at a critical moment in the Admiral's Cup race. His low viewpoint and 300mm lens foreshortened the yacht, emphasizing the speed. Shooting from a boat himself, he took advantage of the amount of light — direct and reflected — and set a fast shutter speed (1/500sec at f8) to eliminate the problem of motion.

► Colour contrast is heightened by a polarizing filter and slow film. The high viewpoint and telephoto lens simplified the background.

◄ Low in the sky, the sun not only gives *Adam Woolfitt's* sea study its colour but also its deep contrast: the breaking wave casts its own shadow on the water, dividing the frame both vertically and horizontally into thirds.

▼ The excitement of this moment can only be caught with a shutter speed of at least 1/500 which freezes each droplet in mid air. The effect is heightened by the lighting — from the back and slightly to the right. Sea spray always gains brilliance from backlighting, and in *Remy Poirot's* picture the dark storm clouds make a perfect background contrast.

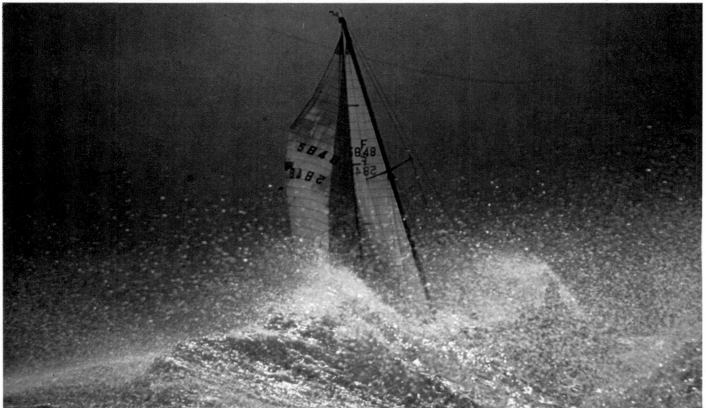

Underwater photography

Taking pictures of underwater scenes is easier than it sounds. The most difficult part is accepting the idea of bringing ordinary cameras near water.

Use a filter: the simplest technique is to fit a polarizing filter on the lens and lean over a bridge or rock. The filter should remove most of the reflections, revealing what is below the surface.

Use a tank: another method is to place the camera in a glass box, like an aquarium, and dip it beneath the surface.

Use a housing: if you don't mind getting wet, simple plastic housings are available to keep camera, lens and flash gun dry. These basic housings work at depths greater than it is safe to swim unaided.

Use an underwater camera: these are generally expensive, but worthwhile if you intend to specialise in this subject.

In the shallows

Photography in the water is associated with the sea. But shallows, where most people do their first underwater work, occur in rivers, lakes, pools, ponds and streams.

A flat-sided glass tank will be most useful to the nature photographer in these conditions. Care must be taken that the camera does not get wet. The photographer will likely end up waist deep in water and the tank becomes progressively unstable the more it is submerged.

If possible use a camera with a waist-level finder. The controls will be accessible and the picture can be easily composed. Hold the lens against the glass to prevent reflections.

Pictures do not have to be taken head-on to the subject with this method. If the tank is held over the side of a boat, say, and tilted slightly, the camera will point into deep water. How much it will record depends on how clear the water is and on the direction of the sun. A simple underwater housing or camera gives much more control than using a tank. The camera can be taken deeper into the water and the photographer can be more active.

Underwater equipment does not have to be used at great depths. The camera can be literally half in and half out of the water.

A little deeper

Mask, fins and snorkel are sufficient equipment to take the underwater photographer down to about three metres. No one should swim alone with

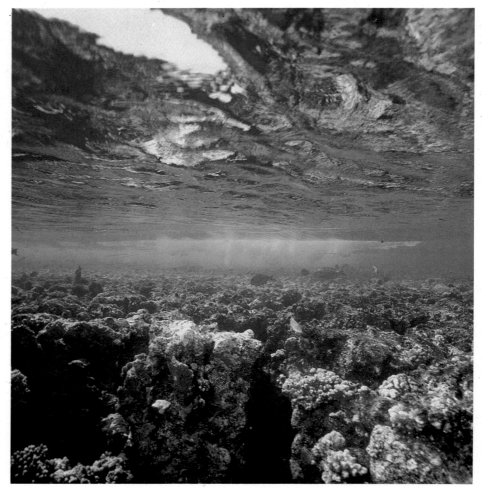

▲ Water's blue/green cast increases with depth. It is impossible to correct deeper than about 6m. *Mike Portelly*

a camera. A companion makes photography safer.

It is necessary to use breathing apparatus beyond a few metres deep. Once the diver reaches 10 metres water pressure doubles and simple housings are no longer strong enough.

The light at depths accessible to the snorkler is bright enough to take pictures. It does not have the strong blue or green cast found in deeper water and, especially, in the open sea.

Underwater housings

To keep water out of your camera you need a water-tight housing. As well as keeping working parts dry, underwater housings enable all necessary controls to be operated with the housing in place. Some housings have over-sized control knobs to make this easier. Commercial makes are available for 110, 35mm reflex and non-reflex and roll-film cameras.

Shallow water housings. At a depth of only 10 metres the pressure is twice that on the surface. The pressure has the effect of trying to collapse the housing and to force water through any faulty seals there might be. Cases designed for use at maximum depths of up to 10 metres are relatively cheap. Any make of 35mm SLR camera (fitted with a standard or similar length lens) fits in the Ewa Marine housing. The casing is flexible plastic and controls are operated through a rubber glove set into the housing.

Transparent polycarbonate cases allow you to look through the camera's reflex viewing system (but only with the eye a few centimetres from the eyepiece). You can also spot any leaks before the camera itself is flooded.

Deep water housings. There is much more choice in this category, but they tend to be more expensive than shallow water versions. Cases are readily available for use down to 100 metres—the deepest that most Scuba divers go.

The immense pressure of deep water makes a 'rubber glove' design impractical because the glove can easily rupture under pressure. Important considerations when choosing a deep water housing are whether the casing allows reflex viewing, whether the camera controls are easy to operate, and whether the camera porthole (the transparent plate through which the camera lens 'sees') is interchangeable. Rigid alloy cases require a special prism for reflex viewing. This can be supplied as an integral part of the housing, or many photographers use an external sports finder frame. Leaks tend to be more difficult to see, but alloy housings are more robust than plastic housings: some can be used 150 metres deep.

Purpose-built cameras

The Nikonos III is one of the few available cameras built specially for underwater use. No casing is needed because all internal parts of the camera are watertight. It is a fairly basic

▼ **Reefs and rock pools can be photographed at low tide with the aid of a glass tank and a camera with a waist-level finder.** *S. Summerhays*

manual 35mm non-reflex camera without a built-in meter. There is no rangefinder for focusing so you have to estimate focusing distances, and the viewfinder is a direct vision type which may cause parallax problems at close subject distances. An external sports finder frame can be fitted for easier viewing through a diving mask. The shutter release incorporates a film wind-on lever, so both operations can be done with one hand. It can be safely used down to about 50 metres.
A range of lenses is available—35mm (which is supplied as the standard lens), 15mm, 28mm and 80mm. Both the 35 and 80mm lenses can be used on land too, but the 15 and 28mm can only be used under water. Lenses cannot be changed under water.

Underwater focusing

Because water is denser than air, objects below water appear, to the eye and the camera, about 1/3rd larger and nearer than in reality. If focusing on a reflex screen this is immaterial, but usually scales are used underwater as they are easier to see. Set the scale on about ¾ the true distance—if something is 4ft away, focus on 3ft by scale.

Lighting

If you are using natural light, try to time your photography so that the sun is overhead, and the water is calm. Reflection and refraction from the surface is then minimized. The deeper you go the greater the reduction in light intensity because it is absorbed by water. Even in clear water on a bright day, and using 400 ASA film, it is difficult to get acceptable results at 30 metres or so.
Purpose-built underwater light metres are available. They can be attached to your equipment with a commercially made bracket if one is not supplied. A cheaper solution is to put an ordinary light meter into a custom-built case, or perhaps a sealed jam jar.
An external light source puts back light absorbed by the water, and restores lost colours (particularly reds). It also allows the use of shorter exposure times and the smaller apertures to eliminate camera shake.
The simplest form of artificial light to use is a torch held by a diving companion. Special underwater floodlights can be used, but most photographers prefer to use flash if natural daylight is inadequate.

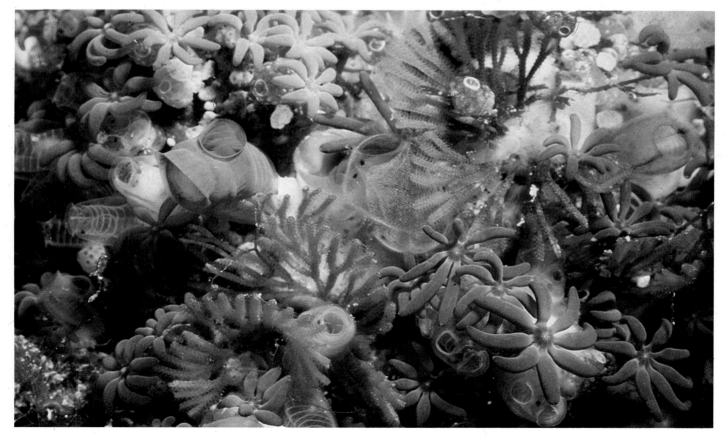

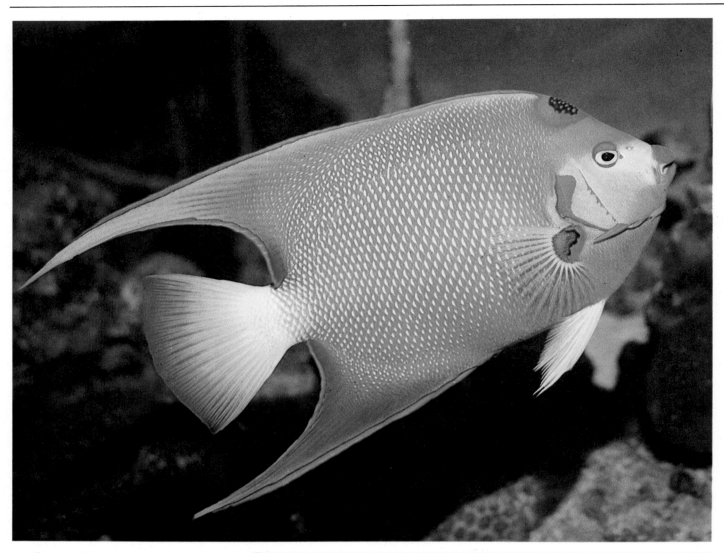

▲ Get as close as you can to underwater subjects to prevent loss of contrast and detail. *Ian Took*

Electronic flash units are available for a wide variety of camera housings, and are attached with special waterproof connections. Many of these are regular land units housed in transparent underwater casings. A number of flash brackets are also available to enable the flash to be mounted well off the camera at an angle of about 45° to the subject. Using flash closer to the camera would illuminate particles in the water, thereby scattering light and reducing contrast. Angling the flash reduces this scattering effect, and gives more modelling and contrast to the photograph.

It is best to make a series of tests with your lighting equipment before you start taking pictures seriously. Take

USING FLASH UNDERWATER

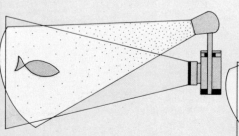

▲ When using flash under water choose the correct angles between flash, camera and subject. If the flash is positioned too close to the camera lens, particles in the water will be illuminated. Light bounces off these particles and is scattered in all directions, dramatically reducing contrast.

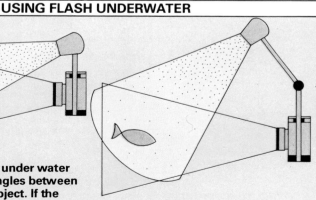

▲ It is better to use a flash gun mounted on a bracket and aimed at the subject at an angle of about 45°. Scatter is minimized and modelling and contrast improve.

photographs of an underwater subject (perhaps a diver holding a colour test card) at varying distances and depths. Use each lens aperture in turn to determine the appropriate settings and to see how well your equipment performs. Make notes on an underwater slate.

Colour correction

In anything deeper than about two metres of water, colour photographs can be disappointingly low in contrast with a strong blue or green colour cast. This is because water acts as a colour filter which absorbs orange and red light.

At depths between two and five metres you can compensate for the blue cast by using the appropriate colour correcting filter (red). Filters reduce the amount of light reaching the film so that exposure times have to be longer. Below five metres the colour cast is probably too strong for correction, in

▼ **Artificial lighting must be used below 6m to record the true colours of subjects like Crinoids, but note that the flash may not have the same coverage as your lens.** *S. Summerhays*

which case supplementary lighting becomes necessary.

In clear blue water, such as is found in the Mediterranean, or in coral seas, a red correction filter is best. In water where visibility is 10 metres or less, a magenta filter is generally better to correct the resulting green cast.

Colour correcting filters are available in different strengths. The Kodak colour compensating (CC) range is available in 5, 10, 20, 30, 45 and 50 CC units. A rough rule of thumb for choosing the best filter is to add 10 CC filter units for each metre of light travel through the water. For example, when a diver is two metres below the surface and one metre from the subject, the total light path is $2 + 1$ metres $= 3$ metres. Using 10 CC units per metre, 30 CC filtration is needed, and this is often standard when taking natural daylight pictures near to the surface.

Slight under-correction is preferable to over-correction—a blue or green cast is generally more acceptable than a red or magenta one because the eye expects underwater scenes to appear slightly blue. Use of a yellow filter for black and white photography close to the surface helps to improve contrast.

CHECKLIST

● Colour casts in open water should be corrected with a 10CC red at one metre deep, 20CC red at two metres etc. plus 10CC for every metre of subject distance. Below 6 metres colour correction is impossible without flash.

● Keep equipment out of the sun. It will dry out the sealing grease.

● Rinse everything thoroughly in fresh water after use to remove salt residue.

● If you do not have an underwater exposure metre this table is for 64 ASA film at 1/60 with overhead sun.

Depth	Clear calm water	Clear choppy water
Below surface	f11	f8
Above surface	f16	f16
3m	f8	f5·6

Add one stop to these figures for every extra three metres depth. Add one stop if water is less than clear. Add two stops if water is murky.

Photographing skies

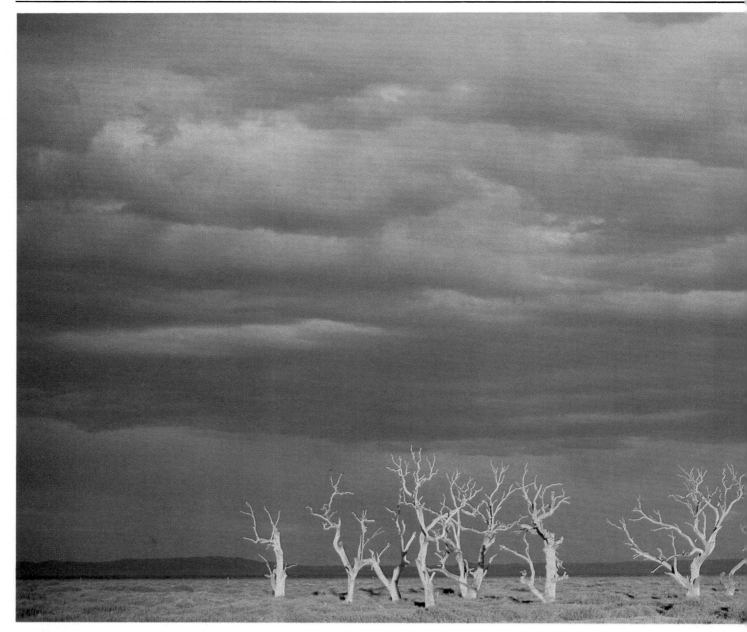

The sky forms a major part of many landscapes, seascapes and outdoor shots of every kind—and it can often make or break the image. But except for the ever–tantalising hope of capturing the perfect sunset, photographing the sky for its own sake is an idea that seldom occurs to most amateurs. It is not only at sunset that the sky produces its most powerful images, however; it is worth keeping an eye on the heavens at all times.

Skyscapes rely for their strength on colour and cloud formations, and on the different moods the sky can create. At times the shapes in the sky are powerful enough to form a self–contained image on their own without the inclusion of anything else—no land or sea, for example, at the bottom of the picture. But for the most part you will probably choose to include some foundation to give your pictures scale and form. On the whole, a skyscape is distinguished from a landscape by the fact that the sky takes up at least three–quarters of the frame.

Exposures

First, a word about exposures. Always take your light readings from the sky itself, even if you are including some land or sea in the shot. You will find that this means stopping down by at least three or four stops from a reading taken from the land, and this will intensify the colours and reinforce the contrast between the areas of clear sky and the clouds.

If you are shooting in colour, use an ultra–violet filter at the very least. A polarizing filter will deepen the blue of the sky even further. If you are shooting in black and white there is a wider choice of filters to experiment with: starting with a pale yellow and progressing through orange to red, these filters have an increasingly

▲ The sky can play strange tricks with light: *Eric Hayman* took this shot in south Australia, where in the evening solid banks of cloud often lift over the setting sun so that a shaft of light bursts through—parallel to the ground. Here he took his reading from the clouds then closed down half a stop to allow for the brightly lit foreground. His exposure was 1/125 at f8 on Kodachrome 64.

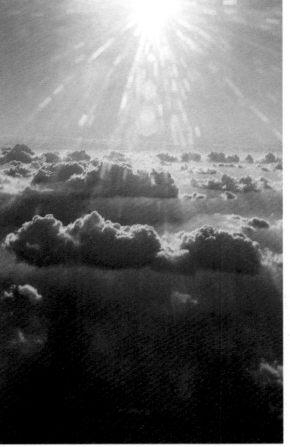

▲ As in the picture on the far left, *Patricio Goycolea* uses foreground detail here, though the lighting gives a directly opposite effect. The tree is strongly backlit, so that exposing for the sky leaves it in stark silhouette.

◀ *Bob Davis* took this shot from an airliner. Though there is no evidence of them elsewhere, the scratches on the window reflect the sun in a starburst.

marked effect on the sky in terms of sharpening the contrast that makes the clouds stand out from the clear sky. No exposure compensation is necessary with a UV filter. The others will require some increase in exposure according to their density, so read the appropriate filter description carefully. Wide angle lenses are very effective in showing a broad expanse of sky—the wider the angle, the greater the impression of space. A wide angle also allows you to include the large variety of colours and cloud types that are often evident in the sky at one time. A wide angle lens on a 35mm camera held upright gives the effect of the sky extending over the viewer's head.

Composition

When you compose your pictures, keep any content other than the sky either very simple or complementary to it.

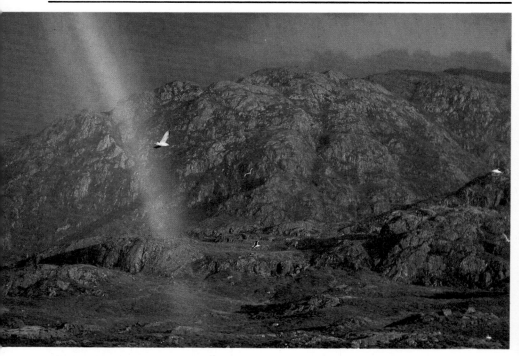

▲ A long lens will appear to bring a rainbow closer, and the spectrum of colours can be intensified by slight under–exposure. *Mike McQueen*

▼ It is rare to see the whole span of a rainbow—as here, with the open sea as a background—so it is worth using a wider lens to include it all. The sunlit foreground evokes the conditions that cause rainbows. *David MacAlpine*

▶ To photograph several forks of lightning in one shot you need a tripod and an exposure of several minutes. The simplest way is to photograph a storm at night, but if there is light in the sky, you can help to prevent over–exposure by fitting a neutral density filter to your lens. This shot was taken in Colorado, USA: the predominance of blue is the combined effect of haze and reciprocity failure.

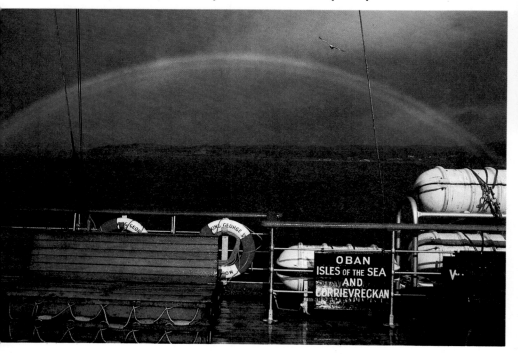

A partial filter—half coloured and half clear—can give extra colour to the sky while leaving the ground unaffected.

Rainbows

Rainbows are a bonus in any skyscape. You can never predict their arrival, of course, and sometimes they may disappear before you have time to set up your shot. If you can, choose a lens that allows you to fill the frame with all or a part of the rainbow—usually a long focus lens—and don't forget the UV filter. To intensify the colours, reduce your exposure from the meter reading by closing down a stop or so.

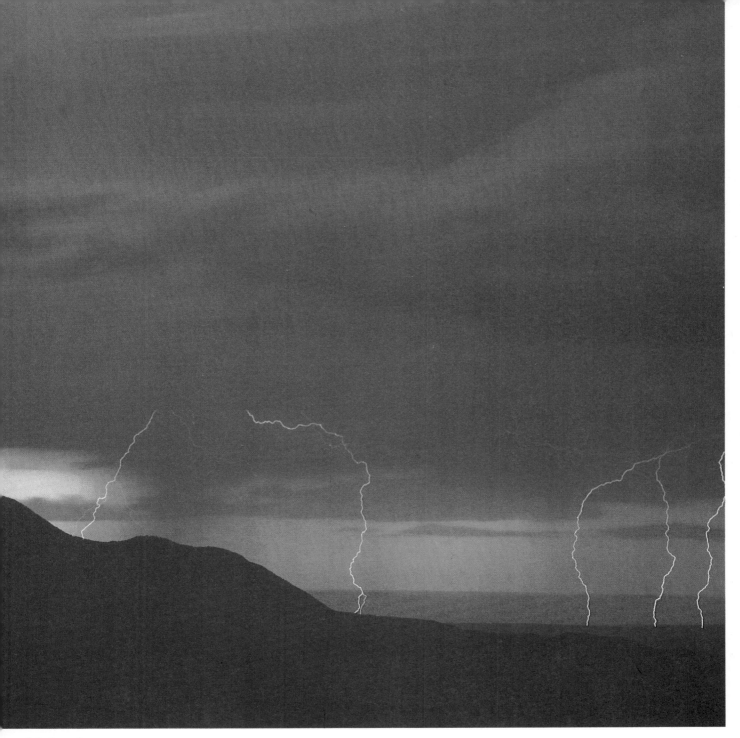

Lightning

Lightning is one of the most spectacular visual effects that the sky offers. Since it is impossible to predict the exact moment that lightning appears it is best to photograph it at night when you can leave the shutter open without over–exposing. First you must identify the direction of the thunderstorm, then set up your camera on a tripod, since you will need to have the shutter open for several minutes to catch the forks of lightning as they appear. If you leave the shutter open for long enough you may well get two or three forks of lightning in one shot.

This lengthy exposure time means that you will have to find a viewpoint where there is no strong light source between yourself and the storm: even street lights would tend to burn out your film. If necessary, tilt the camera so that only an area of sky is visible in the view-finder.
Set an aperture of f11 or f16 and focus on infinity. Use a cable release to open the shutter because of the possibility of jogging the camera during the long exposure. As you begin to take pictures, vary the aperture, bracketing widely since it is difficult to estimate the exposure you need.

You may be lucky enough to be photographing the storm from inside your home in the dry. If so, go to a top floor window from which you may be able to see the lightning hitting the ground. If you do venture outside, try to find a foreground reflective surface—a pond or even a puddle—to reflect the lightning and add fore-ground interest. But if you are outside try to keep a distance of several feet between the lens and rain. Otherwise your pictures can be spoilt by out-of-focus raindrops lit by the flashes. An arch or doorway may offer protection; a large umbrella is better than nothing.

Photographing clouds

Every cloud formation is a unique, shifting blend of colour, shape and light which brightens any dull landscape. Clouds are also a spectacular subject on their own—an elusive subject that needs good timing and precise exposure.

Choose the time

If an overcast day makes a landscape look mundane, return to it when cumulus (like cotton wool) or cirrus ('mares' tails') formations fill the sky. The clouds will change the mood of the picture. Distinctive cloud patterns happen most frequently at times of change—spring and autumn, dawn and dusk, and before or after a storm. It is possible to anticipate cloud types from weather maps on television or in the newspapers. When a depression is forecast, a warm front will be followed by a cold front, which means there will be a predictable series of formations.

Air rises slowly as the warm front approaches to form cirrus clouds high in the sky. Expect the cirrus to thicken into featureless stratus which develops lower down and usually brings drizzle. Take pictures while the sky is relatively clear (unless you want dark, sombre clouds) as the depression may take a day to pass.

The rain stops, wind shifts direction and temperature rises when the warm front has passed. Now is the time to think about shots with the dramatic backdrop of a brewing storm. The sky may be clear but cumulus or cumulonimbus is gathering into giant cauliflower shapes above the approaching cold front.

This front will arrive after perhaps a few hours. It forces air to rise rapidly to

► Storm clouds give dramatic effects in black and white or colour, especially when they are backlit. *E A Janes*

► Below right: colour is important for sunsets, when light from the setting sun paints clouds from below. *John Sims*

▼ With a wide-angle lens you can take an expanse of sky while retaining the horizon to give a sense of scale. When exposure is calculated for the sky, foreground detail often records as a silhouette. *John Garrett*

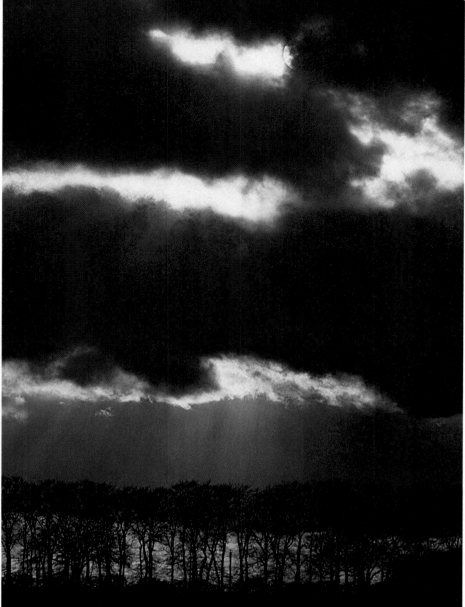

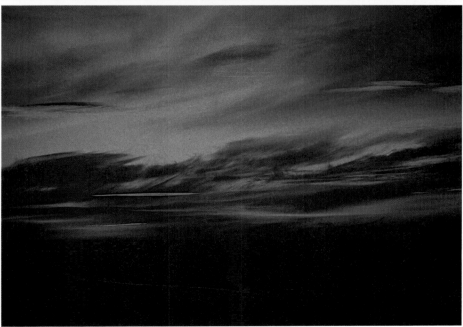

form cumulonimbus clouds. This is when the sun is likely to burst through breaks in the cloud on to patches of countryside or stretches of open water. It is also a good time to catch the cloud with a silver lining—a halo of light formed by the sun behind—and when the rain is likely to pour down. Protect your camera with a plastic bag and watch for a rainbow.

Exposure
Determine correct exposure by pointing a meter at the light areas of the cloud. A telephoto lens on a camera with TTL (through-the-lens) metering gives a more accurate reading. The long lens's narrow angle of view includes only a cloud or part of a cloud in the reading. Under-expose colour slide film by half or one stop. This will avoid 'washing out' the sky and clouds by making the blue more intense and increasing detail in the white.

If a reading is taken off the foreground the clouds may be three or four stops

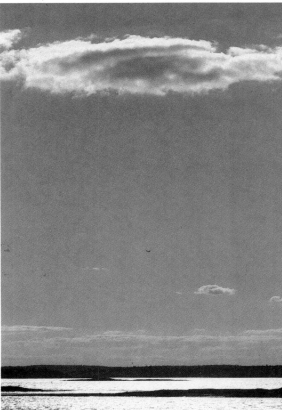

◀ Exposure readings should be taken from the cloud, excluding bright highlights when shooting into the light. *Timothy Beddow*

▶ Clouds change shape rapidly, especially in windy conditions. Even short exposures can show blur from cloud movement. This shot was taken at 1/8 of a second by *Robert Estall*.

▼ All clouds are formed by air rising and cooling. Cloud droplets form when air carrying water vapour reaches the 'dew point'. These cumulus clouds show the level cloud base where condensation starts. *Timothy Beddow* used a polarizing filter to darken the sky to show the clouds to advantage.

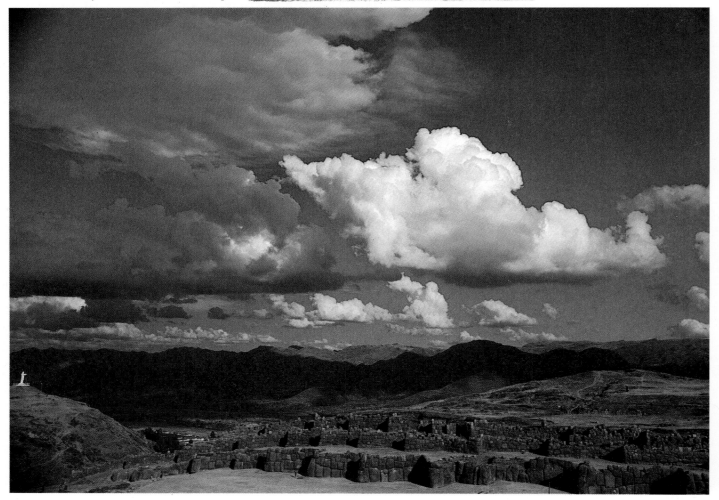

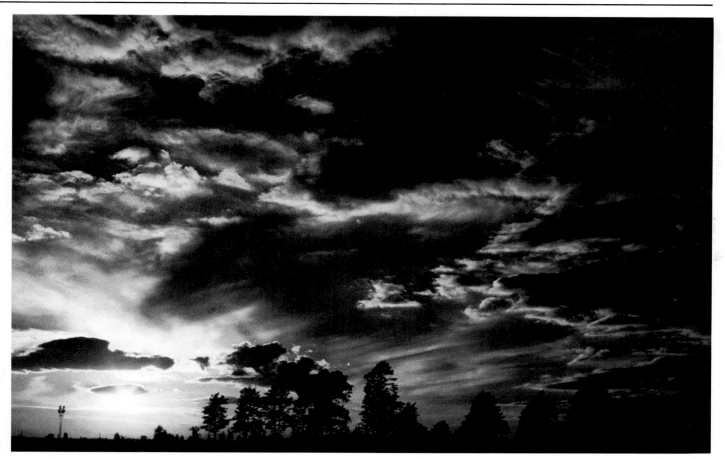

over-exposed. Always take the reading from the clouds. If the picture is on black and white film it may be possible to 'hold back' foreground detail at the printing stage.

Sometimes it will be useful to use fill-in flash on the immediate foreground, especially if the background clouds are dark and stormy. Make sure that the shutter speed is not set faster than the speed at which the flash synchronizes.

The right place
Mountainous areas and heights cause turbulence which makes formations vary and change. A vantage point high up a mountain can give a view over cloud collecting in valleys. Again, take the exposure reading from the clouds.

Lenses
The choice of lens depends on the type of picture. A telephoto lens will pick out small areas of cloud, perhaps showing the shape and texture of cumulus.

A wide angle lens will encompass a large expanse of sky and give a feeling of openness. A mackerel sky is an ideal subject for a 21 or 28mm lens. This formation, of regular cloudlets with the

sky showing through, occurs usually in the evening and catches the red setting sun.

Film and filters
Use a medium or slow black and white film (125 ASA or slower) or a slow colour film, say 25 to 100 ASA. These films can capture maximum cloud detail. Use a polarizing filter, or at least a UV or haze filter, with colour film. A correctly angled polarizing filter intensifies the blue sky which emphasizes the white in the clouds.

Yellow, orange and red filters progressively darken the sky on black and white film. A yellow filter makes the sky grey, a red filter turns it almost black.

Vary colour pictures of clouds with graduated filters. It should be easy to give blazing red clouds an emerald green foreground or make steely, grey skies hover over a yellow landscape.

Foregrounds
A foreground object will give depth and scale to a picture with a large expanse of clouds. Foreground detail will be under-exposed so choose shapes which will have a distinctive silhouette.

If the foreground is highly reflective, like a wet road or a lake, then it will require much the same exposure as the clouds.

From an aeroplane
Clouds can also be photographed through an aeroplane window. There is less variety in clouds seen from above but sometimes the sun is diffracted by the aeroplane window. The diffraction puts a rainbow into the picture.

Slide sandwiches
Spectacular landscapes and interesting cloud formations do not always occur together. The answer is to take pictures anyway and combine them later in a slide sandwich or by double printing.

A slide sandwich is two slides mounted in one frame: clouds and bare land of one superimposed on the empty sky and dramatic landscape of the other. Double printing means printing a foreground from one negative and the sky from another on to the same piece of paper. Make sure that the light shines from the same angle in each slide or each negative, or the result will look unnatural.

Photographing sunsets

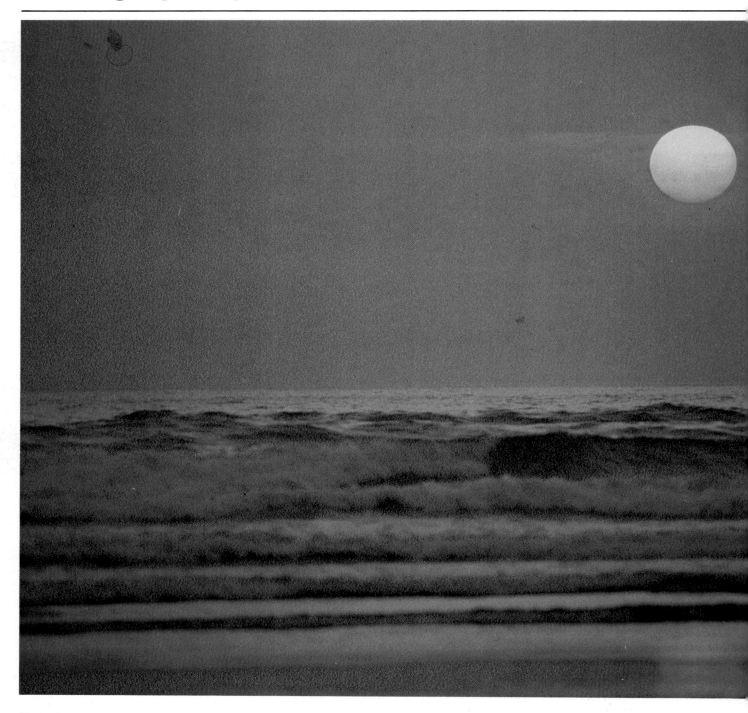

Few of us can resist stopping to look at a spectacular sunset. There can be infinite variations in the patterns and colours of sunsets, and it is not surprising that they make one of the most popular photographic subjects. Yet when it comes to creating something better than a snapshot many photographers fail to make the most of the situation.

One of the first things to decide is that you are going to create a picture, not just record the condition of the sky. This requires a little more thought than the point–and–shoot approach.

Ask yourself: Is the sun going to be the focus of attention or are the colours in the clouds more interesting? Perhaps the effect would be better if the sun was out of the picture altogether and you concentrated on a foreground silhouette against a glowing sky.

Explore different possibilities, looking for the best shots. The most awe–inspiring sunsets tend to occur in spring and autumn, so be especially watchful then. Be on the look–out for those evenings when the sun sets through a slight haze, which has the effect of sharpening the edges of the sun. In the tropics the sun sets faster than in temperate climes, and you will have to work quickly.

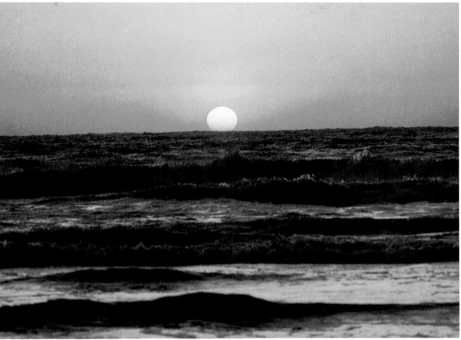

▲ No two sunsets are alike—one of the reasons why they are such a fascinating subject for photography. With a 200mm lens, *Gered Mankowitz* took this shot late on a clear evening at Big Sur, California, exposing at f4 and 1/125 on Kodachrome 64.

◄ With the same exposure and a 300mm lens, *Michael Busselle* took this summer sunset in Devon, England; the haze gave the scene a purple cast.

▼ Working in low light with wide apertures requires you to focus quite selectively. If the sun is the main subject of the shot, set the lens at infinity for a sharp outline. The same is true if you want to show detail in distant clouds. Sometimes foreground detail against a glowing backdrop is more impressive: *John Gardey* decided to sacrifice clear detail in the sunset itself in favour of focusing on the delicate foreground silhouette.

Choosing the right lens

Don't be afraid to shoot with the sun in the frame. If you wait for it to disappear behind a cloud or below the horizon you may miss the most impressive moment. If in doubt take three or more shots at different stages to make sure.

If the sun itself is going to be the most important subject, rather than surrounding clouds or scenery, use a long telephoto lens—the longer the better—

and focus on infinity. Any lens longer than about 300mm will ensure that the sun dominates the frame. But beware; the longer the focal length, the greater the danger of camera shake. This is because you are filling the frame with a distant object, and any slight movement of the camera is magnified.

One solution is to select a fast shutter speed—say 1/500—to freeze camera movement, and open the aperture to compensate. Since you will usually be focused on infinity the narrow depth of field should not be a problem.

Alternatively, you could mount the camera on a tripod to hold it stable. A wall or knee will often provide a useful makeshift tripod. Or it may be sufficient just to brace yourself against a firm object such as a tree or lampost for support.

Long telephoto lenses are very expensive. A useful alternative is a x2 teleconverter which fits between the camera body and lens. This effectively doubles the focal length of the lens, yet is much cheaper than buying a telephoto (though it reduces maximum aperture by a couple of stops).

The beauty of many sunsets does not lie in the sun alone. Foreground shapes can look dramatic with a spectacular glowing backdrop. When concentrating on the foreground, a standard or wide angle lens may be more appropriate. Focus on the subject, and the colours of the sunset will look impressive even if they are not in focus.

Exposure

Light does strange things when the sun is setting, and it will help if you know what to expect.

As the light is constantly changing you must keep checking the exposure reading. It may decrease by as much as one f stop a minute.

If you point the meter directly at the

▶ Many classic sunset photographs show the sun sinking over water, which amplifies the effect: without the sun's long reflection, this shot would have been far less impressive. *Jack Novak* used a red filter, and a small aperture to retain detail in the water.

▶ Below: not all good sunset pictures include the sun itself. *Sarah King* took this shot of a monsoon over the Indian ocean as a gap opened between the cloud and the horizon. Above and below the vivid colours, the even textures of sea and cloud reflect the rays of the sun in a similar pattern.

▼ This cloudy sunset over the sea was shot with an Olympus OM2, a 24mm lens, and Kodachrome 25. The reflection in the water makes the most of the varying hues of the cloudscape. The fact that the sun itself is not in the picture concentrates the eye on the sky.

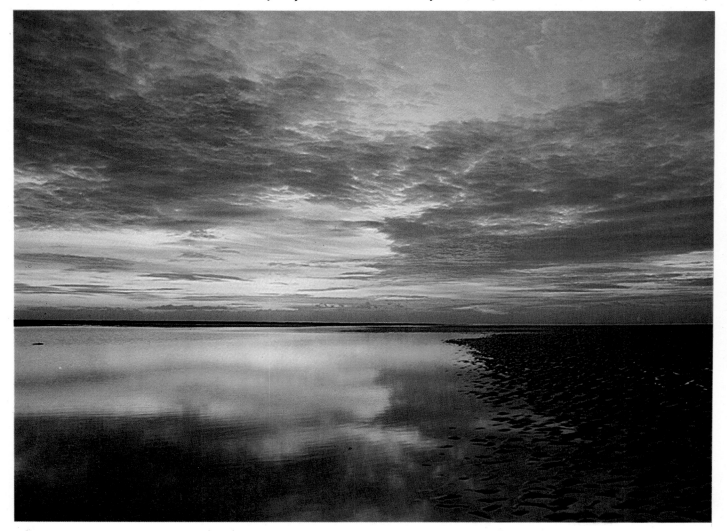

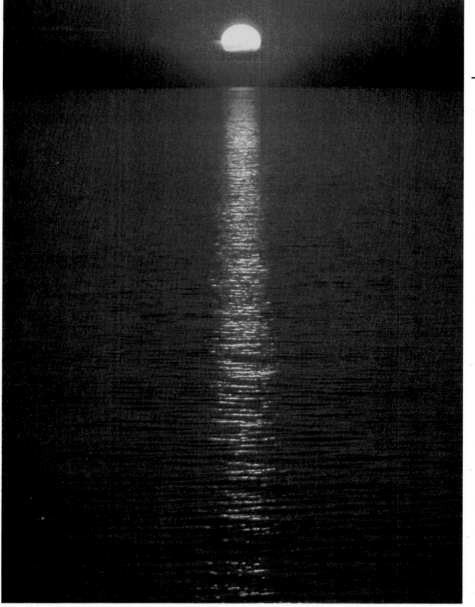

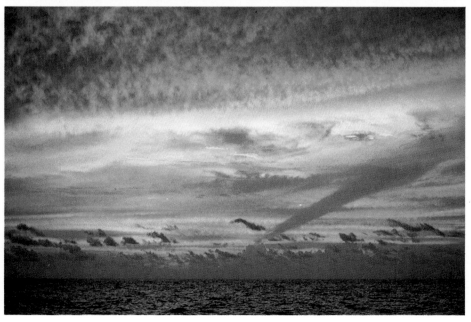

sun it will give an unusually high reading. A picture taken with that reading will turn out very dark and there will be no detail in foreground features. However, this technique is ideal for silhouette shots. Any shape with a distinctive outline, such as a tree, an animal or a person, will make a picturesque silhouette. Remember, take the meter reading from the sunset, not the object to be silhouetted.

An interesting progression from this is to use fill–in flash to expose the subject correctly—using a combination of stop and speed that is correct for the subject—and at the same time retaining the warm colours of the sunset. This is often used effectively in advertisements.

If your camera has TTL metering, the handbook will tell you if it is centre–weighted or takes an 'average' exposure reading from the whole frame. Some meters read the light from the bottom half of the frame; this is because, for a landscape shot, the 'average' meter would take into account the exposure for the sky, and therefore under–expose the foreground. Bottom–weighted meters avoid this problem by exposing for the darker foreground areas.

A hazy sunset gives a weak, diffused light which requires a relatively long exposure—maybe 1/30 or 1/15. Slight under–exposure here will produce richer colours, giving a 'warmer' picture. Though the colours of the sky will be correct, the colours of the landscape will not be strictly accurate with daylight colour film since this is balanced for 'normal' lighting conditions—a fine day with the sun behind you.

There can be no such thing as 'correct' exposure when it comes to sunsets. Over– or under–exposing a shot can produce equally pleasing effects. Try bracketing the pictures; take a shot one stop below, and another one stop above the indicated exposure. You may well end up with a *set* of successful pictures.

Setting up your shot

Be on the look–out for sites which would look particularly attractive with an exciting sunset behind. Make a mental note of any ideal location so you can return when the conditions are right. Some of the best pictures are created only after the photographer has returned to the site many times.

Some birds return to their roosting places as the sun sets. They can provide foreground silhouettes, or their home-

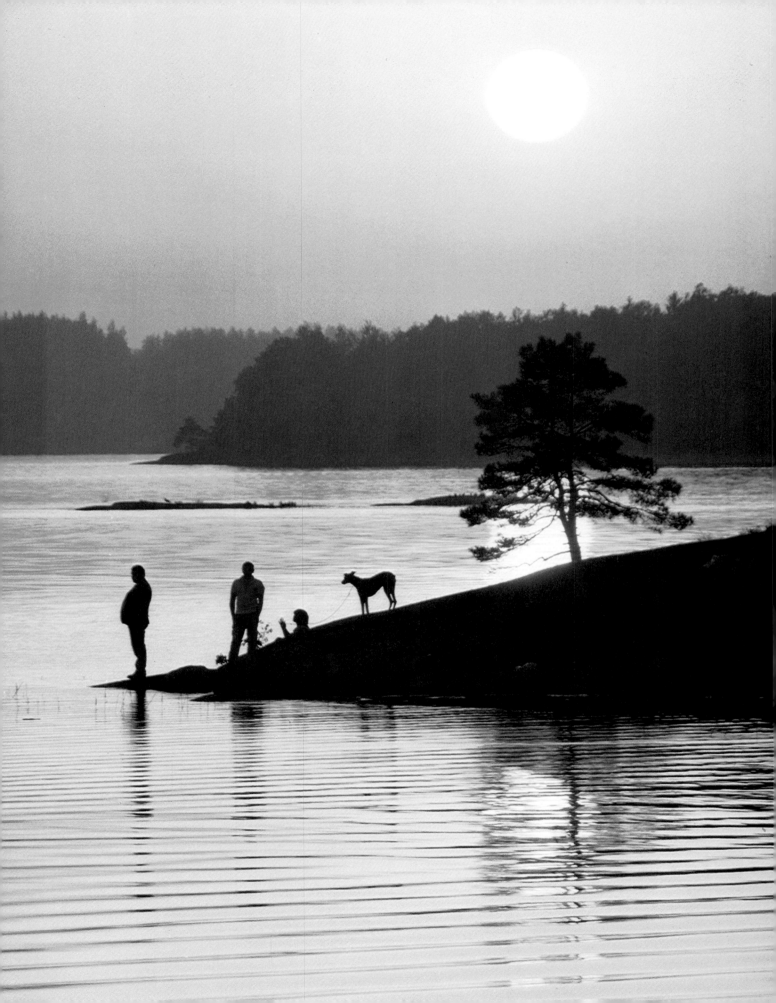

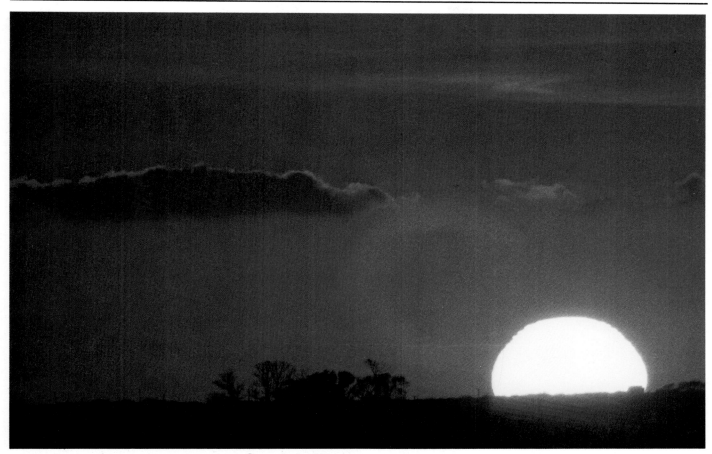

▲ *David Saunders* used an 800mm lens to magnify the sun: to the naked eye the scene was less impressive.

◄ **Shooting while there was still light for a good depth of field,** *Michael Boys* **warmed the scene with an orange filter.**

ward flights could add interest to the sky. They go the same way each day, so you can be ready for them.

So often, though, a magnificent sunset will just happen, and you haven't prepared for it. To make the most of it you must act quickly, looking around for interesting possibilities to add to the image.

Look for objects that will provide suitable foreground silhouettes—a person, a tree, a boat or a distinctive building. An archway or a bough of a tree could be used to frame the picture. Do you have a better choice of lens with you? If you are quick you could take a whole series of shots with different lenses from a variety of angles, and include different foreground subjects. With a zoom lens, of course, you can vary the framing effect without changing lenses.

Special effects

Sunset is an ideal time for experimenting with filters.

Using a yellow or orange filter will change and intensify the natural sunset colours. A starburst filter will create an explosion of light from the sun in a star shape. Prism filters produce multiple images which can be most effective.

Flare from such an intense light source is usually considered a problem. Modern multi–coated lenses have an anti–reflective coating to try to reduce flare. Yet flare can improve a picture by adding impact. A small aperture will yield star shapes, with light bursting out along points of the star. A larger aperture will create a more circle–shaped spread of light.

Sunsets can also be 'faked' by under exposing into–the–light shots. This produces silhouettes and illusion of evening, though usually without the vivid colours of a real sunset.

Sandwiching two or more transparencies together can be a useful way to revitalize ordinary pictures. Try mounting a sunset together with various straightforward shots until you find the most effective combination.

The sky at night

Few people consider the sky at night as a subject for photography. If they do, it is perhaps only the moon that attracts their attention. In fact, the night sky is full of activity. There are satellites, which follow an apparently straight path, while the stars appear to rotate around the north (pole) star. In northern areas there are the 'northern lights', which have their southern counterparts like multicoloured muslin curtains stretching over Australia. At certain times of the year showers of meteorites can be seen making fiery trails across the heavens.

Often the night sky is obscured by cloud or—particularly in towns—by atmospheric haze, which is what makes the stars appear to twinkle. But on clear nights the picture is a fascinating one. The most impressive things about the stars to the untrained eye are their sheer number and the range of their brightness. A closer look reveals that they are also different colours. But it is only after viewing the heavens through a telescope, or through a long lens on a camera, that most of us realize this.

What you will need

There are a few pieces of equipment vital to photographic excursions at night.
A tripod is essential for long exposures and when you use long lenses.
A cable release is also necessary to avoid vibration with long lenses. A release with a lock for time exposures is an advantage.
A torch is essential. Use it to set focus, make adjustments and to jot down notes on each exposure.

A separate exposure meter may be useful, especially since many TTL meters indicate the light level with a black pointer in the viewfinder which is almost impossible to see against a black background. (You can get round this problem by holding a piece of white card up so that it shows on the relevant side of the frame and you can see the indicator. This will affect exposure, of course, but it is better than blind guessing.)
An eyepatch will allow you to keep one eye adapted for darkness while you use your torch to adjust the camera.

▲ The moon is the easiest heavenly body for a beginner to photograph. With a telephoto lens and a tele-converter you can get an image large enough to show the uneven contours of its surface. It is also bright enough to photograph via a telescope or binoculars. *A Wetzel*

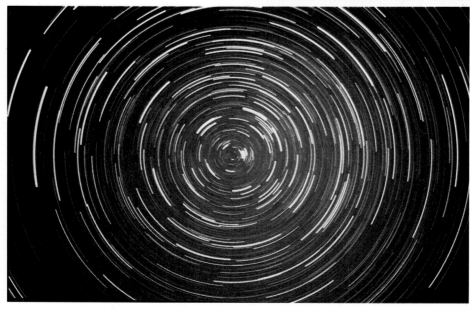

▶ With a standard lens the image of the moon will be too small to fill the frame, so include the horizon in silhouette. Shoot on daylight film. With 200 ASA film, a typical exposure would be 1/30 at f8. This picture was taken in Kenya by *John Reader.*

◀ This picture of the stars circling the pole star was taken with a standard lens left open for four hours. Note the different colours of the stars, made more obvious in the extended trails. *Harry Ford*

230

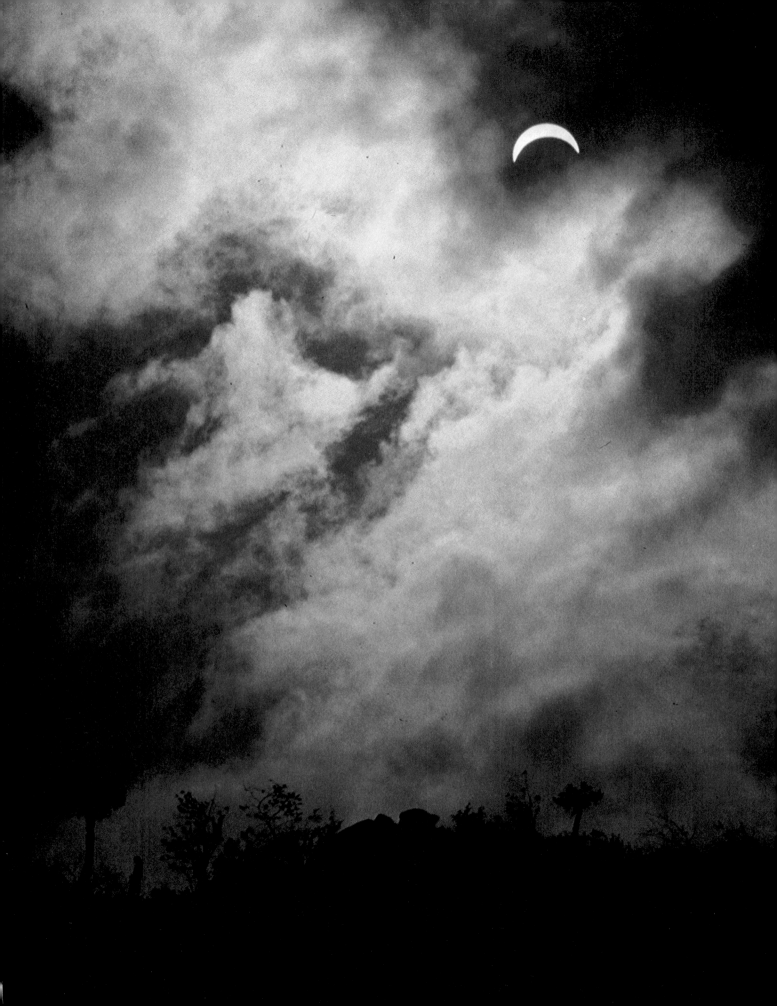

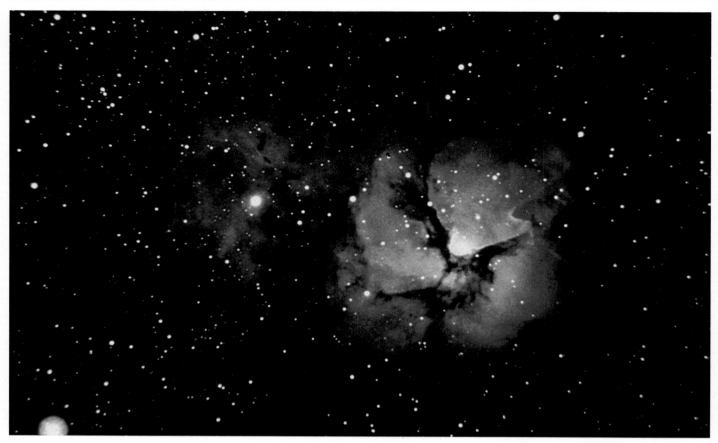

A cardboard shade, in conjunction with as deep a lens hood as possible, will help cut out the effect of any light in the sky from nearby towns. It can also be used to cover the lens temporarily during a long exposure if car headlights pass by.

A telescope or pair of binoculars is a great asset, not only for gazing at the heavens but also as a substitute for a long focal length lens.

The moon

Though extremely long lenses are still far too expensive, good quality teleconverters are now quite commonplace and a focal length of around 1000mm is no longer out of the question. All you need is a 500mm lens with a 2 x teleconverter. This will yield an image of the moon that is about ½ inch (1cm) in diameter and good enough to enlarge. The most interesting part of the moon's disc is the 'terminator'—the edge of the sunlit area—that you see at all times except when the moon is full. Because the surface of the moon is sidelit by the sun, the mountains and valleys appear in sharp relief. Notice that although there is a part of the moon that we never see from the earth, it does not

▼ To fill the frame with a distant planet like Saturn (shown here), you need access to a large telescope. The Celestron C14 fits on to a camera and is equivalent to a 400mm lens. With accessories you can boost this magnification even further.

▲ Nebulae (gas clouds) form dark or coloured patches, visible through telescopes like those used by amateur astronomers. *Harvey Lloyd*

▶ *Ron Arbour's* shot of the Horsehead Nebula 8½ in (21.6cm) reflector.

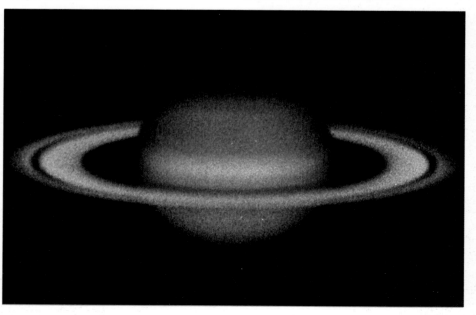

arc of 15° every hour: the longer your exposure, the better the effect.

Choose a clear night for photographing the stars, preferably in open countryside away from any towns which will light up the smoke-laden sky enough to show on your film. For the sake of your camera you also need good weather! A heavy dew may form as dawn approaches, so protect the camera as far as possible without obscuring the lens. On winter nights the air is often clearer than at other times, and sharpest night pictures are taken at about 3am, when atmospheric turbulence is markedly less. But you should find out whether a frost is expected: frost can also be an enemy of the camera.

Load your camera with fast film and set the lens aperture at its widest focusing on infinity. With the camera on a tripod, find the north star in the viewfinder and then frame up on a nearby cluster of stars, bearing in mind the circular path they will travel during your long exposure. Then leave the shutter open for ten minutes to an hour or more, depending on the length of the arc you hope to trace on the film. When the film is finally developed, there may be some surprises. As well as stars, you may find the straight tracks of satellites, or curving trails from meteorites.

Shorter exposures will also give results, if you are loath to leave your camera open to the elements for such a long time. An exposure of 30 seconds will record the stars as points, just as you see them in the sky. Increasing the exposure will not make them any brighter, merely give them time to move and leave 'star trails'. But if there is light in the sky from a nearby town, a shorter exposure will prevent this from overpowering the light from the stars.

For general star views like this, you can include a recognizable object such as a tree or a church spire. If you repeat the shot days or weeks later, you can compare the position of the stars and see clearly the movement of the stars against a background of the heavens.

If you send your negatives off to be processed, the laboratory may fail to print them, as the pinpoints of light may look like a random collection of black spots on the negative. Send the film with instructions to 'print anyway'. They may look like grubby negatives to some, but when printed the results can be very beautiful. If you can make your own big blow-ups in colour, the results can be truly awe-inspiring, like—literally—nothing on earth!

always present exactly the same face to us.

If you shoot slides, use daylight balanced film: the moon is bathed in sunlight while the earth is in shadow. The moon moves quickly—even 1/10 can show elongation. A typical exposure for the moon is 1/30 at f8 on 200ASA film.

Using a telescope or binoculars

If you have no long focus lens but have access to a telescope or binoculars, you may be able to take greatly magnified images of the moon and stars through this. Firmly fix the telescope (or binoculars) on a tripod so that it is pointing at the area of the sky that interests you. Then with the camera on a second tripod, position it about a foot (30cm) behind the eyepiece of a pair of binoculars) and close the gap between them with a cardboard tube, blackened inside.

Set the camera lens at full aperture and set the focus to infinity. To get a sharp image, use the eyepiece of the telescope to focus.

Your TTL meter may be used to decide what shutter speed to use, but the best way to make sure of a good result is to bracket exposures. As a guide, consider that an 80mm diameter refracting telescope has light transmission equivalent to an aperture of f11 or f16, while a 150mm diameter reflector would be about f8.

Tracking the stars

Not all astronomical photography requires a telescope or telephoto lens. With a standard lens pointed directly at the pole star, with a very long exposure you can record the apparent movement of the stars as circular tracks of light. The motion of the earth makes the stars appear to travel through an

THE NATURE PHOTOGRAPHERS' CODE OF PRACTICE

Introduction

In nature photography, there is one hard-and-fast rule of which the photographer must at all times observe the spirit—**"The welfare of the subject is more important than the photograph"**. This is not to say that photography should not be undertaken because of slight risk to a common species. But the amount of risk which is acceptable decreases with the scarceness of the species, and the photographer should always do his utmost to minimise it. Risk, in this context, means risk of physical damage, suffering, consequential predation, or lessened reproductive success. Possible dangers to particular species are mentioned below.

The law as it affects nature photography must be observed. In the UK the chief legislation is the Protection of Birds Acts, 1954-67, and the Conservation of Wild Creatures and Wild Plants Act 1975, though bye-laws may also govern activities in some circumstances. In other countries, one should find out what restrictions apply.

General

The photographer should be familiar with the natural history of his subject, the more complex the life-form and the rarer the species, the greater his knowledge ought to be. He should also be sufficiently familiar with other natural history specialities to be able to avoid damaging their interests accidentally. Photography of scarce animals and plants by people who know nothing of the risks involved is to be deplored.

For many subjects, "gardening" (ie interference with surrounding vegetation) is necessary. This should be to the minimum extent, not exposing the subject to predators, people, or adverse weather conditions. It should be carried out by tying-back rather than cutting off, and the site should be restored to as natural a condition as possible after each photographic session.

If the photograph of a rarity is to be published or exhibited, care should be taken that the site location is not accidentally given away. Sites of rarities should never deliberately be disclosed. It is important for the good name of nature photography that its practitioners observe normal social courtesies. Permission should be obtained before operations on land to which there is not customary free access, and other naturalists should not be incommoded. Work at sites and colonies which are the subjects of special study should be coordinated with the people concerned.

Photographs of dead, stuffed, home-bred, captive, cultivated, or otherwise controlled specimens may be of genuine value, but should never be 'passed off' as wild and free. Users of such photographs (for exhibition or publication) should always be informed, however unlikely it may seem that they care as embarassment can thus be avoided.

Birds at the nest

It is particularly important that photography of birds at the nest should only be undertaken by people with a good knowledge of birds' breeding behaviour. There are many otherwise competent photographers (and bird-watchers) who lack this qualification. It is highly desirable that a scarce species should be photographed only in areas where it is relatively frequent. Many British rarities should, for preference, be photographed in countries overseas where they are commoner. Photographers working abroad should, of course, act with the same care they would use at home.

A hide should always be used when there is reasonable doubt that the birds would continue normal breeding behaviour otherwise. No part of the occupant (eg hands adjusting lens-settings, or a silhouette through inadequate material) should be visible from outside the hide. Hides should not be positioned on regularly-used approach-lines to the nest and should be moved up on a roughly constant bearing. They should not be allowed to flap in the wind.

A hide should not be erected at a nest where the attention of the public or any predator is likely to be attracted. If there is a *slight* risk of this, an assistant should be in the vicinity to shepherd away potential intruders. No hide should be left unattended in daylight in a place with common public access. Tracks to and from any nest should be devious and inconspicuous. As far as possible they (like the gardening) should be restored to naturalness between sessions.

Though nest failures attributable to photography are few, a high proportion of them are the result of undue haste. The maximum possible time should elapse between the consecutive stages of hide movement (or erection), introduction of lens and flash-gear, gardening and occupation. There are many species which need at least a week's preparation.

Each stage should be fully accepted by the bird (or both birds where feeding or incubation is shared) before the next is initiated. If a stage is refused by the birds (which should be evident from their behaviour, to any properly-qualified photographer), the procedure should be reversed by at least one stage; if refusal is repeated, the attempt at photography should be abandoned. In difficult country, acceptance can be checked indirectly by disturbed marker-twigs, moved eggs, etc, provided the disturbance in inspecting the marker is minimal.

The period of disturbance caused by each stage should be kept to the minimum. It is undesirable to initiate a stage in late evening, when birds' activities are becoming less frequent. Remote-control work where acceptance cannot be checked is rarely satisfactory. Where it involves resetting a shutter, or moving film on manually between exposures, it is even less likely to be acceptable because of the frequency of disturbance.

While the best photographs are often obtained at about the time of the hatch, this is no time to start erecting a hide – nor when eggs are fresh. It is better to wait until parents' reactions to the situation are firmly established. There are few species for which a "putter-in" (and getter-out) is not necessary.

The birds' first visits to the nest after the hide is occupied are best used for checking routes and behaviour rather than for exposures. The quieter the shutter, the less the chance of the birds objecting to it. The longer the focal length of lens used, the more distant the hide can be and the less the risk of the birds not accepting it. Changes of photographer in the hide (or any other disturbance) should be kept to the minimum, and should not take place during bad weather (rain or exceptionally hot sun).

Nestlings should never be removed from a nest for posed photography; when they are photographed **in situ** care should be taken not to cause an "explosion". It is never permissible to prevent artificially the free movements of young. The trapping of breeding birds for studio-type photography is totally unaccetable in any circumstances. The use of play-back tape (to stimulate territorial reactions) and the use of stuffed predators (to stimulate alarm reactions) may need caution in the breeding season, and should not be undertaken near a nest.

Away from their nests

It is not always true that, if technique is at fault, the subject will either not appear or it will move elsewhere and no harm will be done. Predators should not be baited from a hide in an area where hides may later be used for photography of birds at the nest. Wait-and-see photography should not be undertaken in an area where a hide may show irresponsible shooters and trappers that targets exist; this is particularly important overseas.

The capture of even non-breeding birds just for photography under controlled conditions is not an acceptable practice. Incidental photography of birds taken for some valid scientific purpose is acceptable, provided it causes minimal delay in the bird's

release, but in the UK this must be within the terms of the licence issued by the Nature Conservancy Council. Taking small mammals for photographic purposes is acceptable, provided they are not breeding and that they are released with minimum delay in their original habitats, but the practice is not recommended. Particular care is needed with shrews, which may starve to death in three hours.

Bats need special care. Disturbance at or near a breeding colony of any bat may cause desertion of an otherwise safe site; several UK species are very rare and two of them, the greater horse-show and the mouse-eared bat are specially protected under the Conservatiuon of Wild Creatures and Wild Plants Act 1975 and should not be taken from the wild except in exceptional circumstances when a licence is required form the NCC. The loss of even one site for these rare species could be critical. Unnecessary disturbance of roosting sites should also be avoided, and photographic visits should be coordinated with those by people studying the colonies.

Hibernators should never be awakened for photography. If it is unavoidable choose a mild spell near the end of a mild winter. Bats are especially vulnerable, since their fat reserves may only be adequate for four or five awakenings in an entire winter. An awakened hibernator should be offered food, but refusal to feed should not be a reason for taking an alternative specimen; it should be returned to hibernation as soon as possible.

Other animals

For cold-blooded animals and invertebrates, temporary removal from the wild to a studio or vivarium (or aquarium) for photography is well-accepted practice, but subsequent release should be in the original habitat and as soon as possible. It is illegal to take from the wild species listed in Schedule I of the Conservation of Wild Creatures and Wild Plants Act; at present these are the sand lizard, smooth snake, natter jack toad and one butterfly, the large blue. Chilling or light anaesthesia for quietening invertebrates is not recommended. If it is undertaken, subjects should only be released when the effects have completely worn off. When microhabitats (eg tree-bark,

beach rocks etc) have been disturbed, they should be restored after the photography.

Insect photographers should be familiar with the Joint Committee for the Conservation of British Insects' **Code of Insect Collecting** and **British Macrolepidoptera; Rare and Endangered Species.** While these allow moderate rarities to be collected, photographers should take a restrictive view of what ought even to be put at risk by their activities.

Plants

The comments in the General section about gardening are particulary important for rare plants within reach of the public. Photographers should be clear about existing plant legislation, for without the permission of the landowner or his tenant, it can be an offence to uproot any wild plant and consequently technical offences may be committed when gardening is involved. Lichens are covered by the Act but fungi and algae are not. The second Schedule to the Conservation of Wild Creatures and Wild Plants Act 1975 list 21 rare species which it is illegal for anyone to uproot, pick or destroy. Both the wild creatures and wild plant schedules to this Act can be amended from time to time.

Trampling of habitats can cause serious damage in vulnerable areas, especially marshes. It is essential that preparations to photograph one specimen of a rarity do not involve treading on other specimens.

Canada
While the principles embodied in this Code of Practice apply to nature photography worldwide, readers in Canada wishing to refer to specific legislation relating to Canadian wildlife should apply for information to the Governments of each Province. The *Migratory Birds Act* is Federal, and copies may be obtained from the Department of the Environment (Canadian Wildlife Service), Ottawa. For further information relating to all aspects of Canadian wildlife, contact the *Canadian Nature Federation,* 75 Albert Street, Ottawa, Ontario KIP 6Gl.

Reproduced by courtesy of the *Association of Natural History Photographic Societies.*

Glossary

Words in *italics* appear as separate entries.

A

Additive colour A method of mixing light where virtually any colour (except the pure spectrum colours) can be produced by adding various proportions of the primary colours – blue, green and red. The additive colour mixing system was used for early colour photographs, such as autochrome and Dufacolour and is used today in colour television.

Aerial perspective The change in a subject's appearance with increased distance from the camera. Aerial perspective remains largely unchanged when going from near subjects to distances of about 30m. At farther distances, depending on atomspheric conditions – subjects increasingly appear softer (less sharp), less contrasty, lighter in tone and bluer.

Angle of view This is the maximum angle seen by a lens. Most so-called standard or normal lenses (for example 50mm on a 35mm camera) have an angle of view of about 50°. Lenses of long focal length (200mm for example) have narrower angles and lenses of short focal length (eg 28mm) have wider angles of view.

Aperture The circular opening within a camera lens system that controls the brightness of the image striking the film. Most apertures are variable – the size of the film opening being indicated the f number.

ASA American Standards Association. The sensitivity (speed with which it reacts to light) of a film can be measured by the ASA standard or by other standards systems, such as DIN. The ASA film speed scale is arithmetical – a film of 200 ASA is twice as fast as a 100 ASA film and half the speed of a 400 ASA film. See also *ISO*.

Auto-winder in the strictest sense an auto-winder is a unit which can be attached to many SLRs for motorized single frame film advance. After each exposure the auto-winder automatically advances the film to the next frame and cocks the shutter. Many units, however, are capable of modest speed picture sequences. Some cameras have an auto-winder built into the main body.

B

Bellows A concertina-like unit that fits between the camera body and the lens. A bellows unit enables the lens to focus on close subjects, and gives a large image of the subject. The magnification of the subject depends on the focal length of the lens and the extension of the bellows. For example, using a bellows unit with a 50mm lens on a 35mm camera gives a subject magnification range of about x 1 (that is, lifesize) to x3.

Bounce light Light (electronic flash or tungsten) that is bounced off a reflecting surface. It gives softer (more diffuse) illumination than a direct light and produces a more even lighting of the subject. There is a loss of light power because of absorption at the reflecting surface and the increased light-to-subject distance. It is best to use white surfaces since these absorb only a small amount of light and do not impart any colour to the illumination.

Bracketing To make a series of different exposures so that one correct exposure results. This technique is useful for non-average subjects (snowscapes, sunsets, very light or very dark toned objects) and where film latitude is small (colour slides). The photographer first exposes the film using the most likely camera setting, found with a light meter or by guessing. He then uses different camera settings to give more and then less exposure than the nominally correct setting. An example of a bracketing series might be 1/60th sec f8, 1/60th sec f5·6, 1/60th sec f11, *or* 1/60th sec f8, 1/30th sec f8, 1/125th sec f8.

C

Cable release A flexible cable which is attached (usually screwed-in) to the shutter release and used for relatively long exposure times (1/8 and more). The operator depresses the plunger on the cable to release the shutter, remotely. This prevents the camera from moving during the exposure.

CC filters These are 'colour correcting' or 'colour compensating' filters which may be used either in front of the camera or when printing colour film, to modify the final colour of the photograph. Their various strengths are indicated by numbers usually ranging from 05 to 50. Filters may by combined to give a complete range of colour correction.

Close-up attachment Any attachment which enables the camera to focus closer than its normal closest distance. Such attachments include close-up lenses, bellows and extension tubes.

Colour balance The overall colour cast of the film or print. Normally a film or print is balanced to give grey neutrals (such as a road or pavement) and pleasing skin tones. The colour balance preferred by the viewer is a subjective choice, and this is the reason for the variety of colour films available, each having its own colour characteristics.

Colour cast A local or overall bias in the colour of a print or transparency. Colour casts are caused mainly by poor processing and printing, the use of light sources which do not match the film sensitivity, inappropriate film storage (high temperature and humidity), and long exposure times.

Contrast The variation of image tones from the shadows of the scene, through its mid-tones, to the highlights. Contrast depends on the type of subject, scene brightness range, film, development and printing.

D

Depth of field The distance between the nearest and furthest points of the subject which are acceptably sharp. Depth of field can be increased by using small apertures (large f numbers), and/or short focal-length lenses and/or by taking the photograph from further away. Use of large apertures (small f numbers), long focal-length lenses, and near subjects reduces depth of field.

Depth of field preview A facility available on many SLR cameras which stops down the lens to the shooting aperture so that the depth of field can be seen.

Differential focusing The technique of using wide apertures (small f-numbers) to reduce depth of field, and to therefore separate the focused subject from its foreground and background.

Diffuse light source Any light source which produces indistinct and relatively light shadows with a soft outline. The larger and more even the light source is the more diffuse will be the resulting illumination. Any light source bounced into a large reflecting surface (for example, a white umbrella, white card, or large dish reflector) will produce diffuse illumination.

DIN Deutsche Industrie Normen. A film speed system used by Germany and some other European countries. An increase/decrease of 3 DIN units indicates a doubling/halving of film speed, that is a film of 21 DIN (100 ASA) is half the speed of a 24 DIN (200 ASA) film, and double the speed of an 18 DIN (50 ASA) film. See also *ISO*.

Dioptre A measurement unit which is used to indicate the power of a lens. The dioptre power of a lens is the reciprocal of the lens focal length expressed in metres, that is, dioptre power = 1/F in metres. For example, a lens of 1 metre focal length is a 1 dioptre lens, a 500mm lens is 2 dioptres, a 250mm lens is 4 dioptres. Most close-up lenses have their strength expressed in dioptres, and when two or more lenses are added together their combined strength is found by adding their dioptre values.

E

Electronic flash A unit which produces a very bright flash of light which lasts only for a short time (usually between 1/500-1/4000 second). An electronic flash tube will last for many thousands of flashes and can be charged from the mains and/or batteries of various sizes.

Exposure The result of allowing light to act on a photosensitive material. The amount of exposure depends on both the intensity of the light and the time it is allowed to fall on the sensitive material.

Exposure factor The increase in exposure, normally expressed as a multiplication factor, which is needed when using accessories such as filters, extension tubes, and bellows. For example, when using a filter with a x2 exposure factor the exposure time must be doubled or the aperture opened by one stop.

Extension rings (tubes) Space rings which fit between the camera body and the lens, and allow the camera to focus on subjects closer than the nearest marked focusing distance of the lens.

F

Fast films Films that are very sensitive to light and require only a small exposure. They are ideal for photography in dimly lit places, or where fast shutter speeds (for example, 1/500) and/or small apertures (for example f16) are desired. These fast films (400 ASA or more) are more grainy than slower films.

Fill light Any light which adds to the main (key) illumination without altering the overall character of the lighting. Usually fill lights are positioned near the camera, thereby avoiding extra shadows, and are used to increase detail in the shadows.

Film speed See *ASA, DIN* and *ISO*.

Filter Any material which, when placed in front of a light source or lens, absorbs some of the light coming through it. Filters are usually made of glass, plastic or gelatin-coated plastic and in photography are mainly used to modify the light reaching the film, or in colour printing to change the colour of the light reaching the paper.

Filter factor See *Exposure factor*.

Flare A term used to describe stray light that is not from the subject and which reaches the film. Flare has the overall effect of lowering image contrast and is most noticeable in the subject shadow areas. It is eliminated or reduced by using coated lenses (most modern lenses are multi-coated), lens hoods and by preventing lights from shining directly into the lens.

Flash See *Electronic flash*.

Flash synchronization The timing of the flash to coincide with the shutter being open. For electronic flash synchronization it is necessary to use the X sync connection and a suitable shutter speed – usually 1/60 sec or slower for focal plane shutters and any speed for leaf shutters. Flashbulbs are used with M sync and a speed of 1/60 sec (preferable) or with X sync and a speed of 1/30 or slower.

f numbers The series of internationally agreed numbers which are marked on lenses and indicate the brightness of the image on the film plane – so all lenses are focused on infinity. The number series is 1·4, 2, 2·8, 4, 5·6, 8, 11, 16, 22, 32 etc – changing to the next largest number (for example, f11 to f16) decreases the image brightness to ½ and moving to the next smallest number doubles the image brightness.

Focal length The distance between the optical centre of the lens (not necessarily within the lens itself) and the film when the lens is focused on infinity. Focal length is related to the angle of view of the lens – wide-angle lenses have short focal lengths (for example 28mm) and narrow-angle lenses have long focal lengths (for example, 200mm).

G

Grain The random pattern within the photographic emulsion that is made up of the final (processed) metallic silver image. The grain pattern depends on the film emulsion, plus the type and degree of development.

H

High key A photograph that consists of mainly light tones, a few middle tones, and possibly small areas of dark tones. The overall impression is of lightness and delicacy. A high key photograph is achieved by using diffused lighting and a subject that is predominantly light in tone.

Highlight Those parts of the subject or photograph that are just darker than pure white eg lights shining off reflecting surfaces (sun on water, light shining through or on leaves). The first parts of a scene or photograph to catch the eye of the viewer are likely to be the highlights – it is therefore important that they are accurately exposed and composed.

Hyperfocal distance A lens that is focused on the hyperfocal distance produces acceptably sharp images of objects that are positioned between infinity and half the hyperfocal distance. Hyperfocal distance depends on the lens aperture, lens focal length, and the film format. For example, a 50mm lens on a 35mm camera set at f8 has a hyperfocal distance of 10m and produces sharp images of objects between infinity and 5m.

I
Infinity In theory, this is a point that can never be reached, a measureless distance from the lens. In practice, a subject is said to be at infinity when going farther away makes no difference to the focusing of the lens. Infinity is considered to be closer for wide angle lenses than for narrow angle (long focal length) lenses.

Interchangeable lens A lens which can be detached from the camera body and replaced by another lens. Each camera manufacturer has its own mounting system (screw thread or bayonet type) which means that lenses need to be compatible with the camera body. However, adaptors are available to convert one type of mount to another.

ISO International Standards Organisation. The ISO number indicates the film speed and aims to replace the dual ASA and DIN systems. For example, a film rating of ASA 100, 21 DIN becomes ISO 100/21°.

L
Lens hood (shade) A conical piece of metal, plastic or rubber which is clamped or screwed on to the front of a lens. Its purpose is to prevent bright light sources, such as the sun which are outside the lens field of view from striking the lens directly and degrading the image by reducing contrast (flare).

Long focus lens Any lens with a greater focal length than a standard lens, for example, 85mm, 135mm and 300mm lenses on a 35mm camera.

Low key This describes any image which consists mainly of dark tones with occasional mid and light tones.

M
Macro lens A lens which focuses on very near subjects without the aid of close-up devices such as extension tubes or close-up lenses. Most macro lenses can produce an image which is ½ life size on the film. See also *Photomacrography.*

Micro lens A term used by some manufacturers to describe their macro lens(es). The prefix micro should strictly only be applied to photography through a microscope (photomicrography).

Microphotography The branch of photography concerned with producing very small images, such as are used in the production of 'microchips'. Microphotography should not be confused with *photomicrography.*

Mirror lens Any lens which incorporates mirrors instead of conventional glass (or plastic) lens elements. The type of lens design is employed mainly for long focal length lenses (eg 500mm), and produces a relatively lightweight lens with a fixed aperture.

Monochrome A monochrome picture is the one which has only one colour; the term is usually applied to black and white prints or slides.

Motor-drive A motor-drive provides motorized film advance, both single frame and sequence. Motor-drive units are generally capable of much faster sequence rates (given in frames per second-fps) than auto-winders.

N
Neutral density filter A filter which, when placed in front of the camera lens, reduces the amount of light reaching the film without altering its colour.

Normal lens A phrase sometimes used to describe a 'standard' lens – the lens most often used, and considered by most photographers and camera manufacturers as the one which gives an image most closely resembling normal eye vision. The normal lens for 35mm cameras has a focal length of around 50mm.

O
Over-exposure Exposure which is much more than the 'normal' 'correct' exposure for the film or paper being used. Over-exposure can cause loss of highlight detail and reduction of image quality.

P
Panning The act of swinging the camera to follow a moving object to keep the subject's position in the viewfinder approximately the same. The shutter is released during the panning movement.

Pentaprism An optical device, used on most 35mm SLR cameras, to present the focusing screen image right way round and upright.

Photoflood An over-run (subjected to a higher voltage than the bulb is designed for) which gives a bright light having a colour temperature of 3400K.

Photomacrography Close-up photography in the range of x1 to about x20 life-size on the film.

Photomicrography Photography through a microscope.

Polarizing filter A polarizing (or pola) filter, depending on its orientation, absorbs polarized light. It can be used to reduce reflections from surfaces such as water, road, glass and also darken the sky in colour photographs.

Primary colours See *Additive colour* and *Subtractive colour synthesis.*

R
Reflector Any surface which is used to reflect light towards the subject, and especially into shadow areas.

Reversing rings an adapter ring which screws into the lens filter thread and permits the lens to be mounted rear-end-out on to the camera body. It is used for extreme close-up work to improve image quality.

Rim light Light placed behind the subject to give a pencil of light around the subject's outline.

S
Saturation The purity of a colour. The purest colours are spectrum colours (100% saturation and the least pure are greys (0% saturation).

Shutter The device which controls the duration of exposure.

Single lens reflex (SLR) A camera which views the subject through the 'taking' lens via a mirror. Many SLRs also incorporate a *pentaprism.*

Skylight filter A filter which absorbs UV light, reducing excessive blueness in colour films and removing some distant haze.

Slave unit A light-sensitive device which triggers other flash sources when activated by the light from the camera-connected flash.

Soft-focus lens A lens designed to give slightly unsharp images. This type of lens was used primarily for portraiture its results are unique and are not the same as a conventional lens defocused or fitted with a diffusion attachment.

Spot meter An exposure meter which reads off a very small area of the subject. Spot meters have an acceptance angle of only one or two degrees. Their usefulness depends on careful interpretation by the photographer.

Standard lens See *Normal lens.*

Star filter When placed in front of the camera lens, a star filter gives a star-like appearance to strong highlights.

Stop Another term for aperture or exposure control. For example, to reduce exposure by two stops means to either reduce the aperture (for example, f8 to f16) or increase the shutter speed (1/60 sec to 1/250 sec) by two settings. To 'stop down' a lens is to reduce the aperture, that is, increase the f-number.

Stopping down The act of reducing the lens aperture size ie increasing the f-number. Stopping down increases the depth of field.

Subtractive colour synthesis The method of producing colours by subtracting the appropriate amounts of red, green and blue from white light. The subtractive colour filters usually employed in photography are yellow (subtracts blue), magenta (subtracts green), and cyan (subtracts red).

T
Teleconverter An optical device which is placed between the camera body and

lens, and increases the magnification of the image. For example a x2 converter when combined with a 50mm lens, gives effectively a 100mm lens. These combinations are inferior to equivalent focal length lenses, but are much cheaper and easier to carry.

Telephoto lens A long focal-length lens of special design to minimize its physical length. Most narrow-angle lenses are of telephoto design.

Through-the-lens (TTL) metering Any exposure metering system built into a camera which reads the light after it has passed through the lens. TTL metering takes into account filters, extension tubes and any other lens attachments. These meters give only reflected light readings.

Tonal range The comparison between intermediate ones of a print or scene and the difference between the whitest and blackest extremes.

Tripod A three-legged camera support.

Tungsten film Any film balanced for 3200K lighting. Most professional studio tungsten lighting is of 3200K colour quality.

Tungsten light A light source which produces light by passing electricity through a tungsten wire. Most domestic and much studio lighting uses tungsten

Twin lens reflex (TLR) A camera which has two lenses of the same focal length – one for viewing the subject and another lens for exposing the film. The viewing lens is mounted directly above the taking lens.

U
Ultra-violet radiation Invisible energy which is present in many light sources, especially daylight at high altitudes. UV energy, if it is not filtered, causes excessive blueness with colour films.

Underexposure Insufficient exposure of film or paper which reduces the contrast and density of the image.

Uprating a film The technique of setting the film at a higher ASA setting so it acts as if it were a faster film but is consequently underexposed. This is usually followed by overdevelopment of the film to obtain satisfactory results. (Also known as 'push processing'.)

V
Viewfinder A simple device, usually optical, which indicates the edges of the image being formed on the film.

Viewpoint The position from which the subject is viewed. Changing viewpoint alters the perspective of the image.

W
Wide-angle lens A short focal-length lens which records a wide angle of view. It is used for landscape studies and when working in confined spaces.

Z
Zoom lens Alternative name for a lens having a range of focal lengths. One zoom lens can replace several fixed focal-length lenses, but results are likely to be inferior.

Index

239

Photographic Credits

Heather Angel 1-6, 9
Hans Reinhard/Bruce Coleman, 7

The Nature Photographer at Large
Mike Anderson 14 (top); Heather Angel 10-11, 17 (bottom); Robin Bath, 25 (right); Derek Bayes/Aspect 12; Ian Beames 23 (bottom); Jane Burton/Bruce Coleman 23 (top left); Eric Crichton 18 (left); Sergio Dorantes 27; Kenneth Fink/Ardea 28 (right); Franco Fontana 29; John Garrett 16, 17 (top), 19 (top), 30, 31 (top and bottom); Ken Gilham 25 (bottom); Helmut Gritscher/Aspect 13 (bottom left); Graeme Harris 22, 23 (top right), 26; E.A. Janes 20, 21 (centre); E.A. Janes/NHPA 19 (bottom); J. Alex Langley/Aspect 28 (top); Raymond Lea 21 (top); I. Lewis 18-19; Peter O'Rourke 21 (bottom); Clay Perry 24-5; A.J. Watson 24; Adam Woolfitt/Susan Griggs Agency 28 (left); George Wright 12, 13 (bottom centre and bottom right), 14 (bottom), 15 (right).

Perfect Landscapes
Heather Angel 32-3; Stefano Bajic 63 (bottom); Timothy Beddow 48; Jean Bichet/The Image Bank 46-7; Clive Boursnell 38 (bottom); Joseph Brignolo/The Image Bank 49; John Bulmer 43, 68; Michael Busselle 44 (bottom); Ed Buziak 38 (bottom left); Julian Calder 38 (top); Bruce Coleman 45; Sergio Dorantes 47, 58 (top); Mark Edwards 52 (left); Robert Estall 69 (bottom); John Garrett 36; George Gerster/John Hillelson 40; Fay Godwin 52-3 (centre); Peter Goodliffe 41 (top and bottom), 42 (top); Graeme Harris 55 (top); 62 (centre); Tessa Harris 66; Tibor Hirsch/Susan Griggs Agency 69 (top); Bob Kauders 44 (top); Gordon Langsbury/Bruce Coleman 67; Raymond Lea 62 (top); Barry Lewis 42 (bottom); Colin Molyneux 37, 39, 50, 54, 55 (bottom), 56, 59, 63 (top), 64, 65 (bottom); Marshall Smith/The Image Bank 51; Walter Studer/KODAK 61; Tino Tedaldi 65 (top); Malkolm Warrington/Eaglemoss 34, 35, 38 (centre); Glyn Williams 58 (bottom); Trevor Wood 57.

Developing Your Landscape Techniques
Heather Angel 70-1, 72; Alan Bedding 92; Chris Bonington/Bruce Coleman 96 (top), 97; Michael Busselle 87; Julian Calder 79, 91 (bottom); Cornell Capa/John Hillelson 74-5; Bill Carter/The Image Bank 89; Jean Coquin 86, 93 (top left and right); Robert Estall 85 (top); John Hannavy 95; Graeme Harris/The Picture Library 75 (top), 85 (bottom left and right); David Kilpatrick 83; Shirley Kilpatrick 93 (bottom); Raymond Lea 81, 82; Douglas Milner 94, 96 (bottom); Colin Molyneux 78 (top), 88; David Morey 90-1; Remy Poinot 77; Brian Seed/Aspect 73 (top); Mike Sheil/Susan Griggs Agency 75 (bottom); John Sims 84; Dennis Stock/John Hillelson 73 (bottom); Malkolm Warrington/Eaglemoss 78 (bottom); John Wigmore 80; Trevor Wood 76.

Photographing Flowers and Trees
Heather Angel 98-9, 107 (top), 109 (top left and right), 111 (bottom), 112, 115 (bottom); Timothy Beddow 102 (bottom); Michael Busselle 107 (bottom), 109 (bottom); Anne Conway 106; Valerie Conway 101; Eric Crichton 104 (bottom) 110 (left); Steve Dicks 108; Sergio Dorantes 114; P. Goycolea/Alan Hutchison Library 110-111 (right); Helmut Gritscher/Aspect 104 (top); Eric Hayman 113; Ekhart van Houten 103 (right); E.A. Janes 105; Tsuni Okuda/Aspect 100; Brian Wood 102 (top), 103 (left; Mike Yamashita/Aspect 115 (top).

Photographing the World of Animals
Helmut Albrecht/Bruce Coleman 132 (top); Heather Angel 116-7, 151 (top and bottom), 156, 157 (top and bottom left); Christopher Angeloglou 124 (top); Ian Beames 118, 131 (top), 146, 152; Ron Boardman 138 (left and bottom), 140 (top left), 143 (bottom left); Michael Boys/Susan Griggs Agency 127 (top left); Sverre Borretzen/Camera Press 143 (top); Ian Berry/John Hillelson 144 (top), 145 (bottom); Jen and Des Bartlett/Bruce Coleman 149 (bottom); Jane Burton/Bruce Coleman 130, 154 (bottom), 155, 157 (right); Julian Calder/Susan Griggs Agency 123 (top), 126, 140 (top); Bruce Coleman 121; Eric Crichton 138 (top); Eric Crichton/Bruce Coleman 136 (bottom); Anne Cumbers 124 (bottom left), 132 (top); Robert Estall 127 (bottom); John Garrett 131 (bottom), 141, 142, 147; Ernst Haas/John Hillelson 144 (bottom); Graeme Harris 128 (bottom); Graeme Harris/Eaglemoss 120; Eric Hayman 154 (top); International Scene 139; Pierre Jaunet/Aspect 149 (top); M.P. Kahl/Bruce Coleman 135 (bottom); Sheelah Latham/Ron Chapman 125 (right); Raymond Lea 133 (bottom); Clare Leimbach/Robert Harding Associates 143 (bottom right); Tom Nebbia/Aspect 136 (top), 148 (top); Fritz Prenzel/Bruce Coleman 134 (top), 135 (top); Masood Quarishy/Bruce Coleman 133 (top); Hans Reinhard/Bruce Coleman 122 (top), 150, 153; Hans Reinhard/ZEFA 127 (top right); Mike Sheil/Susan Griggs Agency 145 (top), 148 (bottom); Homer Sykes 137; Sally Anne Thompson 122 (bottom), 123 (bottom), 124 (centre and bottom right), 125 (left), 129 (top); Malkolm Warrington/Eaglemoss 119; Adam Woolfitt/Susan Griggs Agency 128 (top), 129 (bottom); Joe van Wormer/Bruce Coleman 134-5 (bottom); Ian Yeomans/Susan Griggs Agency 140 (bottom right).

How to Photograph Birds
Heather Angel 158-9, 173; Ian Beames 169 (bottom), 170 (top), 172 (top); Jane Burton/Bruce Coleman 161 (top); Colour Library International 164 (top; Tim Cook 161 (bottom); Per Eide 171; John Garrett 172 (bottom); Alfred Gregory 169 (top; Eric Hosking 166, 167; E.A. Janes 164 (bottom), 168 (bottom), 170 (bottom); Gordon Langsbury/Bruce Coleman 168 (top); John Markham/Bruce Coleman 160, 163; David Sewell 162, 165.

Nature in Close-up
Mike Anderson 177, 192 (bottom), 193 (top), 194, 195 (top left and right); Heather Angel 174-5, 179, 180 (left), 181, 182, 183, 184 (top), 185, 189 (top), 190, 191 (bottom), 197 (top and centre), 198; John Brown/The Picture Library 187 (bottom); Nick Boyce 187 (top); Nigel Coulton 186; Eric Crichton 184 (bottom) 189 (bottom); Eric Crichton/Eaglemoss 176, 178; Ray Daffern/Eaglemoss 196, 197; Sergio Dorantes 180 (bottom); Geoff Doré 180 (top), 192 (top), 195 (bottom); Jeff Foott/Bruce Coleman 191 (top); Helmut Gritscher/Aspect 193 (bottom); Ken Moreman 197 (bottom); David Parker 199 (top); John Shaw/Bruce Coleman 188; John Walsh/Aspect 199 (bottom).

Photographing the Elements
Heather Angel 200-1, 203; Ron Arbour 233; Robin Bath 204 (left); Timothy Beddow 222 (top and bottom); Alastair Black/All-Sport 210; Michael Boys/Susan Griggs Agency 228; John Bulmer 211 (top); Michael Busselle 224; P. Cherry 226; Colour Library International 202, 219; Bob Davis/Aspect 205 (top), 217 (bottom); Fred Dustin 207; Robert Estall 223; Andrew Evans 206; Harry Ford 230 (bottom); Jon Gardey/Robert Harding 225 (bottom); John Garrett 220; P. Goycolea/Alan Hutchison Library 217 (top); Ernst Haas/Magnum 208-9; Eric Hayman 216; The Image Bank 232 (bottom); E.A. Janes 221 (top); Sarah King/Robert Harding 227 (bottom); Harvey Lloyd/The Image Bank 232 (top); David MacAlpine 218 (bottom); Gered Mankowitz 225 (top); Mike McQueen/Susan Griggs Agency 218 (top); Jack Novak/Elisabeth Photography 227 (top); Chuck O'Rear/Woodfin Camp 209 (top); Remy Poinot/ The Picture Library 211 (bottom); Mike Portelly 212; John Reader/Aspect 231; Michael Sales/The Image Bank 205 (bottom); David Saunders 229; John Sims 221 (bottom); S. Summerhays/Biofotos 213, 215; Ian Took/Biofotos 214; A. Wetzel/ZEFA 230 (top); Adam Woolfitt/Susan Griggs Agency 211 (centre).